PRAISE FOR

Moondust

"Splendid!" –Arthur C. Clarke, author of *2001: A Space Odyssey*

"Fascinating and disturbing. We know what happened inside the Apollo spacecraft, but what went on inside the astronauts' minds? Did any of them really recover from their strange journey? Extremely thought-provoking."
— J. G. Ballard, author of *Empire of the Sun* and *Memories of the Space Age*

"Smith's mix of reporting and meditation is highly entertaining, and his superb book is a fitting tribute to a unique band of twentieth-century heroes." —*GQ*

"Forget flower power, the Beatles, and the Beach Boys, forget President Kennedy, the Great Train Robbery, and Swinging London, and even Vietnam if you can: what made the 1960s an unforgettable decade was the conquest of space. . . . When Andrew Smith set out to write [*Moondust*], three of the twelve moonwalkers had already died. [He has given] himself the task of talking to the rest before they too went into eternal silence." —*Guardian*, Best Books of the Season

"Spellbinding . . . written with deftness, compassion, and humor." —*The Observer*

"Smith deftly integrates the experiences of the lunar astronauts into the political and cultural contexts of their various missions. He is a graceful, easy-going writer, and this beguiling tale is replete with joyful wonder. . . . *Moondust* belongs to the same 'New Journalism' tradition as Tom Wolfe's *The Right Stuff*." —*Sunday Times*

"Enthralling. . . . Smith is an ideal narrator: sharp-eyed yet increasingly affectionate about his subjects; expert enough to dissect Apollo minutiae clearly but not so obsessed as to leave a general reader trailing in his jet wash." —*Financial Times*

"Smith's book succeeds . . . because he bungee-cords together so many intriguing digressions." —*New York Times*

"In an artful blend of memoir and popular history, Smith makes flesh-and-blood people out of icons and reveals the tenderness of his own heart." *–Publishers Weekly*

"Smith's book is an engrossing read, full of humor, insight, and appreciation for the vision and outright zaniness that marked the only human mission to another world." *–Space Daily*

"A provocative meditation on lunar travel and humanity's relation to space, pondering such themes as space art, quantum mechanics, New Age religion, UFOs, *Star Trek*, and [Smith's] own childhood memories." *–BusinessWeek*

"Utterly gripping. Smith is both sympathetic and bracingly unsentimental. . . . He also does an excellent job of rekindling the sheer fascination of that period between 1969 and 1972. . . . There are a great many moments when you find yourself lowering the book, looking up at the sky, and thinking: 'How the hell did they do that?'" *–Daily Telegraph*

"A rich mix of cultural history, reportage, and personal reflection. . . . [Smith] comes to see that our fascination with astronauts derives from the fact that they, too, are mirrors into which we gaze reflectively back at ourselves." *–Evening Standard*

"Riveting . . . tying all this together are Smith's first-person, present-tense reminiscences of his Moon-age childhood in California–so vivid you can almost smell the suburban lawns." *–Time Out*

"Smith's mission–gloriously realized in this spellbinding book–[is] to seek out the last nine and discover how the decades have treated the only humans to have walked on another world. . . . A wonderful collective biography written with deftness, compassion, and humor." *–The Observer*

"Wonderful. . . . Smith examines [the questions] not just in the political context of the times but, refreshingly, with regard to the popular culture and the mood of the moment. . . . A fascinating book, often poignant . . . but funny too." *–Daily Mail*, Critic's Choice

Jaime Turner

About the Author

ANDREW SMITH has worked as a critic and feature writer for *The Sunday Times, The Guardian, The Observer,* and *The Face.* He was born in the United States and lives in Norwich, England.

MOONDUST

ANDREW SMITH

HARPER ● PERENNIAL

NEW YORK ● LONDON ● TORONTO ● SYDNEY

MOONDUST

IN SEARCH OF THE MEN WHO FELL TO EARTH

HARPER ● PERENNIAL

Lines from Ted Hughes are from "The Burrow Wolf" in *Moon-Whales and Other Moon Poems*, published by Penguin.

Illustration on pages xii–1 by Jo Walker.

First published in Great Britain in 2005 by Bloomsbury.

A hardcover edition of this book was published in the U.S. in 2005 by Fourth Estate, an imprint of HarperCollins Publishers.

FIRST HARPER PERENNIAL EDITION PUBLISHED 2006.

Designed by Judith Stagnitto Abbate/Abbate Design

Library of Congress Cataloging-in-Publication Data has been applied for.

ISBN 0-00-715541-7
ISBN-10: 0-00-715542-5 (pbk.)
ISBN-13: 978-0-00-715542-2 (pbk.)

06 07 08 09 10 ❖/RRD 10 9 8 7 6 5 4 3 2 1

FOR LOTTE AND ISAAK,

THE STARS IN MY SKY

CONTENTS

MOONDUST

Earth

Moon

O N THE MORNING of July 9, 1999, I set out to meet Charlie and Dotty Duke in the bar of a London hotel. It was to be a brief encounter for a small magazine article of a type that I normally avoided, but even at a glance the Dukes were too intriguing to pass by.

What I knew about them was that in April 1972, Charlie had become the tenth of only twelve human beings to gaze back at the Earth from the surface of the Moon. I knew that he'd stayed there for three euphoric days, then come home and imploded: that he'd lost his moorings and been unable to settle; had terrorized his children and tormented his wife, before eventually finding peace and resolution with her through faith in God. Now the pair ran a ministry out of New Braunfels, Texas. They were in town to talk about it.

The longer I looked, the more fascinated I became with the strange and intense three and a half years in which the landings took place, during which the world seemed to shudder and change shape forever. By the end, a black Rolling Stones fan had

been beaten to death at Altamont and the Beatles had split in acrimony, with JFK, Bobby Kennedy and Martin Luther King seeming like distant memories. Vietnam was effectively over and the counterculture which defined itself in opposition to the war was drifting off to nowhere like dust in a desert wind, while Watergate reared and racial conflict escalated and the pop music that swirled around my ten-year-old head seemed cooler and more cynical than it ever had before. As NASA flight director Chris Kraft would remark, "The best of times for America was also the worst of times." Now recession was bearing down and a darker, harsher world was emerging.

And although the space program was begat by the Cold War, the lunar landings still looked like such a crazy Sixties thing, a last waltz with optimism in a decade which arguably ended on December 19, 1972, when the *Apollo 17* astronauts sailed home knowing that the adventure was over and its promise had been a mirage. No Merry Prankster or acid-popping mystic ever did anything freakier than this, and yet the ambiguities of the enterprise seemed endless. What had humanity gained from President Kennedy's capricious decision to launch his nation at the Moon, and the outrageous cash it required? The lunar program cost twenty-four billion 1960s dollars: at its peak, NASA was swallowing 5 percent of the U.S. federal budget. Was all that time, energy, money, *life*, wasted?

Charlie Duke wasn't the only one for whom the return to Earth was difficult. I traced the others and found that they'd reacted to their experience in wildly different ways. The First Man on the Moon, Neil Armstrong, became a teacher and retreated from public view, "getting back to the fundamentals of the planet," while his partner Buzz Aldrin spent years mired in alcoholism and depression, then threw himself into developing space ideas which all looked impossibly fanciful to me. The naturally rebellious Alan Bean of *Apollo 12* quit space to become an artist, endlessly rendering scenes from the lunar quest in oils, and Edgar Mitchell experienced a "flash of understanding" in which he switched on to the Universe, sensing an intelligence which he would spend the rest of his life trying to understand. Even more dramatically, Jim Irwin purported to have heard God

whispering to him at the feet of the majestic, gold-colored Apennine Mountains, leaving NASA for the Church upon his return. Meanwhile, the fearsome Alan Shepard, the only one to admit crying on the surface, did the one thing no one thought he would do–*could* do: he mellowed.

Among the rest, John Young became a fierce critic of NASA after the *Challenger* shuttle disaster and left the Astronaut Office in a fog of anger and grief, and Last Man on the Moon Gene Cernan admits to a nagging disappointment with everything that has followed his experience with *Apollo 17* ("it's tough to find an encore"). His flight companion, Jack Schmitt, became a U.S. senator, but found politicians myopic and frustrating after the creativity he'd grown used to. He wasn't reelected and I'd heard that he latterly worked as a "space consultant" in Albuquerque. All described an almost mystical sense of the unity of humankind as seen from afar. A lot happened up there. The postflight divorce rate was, in more than one sense, astronomical.

With hindsight, the astronauts' reactions should have been predictable. Suddenly, the twelve had to find answers to a question that had never been asked in quite the same way before– namely, "Where do you go after you've been to the Moon?" In addition to their own hopes and expectations, they had the fantasies of faceless millions at their backs and millennia's worth of lore. The Nepalese, for instance, believe that their dead reside on the Moon; when the *Apollo 14* veteran Stu Roosa visited there, he grew increasingly flustered at being asked, "So did you see my grandmother?" The walkers will forever be caught between the gravitational pull of the Moon and Earth's collective dreaming. Charlie Duke grew angry as he admitted getting letters from conspiracy theorists who hold that the Moon landings were staged and call him a liar.

I liked Duke. At the age of sixty-four he was still tall and handsome and spoke with a balmy drawl that seemed familiar, though it took a while for me to place it. I felt like a child lost in a favorite bedtime story as he described his flight and the striking luminescence of our world as it moves through the lonely black void of space. From the Moon, he said, the planet was like a jewel, so colorful and bright that you felt you could reach up

and grab it, hold it in your hands and marvel at it like the precious thing it is. Then he described his horror at realizing that his life could only be one long, slow anticlimax from there. All that effort and creativity . . . what had it been for? The development of Teflon (a fallacy anyway)? A few photographs? By 1972, Americans didn't give a damn about space. Then Duke spoke of his touching hope that one day "we'll go back there" and I didn't have the heart to tell him that from where I was sitting, that didn't look likely—at least not in his lifetime. Perhaps not even in mine.

When our time was up, I thanked him for a conversation I'd greatly enjoyed and made to leave, but Charlie told me that he had a gap in his schedule, so we could talk a while longer if I wanted to. He then explained that he and Dotty had received some troubling news the night before, when word arrived that Pete Conrad, the wisecracking, larger-than-life commander of the *Apollo 12* mission, the second one to land, had been injured in a motorbike accident near his home in California.

Conrad was the one whose colorful swearing worried NASA suits, but who had kept cool when his Saturn rocket was hit by lightning—twice—on takeoff, sending cockpit alarms into a cacophonous frenzy and the ground into panic. When a journalist doubted his assertion that Armstrong's "One small step . . ." speech was not scripted, Conrad secretly bet her $500 that he could say whatever he wanted when his turn came and nominated his words on the spot. "Whoopie! Man, that may have been a small step for Neil, but it's a long one for me!" she duly heard the diminutive astronaut trill as he became the third person on the Moon on November 19, 1969. He was also the one who took a cassette player on the trip so that he and his crew could bounce around to "The Girl from Ipanema" and The Archies' "Sugar Sugar," and allowed copilot Al Bean to take the pirouetting gold Lunar Module, so spidery and fragile-looking, for a joyride round the back side of the Moon, where NASA couldn't see what they were up to. When they went for their lunar stroll, Mission Control had to tell the two friends to stop yammering and exclaiming their delight to each other, as they couldn't hear a word Dick Gordon was saying from the orbiting command craft.

Then Dotty was called to the phone and came back with the shocking news that Conrad had died of his injuries, and I wasn't surprised to see Charlie Duke's eyes cloud over as he talked about his comrade. I later learned that the place where he fell was called Ojai, a Native American word for Moon, but it was the words Duke left me with that set my mind reeling that day. He said them quietly and evenly, as though uttering a psalm.

"Now there's only nine of us."

Only nine.

On the way home my mind buzzed with the stories Duke had told, yet I also found myself overtaken by a sadness I hadn't seen coming–not because only nine people remain who've seen us from the surface of the Moon, but because one day, possibly one day soon, there won't be anyone who has. Nevertheless, I went home and carried on as before, expecting to think no more about the Apollo project, banishing it to the corner of my mind that it had occupied so obediently for three decades.

But something unexpected happened: the spacemen wouldn't go away. Three years later, I still found myself slipping outside to stare at the Moon in a way that I hadn't since child-hood, trying to imagine the tense drift toward it, the ecstatic re-turn. I wondered whether the Moonwalkers had reconciled themselves to being Earthbound; whether they'd made peace with our world or continued to mourn their strangled hopes. I wanted to know what kind of people they'd become and what they'd learned; how they felt about the weird trip now and whether they thought it had changed them. Even more than this, I wondered why I suddenly cared when I hadn't before. I began to ask myself what the whole thing had been about–what it had *meant*, if indeed it meant anything–and to develop an inchoate sense that the answers to these questions were important, even if I wasn't yet sure why.

And in the end I realized that there was only one way to try and answer them. I was going to have to find the nine Moon-walkers and see for myself where the odyssey had led, while I still could.

WHEN YOU'VE SHARED a moment with the whole world, it can be hard to know precisely where your memories end and everyone else's begin.

I see a blindingly bright California day. I am cruising on my bike, a metallic green Schwinn with swept-back handle-bars and a long chopper seat, which I've only just stopped parking in my bedroom at night so I can fall asleep looking at it. I want to be Evel Knievel and have spent the unending American school holiday building ramps with bricks and bits of wood lifted from local building sites. And no one can out-jump me, *no one*, especially not David, who rides by my side...mad, weird David, who's twice everyone else's size and has a penis like a man's and spends all his time trying to make hang gliders out of 2×4's and sheets of plastic. This morning, I found him begging my brother to jump off his garage harnessed to one of these contraptions and when I

pointed out that if the thing plummeted like a stone without any-one attached to it, it would probably do the same with my brother aboard, he insisted that, if you looked–like really, really looked–you would find that it had moved forward from the ver-tical by at least eight inches. It had, in other words, flown. David's parents sunbathe nude in his backyard sometimes. I can't imagine mine doing that.

No one's in the backyard today. We've just come from his place and his mom and dad are hunched in armchairs, squint-ing at the TV. We've been riding around for hours, and it's the same everywhere. Cars bake in drives. Dads are home. It's as though the grown-up world is frozen and the Universe holding its breath while these spectral black-and-white images float across the screen, the same pictures in every single house, like the ghosts of ghosts of ghosts.

They're going to the Moon. My dad took me into the garden to look at it last night. I saw him frown as it reflected watery gold on his upturned face, as if someone had stepped over his grave or shone a bright light in his eyes. It was one thing to land a man on the Moon, quite another to bring him back afterward. But to have stood there in the first place . . . the thought alone made you tingle. Perhaps coming back wouldn't be such a big deal af-ter that. No wonder David and I, and everyone we know, have spent this summer trying to reach the sky in one way or another.

We're in Orinda, California, a quiet suburb on the eastern side of the San Francisco Bay. It's Sunday, July 20, 1969, and the good things in my life are as follows: my bike; the chattering creek that runs through a ravine at the end of the garden; the fact that my teacher next term is going to be Mrs. Lipkin, the foxy twenty-six-year-old hippy chick who's already been mar-ried and divorced twice and plays Jefferson Airplane songs to her class on guitar. And there's my friend Scott McGraw, who's older than me, wears lank long hair and bell-bottom jeans, goes everywhere barefoot and is the first person to tell me that Santa Claus is a lie *but if you think that's bad, check out what "fuck" re-ally means.* Scott's brother plays in a band called Love Is Satis-faction. *Love Is Satisfaction:* I *love* that.

All the streets in our neighborhood are named after charac-

ters from "The Legend of Sleepy Hollow." This is the kind of thing people do when they're building from scratch, out of nothing, with no past to constrain them. My street's called Van Ripper Lane and it slopes in a long arc from top to bottom. At the top end are the sun-soaked hills of Orinda Downs, where we pretend to ride motocross and find fossils and catch lizards in the rocky outcrops perfumed by wild thyme. When there's a breeze, ripples drift across the tall, golden grass and the hills seem to shimmer and I love to lie in it and let it tickle my face as I stare into the cloudless sky. Sometimes, if you stay there long enough, the smaller creatures forget that you're not part of the hill and they'll scuttle around you without fear. Then you do feel part of the hill and the infinitely receding worlds within it. Within a few years, this will be an estate, full of mock-Georgian houses and fences everywhere. The world is changing.

We coast down the hill and into my drive. David throws his bike on the lawn. I park mine on its stand, issuing a warning to my brother and his tiny, blind-as-a-bat friend Ernie that if they knock it over, I will kill them. Without the wind in our faces, it's hot outside, so we trot through the screen door and into the kitchen, from where a trail of sound and excited voices draws us toward the living room. It's 1:15 PM. My parents' friends the Reuhls and the sweet and elderly Fishes from across the road are leaning forward on couch and chairs, forward over the gold-and-orange shag carpet, clutching beers or cups of coffee tightly with varying mixtures of anxiety and disbelief on their faces. A familiar singsong southern drawl is floating from the TV, decorated with static and peculiar little squeaks and pings which sound like someone flicking the lip of a giant wineglass with their finger. We know this as the voice of Mission Control. His name is Charles Duke, but the astronauts just call him "Houston." There are other voices, too, but they all sound distant and intermingled and it's hard to get hold of what they're saying. An air of expectancy hangs in the room.

Now we hear:

"Thirty seconds."

Silence.

"Contact light."

"Shutdown."

"Descent engine command override. Engine arm, off, 413 is in."

A pause.

Silence.

More silence.

"Houston, Tranquillity Base here . . . the *Eagle* has landed."

No one in the room seems to get it straightaway. The adults look at each other. Then cheering in the background somewhere and the drawl, like a sigh, the first hint of emotion from inside the box.

"Roger, Tranquillity, we copy you on the ground. You got a bunch of guys about to turn blue. We're breathing again. Thanks a lot."

The room erupts. We erupt, too. My dad ruffles my hair and slaps David on the back. All the little kids run in.

"Boys–they're on the Moon!"

Dad has tears in his eyes. It's the first time I've ever seen him with tears in his eyes, and it will only happen once more.

None of us have any idea what has been going on behind the scenes during those final moments, although the evidence was there in the coded monotone exchanges if you knew how to read them.

THE CREW NASA chose for this landmark mission consists of Neil Armstrong, Buzz Aldrin and Mike Collins, and they're a peculiar trio. The flight plan called for Collins to orbit the Moon in exalted frustration, tending to the ship that would provide their ride home, the Command Module *Columbia,* while his colleagues dropped to the surface in the *Eagle* lander. He is a communicative character; enjoys fine wines and good books; paints and grows roses. But Armstrong is remote and self-reliant–Collins likes him, but can't find a way through the defenses–while the live-wire Aldrin just strikes him as dangerous.

The buildup to the mission was insane. On one occasion the astronauts went on a geology trip to the mountains, but couldn't hear a word their instructors were saying for the sound of media

choppers jostling and whirring overhead like ravenous giant mosquitoes. No one knows for sure what's up there, so the newspapers and TV current-affairs programs have been full of catastrophic predictions. One academic has been assuring audiences that Moondust on the astronauts' abominable-snowman suits will ignite the moment it comes into contact with oxygen back in *Eagle*'s cabin, if it doesn't simply explode underfoot. Another warns that the surface may be composed entirely of dust, into which the craft will sink embarrassingly the moment it touches down, never to be seen again. Still more experts worry over the prospect of inadvertently bringing back an alien bacterium that will destroy all life on Earth, as in the sci-fi movies *The Quatermass Experiment* or *The Andromeda Strain*. Magazines contain drawings of what strange, subterranean creatures may lurk below the surface, hungry for roly-poly white snowmen from Earth.

So it's hardly surprising that there's been tension in the cabin of the *Columbia* Command Module. In the early part of the flight, Aldrin kept describing these "flashes" he would see in the corner of his eyes as the Moon loomed before swallowing them into orbit, and Armstrong was irritated by this suggestion of something unknown and mysterious, just as he is when the other man drops to his knees and says Communion after touching down safely. In the lander, or Lunar Module—a bizarre and spindly construction which looks as though it was assembled from toothpicks and egg cartons by a class of five-year-olds, then roughly covered in foil by their moms—he has constantly felt "behind the airplane." Not quite in control, and Armstrong doesn't like that, either.

But the real drama happened as they were coming down, nearing the surface. As David and I sped unsuspecting down the road; as Mum was pulling some beers from the fridge; as my father and Mr. Reuhl and Mr. Fish, who used to pay me a princely two dollars to mow his minuscule lawn and would have paid more if Dad hadn't instructed him not to, were discussing the implications of all this and the probability that they would get to visit the Moon as tourists in their own lifetimes. Mike Collins had released the *Eagle* from *Columbia*'s grip just after 10 AM our

time. They'd flown in formation for a short while so that the Command Module pilot could inspect the other craft from his porthole. Satisfied that it was in good repair, he masked his anxiety with a joke.

"I think you've got a fine-looking flying machine, there, *Eagle*, despite the fact that you're upside down."

In zero gravity there is no upside down. Armstrong played along. "Somebody's upside down," he said.

Then a burst of thrusters took *Columbia* away until the *Eagle* was a little sparkly point of light, like a tiny diamond floating between Collins and the cratered surface. He had considered the chances of success and privately rated them at about 50 percent, unaware that his commander had come up with the same odds. These were generous according to some of their colleagues' calculations.

With ten minutes remaining to touchdown, *Eagle* was 50,000 feet above the lunar surface. Armstrong and Aldrin stood side by side, spacesuited, anchored to the floor by harnesses. Everything had gone according to plan so far and preparations were on schedule. They had pressurized *Eagle*'s fuel tanks, primed the computer and checked their trajectory by training their navigation telescope on the sun. They activated the camera and armed the descent engine. Then Aldrin pressed the ignition button and the rocket engine came to life. Thirty seconds later, the cabin shuddered as they roared to full thrust.

And now there was a problem.

Eagle was facing the Moon, and Armstrong noticed that the landmarks he navigated by were coming up two seconds ahead of expectation: they were set to overshoot the landing area, but the computer hadn't picked up the error. At 46,000 feet, he flipped the craft over, so that the landing radar faced down and he and Aldrin found themselves looking up at the shimmering, miragelike Earth. The ride was noticeably jerkier than in simulation as Aldrin compared data from the radar and computer and found a discrepancy of several thousand feet. Knowing the radar to be more reliable, he decided to instruct the computer to accept its information and act on it, but as he hit the necessary buttons, the piercing buzz of the Master Alarm filled *Eagle*'s

cabin. They looked down and saw the "PROG" light glowing sulphuric amber on the computer display.

"Program alarm," said Armstrong.

His voice stayed even, but the words were clipped, urgent. Aldrin instructed the computer to supply the alarm code and "1202" flashed onto the screen. He didn't know what this meant, but suspected that it was something to do with the computer being overloaded. This had failed to happen in any of the simulation he'd been a part of. Now wasn't the time for it.

The focus turned to Earth and the thirty-five-year-old flight director, Gene Kranz. He knew the alarm was serious, because he'd seen something like it back in the first week of July and he'd aborted the virtual mission as a result. The truth was that he and his staff had been having problems for the last hour, with communications cutting out–sending Mission Control screens blank and filling headsets with static–then resuming for barely long enough to justify continuing the descent. There was a 2.6-second delay in communications with the Moon and so no time for elaboration. In simulations, controllers had discovered a *dead-man's box* which was defined by this delay, in which the LM would always hit the surface before they could react to a problem and order an abort, and about which nothing could be done. Now the exchanges were breathless and suspended, like the *Eagle* itself.

Kranz quickly consulted the people around him, listening for signs of strain in their voices, then turned to the young MIT computer boffin Steve Bales.

But the Lunar Module computer was too complicated for one person alone to understand. Bale knew that it wanted to abort the mission. What he didn't know was why. So he, in turn, relayed the problem to his team of backroom experts, who guessed that the computer, finding itself with too many tasks to perform–again, no one knew why–was automatically returning to the start of its computation cycle, to begin again. In the background, Armstrong could be heard requesting tersely: "Give us a reading on the 1202 program alarm." Aborting a landing at this stage was neither easy, nor certain of success, and once you'd done it, there was no room for

further failure. They decided to carry on. So long as the alarm was intermittent, they could continue their descent safely. If it became continuous, however, the computer could stop working altogether and they were lost.

Standing at the flight controls of the plummeting lander, Armstrong heard Duke's voice.

"You are go for landing."

The trouble was that he and Aldrin had been distracted by the alarms and the mental preparations for an abort. By the time the computer had been pacified and attention returned to the task of getting *Eagle* down, the Moon was only 1,000 feet below and they were racing past the inviting plain on which their hopes had been pinned. In the huge, glowing control room, seventy people who'd spent months and years training for this moment caught their breaths in unison, like a theater audience, when the landing radars abruptly corrected themselves and the little toy Space Invaders graphic in front of them jumped to four miles off-range: at six, mission rules called for a mandatory abort. Armstrong looked ahead and was not thrilled by what he saw: a field of huddled boulders, gathered like the remains of an ancient cemetery around the dark lip of a crater, into which the computer was blindly flying them. He made some quick calculations as to whether he could bring the craft down in front of the boulder field, knowing that they were probably composed of lunar bedrock and the geologists would be ecstatic, but realized that they were still going too fast. He pressed some buttons and took control of the craft, pitching it forward until it was almost upright. Now the rocket was slowing their rate of descent, without diminishing forward speed. He would try to set down in the first clear space he saw.

No one except Armstrong knew about the crater or the boulders. Aldrin had his eyes fixed on the instrument panel and was issuing a steady stream of data, which is what Mission Control and the rest of us were hearing.

"Three hundred and fifty feet . . . down at four . . . three hundred thirty, six and a half down . . ."

Aldrin's remote mantra was reassuring, but masked the fact that, with his partner too absorbed in finding a way to bring

Eagle down before her fuel ran out to tell anyone what was happening, even Mission Control was in the dark. All they knew was that the plan had been ditched and Armstrong was now on his own, a quarter of a million miles from home. There was nothing they could do to help. Duke whispered to Kranz, "I think we'd better be quiet."

Three hundred and fifty feet up, *Eagle* skimmed over the boulders. Armstrong pitched her back to a rearward angle in order to avoid picking up too much speed. He banked left to skirt another field of rocks as the Moon seemed to rear up at him and telemetry showed his heart rate surge.

"How's the fuel?" he asked Aldrin. An unnatural calm in his voice masked the fact that his pulse was now racing at over 150 beats per minute.

"Eight percent," came the reply. Less than in the simulations.

At 250 feet, Aldrin stole his first glance out of the window, then quickly returned to his instruments. Armstrong was still searching for a landing site: he chose one, then discovered it to be flanked by another crater. There was now ninety seconds' worth of fuel left, but twenty of those had to be saved for an abort: if they got to that stage and still hadn't landed, the computer would automatically try to shoot them back into space and putative safety, no matter how close they were to the surface. Back in the control room, an automatic sequencer had begun counting down to such an eventuality, and everyone knew it. Armstrong edged forward and saw a clearing of about 200 square feet, bounded by craters on one side and more boulders on the other. The Moon was 100 feet beneath them. This had to be the place.

Eagle needed to be brought down in a straight vertical line. Any horizontal movement at the point of impact could snap off one of her matchstick legs. Yet, as he listened to Aldrin reciting his litany of figures—"sixty feet . . . down two and a half . . . two forward . . . two forward . . ."—Armstrong suddenly found his view stolen by an eruption of dust and rock that arced away in dense sheets, obscuring the landing area completely. Momentarily unsettled, he was training his eyes on some distant rocks

in order to maintain his bearing when he heard Charlie Duke's voice in his ear, warning "sixty seconds." No one in Mission Control knew about the crater, the boulders, the dust. All they knew was that in every successful simulation Armstrong had landed by now. The years of preparation, the billions of dollars, the lives that had been sacrificed on the way—most notably the crew of *Apollo 1* thirty months previously—all that energy and ingenuity and life was now compacted into the next sixty seconds and the judgment of one man. The room was held in an agonized silence.

At thirty feet, Armstrong found *Eagle* to be drifting backward. He didn't know why, but knew that landing while he couldn't see where he was going would be extremely dangerous. He wrestled with the controls, eventually halting the backward movement, but picking up a horizontal drift in the process. He felt frustrated that he wasn't flying well enough, and would have given anything to buy more time, but there was none to buy. They were now hanging twenty feet above the surface of the Moon and had entered the "dead-man's curve"—the point at which bailing out becomes impossible and if the maneuver doesn't work, you crash.

From the earth: "Thirty seconds."

Aldrin: "Contact light."

Through the storm of dust, whiskery probes attached to the LM's feet had made contact with something. The pilot had been instructed to cut *Eagle*'s descent engine at this height, because engineers calculated that it could be blown up by the back pressure from its own exhaust if he didn't. But Armstrong didn't do it. In his fight to keep the thing steady, he failed to hear Aldrin's call.

Fortunately, the engineers were wrong about the back pressure. Still firing, *Eagle* settled into the dust so easily that neither man felt the impact. Armstrong's hand flew to the Engine Stop button and he announced, "Shutdown." There was a whirr of action as he hit more switches and buttons and Aldrin ran through the post-landing checklist. Then there was a moment of stillness. The two men turned to face each other, grinning through their helmet visors, and clasped hands. After what seemed like an age, Armstrong advised a waiting world that the *Eagle* had

landed. The announcement that his words were coming from "Tranquillity Base" momentarily threw Charlie Duke, who became tongue-tied and began "Roger, Twan–" before gathering himself and offering a correction.

Tranquillity. They were on the Sea of Tranquillity. With ten seconds' worth of fuel to spare, they were down.

Those last ten minutes contained 600 of the most vivid seconds a human being ever lived and we knew nothing of them. Countless things went not exactly *wrong*, but different from plan and expectation, *below optimum* in NASA's arid tongue, and for decades to come Steve Bales will find it hard to listen to tapes of the landing without feelings of discomfort and foreboding, even knowing that it turned out all right. Now Armstrong and Aldrin have to prepare the craft to take off again in a hurry, in case of trouble. After that, they are under orders to get some sleep, but Armstrong won't sleep, because he's trying to work out what to say when he becomes the first human to set foot on another world. No one seems to have noticed that this is also the first properly global media event: in a future the astronauts can't yet see, politicians will have marketeers and spin doctors to help with this sort of thing. In July 1969, however, he's on his own. It's 3:17 PM Houston time, 1:17 PM in Orinda, California. The walk is set for ten hours from now. What are we going to do until then?

WHAT'S IT LIKE to be alive in 1969?

Bobby Kennedy has just been assassinated and so has Martin Luther King. It's a strange word, *assassinate*, which to my eight-year-old ears sounds sort of clandestine and exotic, not like the blunt and scary *killed* or *murdered*. The Kennedy shooting happened a year ago, but I recall it very clearly, because we were driving to Disneyland the next morning and I woke to Dad telling me that we might have to call the trip off because people might not want to skip around having fun at such a terrible time. But in the end they did, so we went. I don't know why they shot him, or his brother. No one seems to know.

I understand more about King than Kennedy. On the windowsill of our classroom last term, there were piles of biographies of famous Americans and I devoured them, but the one I liked best was about Harriet Tubman, the escaped slave who risked all kinds of harm to help lead other escaped slaves to freedom in the north on the "Underground Railroad." The local education authority had cooked up a scheme to mix kids from our mostly white suburbs with black ones from Oakland and take them on field trips. I'd made some good friends at places like the University of California science lab, where you could watch massive, tape-spooling computers do amazing things like make a dot travel from one side of a screen to the other, or count until they reached infinity or you got bored and pressed a red button–whichever came first–at which point they would start over again. The thing I remember most clearly about those outings, though, is Andy Leeman, who was sitting next to me the day they announced it, turning and scowling, "I wonder what it's like to sit next to a *nigger*." Every day on the news, there seem to be pictures of black people being hit with truncheons or pinned to walls by the jets of fire hoses. It's frightening.

In fact, the news always seems bad. Mum watches TV on a weekday morning when they hold the Vietnam draft, live, like a lottery. If your number comes up, she says, you've lost and have to go fight. At summer school this year, they showed us a film called *The Lottery*, in which the population of a small town gathers for an annual festival of some kind, where everyone–men, women and children–has to take a little folded-up piece of paper from a box and open it up. They're all laughing and joking with each other until one woman, whom we've watched shepherding her children to the gathering, opens her paper to find a black spot on it, at which point everyone stones her to death.

Afterward, we had a discussion and I wondered whether the film was about bullying. There's a girl in my class named Kelly, whom all the locally raised kids pick on viciously for reasons that I haven't yet understood. Soon after we arrived from New York, I felt sorry for her and sat next to her on the school bus one day, but everyone else teased me so much that I

stayed away from her after that. She seems to smile a lot, but not a happy smile. And last week, in her summer-school science class, Mrs. Lipkin came in to find that someone had drawn a swastika on the blackboard. She dropped her Coke bottle and threw both hands over her mouth and ran back out. Later she came in and explained why. She was Jewish. I'd been gazing at the symbol before she came in, thinking that it was an interesting shape. I had no idea what it meant. I loved Mrs. Lipkin, who would give me my first Beatles album at the end of the school year, and was upset that she was upset, and then a few days later Scott and I found a gopher snake that someone had strung up by the neck and used for target practice with an air rifle. There's a lot of peace and love in the air according to the songs they play on KFRC, but not necessarily in the air around me.

So, like all eight-year-olds, I recognize brutality to be the inevitable defining feature of my world. And outside of school, life is really okay. We spend our days catching snakes and lizards and frogs and, as if on a mission to prove that adults don't have a monopoly on stupidity, black widow spiders, which we keep in jars as pets. Accordingly, the things I wouldn't mind being when I grow up are: Evel Knievel, obviously; a zoologist specializing in creatures that terrify my mother; an astronaut and/or the lead guitarist in a band, even if Scott assures me that I have to be the bass player because I'm skinny and tall for my age.

Of those four things, what I'd most like to be is an astronaut, but I'm not going to admit that, because all boys want to be astronauts at this time, really *all* boys and even some girls–like Erin Taylor, who I kind of like. And there's nothing at all unrealistic about this, because one thing of which we're all certain is that the future for astronauts is bright. Space sci-fi is everywhere, from *Star Trek* and *Lost in Space* to the *Silver Surfer* comics which taught me to read, to the era-defining *2001: A Space Odyssey*, in which the inscrutable black slab that contains the key to the Universe is dug up on the Moon, by people living on a Moon base. We're in one of those rare moments where imagination and expectation are converging and anything seems possi-

ble. In 1969, there is no doubt in anyone's mind that, by 2001, there *will* be bases on the Moon. There *will* be daily flights into the void, probably run by private companies, and mass space tourism. Communities will orbit the Earth and fan out through the solar system. Today proves that the technology to do these things is available. David is already talking about us saving up to buy a ticket for one of the first commercial space flights, which are on sale now. All we'll have to do then is toss a coin or fight a duel to decide who gets to use it.

With so many troubles on Earth, perhaps escaping to the heavens seems natural and logical. They're making a movie called *Silent Running,* starring Bruce Dern, in which this actually happens as a way of preserving the forests and deserts, and something similar seems to be going on in Neil Young's song "After the Goldrush," where the human race is fleeing its devastated cradle in spaceships, "flying Mother Nature's silver seed to a new home in the sun." Everywhere we turn, there is talk of the Cold War, Vietnam, racial strife and looming environmental catastrophe. But all the bad things that are happening seem to have their corollary in good—none of them appear insurmountable—and we make no connection between those old-world horrors and the staggering ambition of the lunar program. For all their ties to the military, the astronauts are pioneers, talismans, bringers of a bold new space-faring future ...

Sometimes it really does feel like the dawn of a new age.

But the 1960s is the age of false dawns. Top of the charts is the bubblegum hippy anthem "Something in the Air" by Thunderclap Newman. Closing in fast, though, is Credence Clearwater Revival and "Bad Moon Rising."

The afternoon has passed in a blur. We watched some of the space coverage on TV. Joan Aldrin appeared with her three children outside her house in Nassau Bay. One of them was a boy named Andrew, who looked about my age, and an instant visual appraisal led me to believe that his mom cuts his hair, too. They had watched the landing at home with a group of family and friends and couldn't understand the litany of technical data any more than we could. The difference was that Mrs. Aldrin had NASA pals on hand to explain what they meant. She heard

them say that the fuel was almost gone and the astronauts hadn't yet found a place to land, and her head spun. She stood in her crowded living room, holding on to a doorframe, eyes brimming with tears, waiting for the awful instant in which her husband's voice would stop and be lost to her forever, while the whole world listened in. Then she heard him say, "Okay, engine stop." She accepted a hug from someone and retired to her bedroom.

It's coming up to 7:30 PM and dusk is falling. I can hear crickets and birds in the back garden, and the burble of the creek. The Moon's in the sky, a big silver full Moon, and I've been on the porch in my pajamas, which have little blue spaceships on them, just drinking the sight in. They're up there. Up there. *There.* We've been watching the screen for an hour, because Neil Armstrong was due out at 7:00 PM, after he told NASA that he couldn't bear to hang around until midnight, much less sleep. The TV anchor and various experts have been assuring us that everything is fine, though. It takes a while to get those big Michelin Man suits on.

Armstrong is late because stowing the dishes after dinner was never part of the practice routine and it's taken longer than anyone expected. The first men on the Moon are being delayed by dirty dishes: there's something wonderful about that. The *Eagle* is on a bright, rolling, crater-pocked plain. When they had a chance to take the scene in through the LM's tiny, triangular portholes, Aldrin exulted at the unreal clarity in this atmosphereless environment, with features on the distant horizon appearing close by, contrasting beautifully against the boundless black backdrop of infinity. Armstrong wondered at the peculiar play of light and color on the tan surface. He thought it looked more inviting than hostile. He knows this will be his home for only twenty-one hours.

Now, what *do* you say as you become the first human being to set foot on the Moon? Neil Armstrong is an astronaut, not a poet, and certainly not a PR man. He wouldn't have bothered about it much, but people have been writing to him with all kinds of suggestions—the Bible and Shakespeare being the most popular sources of inspiration—and everyone he meets seems to

have an opinion. The pressure is on. It's irritating, because, for him, the landing was the poetry and taking off again his next major work. Still, as he thinks about it, he considers the paradox that it is such a small step, and yet . . . the laconic career pilot comes up with one of the most memorable lines ever offered the English language.

The door won't budge and they don't want to force it, because you could poke a hole through *Eagle* at almost any point. The air pressure inside the cabin is holding it closed, so Armstrong peels a corner back gently and the last of the craft's oxygen screams into space as a rainbow of ice crystals. Aldrin holds the hatch open as the other man sinks to his knees and crawls through, until he is standing on *Eagle*'s porch, surrounded only by Moon and space and the Earth which hangs above him.

He pulls a ring and a small TV camera lowers on a tray from the undercarriage and begins transmitting pictures home. A voice from Earth exclaims, "We're getting pictures on the TV!" And so we are: grainy and unearthly. Upside down at first, then flipped over. Wow. Armstrong tests his weight in one-sixth gravity and launches himself onto the LM's giant landing pad. He describes the surface as "very, very fine-grained as you get close to it . . . almost like a powder." Then:

"Okay, I'm going to step off the LM now."

There's still time for the rapacious Moon-bugs to grab him, but they don't. He tests the ground to make sure it will take his weight, then steps off the LM.

"That's one small step for man, one giant leap for mankind . . ."

He bounces, paws at the dust once more with his boot and finally lets go of *Eagle,* to be free of the Earth and all its creations. He walks hesitantly, unsteadily at first, like a toddler searching for the secret of balance. He feels his way into the rolling gait that Moonwalking demands and takes some photos, until Mission Control reminds him about the "contingency" soil sample he's supposed to get in case of an emergency takeoff. At that moment, Aldrin chips in, too, and the commander snaps, "Right," as the press room back in Houston erupts with laughter—because it seems that nagging is nagging, even on the Moon. Fourteen min-

utes later, Aldrin joins him, cracking a joke about being careful not to lock the hatch on the way out—but all the same, he's covered in goose bumps as he steps away from the *Eagle*. He likes the reduced gravity, is glad of its attention after the weightlessness of space, which feels lonesome to him, as though he's nowhere. He looks up at the half-dark Earth and can make out the slowly rotating shapes of North Africa and the Middle East, then returns his eyes to the Moon and realizes that the soil next to his boots has lain untroubled by life since before those continents existed.

I run out into the garden to bathe in the silky Moonlight and the blood seems to rush to my head. They're standing there now. They're walking on the Moon. I go back inside and President Nixon is on the phone to the astronauts.

"Hello, Neil and Buzz, I'm talking to you by telephone from the Oval Room at the White House. And this certainly has to be the most historic telephone call ever made from the White House . . ."

Throughout the Moonwalk, Aldrin has been wrestling with a strange mixture of emotions, coalescing in an eerie sense that he is part of something that reaches way beyond himself. He's here and there is Moon under his feet, but he feels strangely detached from the proceedings, as though he is simultaneously back home on the sofa, watching himself being watched. Inside *Eagle,* he felt alone with Neil, but now he imagines the presence of the whole of humanity. He wonders what to say in response to the president and decides that it might be best to say nothing at all.

Nixon's still going on.

". . . For one priceless moment, in the whole history of Man, all the people on this Earth are truly one. One in their pride in what you have done. And one in our prayers that you will return home safely to Earth."

Nixon *does* have speech writers.

There is an awkward silence, such as might be encountered in conversation with an elderly uncle who can't quite remember your name. Then Armstrong speaks.

"Thank you, Mr. President. It's a great honor and privilege

for us to be here, representing not only the United States but men of peace of all nations ... men with a vision for the future ..."

It's the 1960s: women still count as men. To some viewers, the astronaut's halting voice sounds thick with emotion, although he will later insist that, with perhaps a thousand million people watching and listening, his thoughts are mostly concentrated on trying not to say anything stupid. He turns his attention back to inspecting and gathering samples of the Moon. It's already proving a far more interesting place than he'd expected. Especially odd is the visible curvature toward the horizon on this relatively small sphere, which lends a kind of intimacy to the landscape. He and his partner struggle to plant an American flag in the lunar soil, and then have difficulty in persuading it to stand up. When the *Eagle* takes off, it blows over.

They're still out there when I lose my battle with tiredness and Dad carries me off to bed. It's a hot night and I'd normally fidget and have trouble getting to sleep, but blanketed in the unreality of the last twelve hours, I'm out the moment my head hits the pillow. The next morning, I wake to sun struggling through my curtains and the world feels a little different. The future seems a little nearer. Nixon's declared a holiday, so my brothers are on the lawn and I'm going to have breakfast before riding down the street to see David. On the Moon, though, Armstrong and Aldrin are about to enter the third act of their own drama.

If it works, *Eagle*'s ascent engine will be an amazing thing. It generates a meager 3,500 pounds of thrust, but that's enough to separate the ascent stage from the now redundant legs of the lander and shoot it back into orbit. The chemicals within it react on contact, thus obviating the need for a potentially troublesome ignition mechanism: in theory, once the valves are opened, the engine will fire and they'll be off. Armstrong had harbored doubts about the reliability of the valves, but the Apollo engineers had rejected his mechanical, rather than electrical, operating system. They have confidence in their design.

Still, as with so much else on the mission, no one has ever done this before and until it has been done, the Moon still owns the *Eagle*. Up in *Columbia*, Mike Collins now confronts his worst

fears. If the rocket fails to propel his comrades the full sixty-nine miles to the intended rendezvous point, he can drop down as far as 50,000 feet to pick them up, but not much lower, because some of the lunar mountains reach nearly to that height. He writes down:

> My secret terror for the last six months has been leaving them on the moon and returning to earth alone; now I am within minutes of finding out the truth of the matter. If they fail to rise from the surface, or crash back into it, I am not going to commit suicide; I am coming home, forthwith, but I will be a marked man for life and I know it. Almost better not to have the option I enjoy . . .

With two minutes to ignition, all Collins can do is wait and listen. With forty-five seconds left, he hears Armstrong remind his copilot of the routine.

"At five seconds I'm going to get ABORT STAGE and ENGINE ARM. And you're going to hit PROCEED."

"Right."

"And *that's all.*"

Collins smiles at the knowing irony in Armstrong's words. Moments later, the commander presses a button and there is a heartbeat-sized pause, followed by a bang and smooth acceleration into the sky. On Earth, Joan Aldrin sinks to the floor, masking her face with her hands, and three days later her husband is bobbing in the Pacific Ocean, waiting to be winched onto the deck of the USS *Hornet.* There is the surreal sight of Nixon addressing them through the glass screen of their quarantine trailer, to be followed by three further weeks of strict isolation at the Lunar Receiving Laboratory in Houston, during which time the men will have ample time to consider the significance of what they've done. Armstrong hopes that *Apollo 11* shows how seemingly impossible problems may be overcome if the will is there. Aldrin watches videotapes of what had been happening back on Earth, of the ecstatic newscasters and spectral pictures and people's houses full of guests in thrall to what they were witnessing, like mine. He begins to appreciate the depth of the

emotions they've stirred and to sense a contradiction which will haunt the rest of his life: that those most quiet and concentrated of moments on the Moon could trigger a kind of mania back on Earth. He turns to Armstrong and says: "Neil, we missed the whole thing."

SUN SPARKLES ON the English Channel.

It's the first day of spring, a perfect sunshiny day after another long, gray, funereal winter, and the Kentish countryside seems to have sighed and come alive. Outside in the street, people smile at the first touch of warmth and, just as assuredly as I find myself humming the first verse of "California Dreamin'" when the leaves start to fall in autumn, I'm tripping along to a silent chorus of "Here Comes the Sun" as I leave the shade of Folkestone station and angle into a tidy, daffodil-lined street.

We're six thousand miles and thirty-three years away from *Apollo 11*—half a lifetime—but time seems to stand still in this quiet south-coast town, making it a good place to chase down memory and hold it up to light, and on the train from London I've been thinking about my own. Did my father really have tears in his eyes? That's how I remember it, but then, the ghost craft I picture hovering above the Moon in a sheen of magic

dust ... well, I can't have seen that. No one saw anything until Neil Armstrong pulled a cord which activated a camera on his way out of the Lunar Module. Then he jumped down to one of the lander's big round feet, described the lunar dirt and stepped gingerly to the surface. One of the great Internet rumors of our time is that his first words were not "One small step for man," etc., but "Good luck, Mr. Gorsky," in honor of a boyhood neighbor whose wife was heard announcing that he could expect to benefit from oral sex "the day that boy next door walks on the Moon." He did get the words wrong, however, because he meant to say—and for years insisted that he did say—"One small step for *a* man ..." Even his memory is not definitive, though in the freeze-frame world we're about to enter, that doesn't necessarily make it less true.

I'm here to see Reg Turnill, who was the BBC's aerospace correspondent for two decades from the late Fifties and is the only non-American to have been presented with NASA's Chroniclers Award for "contributions to public understanding of the space program." In those days the BBC still had a uniquely global reach and the NASA brass knew it. Reg had reserved seats at the Manned Spacecraft Center in Houston and Cape Canaveral in Florida, which was renamed Cape *Kennedy* after the president's death, and from these he watched much more than rockets blasting off, because his own world changed out of all recognition during those years, as TV usurped radio and the invention of videotape made footage-gathering cheap and fast; as the arrival of satellite transmission in 1968 allowed pictures to be shot across the globe instantaneously, shrinking the planet and helping to create the insatiable media we know today. A little-acknowledged fact is that, had the first Moon landing occurred in 1967 instead of 1969 (as JFK's people had hoped, so crowning his second term), it couldn't possibly have made the impact that it did.

Reg is older than the astronauts, eighty-seven, ruddy-faced and wiry, with one of those distinctive old man's voices that waver as though reversing back through teenage. His mind is sharp, but sometimes names slip away and I have to supply a list of options. He'll say:

"And that was when he . . . you know—oh what's his name, the one I mentioned a few minutes ago, uhm . . ."

"You mean Alan Bean? John Young? Scott Carpenter . . . ?"

"That's the one! Yes, he enjoyed his flight rather too much, I'm afraid."

At these points, he'll smile and apologize, explaining that "it's part of the aging process," and I'll be reminded of what a long time ago the 1960s were, even if it doesn't always seem that way.

The aerospace beat was a backwater when Reg took over, but soon it was the center of everything. Over a cafetière of coffee in the bright, seaward Turnill garden, he reminds me of the panic that followed the launch of the first satellite, the Soviet Sputnik in 1957, which set the Space Race running. He describes his knockabout battles with the paranoid U.S. Air Force, whose Cape launchpads NASA had to borrow in the early days, and who used any excuse at all to arrest him and his gang of mischievous reporters. Even into the Sixties, there was an innocence, as everybody was improvising: poor NASA, having had the goal of flying to the Moon (and worse, *getting back*) dropped on them from the Olympian heights of the White House in 1961, had no idea how they were going to do it and the Air Force's attempts to muscle in on the program were "painfully" naked.

Into this breach strode the fourth estate, swarming excitedly around the first astronauts, the silver-suited Mercury 7, who looked like and were treated like a rock group, even though this was fully three years before Beatlemania hit the U.S. in 1964, so there were no rock groups. The Seven were Gus Grissom, John Glenn, Scott Carpenter, Wally Schirra, Gordon Cooper, Deke Slayton and Alan Shepard, who would be fêted as "the first American in space" when he rode his *Freedom 7* rocketship into the sky on May 5, 1961. The truth is that no one had ever seen anything like the rocket stars of "the Original Seven," except maybe in the days of the Wild West.

They were all pilots, mostly drawn from the elite brotherhood of test pilots, even if NASA originally considered skydivers, deep-sea explorers and circus daredevils to be as suited to space

flight as them. President Eisenhower eventually directed the organization to use the fliers, at least partly because they were already on the payroll and working for peanuts, but some refused to apply anyway on the grounds that the newly minted "astronauts" would be no more than computer-guided payload; others, like the legendary rocket plane pilot Chuck Yeager, couldn't have, because these astronaut-passengers needed a degree. "Spam in a can" was the phrase used to describe the space pilots at Edwards Air Force base, high in the Mojave Desert of California.

Two further groups of recruits followed the Seven, most of whom–though not all–were likewise recruited from the military. In September 1962, a group which became informally known as the "Next Nine" included such impressive and Luna-bound figures as Charles "Pete" Conrad, James Lovell, John Young and Neil Armstrong–who'd been trained by the military, but was by this time a crack civilian test pilot working for NASA. Then, a year later, a further batch of fourteen brought the Moon-walkers Buzz Aldrin, Alan Bean, Gene Cernan and David Scott to the fold.

After these, more arrived at regular intervals as the space effort intensified and some of the Mercury astronauts retired, and together they fed three different programs–Mercury, Gemini and Apollo–with three distinct purposes. When the Space Race began, the Soviets were way ahead, so six Mercury flights were needed to prove that American rockets didn't *inevitably* blow up and could lob single astronauts into low Earth orbit and bring them back in one piece. After that, between March 1965 and February 1967, a series of nine missions involving the two-crew Gemini ships were used to develop techniques that would be necessary to get to the Moon. Of particular importance and intricacy were the challenges of "rendezvous" and "docking"; the ability of two craft to find each other and conjoin in space. The Gemini spacecraft, while remaining in Earth orbit, also gave American spacemen their first chance to leave the capsule and float free. Then Apollo reached for the Moon.

None of the seven Apollo missions which were intended to

land went entirely to plan, but even if they had, the plan alone could make your head spin. As it sat on the drawing board in 1967, it looked like this:

First, a huge, three-stage Saturn V rocket ("V" being the roman numeral for *five*) heaves the crew off the ground as they sit in a tiny capsule at its peak, facing up toward the sky. The first two stages fall away as their fuel runs out; the slender third provides a final push to a 116-mile-high orbit above Earth, from where a brief reignition of its single rocket engine breaks the planet's bonds at a speed of 24,000 miles per hour and the long coast to the Moon is under way. Only here does the sweaty stuff start, though, because up to this point the two craft in which the Moon men are to travel have been concealed in or about the Saturn's third stage, and the time has come to free them.

The astronauts are to make the 240,000-mile journey to the Moon in a spaceship called the Command and Service Module (CSM). As its designation implies, this consists of two parts joined together: a Command Module, known to most of us as the "capsule"–the conical pod just thirteen feet in diameter in which the crew live and work and hope to splash down when the adventure is done; and a shiny, cylindrical Service Module, which attaches to the rear of the Command Module and contains the big stuff like the rocket engine and the fuel and oxygen tanks. During the early part of the flight, the CSM has been perched at the tip of the Saturn like a spearhead, while behind it, cocooned by four protective metal panels, lay the equally important Lunar Module, or LM, the ungainly craft in which two crew members will descend to the lunar surface. Now, at a distance of 6,000 miles from home, the CSM breaks free of its Saturn host, is gently guided forward by the Command Module pilot, then rotated 180 degrees on its axis to face the slumbering LM, whence the ship is nudged forward so that it might clasp, *dock with*, the LM and draw it from its berth. In this formation, nose to nose like two insects kissing, the ships drift through space for three days, before slowing dramatically to allow "capture" into lunar orbit. There, they maneuver into a special "descent orbit," an ellipse with a high point of sixty-nine miles and a low of just nine, where the lucky, prechosen pair will crawl

through a hatch from the CM to the LM and drop the short distance to history.

The mere act of describing this outward journey is exhausting, and the return is no simpler. When the astronauts on the surface are ready to leave, the LM's "ascent stage"–the cramped living quarters–will blast away from the spindly-legged "descent stage," leaving that behind in the dust. Back in lunar orbit, they rendezvous with the CSM and climb aboard once more, to be reunited with the colleague they left behind, the one who *didn't* drop sixty-nine miles into history, at which juncture they jettison the LM (an emotional moment for some who've lived in it) and set off for Earth. Three days later, they're circling the home planet again; the CSM breaks into its two constituent parts, with the Service Module being ditched and the Command Module careening into the atmosphere at 24,000 miles an hour, splashing into the sea beneath a trio of gargantuan, red-and-white-striped parachutes, and the trip is over. Naturally enough, job titles derive from the participants' relationship to this system, with the pair who reach the surface known as the Mission Commander and the Lunar Module pilot (even though the "LM pilot" is essentially a systems engineer, monitoring progress and feeding it to the LM's real pilot–the Commander), while the Command Module pilot looks after the mother ship until such time as his crewmates return or are understood to be irretrievably lost. No one can deny the virtuosity of the technique, nor that there is an awful lot to go wrong with it.

There were twelve crewed Apollo missions in all. The first, *Apollo 1,* ended before it had begun, when a fire in the capsule killed its crew–the Mercury 7 veteran Gus Grissom, first U.S. spacewalker Ed White and rookie Roger Chaffee–as they conducted tests in a bay on the ground, bringing despair and an eighteen-month hiatus to the program while NASA's management was overhauled. The next piloted mission was *Apollo 7,* which successfully launched into Earth orbit, followed by *Apollo 8,* which swung the first human beings around the Moon over Christmas 1968. *Apollo 9* then tested the Lunar Module in Earth orbit, *Apollo 10* did the same in lunar orbit, and finally *Apollo 11* set down. Ten such landings were planned, but the

last three (*18, 19, 20*) were canceled as the program's budget was progressively slashed. Furthermore, *Apollo 13* nearly ended in disaster when an explosion in an oxygen tank crippled the Command Module, forcing the landing to be abandoned and the LM to be used as a makeshift life raft to get the crew home. Thus, only six ships reached the surface, between July 1969 and December 1972, each with two astronauts aboard. Those astronauts were:

APOLLO 11 Neil Armstrong and Buzz Aldrin (CM pilot Michael Collins)

APOLLO 12 Pete Conrad and Alan Bean (CM pilot Richard Gordon)

APOLLO 14 Alan Shepard and Edgar Mitchell (CM pilot Stu Roosa)

APOLLO 15 David Scott and James Irwin (CM pilot Al Worden)

APOLLO 16 John Young and Charles Duke (CM pilot Ken Mattingly)

APOLLO 17 Gene Cernan and Jack Schmitt (CM pilot Ron Evans)

Irwin, Shepard and Conrad are gone (heart attack, cancer, motorcycle accident), so nine of the Moon men remain.

Reg runs me through his impressions of the early space program; then we fall to talking about the landings and what a queer ship the Lunar Module was.

"I never thought they could land that thing," he says. "And even then, the prospect of one leg landing on a boulder or a slope seemed so very high."

He also admits that when he heard Aldrin tersely announcing the 1202 alarm during the *Eagle*'s final descent, his one and only thought was, "That's it. They're going to crash." In fact, the more you talk to Reg Turnill, the more extraordinary the whole thing starts to seem. He remembers being detailed to show the interloping Norman Mailer around the launch site as the countdown for *Apollo 11* proceeded ("You didn't care much for him, did you, dear?" notes Reg's wife, Maggie, as she sets a lunch of trout and new potatoes before us). He also describes *2001* author

Arthur C. Clarke stopping by his table as the rocket roared through the clouds to gasp that this was the first time he'd cried in twenty years and the first time he'd prayed in forty. Then the author declared, "This is the last day of the old world," and Reg thought that was marvelous. He also believed it. As they watched, surrounded by people punching the air, clapping, applauding, bawling and shouting "Go! Go!" they all did. When missions *18, 19* and *20* were canceled for lack of funds, Reg shared the astronauts' distress as if he'd been due to ride with them himself.

"They never really got away from the equatorial regions of the Moon," he laments. "There was even talk of having astronauts descending into craters on ropes. These were going to be great missions of discovery."

I catch a cab back to the station thinking that this is the first time–it certainly won't be the last–that I've heard Apollo spoken of as unfinished business. It may have been dead to me for many years, but for the people who were part of it, it remains vividly alive.

BEFORE THE SPACEMEN, Cape Canaveral–The Cape–was a sweltering nothing, paradise for malarial swarms of bugs and birds and alligators who'll still slither into the backseat of your rental car if you ignore the warning signs about leaving doors open, but now it's all flat, ruler-straight highways and boxy wooden houses and malls and motels and more highways. A permanent haze hangs over the area like an opaque shroud and seems to seep into the spaces between things: there are no natural vantage points and there is nothing to see–it's a featureless, beautyless place, which is why the U.S. Air Force chose it as a launching ground for military rockets in the first place, and it wasn't until air-conditioning and astronauts arrived that civilians came scuttling behind, chasing thrills and autographs and cut-price tans. These days, *these days* being July 2002, they call this place the Space Coast.

On the flight from England, I was lost in a brilliant collection of J. G. Ballard short stories called *Memories of the Space Age.*

Written between 1962 and 1988, most of them revolve around the Cape, and Cocoa Beach in particular, which is where the space program's human cargo lived in the run-up to missions. Ballard's thrillingly jaundiced view of the Space Age is that it constituted a crime against evolution, a blind, hubristic leap into a realm where we do not belong, where all we can do is sow our disease and spread the human stain ever more thinly across the Universe. Accordingly, in his stories we find the Cape abandoned, laid waste by microbes from Mars as dead astronauts circle the earth in their capsule coffins, or serving as a beacon for falling space debris, roamed only by irradiated scavengers seeking icons in mangled bits of spaceship or spaceman bones. We find space explorers going insane midflight, haunting a whole world with their "nightmare ramblings." In "A Question of Re-Entry," Ballard's protagonist hunts for a capsule lost in the Amazon forest, amid growing anxiety that "the entire space program was a symptom of some inner unconscious malaise afflicting mankind, and in particular the Western technocracies . . . the missing capsule [was] itself a fragment of a huge disintegrating fantasy."

In "News from the Sun," I find: "Certainly, the unhappy lives of the astronauts bore all the signs of a deepening sense of guilt. The relapse into alcoholism, silence, and pseudo-mysticism, and the mental breakdowns, suggested profound anxieties about the moral and biological rightness of space exploration."

All of which may look like no more than a clever inversion of the claim that the first "Whole Earth" photographs brought back by *Apollo 17* changed our perception of ourselves for the better, but the author was right about one thing: that the Space Age would come to seem an historical anomaly, which didn't lead where expected and significant numbers of people would come to doubt the very existence of. Meanwhile, his references to the fates of the astronauts . . . well, these aren't complete fictions. Ballard knew where he was coming from. Like so much in this tale, what he says is not true, but it has truth.

Perhaps he was also whispering in my ear as I passed through the turnstiles at the Kennedy Space Center, NASA's contribution to the rubric of Florida theme parks. Midday is ap-

proaching and the ground is like a skillet. Everyone else is indoors, but I had to come here first, to the *Rocket Garden*, because this is the real thing; an outside park where the astonishing machines spacemen rode into the sky are on display. And they *are* astonishing, but not for the reasons you'd think, because the surprise is how terrifyingly small they are. I could grab a pipe on the side of the Atlas rocket which powered the last Mercury missions and shimmy up in seconds, while the Mercury Redstone that Alan Shepard flew is slender and frail-looking, topped by a little ribbed bird's beak of a capsule. Who would agree to crouch on top of what now clearly reveals itself as a *missile*, which might otherwise be used to smash a tank, and be shot into Ballard's "cyanide-blue" Florida sky? Assuming the thing didn't blow up first. The capsules weren't even going to have any portholes to see out of until the astronauts/passengers/test subjects/Spam insisted. Only a Saturn IB, which launched *Apollo 7*, the nervy first crewed flight after the *Apollo 1* fire, looks as though it was made to carry people. Yet even that, slumped on its side, is less impressive than in the imagination. Still, the Saturn V, the vehicle which powered Apollo to the Moon, is yet to come. If you want to see that, you have to buy a ticket and be bussed to a special hangar.

Indoors I find a large collection of space art, including a painting by *Apollo 12* LM pilot Alan Bean; a shimmering Annie Leibovitz portrait of shuttle commander Eileen Collins, who became the first female shuttle commander in 1999; a haunting silver-black 1982 rendering of the shuttle *Challenger*, which exploded like a firework directly above this place four years later. The most familiar works are Andy Warhol's Day-Glo *Buzz Aldrin* and Rauschenberg's fast-paced *Hot Shot* montage, which is built around the powerfully phallic image of a Saturn V lifting off. As I look at these last two, I'm reminded of historian Eric Hobsbawm's dismissal of them, and Pop Art in general, with the words: "It is not surprising that in the 1950s, in the heartland of consumer democracy, the leading school of painters abdicated before image-makers so much more powerful than old-fashioned art."

Which is absolutely right, but also misses the point. At the

emerging school's first big show in October 1962 at the Sidney Janis Gallery in New York, Warhol, who grasped the trajectory of his society better than anyone, explained his work by saying, "I feel very much a part of my times, of my culture, as much a part of it as rocket ships and television." More specifically, the critic James Rosenquist summed up what he saw as "post beat and not afraid of an atomic bomb," while for the painter Robert Indiana it was "a re-enlistment of the world. It was shuck the bomb! It was the American dream–optimistic, generous and naïve." It's easy to forget that in the beginning, Pop Art, like the space program, defined itself explicitly in relation to the Cold War–about which there seemed a decisiveness, as if this was a bridge humanity had to cross to its future, grim or glorious as that might be. Thus, when Warhol set up his Factory in 1964, he decorated it top to bottom in silver, explaining that "silver was the future, it was spacey, the astronauts . . ." The impact of the spacemen when they first appeared is easy to underestimate.

Something here feels wrong, though. NASA was late catching on to the power of the image in an age where information was traveling further and faster all the time, and you can still feel this as you watch pasty-legged dads straight out of a Gary Larson cartoon dragging their kids–thought bubbles whining, *What about Disneyland?*–to an IMAX movie about the International Space Station. I sit through it myself and gradually become aware of a disturbance at the back of my mind, evolving into a strong sense of pathos. The movie was directed by Ron Howard and narrated by Tom Cruise and its remorseless tedium seems to say everything about the bind NASA finds itself in after three decades spent loitering in low Earth orbit. And in a flash I see the difference between the space shuttle's 200-mile-high beat and Apollo ploughing 240,000 miles to the Moon: before me now is a space that's been domesticated and rendered routine, while at a quarter of a million miles you've left the Earth and are on the outer edge of experience; are riding the skein between us and Deep Space, being dwarfed by infinity itself. Well over 400 people have now been into space, but only twenty-four have left Earth orbit and been out *there*, all with Apollo. But Apollo's dark allure seems distant here–I've felt none of it–and as I wrestle the

sterile wrapping off my cutlery in the cafeteria, I find myself grumbling that I bet Pete Conrad never used sterile cutlery: indeed, if I hear Strauss's *Also Sprach Zarathustra*–the theme from *2001*–one more time, I may very well attack someone with it. The cutlery seems emblematic of the whole Kennedy Space Center experience so far. Sterile.

So I'm not expecting much of the bus tour, but as we sweep past the alien archaeology of the launch gantries, which look as though they've towered over this wasteland forever, there comes a kind of relief. A breeze blows in from the Atlantic and a wildness takes hold of the land, and now I can picture Shepard and Armstrong climbing steely-eyed into their ships. There's no need for presentation here. Wherever you look, the squat shape of the Vehicle Assembly Building is somewhere in the corner of your vision, growing out of the marram grass, the highest point in the state of Florida and the largest human-made structure on Earth when it was built; the place where they put together the rockets, so big that they say it has its own weather system and could admit the United Nations building through any of its four doors. Then there's the nightmarish crawler, like something from a *Judge Dredd* comic, which transports rockets from the Assembly Building to the gantries at half a mile an hour, running on tanklike tread plates that weigh one ton apiece. This is *not* like anything you've seen before. It's unreal.

And now the bus has stopped and you're climbing off and into a giant brick hangar and–*fuck, there's the Saturn V.*

You can reel off figures and statistics all you like, but until you've stood underneath it, nothing can prepare you for this behemoth, suspended in segments from the ceiling, just astonishing. You try to fit a meaningful portion of it into a photo, but you can't, so you give up. What you think is not "How could anyone make something this big?" because you know that people have been making big things for millennia. But to make something this big, and intend it to fly–*the audacity of this conceit alone*–and then to make it work, to conceive of this impossible twisty chaos of pipes and cables and weird steel tubers and nozzles as big as the bus we just rode in on, *bigger*, and make them do something predictable and controllable and reliable enough to

bet a life on, three lives, *every time* . . . it's just . . . the mind reels in the same way that a Victorian's must have been carried away by one of that era's gargantuan steelworks or power stations. Even at thirty-five years' remove, it's barely credible.

What must it have been like to ride this thing? The geologist Jack Schmitt, the only civilian scientist who flew Apollo, spoke of the difference between sitting on top of one in simulations and during the real deal.

"You start to hear sounds that you've never heard before," he said, then shook his head. "Especially as you approach thirty seconds, this huge Saturn V starts to come alive, almost like an animal."

Bill Anders of *Apollo 8,* the first mission to circumnavigate the Moon, also resorted to anthropomorphic imagery, describing the ride as "like being heaved about; like being a rat in the jaws of a giant terrier."

And from the ground? A flash of brilliant light, followed by a squall of fire and the heart-stopping, agonizingly slow push to clear the launch tower. The final mission, *Apollo 17,* took off into the night and remade the entire sky as a dancing, fiery cathedral dome and the ocean as an orange-gray sea of flame. People describe a guttural quake that rolled toward you like thunder, with almost everyone who watched referring in one way or another to the intense physicality of the experience. The distinguished and then-Apollosceptic British journalist Hugo Young gasped that "in the bedlam of launch, there were, momentarily, no critics of the space program."

I find myself avoiding the numbers, because they seem to flatten and insult Saturn, to tame it to the point where it no longer troubles the imagination. They say that it stood sixty feet taller than the Statue of Liberty and weighed six million pounds at launch, that the first of the three stages had five rocket engines producing 1.5 million pounds of thrust each, but I don't know what any of that means. Among the welter of facts and figures, only two strike me as particularly remarkable. The first is that this rocket was trusted to go to the Moon on only its third flight, where others faced exhaustive test programs before anyone was allowed to climb aboard; the second that it contained close to six million parts, meaning that, even with NASA's as-

tounding 99.9 percent reliability target, roughly 6,000 things could be expected to go wrong *on a good flight*. Yet the Saturn V never failed, nor looked like failing when it mattered and it doesn't take a genius to understand that something very like genius was at work here. What might not be guessed is that it was a Nazi genius. In the words of Chris Kraft, "Wernher von Braun built a masterpiece."

Wernher von Braun: his spirit haunts Apollo like a specter. Reg Turnill's eldest son was born prematurely when one of the first V-2 rocket-bombs von Braun designed during World War II fell on Sydenham in South London. It was years before Reg could bring himself to shake the German's hand. To begin with, his thick accent and mouth full of metal teeth were "quite revolting for the viewer," but one day Reg turned around and, lo, the engineer was speaking perfect English through a gallery of gleaming white teeth. Flight director Chris Kraft found his presence troubling at first, too, and claims to have contemplated punching him on their first meeting out of disgust at his background: NASA's much-loved first director of the Manned Spacecraft Center (MSC), Robert Gilruth, sought to assuage his deputy with the words "von Braun doesn't care what flag he fights for." But in the end, most NASA folk seem to have adored him. Astronauts have frequently referred to him as a genius, a visionary, someone they respected and loved to spend time with.

The traditional view of von Braun has been of a modern-day Mephisto or Faust. He'd dreamed since boyhood of taking his species into space, and when the dream looked most likely to be realized by the Nazis, this son of an aristocrat signed up as an SS officer. Later, at the Nuremberg War Crimes Trials, Hitler's Minister of Armaments, Albert Speer, explained that he and the Party had "exploited the phenomenon of the technician's often blind devotion to his task." Perhaps we can understand this. And as the war was racing toward a conclusion, von Braun led 150 of his top engineers and their families on a hazardous dash across Germany so that they might surrender to the Americans rather than to the rapidly advancing Soviets. Whether he was acting out of compassion or because he knew the presence of his team would strengthen his bargaining position is impossible to

know–although it's worth noting that he left many behind. Either way, 118 of them joined von Braun behind barbed wire as "prisoners of peace," until the Cold War was ratcheted up in Korea (1950–53), and the Germans were unpacked and moved to the U.S. Army's Ballistic Missile Agency at Huntsville, Alabama, with Nazi pasts conveniently forgotten.

Wags began referring to Huntsville as "Hunsville"–they still do–but from this time on, there was no stopping von Braun and his team, which is widely regarded as one of the most talented groups of engineers ever assembled. In the Fifties he became a powerful advocate of space exploration, never shy of tweaking Americans' fear of Soviet domination in this exotic new realm, even fronting a kids' TV series on the subject for Walt Disney (notoriously no liberal himself). Apollo could not have happened without him and he is the *only* person of whom this might be said. His best biographer will point out to me that Stanley Kubrick used to get tetchy when people assumed the mad German adviser Peter Sellers played in *his* Cold War masterpiece, *Dr. Strangelove*, to have been based on Henry Kissinger. The only German with the ear of a president when the film was being made in 1963 was von Braun.

Even at this stage, though, as I crane my neck to gape at his work, I'm aware that history books have begun to be rewritten on the subject of von Braun. His V-2 rocket had been made with European slave labor in caves under the spectacular Harz Mountains of central Germany, but von Braun was always allowed to deny any involvement in, or even knowledge of, these crimes. Dr. Arthur Rudolph, who was in charge of production there and would later work under von Braun as manager of the Saturn V program at Huntsville, was awarded NASA's Distinguished Service Medal in 1969, but later forced to flee the U.S. when a media emboldened by its reporting of Vietnam and the Watergate scandal began to question his past and the fact that workers who sabotaged the V-2s at his Mittelwerk factory were routinely hanged outside his office: estimates suggest that 60,000 inmates passed through Mittelwerk and its associated concentration camps, of whom 25,000 were worked or starved to death in the cold inhuman murk of the tunnels. Von Braun's de-

fense was always that he operated from the research station at Peenemünde and knew nothing of this, and was once arrested by an SS suspicious of his commitment to the cause—all of which now seems doubtful at best. I'll come to see him as one of Apollo's greatest mysteries, somehow representative of the ambiguity at its core: of the tension between this towering act of creativity and the avarice, fear and intolerance that enabled it; of the way all that is best in humanity appears to have been driven by everything that is worst.

On the way out of the hangar, I walk past a corral of remote-controlled mini Mars Rover robot vehicles, where a recorded voice is pleading "Ladies and gentlemen, please do not drive the Rovers into each other!" Poor NASA: they give us these wonderful machines and our first impulse is still to see what they look like when they crash. Ballard would shake with joy. I get back on the bus, anoint my experience with some "memorabilia" from the shop, where the childrens' T-shirts read "I need my space," and head for Cocoa Beach.

MORE BRIGHT LIGHT and desiccated sky, a smell of sea at the end of the pier where I sit with coffee and a book, rapt.

It's been a strange morning already. I found a voodoo charm on the beach but broke it; two small figures, a man and a woman tied together with string and placed in a salsa jar with some red fluid that might have been blood (or alternatively, I suppose, salsa), bobbing in perfect foaming surf in front of me. Slightly repelled, I lobbed it back and watched in horror as it shattered on the soft sand. I kneeled down to pick up the shards, wondering whether this portended bad luck, then had to remind myself that I don't believe in that kind of thing.

An elderly couple ambled by. They looked at the dolls for a long time. He was a sculptor and they lived here, they told me.

"How good of you to stay and pick up the glass," she said.

She had a handsome tanned face with a calm smile and straight silver hair that swam in the breeze.

"Oh, I'm sure you'd have done the same." I smiled back.

"Sure, but not everyone would these days."

These days. When did that phrase come to be an admonition? I'd never thought about it before. Was it so in 1969? 1961? The woman asked what brought me to Cocoa Beach and I told her I'd come to see an astronaut.

"Well, there's plentya *them* around here." Her husband laughed as he took her hand, wished me luck and made to walk on by.

Yes, I thought, but not like this one.

Cocoa Beach, a few miles south of the Cape, is where the astronauts stayed and played while preparing to fly. They raced Corvettes down Main Street and partied around the pool at the plain-Jane Holiday Inn, where it seemingly rained only martinis and starstruck girls, referred to by one astronaut as "Cape cookies," with all high jinks pardoned in advance by the court of fame (the harsher rules of celebrity having yet to be framed). In fact, most of the stories surrounding this place pertain to the Mercury 7 rather than the more cerebral young men who followed them and pushed humanity's envelope to the Moon. Typical of that time are black-and-white photos of the Original Seven member Deke Slayton in a porkpie hat, sucking a cigar the size of a grenade launcher, Updike's Rabbit to a tee, and another of him being flung fully clothed into the pool. Slayton had been raised on a dairy farm in Wisconsin in a town with a population of 150, the eldest of four from his father's second marriage. His early life was spartan: growing up in the 1930s, there was food but little money, so the family lived without electricity and had no radio and Slayton later recalled being taken to the movies just once, but not liking it and scarcely ever going back. It's hardly surprising if the boy grew into a direct, capable, no-nonsense sort of man, ruggedly handsome with the sharpest crew cut in town and minimal tolerance for nicety or introspection.

Deke Slayton didn't fly to the moon—his place in this story is more important than that, because before he could even hit the sky with the Mercury program, NASA doctors diagnosed him with a minor heart condition and insisted that he be grounded. Some say he never forgave doctors and scientists for heaping their caution upon him, which he later associated with the way his hard-pressed mother used to tie him to a tree at the age of

four to stop him from running into the road. Either way, in devastated rage he was removed from flight duty, then put in charge of the Astronaut Corps, making him the single most important figure in the other astronauts' lives: the puppeteer; the man who assigned them to missions–or didn't. Best pals with Al Shepard and the laconic Gus Grissom, and a straight-ahead fighter jock to the core, the word is that he didn't like the comparatively bohemian Scott Carpenter, who would sit in the sand a stone's throw from here, strumming folk songs on an acoustic guitar at a time when the roots clubs of Greenwich Village were teeming and the music was very, very hip. Many people think Slayton also underestimated the sensitive and artistic Alan Bean of *Apollo 12* and was wary of conspicuous intellectuals like Bill Anders, Walter Cunningham and Rusty Schweickart–each of whom would fly but once and miss out on the landings. Known to most people simply as "Deke," he died of cancer in June 1993, and is key to everything that follows.

The end of the pier is a timber square gathered around the shaded sanctum of a bar. It's 11 AM and I'm guiltily agreeable to sharing this space with seven or eight men in T-shirts and shorts, mostly pretty young or pretty old, who dangle fishing lines over the weathered railings, mouths of their beer bottles open to the sky as if in conversation with it. For the past hour, I've been sitting here reading a reprinted edition of *Ether-Technology: A Rational Approach to Gravity Control*, a cult text from the Seventies which claims to show that the kind of anti-gravity technology normally associated with UFOs is not only feasible, but already with us and being kept under wraps by the authorities. That the publishers may regard author Rho Sigma's thesis with less than complete seriousness is indicated by a bold invitation to "Build Your Own Flying Saucer!" on the back cover. More important for me, though, is a modest line above the title on the front, which reads: "Foreword by astronaut Capt. Edgar D. Mitchell, Ph.D." This is the same Edgar Mitchell who flew as Lunar Module pilot on *Apollo 14*, becoming the sixth person to leave his bootprints on the Moon, then came back to embark on a far more curious journey. I've been scribbling furiously in the margins, noting key lines from this five-page foreword, and

they're not what you would expect from a man raised on the strict conventions of the military. Among the passages I've underlined in pencil are:

the view from space has shown me—as no other event in my life has—how limited a view man has of his own life and that of the planet . . .

no other animal commits the atrocities and stupidities men do . . .

in our surfeit of knowledge and paucity of wisdom, we've come near the brink of global destruction . . .

and at the same time other people were living in poverty, ill-health, near-slavery, starvation, fear and misery from prejudice or outright persecution, because as individuals and as a planet we have not had the will to change these conditions . . .

the situation has become desperate, and I became acutely aware of that as I gazed at Earth from a quarter of a million miles away . . .

Followed by the clinchers: "every great advance in natural knowledge has involved the absolute rejection of authority" and "The solution is: *a global change of consciousness.*"

The thing is this. Swaddled in the cosmos on the way back from the Moon, Edgar Mitchell had what he describes as an "epiphany," in which he glimpsed an intelligence in the Universe and felt connected to it, like a lamp suddenly plugged in and switched on after an age hidden in darkness. In that moment, the void seemed to him alive and his description of it reminds me of the English poet-artist William Blake's ecstatic vision of a Universe in which "every particle of dust breathes forth its joy." And what he said to himself was, precisely: *Wow.*

He was fascinated with it, with this feeling of transcendence, which he intuitively related to the euphoric states other civiliza-

tions have conjured with ritual, drugs, contemplation–gods–and when he got back, he left NASA and founded the Institute of Noetic Sciences (IONS), named for the Greek-derived word meaning "of, relating to or based on the intellect." His aim was to reconcile science with religion–and the point at which they met, or at least the bridge between them, he postulated, consists in that greatest of all mysteries, *consciousness itself.* Thus, the key to the Universe is contained in our own minds, and vice versa, the result being that for thirty-two years now, the Moonwalker Dr. Mitchell, who has two bachelor of science degrees to add to his doctorate from MIT, has been searching for this key. People who pass through his gravity field frequently characterize IONS as a kind of New Age cult, with Mitchell the Space Age Colonel Kurtz, the hero who entered into the heart of a darkness even Conrad and Coppola couldn't conceive, and never came back. It's him that I've come to see and I have no idea what to expect. All I do know is that the Florida chapter of IONS is holding a conference 150 miles southwest of here, in the steaming Gulf resort of St. Petersburg, and I'm enrolled. Its theme is "Seeding Spirit in Action," which might mean anything. Yesterday, I couldn't help noticing that, unlike books by the other Moonwalkers, none of Ed Mitchell's writings were available in the bookshop at the Kennedy Space Center.

OF NECESSITY, fate and the vapor trail of the astronauts' lives, rather than the chronology of their flights, will be leading me through Apollo. One thing I learned early on is that there is no agency or press office through which to trace them; that even NASA can't tell you where they are, because most haven't worked for NASA in three decades. Long retired from public life, they can be hard to find and difficult to contact, but I'm happy for the view of America from their waning slipstream, and symmetries are already emerging from the apparent randomness of my success in locating them.

Edgar Mitchell's flight, *Apollo 14,* the fourth to attempt a landing, was like a new beginning for the program. More people crammed into the Cape to watch it launch on January 31, 1971,

than came for *Apollo 11,* because they knew that any serious problems, after the near-tragic failure of *13,* would probably signal the end of an adventure which was already wreathed in doubt sown by severe budgetary cuts. In fact—and every Moonwalker has a story of fate's decisive hand in their story—Mitchell was originally scheduled to fly *13,* but a rogue infection in commander Alan Shepard's ear caused the three-man crew to slip a place. Disappointed though they were at the time, this now looks like outrageous luck. Come to that, the flight-line presence of ego-rich Mercury 7 jock Shepard was outrageous to begin with: shortly after his Mercury flight, he was diagnosed with Ménière's syndrome, a malfunction of the inner ear which brought vertigo and dizziness and caused him to be grounded for the next six years. A risky operation made him available once more at the advanced age of forty-seven, but one respected authority on Apollo will spit to me that sending the science- and geology-phobic Shepard to the Moon "was a complete waste of time—we might as well have sent that jerk to Dallas." Every morning, his secretary hung a sign on the wall to indicate what sort of mood the man they called the "icy commander" was in on that particular day, and this was to the Astronaut Office what the shipping news is to mariners. Alan Bean of *Apollo 12* describes him as like "a tiger shark swimming around a tank of fish." In fact, if Ménière's syndrome hadn't intervened, he might well have captained *Apollo 1* and so claimed commander Gus Grissom's place in wherever it is that tiger shark throttle jockeys go when they fall in the line of duty. Remarkably, though, he was the only one to shed tears when he stepped onto the lunar surface, or at least the only one to admit it.

Mitchell was the anti-Shepard. *Apollo 14* would be his first and only flight. He describes the Saturn V at launch as "coming alive with a kinetic violence unlike anything any of us had ever experienced." Once up, space was "just as beautiful and strange as anything conjured by a child's imagination.... There is a sense of unreality here, with the absence of gravity and the tapestry of blackness broken only by an overwhelming glitter of stars that surrounded our craft." He echoes others in marveling at how "the intricate beauty of Earth overwhelmed the senses,"

and I find it impossible to read his descriptions of spaceflight without yearning to follow him there, a yearning I haven't felt since I was a boy looking up at the sky.

The *Apollo 14* launch went to plan, but trouble started as soon as they left Earth orbit, when the Command Module *Kitty Hawk* slipped the spent third stage of the Saturn and turned to pull the LM *Antares* after it, only to find that the docking mechanism wouldn't work. A solution was improvised in time to save the mission, but four days later, with the two craft separated over the Moon and ninety minutes to the LM's descent, Mission Control became aware that the guidance software was intermittently receiving false abort signals from somewhere. If this continued into the powered-descent phase, the computer, believing there to be an emergency, would automatically activate the ascent engine, separating the upper and lower halves of the LM and firing the crew back up into space. If *Antares* was near the surface, it could crash. Worse, the danger became apparent just as the LM was preparing to pass around to the far side of the Moon, meaning that there would be no radio contact for the next ninety minutes. Back in Houston, there was a thick manual containing procedures for every difficulty that had been imagined. This one hadn't been.

At Mission Control and MIT in Boston, desperate computer experts supposed that a quick-and-dirty response would be to write the abort switch out of the software, and a lank-haired young programmer named Don Eyles, who looked like a Pink Floyd sound engineer, set about doing just that. When it came time to power up *Antares*'s descent engine, Shepard and Mitchell held their breaths, but the fix worked; there was no bang and rush and wrenching of gut at the realization that the landing was off. They understood this to mean that, should an abort actually be required as they neared the surface, a lengthy and potentially fatal series of commands would have to be issued manually to the guidance computer. This risk was worth taking.

Unfortunately, no one foresaw that it would also prevent the LM's landing radar from locking on to the echoes it bounced off the lunar surface. As Edgar Mitchell scanned his instrument panel with increasing despair, caution lights warned that the

radar had gone for a walk. He knew that if there was no radar at known mountaintop level, the mission rules called for them to abort the landing. They were halfway there already and sinking fast and if the radar wasn't working now, there was no very good reason to think that it would be anytime soon. They had thirty seconds. Mitchell found himself muttering, "C'mon, radar— c'mon!" then trying to calm himself, as other LM pilots did, by saying, "It's just like a simulation."

In these moments, Deke Slayton noticed a different tone in his friend Shepard's voice as it crackled into the control room, and he thought: "Jesus, he doesn't care. He's going to land any-way." Commander Shepard later claimed that he had run this notion past Mitchell, who replied, "Okay, Al. As long as we both know the risks," adding doubtfully, "Promises to be interesting" (oddly enough, the LM pilot has no recollection of this ex-change). Yet the charm of Apollo is that while a babyish room-sized computer ostensibly ran the show, the technology still had a physical presence, leaving open the ancient "just give it a whack" route to deliverance. Thus, when the abort switch was playing up, the engineers' first instruction was for Mitchell to tap it with a screwdriver, and when Buzz Aldrin accidentally snapped a key used to arm the *Apollo 11* ascent engine, so ap-parently condemning himself and Neil Armstrong to a whimsi-cal death 240,000 miles from home, one possible solution was jamming a pen into the lock (Aldrin still has the pen). And now, after much scratching of heads, the brains at Mission Control suggested that Mitchell "recycle" a circuit breaker, which is to say, pull a knob out and push it back in again. With time rapidly running out, Ed did, there was an interminable pause . . . and data started appearing. The radar was on. Human beings num-ber five and six landed safely among the hills, valleys and craters of the rugged Fra Mauro region. Legend has Mitchell asking his commander afterward, "just between you and me," whether they really would have risked landing without radar, only to be told with a wink, "You'll never know, Ed. You'll never know."

. . .

FOLLOWING A FIRST, acclimatizing stint on the surface, Mitchell and Shepard climbed back into the LM and tried to get some rest in advance of their arduous main task—the ascent of Cone Crater. As with other crews, any sleep was hard won and shallow when it came; uncomfortable in spacesuits on hammocks, with life-support machinery whirring, pulsing, ticking in the background and the occasional micrometeorite clattering into the ship's thin skin. At one point during their "night," an unfamiliar *bang* emanated from somewhere and they woke with a jolt and a fear that the craft, which had come down with one foot in a small crater and so tilted disconcertingly, was about to topple over. Mitchell had only been half gone anyway, in a private realm of "edgy half-dreams," because his mind was still outside, reveling in the eerie drama of the landscape he'd stepped into—a stark and sun-soaked land where the lack of atmosphere caused shadows to be sharper and more clearly defined than on Earth, almost as if they were produced by backlighting or had a solid, three-dimensional presence of their own. And the stillness, the silence, was like nothing that could ever be experienced on a living planet such as his own. He loved being there.

The pinpoint landing of *Apollo 12* had emboldened mission planners to shoot for highland sites with *13* and *14,* in search of broader insight into the Moon's origin. Prior to the first landing, scientists had divided into two camps on this issue, defending their respective positions with evangelical passion: there were the "cold mooners," who believed our moon to have formed out of wandering debris which had gathered into a sphere over billions of years and gradually been wooed to the Earth, and the "hot mooners," who saw evidence of volcanic activity in all her features and believed she had once been geologically "alive." *Apollo 11* had settled this argument, because the rocks Armstrong and Aldrin had collected on the Sea of Tranquillity included a gray slab of volcanic basalt, meaning that the "sea" was in fact a sea of congealed lava. The Moon had been alive. Nonetheless, while there were many similarities with Earthly basalt, there were enough significant differences to pose problems for hot-moon adherents to the hip "fission" theory, who believed that Earth's companion had been torn from her own

infant belly by a massive collision, possibly with another planet. There was still a lot to learn and scientists hoped that rocks from the rim of Cone Crater, which would have been ejected from deep beneath the surface by the immense force of the impact which had created it, would help.

The outer slopes of the crater rose rough, pocked and high before the LM, wearing the scars of eons of assault from space. Ed Mitchell was looking forward to standing at its peak and gazing down into it: it was as wide as four football fields laid end to end and as deep as two and a half, and to reach it he and Shepard would travel far further from their LM haven than anyone had before. To help them carry their tools, they had a small cart, which they would pull, and a photomap for navigation, but from the beginning Mitchell realized that navigation was going to be much harder than expected, because against the oil-slick sky and flaring sun, he saw only a desert swell of dunelike hillocks; a furtive landscape strewn with depressions and craters which revealed themselves only when you were almost on top of them, like a collection of mischievous kids playing hide-and-seek. Again the lack of atmosphere and curvature of the land played tricks, made everything look closer than it was–confusing, disorienting. He was trapped in a dusty hall of mirrors a quarter million miles from home. With difficulty, he and Shepard found their first geologic sampling stop, then their second, and finally began their climb.

The ground on the slopes was solid, but its undulation and the litter of rocks was greater than had been expected on the basis of the first two missions, and every time the cart's wheels hit one, it reared up in slow motion, threatening to overturn and launch its cargo into the void. In the end the men decided to carry it and quickly grew exhausted from the effort, but trudged on in their restrictive suits anyway, turning only once to savor a view of the crater's smooth outer slope, now zagged with silvery cart tracks leading all the way back to the LM, which glinted like a toy. By Mitchell's reading of the map, they were almost at the top, but the scene wasn't as his training had led him to expect: there were no large boulders skirting the rim–the deepest of the ejecta and the greatest prize for geologists–and moments later

the reason for this became clear. What they'd imagined to be the rim was merely another rise. The side of Cone Crater still stretched dauntingly up and out before them. Shepard breathed: "We haven't reached the rim yet," while his partner radioed Mission Control with the words "Our positions are all in doubt." Shepard's pulse had reached a worrying 150 bpm.

On the ground, discussions were taking place between doctors and scientists as to how important it was to reach the top. Shepard, who weeks earlier had dismissed a geologist's attempts to provide extra tuition in the difficult business of lunar navigation, had spotted some boulders which looked to him like deep ejecta and he wanted to sample them, then turn back, but Mitchell was distraught at this suggestion.

"Oh, let's give it a whirl!" he said. "We can't stop without looking into Cone Crater. We've lost everything if we don't get there."

No one had ever stood at the edge of such a crater before and Mitchell was desperate to do so. When Houston capcom (capsule communicator) Fred Haise suggested they were near enough, Ed muttered, "Think you're finks"–until Haise offered a lifeline, announcing that the walk was to be extended by half an hour and that if they wanted to spend the extra time hunting for the rim, they could. The decision was theirs. Deke Slayton suggested they help themselves by ditching the tool cart, but Ed bravely claimed that it wasn't slowing them down, because he knew they'd need the tools when they arrived.

"It's just a question of time," he said. "We'll get there."

Dragging the cart, Shepard led the way, but they didn't seem to be getting any nearer: it was only when the commander gave their position as "the middle of the boulder field on the west rim," that Mitchell realized he was being taken in the wrong direction. Shepard thought they were west of the crater, but Mitchell felt sure they were to the south. He consulted the map, could now see where they were. Panting heavily, he told Shepard that if they headed north, they'd get there.

So Mitchell pulled. The ground flattened out, which meant the rim had to be close, but they still couldn't see it. It was as though the Moon was playing games with them and in despera-

tion Ed rescanned the map. There was a big boulder which ought to be in view now, but was nowhere to be seen. He knew they were nearly there, yet the time had just run out. Fred Haise said:

"Okay, Ed and Al."

Like Mom calling them home for dinner. Their time was up. So they sampled some interesting-looking gray-and-white-streaked rocks and headed for base and the safety of the LM, where the keen golfer Al Shepard pulled the stunt for which his mission is still best remembered, attaching a golf club head to one of the geology tools and sending a couple of secretly stowed balls arcing into the distance–an idea he got from watching Bob Hope mince about the space center with a club clenched in his fist like a baby rattle. After another fitful nap, the pair of Moon-walkers blasted back into the sky and Edgar Mitchell felt a real, physical yearning, a "strange nostalgia" for the world he'd just left and knew he would never see at close quarters again. Back home, scientists would establish that he and Shepard had drawn within twenty yards of Cone Crater's edge . . . it had been right under their noses, but evaded them anyway.

After the return, Mitchell stuck around for another year, then left NASA to form his IONS research institute. He had found the Moon a welcoming place and had no trouble integrating it into the human story, or his own. To him, "the stillness seemed to convey that the landscape itself had been patiently awaiting our arrival for millions of years." There's a mystic edge to this observation, yet for the thirty-three hours that he spent on the surface, during which he and Shepard collected ninety-four pounds of rock, he felt constant frustration at being too busy to stop and simply look around, take in the feeling of being there. He also felt a powerful angst at leaving, knowing as he did that he would never return, and, once back, became worried by his irritation with the question "What did it feel like to walk on the Moon?" Unlike most of his colleagues, he decided that the problem was not with the questioners, but with himself and the anguish he felt at being unable to recall the feeling of being there. Eventually, he got two friends to regress him under hypnosis, after which he felt sure that something significant had happened

to him on the flight–that the epiphany provided no less than a window on the Universe; a clue as to its structure and our connection to it. He realized that the tightly focused training regime of the fighter pilot and astronaut is at odds with that required of a modern-day shaman, which was how he was beginning to see himself.

Mitchell originally conceived the Institute of Noetic Sciences as "more a state of mind than a place" and began by running it with his new girlfriend, Anita Rettig, whom he married in 1974, adopting her two children into the bargain–for his first marriage to Louise Randall became one of many to collapse soon after a Moonwalker's return to Earth. Mitchell is hard on himself about this, blaming the anxiety and absence enforced by his career, multiplied by his own self-absorption, for a failure to understand his wife's unhappiness. While his dream had been drifting into view, he confesses, "there were never any guarantees, and for a mother and her children, the lifestyle meant friends and playmates left behind" as the family was dragged from base to base. At any rate, the crises came fast. In the beginning, influential people wanted to meet and be associated with an Apollo astronaut, but the Moondust gradually fell away and the businessman who had agreed to back IONS withdrew, leaving the dream in ruins. Nevertheless, money did arrive in fits and starts: on one occasion, according to Mitchell, a hippy girl in a VW camper van arrived with $25,000, dropped it off and puttered into the sunset without even leaving a name. Soon they were able to initiate research into paranormal phenomena like extrasensory perception (ESP), and the health benefits of acupuncture and meditation, which was still considered pretty "far-out" stuff in the 1970s. At the same time, Mitchell was forced to engage in another struggle, fighting a drift toward both mysticism and his own deification within the organization. He even felt compelled to shave off the beard he'd grown at one stage, in order that he might look less biblical.

On the more far-out fringes of the organization, it had been noticed that the number of Moonwalkers, twelve, corresponded with the number of Jesus' disciples. Things were getting weird down here in Florida and, by the decade's end, with his creation

slipping away from him and five kids to put through college, he began to distance himself from IONS. In 1982, he was removed as chairman.

LAST NIGHT, a brilliant sunset flared over the Gulf of Mexico and when it had finally burnt itself out, a vast Moon hung above the glassy water in its place. Years of living in a city where the sky is seldom clear mean that I still have to force myself to look up most nights, but this night the sky wouldn't be ignored: there she was, a soapy white, with delicate traces of blue and the enigmatic shadows which so enchanted Galileo when he became the first person to view them through a telescope in 1609. His findings caused a sensation when he published them the following year, but it wasn't until a generation later that the Moon's features were given the lyrical names that we still use today. To Giovanni Battista Riccioli, preparing his lunar atlas in 1651, the shadows looked like seas, and so we have the Sea of Tranquillity, Ocean of Storms, Lake of Dreams, Bay of Rainbows ... *Mare Tranquilitatis, Oceanus Procellarum, Lacus Somniorum, Sinus Iridum.* Someone called them the poetry of the Moon, which rides an ellipse around the Earth, but doesn't spin, always presenting the same face, keeping the other one hidden. Thus, the "dark side" doesn't exist: there's only a meteor-battered "far" side, sometimes dark, sometimes light when it's facing the sun–where, to this day, no one has trodden. Like the moons of other planets, our Moon has a proper name, too. She's called Luna.

What *does* it feel like to stand there? How extraordinary to think that only nine people on Earth right now could know the answer. And that one of them is so close by.

ALWAYS THAT PECULIAR mix of apprehension and excitement at walking into a roomful of people I don't know.

It's a light, warm Friday morning and the airy common room being used to greet and register "Seeding Spirit in Action" delegates is buzzing. Afterward, I'll try to recall who was there and mostly am left with a milky impression of Indian prints and

open-neck shirts and smiles which bob about the room at varying heights, like bees tending flowers on a hedgerow. Nice people. On white Formica tables lie books and magazines and lots of leaflets with affirmative headings like "Celebrate" and "Yes!" and "We are explorers . . ."–the latter being a slick number decorated with beautiful people and butterflies and photos of IONS's new "international campus," which sits on 200 picturesque acres just north of San Francisco, because things have looked up in the past decade.

A flyer catches my eye. It says:

MEET the MAN!
Reception with
Dr. Edgar Mitchell
Founder, Institute of Noetic Sciences
Fundraiser for IONS
Saturday 5 PM, Fox Hall

I pick one up and the woman behind the table beams. "Oh, yes, you've gotta come and meet Edgar. Such a special man. He smokes roll-ups, you know."

What?

And suddenly he's here.

Did I expect a fanfare and a shaft of light? No. I'm not sure what I expected. What I *hadn't* anticipated was this sense of disorientation, which will turn out to be common among people seeing the lunar astronauts for the first time, and in this instant I understand how strange my project is. The undertaking we associate Mitchell and his tiny cadre with may have ended abruptly thirty years ago, but it has never been equaled since–in fact, with every passing year it has come to seem more eccentric and incredible. Science has advanced and technology leapt forward at a dizzying rate, but in this one domain, Deep Space, *their* domain, there has been . . . nothing. So while the world has changed, we have changed, the pictures and deeds of the Moonwalkers have remained ever present, yet frozen definitively in the imagination as they were then, making sight of them as they are now a shock. It's like Dorian Gray in reverse: they have a

real age and a Moon age and your first impulse is to stamp your feet and cry, "How dare you be *old!*" Thinking about this reaction later, I flush with embarrassment.

For the man in front of me *is* old. He's seventy-one, about five foot nine, with still-dark short hair, ruddy skin and a very modest paunch. He's wearing khaki trousers and a dark green, logoless, vaguely eastern-cut short-sleeve shirt and has entered with an attractive, Latin-looking woman of roughly his Moon age, who turns out to be his current partner Anna. His wire-rimmed spectacles and the curiously unmemorable parameters of his face are familiar, but the creeping estrangement of flesh from bone means that I wouldn't have recognized him in the street. He moves easily, but there's nothing commanding in his stance and he doesn't seem to waste words or emotion as IONS officials slowly note his presence and move to greet him, which they do warmly. There's a hesitancy in his smile, a sense of containment about him. In these moments, he looks shy.

And yet the instant he stands at the front of a lecture room, looks up and starts to speak, the years fall away like ice from a rising Saturn rocket. Today is given to five "pre-conference institutes," which run concurrently between 10 AM and 4 PM and boast bewildering titles like "Awakening the Voice Within," "Conscious Circle Work: Transforming the Media" and "Spirit in Action"–a facilitator for which, I can't help noticing, is a twenty-eight-year-old named Ocean. But the last, "Frontiers in Consciousness Studies with Edgar Mitchell," is the one for me and five minutes into it I'm already reeling at the breadth of his experience, which runs way beyond anything that would have been available to (or inflicted upon) my generation.

He talks about the current "crisis of civilization" and our "rapid descent toward some new equilibrium," then leaps back to his early career landing jet fighters on aircraft carriers, which sounds like the most terrifying occupation on Earth, thence to Sputnik, "which changed everything–up to then, we really didn't know what was out there." His voice is deep, with the assumed authority of a police chief briefing his team of detectives. *Okay, the Meaning of Existence has been terrorizing the community for 200,000 years and it's time to nail the bastard. Now, be careful out*

there . . . He describes the dire warnings there'd been about what space might do to the human body and the marvel of finding that the body set about adapting almost immediately. Looking back, he is struck and a little charmed by America's naïveté at the time, as reflected in the movies of the late 1950s, with their space invaders and omniscient scientists and parents wringing hands over the relatively innocent rebellion of their teenagers. Prior to the 1950s, there was no such thing as a teenager.

There was also the joy of finding that the eye was so much more powerful without an atmosphere to cloud it. He thinks this was one of the reasons why lunar astronauts found the return journey so moving, with the Earth in their sights. Only twenty-four people have ever left Earth orbit and seen her from the per-spective of Deep Space—all American and all between the Christmases of 1968 and 1972. The difference between near and far is enormous: the orbital astronaut experiences the planet as huge and majestic, while from afar it is tiny, beautiful, and shockingly alone. In a rare instance of candor, Neil Armstrong once remarked that while on the Moon, he became aware that he could blot out the Earth with his thumb and when someone asked whether this made him feel really big, he replied, "No, it made me feel really, really small." Which brings us to the "epiphany."

Edgar Mitchell was already interested in the paranormal, af-ter being introduced to it by friends at MIT. It was a voguish field at the time, perhaps as a result of the questioning of convention that came with the Sixties, which fed a broader interest in East-ern mysticism and alternative readings of reality. So it was in the universities and on TV, but it never cut much ice at NASA, which is why there was embarrassment when word leaked out that *Apollo 14* astronaut Edgar Mitchell had conducted a private ex-periment into it on the way to and from the Moon, "transmitting" mental images of randomly chosen shapes to four people back on Earth at prearranged times. Unfortunately, his accomplices had failed to take account of a slight delay in the launch, so were out of sync with his attempted projections. In what looks a little like rationalization, the astronaut claims that the results were still significant, as the other subjects' guesses were far wider of

the mark than would be statistically expected, suggesting to him a subconscious knowledge that something was wrong. What-ever the case, Mitchell was betrayed by one of his collaborators and word leaked to the media shortly after splashdown. Another independent-minded Apollo astronaut assures me that, had commander Shepard known of Mitchell's intentions before-hand, the younger man would certainly never have flown–not on any mission. But Ed kept it wholly to himself. No one at NASA had the vaguest notion that this hippy stuff was going on right under their noses. Curiously, Deke Slayton claims to have been more open-minded. "I thought it was worth a look," he says. "Hell, NASA doesn't know everything."

The epiphany led Mitchell to ask, "What was causing this ex-hilaration every time I looked out of the window?" It seemed that nothing in conventional science or religion could explain it in a way that satisfied him, but that nearly all religions had *talked about it*. Mainstream science, with its conventional view of mind and body as separate entities occupying distinct realms (the world of spirit versus the world of matter), is incomplete, while religion acknowledges the "transcendent experience," but misinterprets it. It occurred to him that "God is something like a universal consciousness manifest in each individual, and the route to divine reality and to a more satisfying human, material reality is through human consciousness." In time, he saw the kind of epiphany he had as "a latent event in every individual."

Now, if all that's a bit heavy, consider this. For the drive south, to get me into the mood of the period, I'd popped into a record store and bought a CD which I hadn't heard in a number of years. *The Psychedelic Sound of the 13th Floor Elevators* had been released in 1966, the year Ed Mitchell entered the Astro-naut Corps, and, to my great amusement, the sleeve notes began with the words: "Since Aristotle, man has organized his knowl-edge vertically in separate unrelated groups–science, religion, sex, relaxation, work, etc. . . ." This, they go on to contend, is a bad thing. Of course, the Elevators' prescribed remedy for this conceptual downer was truckloads of LSD, with the result that these natives of Austin were not loved by the Texan authorities and eventually fell apart when their most iconic member,

singer-guitarist Roky Erickson, was committed to a mental institution after one trip too many. All of which leads me to two thoughts: first, that while Ed Mitchell might have been working in a vacuum in space, he wasn't back here on Earth–his ideas were not mainstream, but they were around; and second, that the more he talks about his epiphany, the more it sounds to me like that ancient tribal ritual known in Britain as "knocking back a tab of ecstasy." Could his euphoria have been the result of a simple chemical process, the ecstatic release of serotonin in an overexcited brain?

As the talk progresses, Mitchell acknowledges Timothy Leary and the drug culture of the Sixties, saying, "it appears that those [ecstatic] states of mind can be naturally derived, you don't need psychedelics to do it." What he's suggesting is that these states are not delusional, or even purely private, but are manifestations of real, physical processes in which the subject tunes in and turns on to the Universe itself. Behind this claim is a new and still highly speculative cosmology called Quantum Holography, which appears to be based on extensions of ideas mooted by the distinguished Princeton physicist Professor John A. Wheeler, who was a colleague of Einstein's and originator of the term "black hole." Mitchell doesn't mention Wheeler by name, but he does say that the quantum hologram was "discovered and experimentally validated" in Germany by Professor Walter Schempp while he was working on improvements to MRI (magnetic resonance imaging) scanning technology.

Underlying Mitchell's conception of the hologram is the discovery in the early part of the last century that at the atomic and subatomic level, the elements of the Universe do not obey the laws of Newtonian physics. The study of the laws governing this realm is called quantum mechanics and one of its big mysteries is the apparent fact that if you separate two particles, they continue to maintain some sort of nebulous connection, even if they end up at opposite ends of the Universe: in the jargon, they "resonate." This property is called "nonlocality" and Einstein objected to it on the ground that the particles (or whatever force connects them) would have to move faster than the speed of light for it to be true, but it's since been pointed out that Einstein, like

Deke and NASA, didn't know everything. A great deal of time and effort has been spent trying to explain the mechanism by which this happens, but no one yet has.

Professor Wheeler addressed this difficulty by suggesting that the fundamental stuff of the Universe might not be energy and matter, as conventional physics holds, but *information*–with information being defined as patterns of energy. This suggests the further, more shocking possibility that a Universe which appears to us as three-dimensional (four if you count time) is in fact two-dimensional, flat, like a hologram: that just as a trick of light allows three-dimensional images to be carried on a flat piece of film in a hologram, the cosmos is composed of "information" painted across a vast, two-dimensional canvas which we know as "infinity." It's hard to imagine a more alien idea (Descartes's suggestion that our world could simply be the trick of a malevolent demon seems comforting in comparison), but its advocates claim that recent studies of black holes provide evidence for it.

As I understand it, Mitchell's distinctive contribution to the theory is to suggest that the canvas of infinity either consists in, or is connected to, what is called the "zero-point field," the field of quantum fluctuations, of *energy* that exists at a temperature of absolute zero and fills all space, even where we previously thought there was nothing but void. The existence of this "field," sometimes called "vacuum energy," is widely acknowledged, but Mitchell's contention that it "sustains the form and existence of matter at the quantum level" (which is to say, *keeps it together*), and is in permanent resonance with everything, is not. If he is right, then the old conceptual division between mind and matter that has underpinned Western science and thought since Descartes's time (it's been called "Cartesian duality" after him) is illusory.

Now we come to the bit that I like, because the most important implication of all this, Mitchell reports with an arching of his eyebrow, is that "we are quantum matter, not just classical matter, and it appears that we can recover nonlocal information." He points out that such a thought hasn't always seemed exotic: after all, what is prayer if not "information intended to be

received nonlocally"? And this is what he thinks happened to him on the way back from the Moon. For the first time in his life, he was in resonance with the Universe, as can also happen when people meditate, experience telepathy, or believe they've been reincarnated ("they're merely tapping into the information– that's why there are so many Cleopatras and Caesars!"), all of which are dismissed by conventional science simply because it has no way to make sense of them. In this way, Mitchell feels he can further explain ESP, the occult, and Jung's "collective unconscious"; can make sense of near-death experiences and telekinesis, of Sheldrake, Geller, et al. It's like there's a huge hard disk in the sky, which we can hook up to, *resonate with,* if we know how. And this is what we've called God. The Universe is conscious, because we are, and it learns, because we do. Nature is about information, process, sharing: pretty much what the mystics have been telling us for millennia. So Teddy Pendergrass–or was it Barry White?–was right. Everythang really is everythang.

Mitchell takes it further, though. With such an understanding of the cosmos, "we can try to create a world with more tolerance, satisfaction and openness," he says. This will be the "Wisdom Society" of his and IONS's dreams. "True spirituality" and "true science," he says, are looking for the same thing. "We must think of consciousness as a process." For the record, the "U.S. quantum physics community" is skeptical of all this, because Mitchell's reading is "hidden in the traditional formulation; you have to get to a deeper level to see it." In fact, I will learn that most mainstream U.S. scientists still consider his interpretation of the available data to be way out on the margins. These days he mostly finds himself working with German, British, and Belgian physicists, who, he says, are more openminded. I remember that the biologist James Lovelock, who in the early 1970s developed the Gaia hypothesis (that the Earth and its ecosystem should be thought of as a single organism), worked for NASA as well.

Suddenly I hear a sharp clap of hands and look up from my notebook to see Mitchell grinning broadly. I glance at my watch and see that four hours have passed.

He runs his eyes around the room and teases, "Got it?" at which his audience smiles and nods with an insouciance that I take to mean "Look, we'll take your word for it." I myself feel as though I've just completed the New York Marathon by bouncing along it on my head and am stewing in the melancholy knowledge that I'm going to have to read up on quantum mechanics when I get home. All the same, I've enjoyed Mitchell's discourse and now I introduce myself to him as he gathers his papers. We chat for a while, then agree to convene the next morning for a proper conversation. As I leave the room, I hear someone gushing to a companion ". . . and that was when I got into biofeedback!"

ONLY IN THE EVENING, at the Conference Opening Gathering, do I begin to appreciate what I've stumbled across here in Florida.

I stroll in late to find two women whom I'd guess to be in their early fifties banging drums and hauling some of the 200-odd attendees to the front of the hall for a Dance of Universal Peace. I try to slink down the side wall inconspicuously, but it's no use—I am a sitting duck by virtue of my lateness, doomed to spend the next half hour twirling around in a big circle with several dozen people whom I don't know, chanting "I am sunlight/I am shining," and if in the end I learn to enjoy it by imagining that I am on my way home from Woodstock, I also can't help noticing that Edgar Mitchell remains anchored to his seat as if stapled to it by Zeus himself. Before the weekend is out, I will have pretended to be a singing tree at an "Embracing the Circle" workshop, and panicked when a faith healer asked, "To what god do you pray?" and an image of the former Conservative Secretary of State for Health Virginia Bottomley popped into my head (what the . . . ?). I will have listened to a young hippy tell a story which ends "if it's possible that talking to fruit flies can bring peace, imagine what it could do for people" (audience members nod sagely), been "presenced" by Tibetan singing bowls, and had conversations about paranormal experiences that a few magic mushrooms might have rendered intelligible,

but probably wouldn't have. Yet I will also have met many bright, warm and well-informed people: people who were young adults when Edgar Mitchell went to the Moon and watched his journey from the perspective of a counterculture which they've never abandoned or broken faith with. There are left-field scientists and academics, humanitarian and civil rights activists and every complexion of New Ager. To find an astronaut, let alone a Moonwalker, keeping this kind of far-out company strikes me as extraordinary. That I never once see Mitchell patronize, dismiss or condescend to even the more dippy elements seems even more so.

After the dancing, a nice talk on the pre-European history of Florida gives way to a valedictory address by the outgoing IONS president Wink Franklin, who turns out to be an engaging and witty character and spends the first five minutes ribbing Edgar about the lunar-hoax theory. He's joking, obviously, but this will turn out to be a real issue for the Moonwalkers, because over the past three decades it has become the most widely believed conspiracy theory of them all, holding that the Apollo astronauts never left Earth orbit and that the landings were filmed in a studio in the Nevada desert. A hard-core cadre of writers and filmmakers are behind most of the more seductive claims and as yet I have no notion of how closely they will follow my own journey, but they will–right to the end. Franklin grins as he says: "I'm sure many of you have heard Edgar tell his story about going to the Moon many years ago, and I guess some of you might even have believed it . . ."

And we all laugh, even Mitchell, then move on to other business, and at the end of an evening in which I find delight and disbelief in equal measure, I'll be marveling at the fact that what I appear to have found in IONS is the place where Apollo and the counterculture it shadowed actually *meet*. In my wildest dreams it had never occurred to me that they would.

The next morning, I find Edgar sitting on a tree-shaded bench outside the common room-cum-"noetic café" in the middle of the campus. A Marlboro Light is pinched Artful Dodger–style between his thumb and forefinger and amusement must show on my face, because he looks momentarily discon-

certed, then takes a big drag and stubs it out. Most of the astronauts smoked back in the day, but while most, like the rest of us, have since given up, Ed's hung in there. I don't know why this should seem pleasing, but it does.

Everyone else is at gatherings or workshops and we're alone with the stillness of the morning. We begin by talking about the epiphany, which continues to hold such power for him. The feeling was one of bliss, almost like being in love, he says, lamenting the fact that in English we have words for anger, happiness, sadness, frustration, but not for this overwhelming sensation which has been at the root of all religion.

We spend a long time talking about Quantum Holography and this appealing idea that the information of the whole exists in every constituent part; that a little piece, a tiny particle, might contain all the information pertaining to everything that exists or has ever existed, if in diluted form. The conversation ranges across history and philosophy, different cultures and religions, and while he doesn't "Believe" in any conventional sense, there's an infectious *sacredness* to the way in which he speaks of the cosmos. Again I am reminded of William Blake, who used to have ecstatic "visions" and spoke of seeing "the world in a grain of sand." Mitchell knows about Blake, saying, "lots of artists and writers have spoken about it, in lots of cultures," and repeating his theory that it happens "when the brain is in resonance with the fundamental stuff of the Universe." Then we're back on the zero-point field, where he tells me that there is no space and no time and it sounds like he's describing science fiction. Indeed, I will talk to scientists who tell me that he is, but I'm not sure how much I care, because his conception of the Universe strikes me as rather beautiful, almost a work of art in itself. Pressed on this issue, he admits that: "We haven't proved anything yet, just proposed an explanation for a lot of things we've written off because we couldn't make sense of them."

He speaks quietly, with the measured urgency of Captain Kirk addressing his Star Log and I quickly learn that he doesn't do small talk, becoming awkward and tongue-tied if you try to make him. He confesses that his family used to tease him about being so serious and he knows himself well enough to be able to

joke about this. When I callowly wonder why he signed up to fly combat in the pointless American engagement in Korea, noting that it's hard to imagine an Ed Mitchell of my generation having done that, he is patient with me: he looks pensive for a moment, then describes a reality that hasn't touched my charmed life. He was drafted.

"I was gonna have to go to war, and I'd been flying since I was young, so I chose to do my service as a pilot, which is how I got where I was. The fact is, I didn't plan a military career. And it was only when Sputnik went up that we got involved in the Space Race. Becoming an astronaut is something that happened."

His childhood is instructive to this, because Mitchell's mother was a devout Southern Baptist with a strong antiwar bent, who hoped that her eldest child and only son, born in September 1930, might grow into either a preacher or a musician. Ranching the plains of west Texas, the family had managed to prosper through the Great Depression and the Dust Bowl, but been hit hard when the wheat crop failed one year, necessitating a move to a little clapboard house with outside plumbing in New Mexico where the men drove spikes on the Santa Fe Railroad. Before long, they had moved again, prophetically it seems, to Roswell, New Mexico, where Mitchell senior gradually built up a cattle farm. In fact, cattle was in the family, for his grandfather was known abroad as "Bull Mitchell" on account of his trading skills and Edgar recalls other ranchers traveling to Argentina or Brazil and sending back postcards addressed only to "Bull Mitchell, New Mexico," which would find him with no trouble.

That Edgar Mitchell lived in Roswell is bizarre in several respects. On the way to school, he walked past the house of Robert Goddard, the mad-scientist father of American rocketry, about whom the neighborhood kids wove swathes of Boo Radley–style mythology and whom the media of the day ridiculed as a fantasist for his dream of riding into the stars. He also saw the luminous glow from early nuclear weapons tests at the White Sands Proving Grounds and, in 1951, heard the rumors that an alien spacecraft had crashed just outside the city limits, to be spirited away, along with its pilots, by the paranoid authorities–a story

which regained currency in the 1990s, when a film purporting to show one of the dead aliens being dissected achieved widespread notoriety. The film was a hoax, but this unremarkable southwestern town remains a mecca for UFO believers from around the world.

Mitchell got a job washing planes at the local airport and was flying solo by the age of fourteen. He felt a special relationship with the machines, as though they became part of his own body when he climbed inside the cockpit womb, and went on to become an exceptional pilot, savoring the "sense of freedom" and "release from the Earth" that control of a plane gave him. No one in his family had much formal education, but he won a place at Carnegie Mellon University, where he went to study engineering in 1948, met his first wife, Louise, and when money was tight worked midnight shifts cleaning slag from blast furnaces at a steel mill. A stint in the Navy took him to Korea, after which he came home to train as a test pilot. He used his analytic skills to help develop delivery systems for nuclear bombs and was all right with this, he says, so long as he obeyed Albert Speer's dictum and buried his mind in detail and problem solving. Nevertheless, the implications of what he was doing disturbed him and he began looking for something that he could open his imagination to, and eventually saw a way forward with the launch of the Soviet Sputnik satellite and the Space Race in 1957.

He began to study aeronautical engineering, Russian, and Einsteinian physics. He still went to church, but felt himself becoming an agnostic, while also coming to recognize the influence of his mother's hellfire fundamentalism on his thought; but by the age of thirty-six, a Navy pilot with a wife and two children who had been pushed and pulled around the country in the service of his career, he felt that he had "managed to place myself rather precisely at a critical juncture in the history of humankind."

He wrote to NASA, but for the longest time the phone refused to ring.

Then, in the spring of 1966, the call from Deke Slayton, head of the Astronaut Corps, finally came. This fourth intake of astro-

nauts was sarcastically dubbed the "Original Nineteen" and they understood themselves to have little chance of flying on Apollo. In deference to this apparent fact, Mitchell's private ambition was to command the first crewed mission to Mars, but even as early as 1970, it was clear that there would be no such mission. He applied himself anyway and with surprises springing up everywhere as far as the lunar crews went, he got his chance. Slayton remembers him as "one of the smarter guys in the astronaut office." Just how smart, Slayton and the others hadn't yet understood.

He tells me that while the people he worked with at NASA were grateful for Kennedy and the political machinations that led to Apollo, few of them went to the Moon in order to beat the Russians. As far as most were concerned, he says, "We were going 'cos we wanted to go."

I like the way he uses the profoundly un-NASA epithet "lovely" to describe the people attending this conference, and then again in reference to the benefactors ("very lovely people") who eventually showed up with help. He tells me that some wealthy people have now "bought into the dream," but he doesn't ever seem to have been much concerned with acquiring money for himself: he thinks this might be because of his background, where money was never abundant. Even so, it must have been disorientating to suddenly find himself surrounded by former flower children and liberals. Could he even understand what they were saying?

"Yeah." He smiles. "The transition from a structured military environment to a public environment was quite a transition for me. One thing about the military is that you trust what people say to you, because that's necessary and lives depend upon it. And in public life"–he shakes his head and laughs ruefully– "that's not true at all! So I had my lunch stolen quite a few times by trusting and believing people I should not have. But I learned not to be quite so naïve."

He didn't experience the "comedown" that some of the other Moonwalkers did?

"No, I tend to think that what I've done in the thirty years since is more important than going to the Moon. The Moon–

okay, that was powerful, it's history, groundbreaking stuff of the twentieth century. But for me personally, I think pioneering what I've done here with noetics will in the long run be a more important advancement."

Strange, I observe: Charlie Duke says the same thing about his church work. Ed's eyes light up.

"See, the point is, Jim Irwin, Charlie Duke, myself and others had the same experience, I think. But you express it in terms of your own belief system, your own experience and your training. And me being more of a philosopher and scientist, I looked beyond the *easy* explanation of religion. Alan Bean–a lovely fella– he expressed his in his artwork. And even the ones who haven't shown outward signs of change"–he leans forward and jabs a finger at the space just beyond my right elbow–"that doesn't mean they didn't feel it, too."

Test pilots, he goes on to note with a smirk, "have never been noted for introspection or spontaneous eloquent expression," but he does believe that "it's significant that many of the men pioneering space flight began to express more openly a more subtle side of their personalities after returning home." Even Shepard loosened and a LM deputy program manager is also on record as saying that the lunar astronauts did change; became less outgoing, more pensive. Wouldn't their training as test pilots, with its emphasis on self-control, have militated against being affected by what was happening around them? Mitchell thinks this is a misconception, saying:

"My experience taught me to open up my emotions, or at least to become more aware, to become *more* sensitive to what's going on in the body. It's quite true that in that business you have to learn to manage your emotions. But of course, that's what the mystic disciplines are about, too. That's what's taught by the Tibetan Buddhists–and I greatly admire their scholarship . . . it is about learning to manage your emotions."

We talk about family and the huge divorce rate in the Astronaut Corps. At the beginning of the Sixties, marital breakdown still came with shame; worse, NASA considered it bad for the image of the program and it was made clear that divorces would cost flights. Yet even NASA couldn't resist the social revolution

that was ushered in by the contraceptive pill. By the end of the 1970s, the divorce rate would be five times what it had been in 1961, with the highest rates in the nation settling on the Cape Kennedy area of Florida. Mitchell attributes this phenomenon more to the "devotion to duty that was required just to get the job done" than to the spiritual upheavals that followed the trip– though I will come to doubt this view. He shrugs meekly when I press him on his own progress through three marriages, saying, "I don't really know how to answer that question. It's just life . . ." A chortle rises from somewhere deep as he admits of his six children that: "No, none of them have been eager to go my way . . . they recognize that Dad's kind of a unique character."

We chatter for a while about Richard Nixon, who was president at the time *Apollo 14* flew and is becoming a figure of some fascination for me, then spend a long time discussing Wernher von Braun. It transpires that prior to his flight, Mitchell spent a week sharing a house with the rocket scientist and Arthur C. Clarke, who was by then regarded as one of the most influential futurist thinkers on the planet, because for that brief period sci-fi was seen as something more than escapism. Mitchell calls it "a powerful experience, which profoundly affected my thinking and my determination to persevere," and yet I'm still surprised by the grim determination with which he defends the ex-Nazi, concluding that "I have great respect and great caring for the man." This also draws me back to a surprise in yesterday's seminar, after Mitchell had finished speaking and thrown the floor open, providing the cue for a few male believers in chinos and sports jackets to trade phrases to see whose was the longest ("phase conjugate adaptive resonating" won by a nose), and an elderly woman with flame-orange hair to ask about reincarnation, then a young hippy chick with long blonde hair to enthuse about the mysterious crop circles she'd seen in England the previous summer, while I wondered whether to raise my hand and reveal that I'd made one of those once with a couple of crop-circle hoaxers–a beautiful, complex, 180-foot formation which took us about four hours to lay down in the dead of night using wooden boards and rope, in a field that turned out to belong to a hugely famous British composer of musicals.

In his response Mitchell pointed out that his theories do not support postmortem consciousness ("consciousness does not survive: only the information does") and to my relief, he was noncommittal on aliens and crop circles. At that juncture, however, another woman had raised the subject of UFOs, at which Mitchell smiled conspiratorially and claimed to know "old-timers who were around at the time of Roswell and when there were so many sightings–high government and NASA officials–who insist that there's been a *cover-up*." He added that "My confidence in that statement has risen to the high ninety percents." Now I ask if he will reveal what he knows or thinks he knows about UFOs?

"Oh, I revealed everything I know yesterday," he says. "I don't know more than that. I've had no personal experience with UFOs. I've talked with many of the people in *the system* and I've observed and kept up with the literature . . . but I know there is hidden material. I know there is cover-up material. And breaking that out is important, but so far we haven't been able to break the code. We haven't been able to get to the people involved. And it's something beyond this government. Even our presidents in the United States don't have access to this. Or somehow they're hushed."

Why?

"I don't know why, and it's the same as in science; the Belgians are more open, the Russians are more open, but we've never been able to crack it open in this country. And to me it threatens our entire system of democracy. There is a power structure that has control of some information that is not accessible to the public."

I don't know what to make of this. Wink Franklin *was* joking about the Moon-hoax thing, wasn't he? It seems interesting to me that Ed Mitchell sees conspiracies in space, just like the hoax theorists.

"Yes, Wink was teasing me. But you're right, we do get a lot of stuff about the landings having been faked. And I'm not sure how much people really believe it, or whether it's a mark of disgust with the government, or whether it's just people trying to get fifteen minutes of fame in selling a story. Who knows?"

He tells of a man who showed up with a camera crew purporting to be from a well-known documentary TV channel, only for the interviewer to wait until the camera was rolling, then slam a Bible on the table and drawl: "Put your right hand on that and swear you went to the Moon!" It turned out they were making a film about the Great Moon Hoax, and for a glorious instant, I picture Ed engaging them in an earnest debate about the precise nature of the God to which he was being asked to swear. That would have cleared the house. Instead, he politely showed them the door. Charlie Duke got angry when he talked about the conspiracy theorists, I tell him. He smiles broadly.

"Well, I just discard 'em. I try not to let anything make me angry for very long. If I get that feeling, I try to get rid of it."

We return to his interest in paranormal phenomena and now he springs something that's harder to dismiss lightly. He mentions that in September last year he was diagnosed with prostate cancer. Doctors were ready to operate, but it's an unpleasant operation which he hoped to avoid, so he gave himself a few months to try some alternatives. Detox had some effect and he found a nutrient which helped, but was then controversially pulled off the shelves by the FDA. The PSA value in his blood, a measure of the tumor's activity, began to rise again, until one day, at an IONS board meeting, someone suggested they do a "healing." By which they meant *faith healing*.

Mitchell had never done this before and invested no hope in it. But as he tells it, the ritual lasted for twenty minutes and "felt like being plugged into a twelve-volt battery." For four days, he felt off balance: "Something *Wow* had happened." Then he came back down and at his next medical examination, conducted with new, more sensitive equipment, he was told that there was no cancer activity.

"Naturally, my emotional mind was pretty overwhelmed," he says quietly. "But my science mind was saying 'I'm not sure I really believe this . . .'"

Yet he's still here. A year from now, we'll be talking on the phone and exchanging e-mails, and he'll tell me that he thinks the important factor is intentionality—the focus of different wills on one object or goal. During moments of high attention on the

OJ Simpson trial, he claims, the random-number generators in Las Vegas casinos began to go off-random. The question he asks is: does our attention, our focus, create "negentropy" (the opposite of entropy), that is, order, in the natural world? If so, the Universe *can* be said to be conscious.

It strikes me that these are the types of things I used to hear clubbers and drug evangelists like Timothy Leary saying after taking ecstasy and DMT in the early 1990s at the time of the Acid House craze, and again I wonder whether the epiphany could have been a chemical thing, originating within the brain rather than the Universe. Later, I will e-mail Mitchell this thought, and ask whether he has ever experimented with meditation or hallucinogens–because to me the precise nature of his epiphany is important to everything that follows from here. He tells me:

"I think it has something to do with chemical reactions, [but] it appears to me–and this is going beyond what I describe in *The Way of the Explorer*–that these transcendent experiences have to do with a resonance of the brain and body with the external world. And it appears that the more the brain and body get in resonance with their environment, the more likely one is to have this type of experience. That is what–in my opinion–the transcendent experience is really all about."

Addressing the question directly, he further explains:

"And, yes, Andrew, I have been a longtime meditator–since the spaceflight. It helps reproduce the samadhi state experienced on the spaceflight and more. I have tried a bit of psychedelics experimentally, not extensively."

Then he adds, drolly:

"I recommend the path of meditation."

I've also wondered whether this urge to reconcile science and religion might be as much about closing the gap between two sides of himself, the educated über-rationalist and the reeling mystic his mother sought to raise. He once admitted to still harboring "a secret fear of God," thanks to being brought up with a strong sense that "the potential for damnation lay in the spoken word, even perhaps in thought." Could this have been what drew him to both of those things in adult life: danger? Were they his sex and drugs and rock 'n' roll? He cocks his head

to one side. This is a new idea, to which he seems unable to find a response, so I change tack. Does he still harbor a secret fear of God, even though his rational mind doesn't "Believe" anymore? This time the answer is firm.

"No."

It's gone now?

"Yeah. It took years, though. When I came back to doing the work I do now, there was only one assumption: that we live in a natural Universe, not a supernatural Universe. Therefore it's knowable. And if it's knowable, science ought to be able to figure it out. That has been my credo for thirty years, and the more we dig, the more it appears to be correct."

Mitchell casts his eyes to the sky and absentmindedly pushes his dentures forward with his tongue, then pulls them out and contemplates them for a moment. I stifle a smile, but find something moving in the tableau. His mind is so young that it's easy to forget his roots in a time when all Americans didn't have perfect teeth. He suddenly wakes up to what he's doing and crams the dentures back into his mouth, just in time to see a woman who claims to run a "holographic consciousness cruise" business barreling toward him with some ethereal "machine" she wants him to try. I watch him try and fail to wriggle out of this: in his time Edgar Mitchell has defied gravity, death and ridicule, but a determined New Age matron is something else entirely. I just have time to note that some of his former colleagues, most specifically Buzz Aldrin and John Young, actively campaign for a return to the Moon, with all the expense and energy that would require, and to ask what he thinks.

"Well. We started, so I think we probably should go back to the Moon in order to gain more extraterrestrial experience, before we start the long voyages to Mars and the outer planets—which we're gonna do eventually. So there's something to be gained by going back to the Moon. Experience and additional knowledge, making it more routine to go into space than it is now. This is still not like flying an airliner across the country."

As I hear it right now, Aldrin's argument is that it can be commercially exploited, while Young seems to consider it necessary for our survival as a species. Something along the lines of

"We've screwed up this planet, so we'd better get some others."
At this, Mitchell's brow knits and his expression becomes un-
characteristically stern.

"That's not the answer. No. We've got to solve the problems
on this planet; then we're more ready to go. We can take some-
thing good with us instead of our brand of insanity. When I go to
Mars and look back at this tiny little dot, it's utterly stupid to say,
'I came from the United States. Or France. Or the Republic of
China.' And we're not ready to do that yet."

I'll see Edgar a little later at the fund-raiser advertised on
that leaflet, where a short introductory video detailing his ex-
ploits with *Apollo 14* will be accompanied by–*sigh*–*Also Sprach
Zarathustra* and he will give a talk, then move through the room
looking a little lost, until the outgoing Anna arrives to hold his
hand. She clearly adores him. I inquire after the efficacy of the
"machine" he was presented with at the end of our interview,
but he just smiles. Later still at the grand finale, a big plenary
meeting, Mitchell speaks urgently and with passion as he ad-
dresses the question, "What is the global crisis teaching us?"
while I try to take notes but struggle to keep up.

He begins with George W. Bush and the reaction to 9/11, de-
claiming:

"We have fundamentalists inside and outside our system,
who are equally dogmatic and certain that they are right. I un-
derstand that terrorists need to be stopped, but I, for one, am ap-
palled that we have to resort to killing to do it. That's not where
the solution lies. It doesn't advance us or our problems and it's
being used as a screen for other measures, like drilling in
wildernesses and eroding civil rights."

At the root of terrorism and much global conflict is the
grossly unequal distribution of income throughout the world–
and this is increasing, he contends, rising to a climax.

"So if we want to understand about corporate greed, we must
first look in the mirror. The sane lesson appears to be that the
solution has to start here."

He taps his head.

"How can we correct all this? Our approach begins with

high-mindedness, with finding a deeper mind, realizing that we are one, that we are children of nature. I urge you to take these thoughts away with you."

A deafening ovation follows, which I join in with, still unsure of how seriously to take Mitchell's ideas, knowing that I'll be leaving here with more questions than I brought. Within months, however, the cyber journal *Wired* will be dedicating a whole issue to the theme of God versus Science, in which eminent scientists and thinkers note that the more we learn, the less contradictory these previously warring faiths appear to be–that indeed they may turn out to be one and the same . . . just as Ed's been saying for three decades. Not long after that, *Scientific American* magazine will be devoting its first cover to Quantum Holography.

Even then, I will have no clear idea of whether Mitchell is right or wrong, but that assessment doesn't much concern me as I pack my bags for the drive north to Orlando. The lesson I'll take from my IONS experience is that the Moonwalkers aren't going to be the straitlaced military men I'd expected–and by extension, I already see my own journey spinning off the imagined tracks. How typical or atypical Mitchell's feelings about his lunar sojourn are, I don't yet know, but he has provided a benchmark against which to set the experiences of the others. The weekend has felt like a bridge to another time and place. Now I'm ready to cross it.

WHAT WAS IT LIKE, spinning into that inky night, answerable only to the stars and silhouettes of hills crouching in a near distance that might as well have been infinity? And on the journey home, how the night must have sparkled and the spirit flown. Intoxication. No cares. Peace . . . joy . . .

Trouble is, today I can hardly remember any of it and I feel–not to put too fine a point on this–like shit. Come to that, the place looks no better than I do this morning. Everything they say about Las Vegas is true. Already, I've had $350 stolen from my room, almost walked into some mini drug-gang turf war and stayed up drinking ten-dollar margaritas with a gaggle of friendly hookers at Bellagio, where I'd actually gone to sit and read a book about space suits: by the end of the evening the barman, who was a ski instructor in winter and thus looked to have stumbled upon a way of life that could only be improved upon if it included an annual fortnight standing in

for George Clooney, was my *hermano*. But now it's morning and from my $29.95-a-night thirteenth-floor room at The Sahara, all I can see is building sites and crematorium-grade dust covering a world that has turned grayer and more nondescript than it would have been possible to imagine twelve hours ago. They say that in the Fifties you could see A-bomb-test mushroom clouds from the Strip. Was the Moon a little like Vegas in the morning? You wouldn't bet against it.

Through the sore head, a question that is being asked all over town as the veil lifts on this scrabby Saturday: how did I get here? It's no surprise to find that lunar astronauts pass this way, because back in the glamour days, when the boys were still test pilots and stationed in the desert and life was all about—as Tom Wolfe had it—"Flying & Drinking and Drinking & Driving," this throbbing oasis was their playground. Yet I've come in search of one astronaut in particular and when I heard where he could be found, my first reaction was surprise, closely followed by amusement, bemusement, curiosity. This afternoon, I'll make my way to a hotel a few blocks back from the Strip, where I expect to find Richard Gordon, the Command Module pilot from everybody's favorite mission—*Apollo 12*, the second to land and most joyous of them all—signing autographs at a *Star Trek* convention.

Unlike Edgar Mitchell, Dick Gordon is one of the boys. You won't find a person in the program with a bad word to say about him. He was a record-setting pilot, a selfless astronaut and a nice guy. He was the second man, after Mike Collins, to *not* land on the Moon, and they say that he's never once complained about that, at least not in public, but I do wonder how it feels to have gone so tantalizingly close and been denied the one small step.

Flying four months after *Apollo 11,* in November 1969, the *Apollo 12* crew of Gordon, commander Pete Conrad and Lunar Module pilot Alan Bean loved each other, really loved each other, like brothers. They drove matching gold Corvettes, which Conrad had got them a deal on, and they always gave the impression that while what they were doing was important and dangerous, it was also fabulous. And fun. Even thirty years after,

an acquaintance who spent time with them just before Conrad's freak death on that motorcycle describes the closeness of soul mates. Some had expected that *Apollo 12* would be the first mission to land on the Moon and there must be a little part of everyone involved that wishes gap-toothed, wiseass, supersmart Pete Conrad could have been the first human to set foot on it and that his modest and engaging crew, who carried none of the darkness we'll find in *Apollo 11,* could have been our eyes and ears there. Still, where Armstrong got to be the first one to stand on another celestial body, Conrad has the more loveable distinction of being the first to fall over on one. By all accounts, he was one of a kind.

Gordon and Conrad had roomed together when they were flying carriers in the Navy. They'd also been in space before, aboard *Gemini 11* in September 1966, during which Gordon became the fourth American to walk in space, an experience which, under favorable circumstances, seems as moving as any an astronaut can have, like being born a second time. That wasn't Gordon's experience, though. During his walk (Extra Vehicular Activity, or EVA, in NASA-speak), he had some tasks to perform, one of which was to attach a tether to an Agena rocket with which he and Conrad had rendezvoused and docked. Unfortunately, no one had foreseen that in the weightless conditions, he would have no way of clinging to the Agena in order to accomplish this and by the time he had done it, he was blinded by sweat and close to incoherent with exhaustion. Conrad feared that Gordon hadn't strength left to make it back and the unwritten rule was that in such an event, he would have to cut his friend adrift and come home bitterly, wretchedly, alone. Through an immense act of will, Gordon got close enough to the *Gemini* for the other man to haul him in, but it was a close-run thing. Conrad later said that of all the situations he faced in space, this was the one that scared him most.

Then there was the lightning incident during the launch of *Apollo 12,* in which the Saturn rocket was hit twice, turning the cockpit into a casino of warning lights and alarms, as the electrical system went off-line. Many people think that the craft launched into an angry sky because President Richard Nixon,

feeling confident after the success of *11* that *12* wouldn't blow up and embarrass him, had flown to the Cape to watch. But the crew kept their cool (Conrad's pulse rate didn't even rise) and Bean found an obscure switch that reset the power supply. Disaster had been averted–perhaps: Houston would remain concerned that the Command Module parachute-release mechanism had been damaged. After much discussion, it was decided to continue to the Moon anyway. If the parachutes didn't open before splashdown on the way back, the crew were mincemeat wherever they'd been or not been in the meantime. Let the lunar landing be a last cigarette before the cosmic firing squad.

The chutes worked, obviously, but there's no sign of Dick Gordon yet.

I've just entered the autograph area, which reminds me of a particularly austere primary school Christmas fair. Formica tables hug the walls and corral in the center of the rectangular room, all festooned with 8×10-inch photos of actors playing space cowboys and Indians. I stand and take in the scene and–as so often around actors–gradually begin to feel a kind of terror. Some of these roles were going to be big breaks, but what I see here are bad breaks, squandered opportunities, illusion, delusion . . . failed expectation. And I'm not sure whether the fear is theirs or mine, but for a moment it feels like the precise negative expression of that peace Edgar Mitchell claims to have found on his journey, and I feel plugged into it, much as he did.

A hand thrusts toward me. I look into a confident smile that I don't recognize, then down at snaps of a swarthy man in a Reynolds Wrap space suit. Major Don West, the curly-haired mate from *Lost in Space*. Real name Mark Goddard. He was on TV every day through my childhood.

"Hi–how're you doing?"

Unable to find an honest answer, I nod and move on to a bad guy from *Babylon 5,* who reeks of alcohol and hits on the woman standing next to me, prompting us both to move on to the next table, where another serial sci-fi villain starts to tell us about his painful divorce from his actress wife and the difficulty of paying child support since 9/11 knocked the bottom out of the WASP malefactor market. After that, the small queue in front of

Denise Crosby (Lt. Tasha Yar in *The Next Generation* and grand-daughter of Bing) is not without attraction, but I keep moving until finally there is a white table tucked away on its own, reflecting the white wall and white ceiling, on which sits a small piece of card, folded into a V and bearing the Magic Marker legend: "Dick Gordon."

But he's not there.

Disquieted, I retreat to the main hall, where *Star Trek* celebrities are facing the fans. The promoters of this event, Slanted Fedora Entertainment, are one of two main organizations who take these shows on the road, like a traveling circus. Their rivals staged a spectacular convention in Vegas recently, which hit ticket sales for this one. As a result, Fedora decided to throw open the doors of the exquisitely anonymous Alexis Park Hotel and treat the event as a party, to which the world is invited. Needless to say, the world as such hasn't come: there are a lot of young people who look like merchandise sellers on a Marilyn Manson tour; others are dressed as characters from the perplexing array of *Star Trek* spin-offs. Some carry clipboards and notebooks, moving between the "dealer room" and the autograph chamber with a pious gleam in their eyes.

Four actors stand onstage, holding microphones. Two I don't recognize, but Walter Koenig is instantly familiar as Chekov from the original series, and the drunk bad-guy lech from next door is unforgettable. He looks a little like Bruce Willis and has a beer in his hand.

A question from the floor:

"Who's the most famous person you've ever met?"

"Marlon Brando," someone says to great enthusiasm.

"Cary Grant," offers Chekov.

More clapping. Almost Bruce tells a story about meeting Charlton Heston, "fucking *Moses*," at a urinal, which ends "then he left and I could piss again," and Chekov suddenly pipes: "Betty Grable!" to thunderous applause. A very large man with a beard asks a question about favorite drinks, which Almost Bruce is still kicking around when the MC announces that Denise Crosby is now due onstage and a ripple of anticipation passes through the hall as she arrives, smiling a little tensely, I think.

She talks about her career for some time, focusing on her understanding of Lt. Yar, but when she's finished, nobody can think of any questions to ask.

"Aw c'mon, you gotta have some questions," the actress scolds.

Okay. The bearded man raises his hand.

"Uh. You're not in the new movie, are you?"

A long speech ensues, which is hard to follow beyond the fact that she thinks she should be.

". . . 'Cos it has *Romulans* in it, like, you know–*duh!* So I called the producer, Hal, and I said, 'Hal, you should pop me in the movie . . .'"

Another question, "Why did you leave *Star Trek*?" is like one of those tiny Japanese pellets that you drop in a bath and watch grow into great paper jungles.

"I've never regretted leaving *Star Trek*. I was at an impasse. And I was beginning to feel like a glorified extra. And had I stayed, I wouldn't have done *Pet Sematary*. I wouldn't have done *Key West*, or . . . a number of other things! Then, I came back for *Yesterday's Enterprise*."

From the floor: "That was a beautiful performance!"

Applause. She beams.

"Thank you *so* much."

Someone else from the floor: "Will you ever do *Playboy* again?"

A tense pause.

"Wow, that *is* off the subject of *Star Trek*. That was in 1980."

"I know–I have the issue!"

I go back to the autograph chamber and the Dick Gordon table is still empty. Then, just as despair is about to take hold, a small, elderly man in thick, black-rimmed spectacles crosses the threshold and heads in the right direction. I realize again that the man I've been looking for is an athletic thirty-nine-year-old beaming from an Apollo romper suit. He walks upright and slowly, so as not to upset the mustard-smothered hot dog and fries he balances on a paper plate with his left hand, nor to spill coffee from the Styrofoam cup in his right. Blue slacks and a green check shirt strain to tame a lordly paunch. Reaching the

table, he puts the coffee down and, suspending the hot dog plate in the air above it, rotates on its axis until he is behind the table, where he sits down. He glances up and grins broadly at someone who walks past. When he smiles, he reminds me enormously of Roy Orbison.

I watch for a while. Dick Gordon eats. No one notices. The room has filled up and queues have formed in front of some of the other tables. One of them is getting long and there's enough of a jam that I can't even see who it's for. A roomful of people who are famous to one degree or another for pretending to be death-mocking space adventurers and here, tucked away in a corner, is a real one, and no one knows who he is. Or wants to know. The fakes look more convincing.

I buy two Gordon photos from a table in the middle of the room and take them over, introduce myself. He invites me to sit down and help collect the "widgets" which are used as currency here. He's relaxed and affable, with a pilot's eye for the deflecting wisecrack. He talks about space the way your neighbor might discuss aphids over the garden fence. Flight controller Chris Kraft once observed that, while Deke Slayton put together crews that he hoped would complement each other, "it was a real feat because he was dealing with a group that included world-class prima donnas." It seems unlikely that he had Dick Gordon in mind when he said it.

Almost immediately, a young man approaches with a nervy smile. He's dressed in black and wearing a cape.

"Did you actually walk on the Moon?" he blurts.

No, Gordon tells him, he stayed in the spacecraft while the others went. He starts to expand, but the boy cuts him off with an "Oh." He lifts his eyes to the wall, smiles wanly, and moves on, much as I had with Major Don West from *Lost in Space*. The astronaut betrays no emotion.

We talk about the origin of Apollo and he takes a comfortably apolitical line on it: "Kennedy had the foresight to challenge the American people to go to the Moon . . . we hadn't even been in orbit at that stage . . . we were all saying '*what?*'" He talks about the technological benefits of the program: miniaturization, communications advances, better weather forecasts, in-

creased interest in science, and as always when enthusiasts speak this way, the figure of 24,000,000,000 1960s dollars looms like a planet in my imagination, because the claim that any meaningful technological advances would have failed to happen but for a $24 billion space program is incredible to me. I just don't buy it. If Apollo *can* be justified—and I'm keeping an open mind on this at present—it's for other reasons.

I tell him about my encounter with Charlie and Dotty Duke on the day of Pete Conrad's death and he nods his head firmly.

"Yup. The eighth of July of 1998."

Afterward, I remember that it was actually 1999. I wonder if he's thought about the fact that there are only nine Moonwalkers left and one day there won't be any? His eyes go misty and he talks slowly, as if tackling a complex equation.

"Yeah . . . I guess it won't be very long . . . because twenty-four guys ventured out there . . . twelve walked on the Moon . . . then Jim Irwin, Alan Shepard and Pete Conrad . . . that's right, there's nine left!"

Does that worry or upset him?

"Well, we are all getting older, obviously, but the thing that's worrying me is that we haven't been back. Gene Cernan was the last man on the Moon and that's thirty years ago. So you think about that, and that's a startling thing to me, that we haven't been back there."

Gordon had particular reason to feel disappointed at the cancellation of the final three Apollo missions, because he was due to command *18*. He could have been handed *17*, in fact, because NASA was coming under huge pressure to send a scientist up and his Lunar Module pilot, the geologist Dr. Harrison "Jack" Schmitt, was the only one. In the end, they took Schmitt and left the commander behind. I ask how he felt about that.

"Aw . . . I accepted it. I had a lotta fun with Gene Cernan. I used to arm wrestle him for *17,* knowing that *18* wasn't gonna fly. I kept telling everyone, 'You can't take my Lunar Module pilot—I gotta go with him!' But I stayed. After *12,* I probably coulda done like Pete and Al did, gone on to something else like Skylab, but I wanted to go that last sixty miles, so I stayed with Apollo, flew backup on *15.* Then *18, 19* and *20* were canceled."

Is this something that still haunts you?

"Not really. You mean not going on *18*?"

No, not going the extra sixty miles.

"Nooo, not really. I had my turn, my time. And was very fortunate to have done that. There's no regrets."

Gordon left NASA in 1972 and was invited by a friend to become executive vice president of the New Orleans Saints football team. One of the other astronauts has pointed out that many of them were offered prestige jobs that they had no training for after returning from space. Gordon was with the Saints for five years, then moved into "the oil patch" back in Houston. For a while he worked with the famous oil-rig troubleshooter Red Adair. Later, he went back to aerospace and into computers. He's talking excitedly about the engineering challenges of raising North Sea platforms when he abruptly looks up.

"Herbie!"

A stocky black military man has approached and is introducing a colleague, evidently a pilot. There is instant bonhomie as they discuss bases they were stationed at and the specifications of planes they've flown. Just by being pilots, they share something which the rest of us could never share. Gordon doesn't boast about the speed records he set, or seem to assume any kind of seniority. Pilots are pilots. Everyone else is a not-pilot.

When he's finished, I still want to know why he's here.

"Oh, I enjoy getting out and meeting people. It gives me something to do."

A middle-aged woman appears, grinning broadly.

"I want a real hero." She beams. "The real guy who went into space! How much is that?"

Dick explains the widget system ("they won't let me handle money!") and she goes off to buy one. She is replaced by a younger Australian woman, who points at the image of him sitting on an Agena rocket during his *Gemini 11* spacewalk.

"Is that really you?"

Yes, he tells her, that was in 1966.

"Wow," she replies. "That was when *Star Trek* was getting going. An amazing decade."

She asks about the sensation of hanging in space and he

doesn't really answer her, perhaps because all he remembers is being sweat-blind, exhausted and scared, so she moves on to the space suit. It looks kinda clumsy. Yes, ma'am, he tells her as he signs her picture, it was. And the first woman is back, proffering her widget.

"So you were on *Apollo 11?*"

AN ANNOUNCEMENT COMES over the PA about "Syd" taking a five-minute break from signing and a groan rises from the crowd in front of one of the tables.

We talk about families. Like most of the early astronauts, Gordon is from classic white working-class stock, with Scottish and Irish ancestry and a great-grandmother who was one of the first European women in the Pacific Northwest. The family homesteaded with grants from President Grover Cleveland in the nineteenth century and worked hard to scrape a living.

Did he catch the flying bug at an early age? I want to know.

"No, never did," he replies. "That happened because of the Korean War."

Like Ed, he was in the naval reserve while at university in Washington and had two cousins who'd been World War II pilots. Rather than be drafted, he decided to enlist and learn to fly. He was sent to Pensacola as a naval cadet.

"And I fell in love with an airplane. End of story." He laughs.

He has six kids from his first marriage of twenty-seven years, half of whom went into the Navy, like him, though one of his four sons was killed in a car accident in 1983. His eldest daughter is a nurse, he tells me, and the youngest, born in 1961, is married to an FBI instructor and lives in Virginia. "They're all kind of East Coast types." He smiles. So far, they've given him seventeen grandchildren. I wonder what his kids thought of having an astronaut for a dad and he tells me that most of the astronaut families lived in Houston suburbs near NASA HQ, surrounded by other NASA people—they didn't think anything of it.

"I'll tell you what, when my eldest son was eight or nine years old in 1963, his teacher overheard this conversation between my kid and another boy, where they were getting ac-

quainted and Rick asked, 'What does your dad do?' The other kid said, 'He's a sheriff,' and Rick went, 'Wow, he's a sheriff? Does he wear a badge? Does he wear a gun?!' and got all excited. Then the other kid asked Rick what his did and he replied, 'Aw, he's just an astronaut.' True story! I always say, well, that puts everything in perspective. I thought that was pretty good."

When I repeat this to the daughter of another astronaut, she will snigger that her father used to tell the same story. Asked whether he experienced any kind of post-space comedown, Gordon shrugs.

"Naw. Why put yourself through the bother of comparing? Why would you want to torture yourself by thinking, 'My God, I'll never be able to do anything like that again'?"

But some of the others seemed to.

"Yes, that's true. And I think that's very unfortunate."

Has he found that kind of excitement anywhere else? I ask, and the answer catapults back.

"No, you never would! You never would."

Then I ask if he still flies.

"No, I, I . . . when I could afford it, I didn't have the time, and now that I've got the time, I can't afford it. Uncle Sam paid for most of my flying."

And a bell rings in my head. We assume that Uncle Sam handsomely rewarded the single combat warriors who hung their asses far out over the line and did one of the most amazing things that any of us can imagine. But no. Not at all. When they went to the Moon, they received the same per diem compensation as they would have for being away from base in Bakersfield: eight dollars a day, before various deductions (like for accommodation, because the government was providing the bed in the spaceship). The *Apollo 11* Command Module pilot Mike Collins had considered submitting an invoice for travel expenses at the standard eight cents per mile as a joke, which came to around $80,000, but found that someone had already tried this–only to be presented with a bill for one launch-ready Saturn V rocket, at about $185 million. The rest of the time, the military-sourced astronauts were paid according to rank. Most were captains, pulling around seventeen grand per annum by the end of the

Sixties–not great for a highly educated and skilled thirty-nine-year-old, even then. Some have since learned to trade with varying degrees of dignity on their status as Apollo astronauts, but a cruel hierarchy exists, whereby the presence, signature, image of a Moonwalker is worth vastly more than those who sat out the last sixty miles. The irony of this is that the CM pilots were assigned to the job by virtue of their superior experience to the LM pilots who went all the way: Deke Slayton had a rule that no rookie could take charge of the Command Module, their ticket back to Earth. That's why Dick Gordon is here, as adornment to the pretend cosmic heroes, and the junior member of the *Apollo 12* team, Alan Bean, who'd never been into space before that flight, is not. When I tell one trader of space memorabilia about having found Gordon playing third spear carrier to Walter Koenig, he shakes his head and laments:

"Well, Dick's got to work for a living because he wasn't a Moonwalker. That's what it is. There's a very sharp line between the Moonwalkers, who are very collectable, and the Command Module pilots."

So the Command Module pilots really were on their own when the space program walls came tumbling down. Before I've finished my travels through Apollo I'll find Al Worden, the *Apollo 15* CM pilot who published a book of poetry inspired by his trip, sitting among topless tabloid models and ex–soap stars at a fearsomely depressing autograph show in Northampton, England. The fact is that we, the people, make fickle pension-fund managers, and I wonder if that's why some of the CM pilots have since fallen into a silence more deafening even than Neil Armstrong's.

I ask what's the most important thing Gordon has learned up to now and the question throws him.

"Hm. I've never been asked that question and have not given it that much thought. Huh. It's an intriguing question. What have I learned? I'll have to think about that . . ."

An Asian woman steps up, accompanied by her American husband. She tells us that she's a doctor and her patients laugh because her office is plastered with nothing but pictures pertaining to space exploration. She's in family practice and her hus-

band's a surgeon and they've come not for Chekov or Major Don, but for Dick. Genuinely thrilled to meet him, she sends her man off to get a picture and when he returns, he twinkles.

"You know, the only job I ever wanted to do more than mine was yours."

Dick is modest: "Well, it was a rare opportunity, I'll tell you that."

There's something touchingly pure and childlike about the surgeon's enthusiasm. The Cold War doesn't figure in it and neither does the cult of celebrity or even ambition in the generally accepted sense. They go away and Gordon, unprompted, returns to the question of what he's learned. The extent to which it's gnawing at him is beginning to make me feel bad for asking. I tell him to forget it, it's not important. But he won't. Maybe the value of teamwork, he suggests. Or of being goal-oriented.

"I don't know. That's a damn interesting question. I hadn't really thought about it. What have I learned? Ha!"

I ask whether he has any regrets?

"Well, we devoted so much time to our work. I turned around one day and my kids had gone. They'd grown up, and I missed it. I missed a lot of it. And if I have any regrets, that would be one of them, that I missed their maturation process as they were becoming young adults."

Maturation process. You can take the man out of NASA, but . . .

A young Trekkie with eyes like Ping-Pong balls turns up and asks questions which suggest that he knows very little about the Moon landings and half believes that they never happened.

"Space is always interesting and, as sci-fi fans, we always feel that we can't get there soon enough," he declares, before loping off.

Getting ready to go, I idly ask what hotel he's staying in and he tells me he's at the Tropicana, because his stepson works security there and got him a special rate: twenty-nine dollars a night—pretty good, huh? Someone walks by and cracks a joke about (Senator) John Glenn, who, as a member of the Mercury 7, became the third American in space and recently flew on the shuttle at age seventy-seven. We get to talking about Mercury

and, without meaning to, Gordon says something that remains with me for the rest of my trip. I tell him that I hate confined spaces and can't imagine climbing into one of those tiny capsules. He looks at me with mild disbelief.

"Well, I don't know," he says with a shrug, "you've got the whole Universe outside your window."

I shake his hand.

But one more thing: I wonder whether the relationships between him and his former colleagues have changed over the years, now that the competition is over? He thinks for a moment.

"Well, there was a tremendous amount of competition until you'd get on a flight crew, but once you were on, that was it."

This is not quite true, at least not for everyone. I try again. So relations are pretty much the same as they were thirty years ago? The answer makes me roar with delight.

"No, I think they are. Basically, we're all reasonable folk and good friends. Some we like better than others, just like real life. And then of course there's *Buzz Aldrin*."

I leave a gap for him to elaborate, but he doesn't. All he does is glance balefully down at my minidisc recorder as it whirrs away on the table.

Then of course there's Buzz Aldrin.

THINKING ABOUT GORDON in the desert.

Rather than fly, I decided to drive to LA through the Mojave Desert, which is much more beautiful than I remember from childhood. It's the end of the day and the sky's painting a singed rainbow of purple, gold, vermilion across the sand, while clouds flame and the jagged mountains point like spectators at a firework display toward a perfect sliver of silvery moon. It's majestic even from the road, but these teeming highways still remind me of the fear I felt as a boy during the oil crisis of 1973; of sitting in the back of the car for what seemed like hours just to get a few gallons; of the ill-temper and selfishness that seemed to erupt around the pumps, a tiny taste of hell.

So I pulled off the highway and into the wilderness, and in three hours of driving, walking, wandering I've seen only one

other car. I'm aware that somewhere out there is Edwards Air Force Base, where many of the lunar astronauts trained as test pilots in the 1950s under the command of Chuck Yeager, who a few years previously had broken the sound barrier in the squat, screaming Bell X-1 rocket plane. Prior to that, many experts had considered the sound barrier absolute, a wall beyond which our human frames could not survive, but Yeager proved them wrong and was a hero to the young Apollo men, who still had no idea of the magnified destiny that awaited them.

I've wanted to know what going to the Moon meant to those who went, and in relation to this Dick Gordon and the Command Module pilots already look more significant than I'd imagined—despite the fact that Gordon consciously revealed little. A lunar orbit took just under two hours to ride, but forty-seven minutes of each was spent in complete isolation as the CSM passed around the far side, bringing a solitude that one NASA employee memorably described as the most profound any human being had experienced "since Adam." They were the ones who came nearest to the imaginings of popular culture at the time, as expressed in songs like Elton John and Bernie Taupin's "Rocket Man" and David Bowie's "Space Oddity," or films like Tarkovsky's *Solaris* (released in 1972 and since re-imagined by Steven Soderbergh), where the gulf between terror and exultation collapses: a state best evoked on Earth either by drowning or going insane. Neither is this the fancy of a few artists: in his book *Carrying the Fire*, the *Apollo 11* CM pilot Michael Collins reveals that his aviator hero, Charles Lindbergh, wrote to him, saying:

"I watched every minute of the [first] walk-out, and certainly it was of indescribable interest. But it seems to me that you had an experience of in some ways greater profundity . . . you have experienced an aloneness unknown to man before."

In describing the experience of being on the far side, in the dark, facing out toward the impenetrable depths of the cosmos and separated from all humanity by the bulk of the Moon—out of sight and unreachable and utterly, utterly alone—Collins actually used the word "exultation." In the early stages of this aloneness, he was heard saying nervously to his Moon-bound

partners as they drifted away in the LM, "Keep talking to me, guys." Finally, he grew to like this feeling of solitude, but paid a high price for it, admitting afterward that "I just can't get excited about things the way I could before *Apollo 11;* I seem gripped by an earthly ennui which I don't relish, but which I seem powerless to prevent."

Collins is very rarely heard of or seen in public these days, and hasn't been for many years. On film, I will eventually hear a couple of unidentified Command Module pilots confessing more frustration at their fate than Gordon was prepared to allow in Vegas. One says, "I was disappointed. I wanted to go with them so bad I could taste it." Another laments: "I wish I could go down there with them. You may not talk about it very much, but part of your training is coming back by yourself if anything happens [to the LM]. Wish the damn thing could hold three people . . ." All the same, there was wonderment in the situation. Ed Mitchell's crewmate Stu Roosa was fascinated with the way his craft would plunge into the Moon's shadow and impregnable darkness once every hour and a quarter, as though crossing into another dimension. It was a darkness and an aloneness you could *feel,* he said, which seemed to enter you as you drifted deeper into it, playing tricks with your vision and sending a little chill down the spine. The *Apollo 15* CMP, Al Worden, felt the far-side aloneness, too, but couldn't stop looking at the stars which shone so bright back there, wondering how the sky could hold so many of them. They were everywhere.

Also emerging is a broader story about the twentieth century. I've been reading a book called *The Greatest Generation* by the broadcaster Tom Brokaw. He writes about that group of men and women who came of age during the Great Depression, during which thirteen million Americans were out of work, who sacrificed their early adulthoods to World War II, then came home and worked to revolutionize the U.S. economy, leading it into what economists describe as the most spectacular period of economic growth the world has ever seen.

They didn't achieve this in a vacuum, of course. Brokaw doesn't linger on it, but the fact of the matter is that the U.S. economy emerged fit and powerful from World War II, able to

muster two-thirds of the world's industrial production while the rest of the planet was in tatters. By the end of the Fifties, the whole of the industrialized world had joined in the spree and those members of Brokaw's "Greatest Generation" who'd survived the carnage in Europe and the Pacific were about to enter an age where, to paraphrase John Updike, the chief question would be not "Why?" but "Why not?" As it happens, this question would reach a kind of Day-Glo apogee in 1968–9, before receiving a most eloquent and unequivocal answer at the end of 1972. The precise period in which Apollo was traveling to the Moon.

But we're getting ahead of ourselves.

The wonderful irony is that these returning war heroes gave birth to the group we now know as "baby boomers," who were born immediately after their parents' return from that long war. Statisticians will tell you that the baby boom carried on until 1964, but in terms of shared experience it ended long before then. The "boomers" entered a world of plenty; of full employment and vastly expanded educational opportunities, in which the security their parents had dreamt into being was taken for granted, even despised. The shock of the 1950s had been that the upper- and middle-class young chose to take their style from the urban poor. *Rock 'n' roll* was black slang for "sex." Jeans had been workers' wear. The novel term "teenager" was coined during this time and the notion of youth martyrdom was born– because youth was no longer seen as a transitional state: it was an *ideal*, which found its pithiest distillation in the line "Hope I die before I get old" from the Who's "My Generation." Thus the "generation gap," a source of much hand-wringing from the mid-Fifties on, was born. Between 1955 and 1973, the value of record sales in the USA rose from $277 million to in excess of $2 billion.

Significantly for the lunar story, this combined with the booming economy to produce a veneration of all things "new," for which "Space Age" came to be shorthand. Modern "consumer" society was born at this point, as design eclipsed function and every new product was obliged to pretend not just to improvement, but to *revolution*. By the end of the 1960s,

Richard Nixon could be found sitting alone in the White House, scratching notes to himself about what kind of presidency he wanted his to be, but the notes didn't say things like "end Vietnam War" or "sort out Palestine mess." They said: "Compassionate, Bold, New, Courageous . . . Zest for the job (not lonely but awesome) . . . Progress–Participation, Trustworthy, Openminded." Impressions and images. You wouldn't have found anything like this in Ike Eisenhower's drawer. But Ike's world was no more. This was the Space Age.

The desert's dark now and I pull into the laser train of headlights on Highway 40, heading for an overnight stay in Barstow, on the Mojave's edge, where the crisp morning finds winddriven clouds racing shadows down the hills and that peculiarly dissonant groan of a freight train creeping across the desert floor, as evocative as a Miles Davis solo and echo of a time when, as Mailer had it, "the wind was the message of America." I could stay forever, but instead press some CDs into the car stereo and set off again for LA, where I hope to be meeting the second man on the moon, Buzz Aldrin. I've chosen music to evoke the period I'm about to enter and as I pull out of the Comfort Inn parking lot, the Strawberry Alarm Clock are singing a song called "Sit with the Guru." The chorus asks hopefully: "How many tomorrows can you see?"

That was recorded in 1967. The tomorrow I see will be Wednesday, September 11, 2002, the first anniversary of the World Trade Center outrage. All week I've been wondering whether Aldrin realized the significance of the date when he chose it.

A TREAT: my favorite hotel, The Hyatt in Sunset Boulevard. Little Richard used to live in a suite on the top floor and guests of my acquaintance are forever claiming to have stumbled across him in the lift or wailing "Tutti Frutti" in the bar when there wasn't much on TV. I was asked to meet with him once and he kept leaving cryptic messages on my voice mail, two floors below, about not being able to hook up before dusk on account of

his religious beliefs, and the importance of consulting with his "friend" about the most propitious time for our congress. His giggle could have been composed by Rachmaninov.

I was wondering whether the greatest rock and roller of them all still stayed here as I went through the ritual of switching on CNN and hanging up my shirts. I'd moved to the bathroom to fire up the shower when I heard the words intermittently:

". . . this afternoon . . . the seventy-two-year-old former astronaut Buzz Aldrin . . . as he left a Los Angeles hotel . . . Beverly Hills police arrived at the scene . . ."

Skin crawling, I rushed back into the bedroom, then stood, stared, tried to catch hold of what was being said . . . almost squealed with delight! The story went like this:

Aldrin's gone to the Luxe Hotel to be interviewed by a Japanese TV crew, who turn out to be making a program about the lunar-hoax theory. Whether by invitation or not, a second camera crew arrives, led by a man who—*mark you this*—thrusts a Bible in the former astronaut's face and demands that he put his right hand on it and swear that he really went to the Moon. At this point, Buzz remembers a pressing prior engagement, assays an emergency egress, and is being escorted across the road outside by his stepdaughter when the conspiracist appears behind him, making the same demand as before. By some accounts, the younger man pokes the older man with the Good Book, perhaps even calls him some names—"You're a phony, Aldrin"—stuff like that. But the point is that by all accounts, the response of the wiry former space hero is to spin on his heels, draw back his fist, and land one square on his tormentor's wagging chin. Five feet ten and 160 pounds going at six-two and 250 . . . a cheer goes up from the stands! Except that now the Good Book's owner, a Mr. Bart Sibrel of Nashville, Tennessee, is threatening to file a criminal assault complaint. He says his jaw hurts and, man, in this I do believe him. Tomorrow morning's *Los Angeles Times* will contain a picture taken at the point of impact and the expression on Aldrin's face is simply beyond the reach of words. Slightly blurred, he looks like Kermit the Frog auditioning for *The Exorcist*: as though his head is about to turn

inside out. I'll spend the next two days trying to track Sibrel down in order to get a firsthand view of the damage, but he seems to have disappeared from the face of the Earth. Abducted by aliens, I shouldn't wonder.

And then there's Buzz Aldrin!

The word "maverick" does him no justice at all. In *Carrying the Fire*, which was published in 1974 and is still by far the best astronaut memoir, Mike Collins supplies pen portraits of most of his Astronaut Corps colleagues. Not all of them are as polite as you might expect, Aldrin's least of all.

"Heavy, man, heavy," is what Collins says. "Would make a champion chess player; always thinks several moves ahead. If you don't understand what he's talking about today, you will tomorrow or the next day. Fame has not worn well on Buzz. I think he resents not being the first man on the Moon more than he appreciates being the second."

This contains a hint of the spectacular fall from grace that would follow *Apollo 11* and was little understood at NASA. Much later, Collins laments:

"[Neil] never transmits anything but the surface layer, and that only sparingly. I like him, but I don't know what to make of him, or how to get to know him better. He doesn't seem willing to meet anyone halfway . . . Buzz, on the other hand, is more approachable; in fact, for reasons I cannot fully explain, it is *me* that seems to be trying to keep *him* at arm's length. I have the feeling that he would probe me for weaknesses, and that makes me uncomfortable."

He adds that "a closer relationship, while certainly not necessary for the safe or happy completion of a space flight, would seem more 'normal' to me," and that "even as a self-acknowledged loner, I feel a bit freakish about our tendency as a crew to transfer only essential information, rather than thoughts or feelings."

Best and most revealing of all, though, is the passage where Collins considers the three men's relative neatness, saying:

"I am probably the sloppiest, and I consider myself neat. Neil *is* neat. Buzz is not only neat, but almost a dandy. When he is decked out in full civilian regalia, he is a sight to behold. On

more than one occasion I have seen him and his newly pressed iridescent suit festooned with more totems than one would believe possible. Once I counted ten."

The thing to note here is that Collins was counting. Aldrin was dashingly handsome, extremely bright, but a very poor public speaker and communicator. His pulse at takeoff was 110 bpm, the lowest of any Apollo astronaut, but around the Astronaut Office he was considered to be an agitator and political game-player, though he certainly wasn't the only one and looks actually to have been rather clumsy and unskilled at maneuvering in the subtle, back-slapping, one-of-the-guys way that men like David Scott and Gene Cernan excelled at. He wasn't one of the guys and nor, for that matter, were either of his *Apollo 11* crewmates. The German-born Pad Leader Guenter Wendt (known to the astronauts as Pad *Führer*, ruler of the launchpad) will tell you that, for all Deke Slayton's efforts, the *Apollo 11* crew never gelled, and remained remote from each other throughout. You'll still find Apollo vets muttering darkly about Aldrin, though. Wendt is not courting controversy when he avers that "some considered him to be arrogant . . . he became quite a bit of a loner and not too many people cozied up to him." Nevertheless, people will pay his fee of $250 per autograph ($500 if the item has already been signed by another astronaut), where most others charge $20 to $40. Or, like Armstrong and Collins, refuse to sign altogether. He's a curious icon indeed and I go to bed feeling more than ever intrigued by him.

THE MORNING OF SEPTEMBER 11, we're at Ground Zero on TV, listening to a litany of names of the people who died in and around the Twin Towers. I'm struck by how many of them are Italian, Irish and Hispanic, and can't help noticing, as in most situations, come to think of it, how many Smiths there are. In the time that I've been conscious of the world, there's been no shortage of events to burn a memory into most people's minds of where they were when they heard about them (Martin, Bobby, Elvis, John, Diana, the crew of the shuttle *Challenger*). Then there are the two which nearly everyone recalls receiving news

of: the first Moon landing and this. And today they're coming together for me. Strange isn't the word. It's hard not to notice that of all these world-shaking events, the landing of *Apollo 11* is the only one that doesn't involve death.

There are other connections, too. Turning right into the traffic on Sunset, I find myself breathing the words to "For What It's Worth" by Buffalo Springfield, the Sixties group which launched Neil Young and Steven Stills. I must have heard the song a thousand times, but only on the way from Vegas did I learn that the lyric is about the LAPD's violent dispersal of an anti-Vietnam demonstration right here on the Strip, in 1966, just a year after thirty-four people died during riots in nearby Watts. Frank Zappa, who called his daughter Moon and had a father who worked on missile systems at Edwards while Neil Armstrong was flying rocket planes there (and used to bring home mercury and the pesticide DDT for his son to play with), wrote about the same episode on his satyric opus *We're Only in It for the Money*–but it was the Springfield tune, with its chorus that began "Stop, children, what's that sound?"–the sound being gunshots–that became a rallying cry for West Coast students. It's on my mind because the incomprehension and paranoia it expressed can be felt in the air today, thirty-six years later.

And yet, 1966 was a good year for Buzz, one of the best.

His sister gave him the nickname "Buzz." She was only eighteen months old when he was born a few months into the Great Depression, on January 20, 1930. The third child and only son, he was known to the family as "brother," but when Fay Ann said it, it came out as "Buzzer," which evolved into Buzz. He's since made her mispronunciation official by deed poll.

He was the only son of a vaultingly ambitious oilman of Swedish stock, a wartime colonel who made for a stern and remote father, and a mother whose maiden name–and you couldn't have made this up–was Marion Moon. They were well off, and he recalls the chief influence on his young life as having been a black housekeeper named Alice. "Her enthusiasm for my world made it grow, and more by demonstration than by words she taught me tolerance," he says in a now out-of-print autobiography. At first he was an average student, but averageness was

not well received by his father. He claims never to have been socially adept, but by the time he left high school, his grades were good enough to get him to West Point, where he excelled academically and athletically. He shot down two MIG-15s in Korea, returned to take a doctorate in Manned Space Rendezvous at MIT and joined NASA's third group of astronauts in 1963.

Nevertheless, at the start of 1966 Aldrin was one of the seven from twenty-seven active Astronaut Corps members who hadn't been allocated a seat on Gemini, making his chances of flying Apollo look very slim indeed. Feeling himself to be an "odd man out" and suspecting a Navy bias in crew selection, he tried pressing his case with Slayton, but that seemed to make matters worse–until fate intervened in the most bitterly equivocal fashion. Adjoining the Aldrin garden in Houston was that of Charlie Bassett and family. The women of the households were friends and the children played together, while Bassett and Buzz got along fine. But one February morning Bassett and another corps member, Elliott See, took off to St. Louis in a T-38 trainer jet. The pair were scheduled to fly *Gemini 9* and were going to visit the capsule, but on their approach, with the weather worsening, they misjudged their rate of descent and ended up hitting the roof of the hangar where the spacecraft was being assembled. Both men were killed and in the ensuing reshuffle of seats, Aldrin wound up with the very last place in the program, on *Gemini 12*.

Buzz seized the opportunity with both hands. Charged with following the near fatally flawed spacewalks of Gene Cernan and Dick Gordon, and with proving that tasks beyond merely wafting about could be safely performed in space–because if they couldn't, Apollo was in trouble–he disdained Cernan's view that "brute force" was the answer to working in zero gravity. Instead, he conducted an incisive analysis of the problems and showed great invention in designing tools and techniques that would make working in space easier. The upshot was that, where death shadowed previous EVAs, this one went like clockwork. Now Apollo was on and Kraft, Slayton et al. could hardly fail to recognize such application and intelligence. A friend's gift

of death had let Buzz in and if the engineers' nickname for him, "Dr. Rendezvous," contained a hint of sarcasm, it hardly mattered anymore. He was named to the backup crew of *Apollo 8*, which led to the "prime" crew of *11*. He still didn't expect to be first to the Moon, until one day Slayton called the crew into his office and announced, "You're it." Not wanting to break the news to his wife over the phone, he waited until she picked him up in a station wagon full of dirty laundry later in the day. According to him, he told her in a Laundromat off NASA Road 1. He claims to have spent the long Fourth of July weekend before the flight dismantling and reassembling a dishwasher.

There are a number of reasons why Aldrin is not every Apollo astronaut's cup of tea. The first is his behind-the-scenes campaign to be first on the Moon. To a degree, his frustration with being second was understandable. Up to *11*, commanders had kept with tradition by staying in their craft while others stepped out. NASA tried to deny it afterward, but the early checklists showed Aldrin leaving the LM first and my sources confirm that the media were apprised accordingly. What happened? Turnill and Collins both suggest that Armstrong exercised his power and commander's prerogative to change the plan. On the other hand, Chris Kraft maintains that a summit attended by himself, Deke Slayton, MSC director Robert Gilruth and his deputy, George Low, considered Armstrong better equipped to handle the clamor when he got back—though they still had scant idea of how clamorous that clamor would be. Aldrin lobbied backstage and, perhaps more significant, so did his father, who was furious to find his approaches rebuffed. Buzz admits that the old man "planted his own goals and aspirations in me," but it looks as though he did more than that: he tried to enforce them. Both Aldrins suspected that Armstrong had been favored because he joined the space program as a civilian and was thus untouched by the continuing debacle in Vietnam. As a last resort, Aldrin Junior approached his commander and suggested that the change of plan was unfair. Of that conversation he says:

"[Armstrong was] a no-frills kind of guy who didn't talk a whole lot, but usually said what he meant. But there was a more

complex side to Neil . . . Neil hemmed and hawed for a moment and then looked away, breaking eye contact with a coolness I'd never seen in him before."

NASA explained the decision by saying that the commander would be closest to the door and it would be difficult for the LM pilot to get past him. Aldrin claims to have experienced relief once the decision was final, but some say his mood darkened thereafter. It has since been noted that he took no photographs of Armstrong on the surface–none–and that the only image of the commander is as a reflection in Aldrin's visor. At one point, Armstrong actually called his junior over to snap him by a commemorative plaque he'd just unveiled, but the LM pilot, hilariously, barked back that he was too busy. There are two big laughs in "Deep Space Homer," the episode of *The Simpsons* in which Aldrin makes a guest appearance: the first occurs at the start, when Homer almost expires with boredom at being forced to watch another shuttle launch on TV ("the lion's share of this flight will be devoted to the study of weightlessness on tiny screws," enthuses the commentator); the second comes with the embarrassed silence following Buzz's introduction as "the, er, *second* man on the Moon."

"But remember, second comes right after first!" he chirps desperately.

The other reason Buzz never made homecoming queen in the Astronaut Office is that he wrote about the rise and fall in a brave book called *Return to Earth*, which hit bookshops as early as 1973, when the Apollo aura was still fresh. In a society of men used to being presented and received as omnipotent heroes, where divulgence was anathema, it's easy to see why the book caused alarm. Some of it is divine. Among the fruitier revelations were:

1. That the constant emphasis on setting "records" in space was PR-driven.
2. That the spacewalks had not all gone to plan and lives had been in jeopardy.
3. That there had been arguments about who would step onto the Moon first.

4. That the first thing he did when he got there was kick the dust and watch it sweep away in great arcs; the second thing, while the world watched in rapture, was pee.

5. That the condoms they'd used for collecting urine were a source of great anguish because "our legs weren't the only things that atrophied in space."

6. That hydrogen bubbles in the water supply they used to rehydrate food had given them the farts and *Columbia*'s interior didn't smell so good (there was "a considerable fragrance") by the time they got home.

7. That members of the corps, including himself, had failed to resist the advances of space groupies and some– including himself–had conducted affairs.

8. That some of the astronauts had used their status to form questionable business alliances which would land them in trouble.

9. That he didn't know all the answers and was perfectly capable of being scared–though mostly by things other than spaceflight, like the media and speeches.

10. A hint that Armstrong's "one small step" spiel might have originated with a NASA press officer after all.

By the end, we're very prepared to believe Aldrin's contention that diplomacy isn't his long suit, but there's also plenty of stuff to remind us that they were all improvising. For instance, there is the description of being in the "mobile quarantine unit" on the deck of the USS *Hornet* after splashdown, ready to be addressed by President Nixon through a broad, narrow band of glass when the national anthem pipes up, forcing the trio to stand. "We didn't know that three astronauts would stand up and present three crotches to the world," Aldrin laments, adding that they sat down afterward in a tailspin of fear that their flies might have been open. And how delightful that, having informed his wife of the Moon trip in a Laundromat, Aldrin's first words to her now were "Joan, would you bring me some Jockey shorts tomorrow morning?" because he was annoyed to have been supplied with boxers by NASA. Her response was to blurt "Oh, thank God!" and burst into tears. Hardly Bogie and Bacall, but touching nonetheless.

More serious is Aldrin's account of the rock-style "Giant Step" tour, a global PR junket which he, his fellow crew members and their wives were hauled through upon release from quarantine. "When I think of that tour, I think of liquor," is what he says. More specifically, he recalls Armstrong's disapproval—later withdrawn—when he danced with Miss Congo in the Congo; Joan's jealousy at a party thrown in Rome by the curvy actress Gina Lollobrigida; the trio's thwarted desire to get out and speak to people, rather than attending endless dry diplomatic receptions; how the women drew closer to each other while the men drifted apart; his and Joan's sudden apprehension, at a reception in Norway, that he had been used and discarded and that life was never going to be the same again, at which point she cried, then he cried. "I felt all six of us were fakes and fools for allowing ourselves to be convinced by some strange concept of duty to be sent through all these countries for the sake of propaganda, nothing more, nothing less," he says dolorously. The drama acquires a surreal edge through being played out against an impossibly glamorous backdrop. Her Majesty Queen Elizabeth II of Great Britain, Aldrin reports, was "surprisingly small and buxom," while Joan issued him an ultimatum to stay home more or move out after a birthday bash held by the despotic Shah of Iran. None of this had anything to do with the lives they'd known before.

The socially relaxed Collins remembers his crewmate growing more and more distant, retreating at times into "stony-faced silence," just as Aldrin had earlier remembered reading a sci-fi story as a kid, where some voyagers go to the Moon but return home insane: it had given him nightmares, and the nightmares left a shadow which followed him on the real-life voyage he eventually took, so that when "flicker-flashes" of light began to appear in the corner of his vision, his first, barely conscious thought was that the Universe was coming for him. Was there fear in his voice when he first mentioned them on the flight? Is that what irritated Armstrong so much? Come to that, was Armstrong afraid of them, too? Either way, the Universe did get to him. Aldrin came back and blew like a supernova.

The Air Force made him commandant of the aerospace school at Edwards and he left his family for Marianne, the woman he'd been having an affair with for some years, but both situations collapsed in a fog of despondency. *Return to Earth* ends on a hopeful note, with him boldly submitting to treatment in a psychiatric hospital–so spelling the ruination of any future Air Force career, despite his father's continued efforts to get him promoted to general–and trying to start over again with Joan and the family. Heartbreakingly, this rapprochement with life didn't last. Aldrin eventually returned to the other woman, but the union was brief.

In fact, he'd been suffering from severe depression and alcoholism. He was forty-two and had no idea where he was going or what to do with the very different void, the *existential* void, that now yawned before him. It must have felt terrifying, as though the Earth were punishing him for his impudence in leaving it.

Ed Mitchell was equipped to face this. Buzz Aldrin wasn't. There was no safe place to stand, let alone fly. He worked on an innovative design for the space shuttle, but it was abandoned; then as a director of an insurance company and a cable TV firm. He criticized other astronauts for their business dealings, which endeared him to no one, and launched an idealistic youth forum aimed at bridging the generation gap, but it never quite caught fire. After the breakdown that precipitated his departure from Edwards, he developed a fear of sleeping in darkness. Joan said he judged himself too harshly. It's strange that photos from this period show him smiling, with a fashionable beard, looking every inch a matinee idol. The Space Age had found its Marilyn.

THE ASSISTANT'S E-MAIL said 10 AM and it's 10 AM now. I've mistimed my entry into the swank heart of Wilshire–*how long is this bloody road anyway?*–and am angry with myself by the time I spot the marble and gold block where Aldrin lives with his redoubtable third wife, Lois. I locate a barely sufficient parking space around the corner, almost spark a fight by ramming the

back of a mobile java van while trying to squeeze into it, then apologize profusely and break like a thief beneath a paranoid 9/11 sky full of circling helicopters.

First the slightly bad news. Years of propaganda from those post-hippy Californian grade school teachers have left me with a residual mistrust of ties and collars, those flashy trappings of The Man, but they say Buzz is a snappy dresser, a disciple of precision, so today I will be, too. A trip to the Beverly Center netted a gray Agnès B suit as worn by Harvey Keitel in *Reservoir Dogs,* a brown Burro shirt–chosen after several carefully considered changes–and some proper Patrick Cox shoes. A bronze silk tie purchased last-dash from the hotel boutique this morning and knotted with the help of the concierge is the prime cause of my lateness. Now I present myself to a liveried receptionist after sprinting three hundred yards in a funk, looking for all my efforts like a sales rep ejected from a strip joint for panting too hard.

So to the worse news.

"Hello. I've come to see Dr. Aldrin," I announce.

The receptionist looks at me blankly.

"Who?"

"Er, Dr. Aldrin. Am I in the wrong place?"

My head swims. I don't believe it. I *am* in the wrong place. But wait: the receptionist's lips begin to curl upward, until he is grinning broadly.

"Oh, hold on–you mean *Buzz*?"

Good news, until he calls upstairs to be told that Aldrin's assistant has been trying to reach me in order to postpone our meeting in light of yesterday's unfortunate events. Bad news . . . except that, seeing as I'm here, we might as well carry on as planned. Good news!

The elevator won't stop at the correct floor, because security concerns dictate that you need special dispensation to get out there, and a member of the staff has to come up and arrange it for me. Once out, there's a private hallway leading to a broad, glossy white door with gold fittings. It opens, and there, backlit through its frame, glowing like an eclipse through the halo of light–the man carries his own corona, for Christ's sake–stands

Dr. Buzz Aldrin, tanned and smiling and wearing nothing more than a NASA T-shirt that must once have been white, and the smallest pair of small blue satin running shorts that I have ever seen. His feet, unlike mine, are bare. On the way in, I ask if he'd like me to follow his example and remove my shoes in deference to his spotless natural fiber carpet, but he chuckles and soothes:

"Naw, don't worry. We're just not as traditional as maybe you guys are."

Lord, save me from myself.

Aldrin has good legs for a seventy-two-year-old and looks astonishingly fit. He's been sober for many years now and spends his time agitating for a resumption of "manned" space exploration, struggling to scare up investment for his futuristic projects, making lucrative public appearances and, of late, writing novels. He walks me through the living room and seats me on one of two cloudy cream sofas, then offers coffee and stalks off to the adjoining kitchen to fix it. In his absence, I gaze around the large, high-ceilinged room in what must be a very spacious apartment, neatly adorned with Moon-themed awards and paintings and expensive-looking furniture, and my mind reaches back to Dick Gordon signing autographs for ten bucks a pop in Vegas—which is perhaps why the Chaplinesque commotion coming from the kitchen takes a while to register. After a brief interval, punctuated by more clatter, Aldrin calls through to ask whether I'd like milk or creamer, but the question seems to be rhetorical, because he clearly has no idea where to find either. In the end, he's forced to swallow pride and call Lois, who sweeps in, petite but crackling electric with her gold-rimmed specs and bonnet of tightly curled gray hair. She calls him "Buzzy" and hugs him like a naughty five-year-old and he seems to melt in her embrace, appearing natural and at ease for the only time. Someone close to Apollo tells me that when Lois arrived after the debacle with Marianne, they all thought she was an airhead, but they soon changed their minds. She scolds him playfully:

"He can go to the Moon, but he can't make a cup of coffee . . ."

Which, on the face of it, would make a fantastic epitaph one day.

The ex-astronaut sits down and leans forward, cradling his coffee. We chat for a few minutes about this place, their old one in Laguna Beach, the horsey community in the San Fernando Valley where he tried so hard to piece together his life with Joan after retiring from the Air Force.

". . . and my daughter had a horse, so I moved there and got that out of my system, sorta . . ."

Then he pulls up abruptly.

"Now, review if you would how this started and, ah, for some reason someone said, 'He wants to talk about F-86s'—is that right? That isn't really what this says." He fingers the printout of an e-mail I sent to give him an idea of what I wanted to talk about. "But that's fine."

He has a deep voice and enunciates his words with extraordinary care, though the order in which they appear can be less decisive. His syntax can be disorientating when you're with him and takes a while to tune in to, but once on the page you see that he speaks a private creole of tiny sentences with no predicate. They capture the essence of a thought and are often very direct in themselves, yet circle like moons around something that Buzz can't quite bring himself to say, like the speech of a small child, or haiku. There is also the impression that, even when idly discussing the weather, a portion of his psyche still believes itself to be apprising Mission Control of its current status—then, just when you might feel that he's sounding self-important, he'll surprise you with an example of startling self-awareness or a self-deflating confession. At the height of her preflight fear, Joan Aldrin confided to her diary that "He is such a curious mixture of magnificent confidence bordering on conceit and humility, this man I married," and it doesn't take long to see what she meant. Sometimes when he speaks, you feel that what you're actually hearing is the grunts and groans of two wrestling teams doing battle inside his skull.

We begin by talking about the pair of novels he's cowritten, which I read in Vegas and Barstow. The first, *Encounter with Tiber*, was published in 1996 and is an unwieldy space mystery about a message left by an alien civilization on the Moon. The second, a sci-fi whodunit called *The Return*, is tighter and lighter

of touch. In both, the villains are visionless bureaucrats in the post–Apollo NASA mold, and politicians who won't pony up the dough for essential stuff like Mars Cyclers (more of this in a moment). It plays against the backdrop of a new Space Race with China, which three years later is beginning to look remarkably prescient, because a Chinese space program is on the launchpad. I ask him how he'd foreseen this and he begins by talking about his writerly ambitions, which surfaced in 1975 or 1976, but took twenty years to focus.

"I kind of challenged myself, 'What can I do with what I've experienced?'" he says. "The idea was to talk about what people didn't know about space travel, or what they erroneously thought about it . . ."

Eventually, he gets to China and its purported lunar ambitions, which have been exciting the European press for several months without gaining much attention here. Aldrin tells me that he first heard mutterings on "the underground."

"What," I splutter, "the *space* underground?" I can't imagine what such a thing would be for.

Yeah, he tells me. There are rumors that the Chinese, for whom the Moon has special cultural significance, are also looking at Mars—just as we were in 1969, when von Braun tried to use the success of Apollo as a springboard for his big play, which he presented to Congress that autumn: nuclear rockets assembled in Moon bases, to reach the red planet in the early 1980s. Inevitably, the politicians balked. With Apollo struggling for cash and Vietnam in full swing, they could never support an extension of the program into Deep Space, and for the next decade and a half, the adventure seemed over, done, an arcane relic of a more affluent and optimistic time. Yet a change came with the *Challenger* shuttle disaster in 1986, after which a shadowy cadre, formed out of a few enthusiasts, organizations and maverick billionaires, began to agitate for a return to the stars, questioning for the first time NASA's custodianship of "The Dream." Now Aldrin had something to believe in and apply his mind to and ideas tumbled from his head, including a Moon Cycler, which would travel perpetually between the Earth and the Moon, moving people and materials between the two bodies.

When others convinced him that this idea would be better applied to Mars, lots of experts doubted whether it could be done, whether the necessary orbits could be traced—*whether they exist in physics*—but Aldrin found them. By his elegant conception, the cycler would sweep around the Sun and swing past Earth and Mars forever, using only the force of the heavens, gravity, for fuel. It was around this time that he kicked the drugs and booze. To him, the books are about giving context to some of his ideas. They're trying to be realist rather than futurist. Buzz rehearses the arguments about whether to go back to the Moon or Mars first, managing to find a typically maverick case for going to the moons *of* Mars. Then he stops and says:

"So that's two very different philosophies, neither of which are going to be really implemented."

What? But he devotes his life to this, I say, and he explains some of the background politics of the situation, describing a web of vested interests, woven around established contractors, government agencies, the armed forces and NASA. I recognize all of this from *The Return* and it sounds intractable. Isn't there something quixotic about spending time on all these ideas when he knows they stand no chance of becoming real?

"Well, it looks as though the cards are playing out and someone will swoop in there and snatch victory from . . . whatever. And we might lose out, but . . ."

Aldrin shrugs and trails off, while I try to work out what the devil he's saying.

Keen to move on, I note that the decision to try his hand at writing is interesting, because—and even before I've finished the sentence, he's muttering "I don't"—because writing sounds like such hard work for him—"I *don't*"—as he describes it in *Return to Earth* and . . .

Sorry, Buzz, what did you say?

"It is. Hard work. And I *don't write*. I can take a piece of paper and outline a few things, but I much prefer drawing a graph, where things move from left to right in time periods and I see what's moving, or maybe I'll look at orbits and try and work out progressions of orbits. Not just one mission, but what are the progressions, what are the buildups."

Once again, I'm not quite sure what is being said.

"Right now, the basic scheme of things in my mind is different than NASA's. NASA has been sitting there kind of doing nothing and now they've got a little bit of new leadership and it looks to me as though they're going to say, 'We, NASA, are tired of being in low Earth orbit—we're going to go beyond!'"

He sounds so much like Buzz Lightyear when he says this that I have to resist an urge to applaud.

"But I think that's just eyewash. I don't think they're going to be able to do that the way it should happen, until we get the people behind the program. We do that by passenger travel, and we build up a transportation system that takes the people up and back efficiently, cost-effectively and reliably—and they have a place to go. So we have to have a hotel . . ."

"A hotel in space? Is *that* all?" I tease, and Aldrin shrugs and shapes a rueful smile and admits that he hasn't really figured out a niche for himself yet. But something strange seems to happen, as though a switch has been flipped, and the humble amiability disappears. Out of nowhere he says:

"I achieved something in space. To then transfer that into making cookies isn't that much of a thrill. Or selling beer or something."

Charlie Duke and Alan Shepard both did well with beer distribution businesses in the turbulent time after NASA. Is this a dig at them? I remind him of the disdain he's heaped upon some of his ex-colleagues' business activities over the years, suggesting that they were compromised through their alliances with powerful individuals and corporations.

"Well, I don't know, some of 'em clearly have some very good management skills and have been able to turn that into very good careers. And they're now enjoying life, in their definition of enjoying life. I have never felt that I have to have toys and airplanes and such to fly around. There's great enjoyment in doing that—when you're doing it—but it tends to take your attention away from . . . something more nebulous. It's hard to do both."

I mention Charlie Duke and the unwitting role he played in bringing me here, but before I can finish the thought Buzz is back on a train of his own.

"Mm-hmm. Yeah, I'm having dinner with him Friday night. He's a very . . . uhm . . ."

He takes a while to choose his word. I'm expecting "charming," or "nice," because that's what most people say about Charlie.

"He's a very *neutral* guy, who is enthusiastic, but he doesn't get labeled one way or the other. And I think, as such, he's picked up a need, whenever we've had an astronaut reunion, he's made an effort to identify an opportunity for the ancient order of astronauts to get together. And that strikes a very, ah, *harmonious* chord with me, 'cos I've tried to do that, to get the people organized into more of an *esprit de corps* way, and then see what happens outta that . . ."

I think that what he's just said is that he wishes Charlie would champion space more, but he's fond of him all the same.

"But that [my] lack of being a dynamic salesman and leader has resulted . . . well, there's been another impediment, too. The *peckin' order*, haha, has seniority . . ."

A pecking order? Among the astronauts? All these years later?

"*Very* much so. Oh, yes, yes. It's very layered and defined."

Where do you think you come in it?

"Well, there's a first group of astronauts and a second group, then the third group. And where you flew. And whether you were a commander."

And you were in the third group, flew last, didn't command . . . he nods wordlessly.

"And then there are a lot of little detailed reasons why John Glenn did not assume the role that was given Yuri Gagarin or Alexei Leonov by the Soviets. And certainly, Neil hasn't assumed that role."

He means the role of a figurehead and advocate for space. I ask how he and Armstrong get on these days? Has the relationship changed?

"It's fine. But what I want to see happen does not get any support. From hardly anybody."

I'm sure that I read somewhere about Al Bean regretting the lack of *esprit de corps,* I say. I'm expecting something like con-

tempt in return, because Bean the aesthete really has abandoned the space effort. But no.

"Al has been the one guy who has said, 'What a wonderful book that was that you wrote,'" he says, and a kind of tenderness enters his voice. "The only one that has said that."

Buzz sounds a little offended by my assumption that Bean was talking about *Return to Earth*.

"No, *Encounter with Tiber*," he bristles. "See . . . I think there's, there's still a reluctance on the part of the early astronauts to think that carrying passengers is a good idea . . ."

And we're off into the cosmic dust again.

I WAS BORN the year Apollo began, in 1961, Aldrin in 1930: when he'd finished with the Moon, he was about the age that I am now, so I know that even under normal circumstances most of the clichés surrounding midlife turn out to have truth. Still, the rest of us can kid ourselves that the best is yet to come and occasionally we might even believe it. Occasionally it might be true. Yet Aldrin was afforded no such comfort, and he admits that he was underprepared for almost everything that followed. Especially the "What next?"

"Then there was such an overwhelming involvement in public appearances, that were just not satisfying or anticipated with relish . . . and there was a competitiveness among the three of us that was kind of quiet–there was always, in my mind, the audience who was looking and saying, 'I like this guy'–'No, he's better.' And we wanted to avoid that stuff, you know? To keep doing that continuously . . . it was competitive enough to begin with!"

But weren't you always very competitive anyway, I blurt? Mike Collins said that he felt uncomfortable in your presence back then. That he had the feeling that you would probe him for weaknesses . . . There is a very long pause.

"Made Mike uncomfortable?"

Well, yeah. That's what he said. Another pause ensues, during which I have an almost physical sense of him processing this information, trying to integrate it into an autobiographical

story that doesn't hurt too much. When he speaks, he does sound hurt.

"The thing is, I was trying to get support for ideas. And vindication and pointing out things that maybe people hadn't thought about. And maybe that made them uncomfortable. Well, I guess . . ."

I'd assumed Aldrin to have read Collins's book, but it seems that he hasn't. I try to change the subject, but he interjects, his voice speedier and more passionate.

"See, if you're concentrating on some effort like this and somebody brings up something extraneous and says [adopts high-pitched voice], 'Well, what do you think of this?' Well, that'll make people uncomfortable. I don't think I was ever doing that. What I was bringing up was something that had to do with things I knew a lot about, and I wanted other people to contribute. And that had to do with rendezvous or something, instead of 'What's the latest motorboat?' or 'How's the golf score coming?' That's not of interest to me."

For the record, Alan Shepard rubbed a lot of people up the wrong way, too, but never had the sensitivity to care about it. I tell Aldrin that I think what he did after his flight, in acknowledging frailties which were considered improper in that environment, was very brave. I've tried to imagine myself summoning that kind of courage, but haven't so far been able to. He seems to relax.

"No, no. It was not expected of you to, ah, air frailties. But you see, I didn't even know the problem then, which was alcoholism. And that's something that's hard to talk about, because of the mechanisms of recovery. You don't want to go around talking about it and bragging that you've recovered from something, because you really haven't. You have a reprieve. We call it a daily reprieve. But I recognize it, when I look at that area of challenge, and when I see people who have done so much, and who are continuing to do so much for other people. All I've done is succeed. I've not been all that tremendously helpful, except in one realm—and that's as an example. But I can't really wave the flag about that example either, because that's not great humility, and the one thing the process teaches you is humility."

As already noted, *Return to Earth* ended with the depression under control and the family back together, trying for a fresh start in California. There was an impression of optimism, but it all fell apart again. I wonder aloud what happened.

"Well, we wanted to put that optimistic note on it, as we did on recovery—which was uncertain. And both fell apart. The recovery didn't work, 'cos I didn't know what the problem was. Or it wasn't clearly identified. And neither did the optimism of bringing the family back together again. And the two fed each other, really."

He nods gently.

"Yeah. And so in trying to resolve that, I got married again to somebody and that didn't work at all. So then I spent a long time putting things together and trying to figure out what I ought to be doin'. Then it wasn't until the late Eighties that I began to get to a sufficiently healthy status."

It's hard not to smile at the language. *Sufficiently healthy status.* Was there a turning point in that period? It seems a long time to struggle alone. He talks more about his grand plans for space and the recovery that coincided with them, though he acknowledges no connection, and then about an invitation he received last year to sit on the U.S. Commission on the Aerospace Industry.

"Humbling in a way, because all the other eleven guys are experts in their field and its mostly management, corporate structure, legal *this*, defense *that*, or financing... and I'm the space guy, you know? The guy that's on this end of the country—everybody else is over there."

He waves vaguely in the direction of the East Coast. I'm not quite sure where this is going, but am by now able to recognize this last statement as vintage Aldrin; at once modest and massively self-aggrandizing, as though every breath the world offers him must be repaid with an achievement. While I'm contemplating this, he continues with the story.

"I felt challenged and the problem of not writing things down is really getting to be a difficulty. So I've harnessed some support people—"

"Wait, wait," I interrupt. "You don't write things down at all?"

"No."

Why not?

"I don't know. It has progressively grown . . ."

So you don't do it at all?

"Well, I fine-tune things. And I look at what's been done by people who've done it very, very well."

I hadn't grasped the implications of what he'd said earlier. He doesn't physically write anything at all. Is it a kind of phobia?

"Yeah, it is. It really is."

I've never heard of that one.

"Well, I don't know that other people suffer from it."

Where does he think it comes from? I ask, wondering whether he might be dyslexic. Has he tried to get help for this condition?

"Well, I've been able to successfully . . . erm . . . *exist,* without doing that," he says. "And it just becomes a *characteristic,* maybe."

Then he goes off on what seems like another tangent, but actually might not be.

"I didn't want to get into, um, *skiing,* unless I could do it real well. Then after a while I realized, 'Jeez, you know, you're missing something if you don't get into these things.' So, um, I'm now a pretty good skier. But it's not as natural as if I'd been doing it from the twenties and thirties on. I've given golf a chance, but it's so time-consuming. And messing around with a lot of people, and being among the bottom of talent, is not consistent with having been on the Moon."

His eyes crinkle into a smile, then a laugh—and I laugh, too, recognizing something of what he describes in myself. He likes scuba diving, he tells me, because he is forced to realize that "it's not a contest under there, it's very individualistic and you need to develop your individual ways of dealing with things." In the deep he can let go. No one's watching or judging.

Buzz was the youngest of three siblings, the only boy. I ask whether his dad is still around, knowing it to be unlikely. He goes very quiet.

"No, no, no. He died in 1978. No, '74."

Aldrin Junior, referring to the old man's interference in his

career, once speculated as to whether "it was a bit difficult for him to accept that my own goals had begun to exceed those he set for me." I wonder how he felt when his dad died? This is exactly his response:

"Well, it was kind of sad, to, to, uh . . . Because he . . . he, he, he began to, uhm, have a, have an existence that relied on my achievements. And I felt, 'Fine, that's wonderful, but he's not right in there, he doesn't understand what I'm doin'.' A-and, t-t-to have an, have an individual existence didn't rely on that. Uhm. He still had connections with people from years ago, and a respect, to a degree, that was very helpful. But the cutting-edge things that I was trying to be associated with, it was just not something that I could sit down with him and talk about. Uhm. And–ah."

The voice is very hushed, almost whispering now.

"Let me see. Ahm. He died in '74 and I'm seventy-two. And I've got a son, now, who's forty-three. And I relate very closely to him and I try and relate to the older son, too. Ahm. And I get a lotta help, back and forth. And that didn't exist with my father. Regrettably, you know, it just . . . really wasn't there."

I also had a father who projected some of his unfulfilled or unfulfillable ambitions onto me, I say, and although I loved him and still miss him, I was shocked to find that, when he died, there was a little corner of me that felt *relief.* The burden of expectation got lighter. I still feel shame when I think about this. He drops his eyes to the table in front of him, then fiddles with his hands.

"Well, I . . . I had to come to that a lot . . . earlier." He emits a rueful snort. "Like, in high school on the football team. That was not somethin' that my father got involved in particularly. And at West Point and MIT . . ."

There is another very long silence. For a moment, he really appears to be teetering on the brink of tears.

"There are a lot of conceptions that come out of *Return to Earth,* that my father was a very influential person and that when he said something, that I immediately did that. And I've been trying to counteract that."

Men and their fathers: the touchstone so easily becomes an

instrument of torture. There follows a discussion of Edwin Aldrin Senior's wish for his boy to go into the Navy rather than the Air Force, in which he seems to admit that his father was right. The Air Force was working toward its own rocket-powered space planes in the late 1950s and wanted to keep its best pilots, while the Navy read the runes right and pushed its people into NASA. "Right or wrong," he concludes, "the Navy had an organization that wanted to explore, take advantage of whatever came along, in a very possessive way." The Air Force also retained a latent suspicion of this new form of flying that wasn't real, stick-and-rudder flying. Aldrin says nothing to suggest that they were wrong.

"Gemini and Apollo were computerized and preplanned, so the era of the pilot in command, having the creativity to decide what he wants to do—that's gone. Only in an emergency is it apparent. And in an emergency, like *Apollo 13,* they had no idea what went wrong. It was like, 'We got a problem, all the lights are comin' on!' And it was up to the ground to figure out what the problem was! And we still have former astronauts saying that the ultimate decision is with the guy in command of the spacecraft. Well, that's not true at all. It's true when it comes to saying 'bail out' or a few other decisions. So I'm a fighter pilot and I want to be in control. I'm perfectly willing to see the wave of the future and if anything, I might overcompensate, just to make sure that I'm not following a stereotyped path. I want to really look at the unusual. I mean, that's why I wrote *Encounter with Tiber,* to stimulate the unusual thinking."

He's taken all my line and headed for the deep water again. I seem to recall him saying that he'd rather not have been on the first mission to land. Does he still feel like that?

"No. And I didn't really feel that way at the time. It was an observing of an option. And it really wasn't available." He laughs. "But it was the postflight pressure that prompted me to say, 'This is gonna lead toward, ahm, challenges that I don't relish.' And they were not ones of performing the mission. They were ones of elaborating and being clever and whatever else."

From the Space Age to the Media Age and a foretaste of modern celebrity culture. In my experience, almost everyone has

trouble living in the eye of that one for any length of time, however much they might think they want it. And his mission was more than just a media event: the idea of what they were doing had an almost primal fascination and I'm already starting to think of Apollo as a crossing place, a place where two worlds meet briefly, then part forever. Hardly surprising if some of those involved fell through the cracks.

Just then, Lois bustles in, bearing a copy of the Sibrelgate story from this morning's *Los Angeles Times*. She shows it to Buzzy.

"Oh, that's pretty good," he says.

"It *is* pretty good," Lois replies, then turns to me with a smirk. "Did you hear about everything?"

I tell her about the hotel news and she laughs at her daughter's chagrin over having been photographed crossing the road with Buzz in her frumpiest attire. "She has so many cute outfits, but she didn't know she was going to be filmed!" She shakes her head. Buzz has been poring over the picture in the paper.

"I suspect that that's . . . I think that's after impact," he pronounces finally. "'Cos it's not going in the right direction."

By "it" he means his fist. Lois and I erupt into laughter at Aldrin's need to analyze the trajectory of his punch and in the end he joins in, chuckling, "Well, who knows? Haha." Underneath it all, they're worried, though, seeming particularly preoccupied with the response of the media. Aldrin appears to feel about the media the way a crab must feel about seagulls, a mixture of deep resentment and exaggerated respect, bound in resignation. This time he was set up by a former friend, a wealthy Japanese socialite who now has her own TV show in Tokyo, specializing in the bizarre. She didn't tell him that this particular program was about the lunar-conspiracy theory. I ask him if he really hit Sibrel.

"Oh, yeah." He smiles.

A year or so into the future, a similar trap will be set by the comedian Sacha Baron Cohen, masquerading as the hapless hip-hop media star Ali G. Admittedly, "Ali" opens with a good one ("I know this is a sensitive question, but what was it like *not* being the First Man on the Moon—was you ever jealous of Louis

Armstrong?"), yet on this occasion Aldrin comes off better than Cohen, I think, who will surely be disappointed to meet with nothing but polite good humor, even when he asks: "Do you fink Man will ever walk on the Sun?" and calls him Buzz Lightyear. Right now, however, Buzz and Lois are afraid that Sibrel will sue in a bid to gain even more publicity for himself and his cause. In the end, he won't, but Aldrin is no stranger to law courts. At one stage, I make an offhand remark about the honor of having a Disney character named after him (meaning that parents are forever introducing him to their otherwise uninterested kids as "the real Buzz Lightyear"). I've forgotten that he took Disney to court over this. He also sued Omega for advertising their watches with a photo of him wearing one they'd given him on the Moon (they presented one to all of the astronauts prior to their flights). He tried to get compensation, but ran up against some tough Swiss lawyers and failed.

"It gets pretty nasty after a while. And I'm trying to tell 'em, 'It was my decision to take yer watch to the Moon. Neil decided not to for whatever reasons. It was my decision: where are you helping me with any of that?'"

Before long, I'll get a chance to wear the watch Armstrong chose not to take. For now, though, Aldrin's preoccupation with money is not so hard to empathize with. No one can look at an Apollo travel expenses voucher without assuming it to be a fantastic joke. His framed version reads:

PAYEE'S NAME: Col. Edwin E. Aldrin 00018
FROM: Houston, Texas
TO: Cape Kennedy, Fla.
Moon
Pacific Ocean
AMOUNT CLAIMED: $33.31

After the years of torpor, he probably feels as though he's got some time to make up for. Still, empathy or not, the concern with cash is not always pretty. There follows a long complaint about the unfairness of his missing out on a promotion after his Apollo flight, then a long defense of his stance over the issue of

who should leave the LM first–despite the fact that I haven't mentioned it. He tells me that he asked the other LM pilots for counsel on "what my position oughta be." I ask what the response was.

"They have written books saying that I asked them to defend my cause. And to take a very aggressive position."

Who said that?

"Well, [*Apollo 17* Commander, Gene] Cernan did, among a number of other things. He's a very competitive person. Very driving to put his 'Last Man on the Moon' as a very significant position."

Last Man on the Moon is the title of Gene Cernan's recently published memoirs. Clearly, there's some bad blood here. Aldrin raises Cernan's near disastrous *Gemini 9* spacewalk, as a consequence of which NASA withdrew an experimental maneuvering backpack from *Gemini 12,* with which Aldrin would have been able to steer himself through space as per the Bond film *Moonraker.* This is how he explains it.

"Because of that failure and others, as I came along, NASA canceled the maneuvering unit from *Gemini 12.* That hurt me, that they did that. Anyway, there are a lot of little issues like that, where you're damned if you do and damned if you don't. That kind of a situation. I've got a fighter squadron that I was in from '56 to '59 and we get together every year now. But do the astronauts get together? No. There's still this . . ."

He's groping for a word and I try to help out with "competitiveness?" but I'm wrong.

"Well, there's this *withdrawal*–'That's my life then, I'm doing different things now . . . I'm flying airplanes, I'm doin' that stuff.' And you know, everybody has a slightly different reason for justifying their–I'm gonna put a label on this–their *disinterest* in the present space program."

He says this in a milder tone of voice than you might imagine. "Disinterest?" I query.

"I think they have a bit of a disinterest. Are they going to conferences about determining the future of space? Are they keeping aware of this?"

I offer John Young, who commanded *Apollo 16* and flew the

first space shuttle mission, and who still works for NASA in Houston.

"But that's his job. He's drawing Navy retirement and civil service pay. And they keep adding up. So he's a very astute guy and he contributes tremendously, and he's taking advantage of everything that comes along."

I ask who Aldrin was closest to during his time with Apollo? He takes a while to think about this.

"I had an identification, I think, that wasn't really carried out, with Pete Conrad. It was an identification of, you know, let's do things the right way. When Neil and I were on the backup crew for *Apollo 8*, we were very mutually supporting of creative ideas, of supporting ideas for that mission. And that was a real closeness. Earlier than that, there was a significant closeness between myself and [*Gemini 12* crewmate] Jim Lovell. But on *Apollo 11* there was clearly the test pilot, the commander and then the junior guy, you see."

He smiles and produces a little laugh, *hu-huh.* He was the junior guy.

"Um. And the timing of where you were selected was dependent in a way on a peer rating system, which has its popularity aspects–who you get along with and so forth has an impact on who you think ought to get the choice assignments."

He sighs as though he's been holding his breath for a long time. As part of the selection process, Deke Slayton asked his astronauts to rate each other in confidence.

"So, there was an aspect of our third group of astronauts rating each other as to who's going to fly first, second, third and fourth. And where was I? Very near the bottom of the list in the ratings of, uh, ahm. Otherwise I'd have been able to fly much earlier. But the way it was going to work out, I wasn't even gonna fly in the Gemini program."

I'm wondering how Aldrin knew the results of Slayton's polls: even those closest to the Astronaut Corps chief claim never to have been told more than that they were "surprising." I wonder if he's assuming his unpopularity? Clearly, Aldrin felt himself to be an outsider.

"Well, yeah, being an egghead from MIT. I mean, they didn't

give me any credit for shooting down airplanes in Korea. I'm not ashamed to say that I evaluated my career and did not want it to depend on my astuteness and my high skill as a pilot. So I selected a path different than a test pilot. Now you get into a business where everybody's a test pilot except you and a couple of other guys, who were also sort of branded as eggheads . . ."

We wind our way back to the future of space exploration versus low-orbit fiddling and Buzz is enjoying himself again. It's strange, though: even when he was settling scores with Cernan and cursing his place on the ziggurat, what one felt from him was not so much anger as the sulky incomprehension of a boy who can't work out what he must do to join the gang. Yet, the longer our conversation goes on, the more I find a truly strange image forming in my mind, of myself sitting on the couch, slowly transmogrifying into the father to whom he still imagines a debt of justification. This is not a comfortable feeling. Either way, he loves this Mars stuff and hearing him talk of it is fun, as if the days of *boldly going* might return. He smiles and leans back into the sofa, causing his teensy shorts to ride up his legs and afford a more generous view of the Aldrin extreme upper thigh region than I'd thought to anticipate.

He mourns the eleventh-hour failure of an effort to get pop star Lance Bass of the boyband *NSYNC onto a Russian flight to the International Space Station, alleging that his Hollywood backers started trying to haggle and play cute with the Russians–something you don't do. He thinks sending Bass up might have helped and, who knows, he might be right: the longer I look at it, the more I will come to think that Apollo was an emanation of popular culture before it was anything else. With due respect to the world's boybands, however, I'm not sure that they're the first place you turn for the "communicators" Buzz covets.

Suddenly aware that I've been here a very long time, I hurry to a question that's been circling in my mind for a while: does Aldrin still suffer from depression? He speaks haltingly at first.

"No, I, ah, may get kind of fed up with things and decide to escape and ignore things, and then I may find it difficult getting back into the swing of things again. Ah. *Ahm.* I think there's a

history of being exhilarated with success and depressed with failure, that will never leave. Some people are kinda steady and they deal with both. Other people are more affected by those situations that come along. And to see the sunny side of crappy situations is a challenge!"

A deep laugh and Aldrin's eyes crinkle with amusement. As I watch, thirty years seem to just fall away. Again I find myself unbalanced by his candor.

"And there's a characteristic of depression, which people who've been there know, which is that when you're in it, you'll be so convinced that it's never going to end that you cannot see the way out. If you can see the way out, you do that. But the characteristic of it is that you have no idea how you can possibly get out, or you refuse to take the steps that, intellectually, you know may help. You're more comfortable just stewin' around. That is not real threatening, but it's inconvenient. 'Cos it means that I cannot tell someone six months ahead of time that I'm gonna be thrilled to go and entertain their gathering, or whatever it is. I may not."

Does he think the lack of understanding of this condition affected his career in space, or his working relationships? He considers carefully before answering.

"Naw, I don't really think that was much in evidence during the active stay with NASA."

Because you had clear goals?

"No, I was focused on space business more than lighthearted trivia. And a lot of people like extemporaneous, backslapping trivia. The life of the party. Ahm . . ."

As I gather up my stuff and get ready to go, Aldrin asks if I can send him a tape copy of our conversation, saying, "I think that, some of the things I've touched on, I might have trouble getting all of those as well as we've been able to cover them here"– and naturally, I'm stunned to think that our encounter might represent the Moonwalker at his most clear and articulate. I've enjoyed talking to him enormously, but when I hit the street below, a wave of exhaustion will break over me such as I have rarely felt before, because, syntax aside, Buzz Aldrin has proven to be even more intense than Edgar Mitchell. I find myself won-

dering whether the others are going to be like this and whether the trip really did change and unsettle them, as Mitchell suggested? Or whether this kind of intensity is what you needed to get there in the first place? I tell him that I'll be happy to send him some tapes, then mumble something about his life journey having been more—the word slips out involuntarily—*intense* than most.

"Yeah," he chuckles, "and I think there's a need to balance that intensity with an easier association with levels of society that can help network actions mutually between people."

Now I'm laughing. *Buzz: what did you just say?*

He cracks up, too. Because he knows. And in this moment, it's impossible not to feel a real liking and admiration for him.

Soon afterward, we're almost at the door and I stop, feeling a little like Peter Falk in *Columbo* (but better dressed, obviously), with "just one more thing." In the Aldrin family photos from the late Sixties, I couldn't help feeling an affinity with his son Andrew, who was born a few years before me. I'd hoped that I might speak to him, compare childhood perspectives on the Space Age from the inside and outside.

Buzz talks fondly of the son he had to leave as a young teenager when the family fell apart. He tells me that Andrew has just taken a job with Boeing and is house-hunting in Houston this week, and that he'll be happy to give me his phone number.

"He's got a great future that I think is unfolding. He's very well appreciated and liked by all the people he comes into contact with."

This being a trait that Buzz has felt the lack of, I joke, drawing a weary smile in response.

"Well, I appreciate the fact that he is able to do that. I think my father had some of those tendencies of not exactly fitting smoothly in."

And you picked them up?

"Yeah."

We shake hands and he gives me a business card which delights me by reading simply, "Buzz Aldrin: Astronaut," but before I can step out the door, Lois comes charging along the corridor from the back office, clutching a note she's preparing to

circulate to the couple's friends about the Sibrel incident. She cackles as she hands it to me and I read it aloud. It says:

"Buzz went to the Moon in peace for all mankind, but it looks like he had to change his motto."

Her eyes flash and she almost collapses with laughter.

"Is that good?" she entreats.

But before I can answer, she's flying back down the corridor and as I reach for the elevator call button outside, I can still hear her voice, retreating into the distance, still demanding of no one in particular, "Is that good? *Is* it?" And I guess it is.

MY WORLD IS SHAPES and patterns.

I like the airplane wallpaper by my bed; the black-and-white dogtooth check of the sofa which Mum and Dad fold out to sleep on at night; the candy halo sun which hovers above a bull on a Picasso print in the hall, which I can stare at for hours and have a terrible desire to eat. At night, they play bagpipe records to send me to sleep and seem to think this is normal.

I'm forever told not to touch the pigeons in Washington Square Park, where the old men play chess all day. Germs: strange, squiggly things that you can't see but which sneak up when you're not looking and make you have a bath. Mum is unclear about whether the squiggly things I see if I half close my eyes and look into the light are germs. My hope is that they're not. What with bombs, and beatniks out on West Fourth Street, and the people who put razor blades in apples at

Halloween, and a second brother who they told me was going to be Mark, then turned out to be *David*–and the nightmarish Red Skull, who causes Captain America such trouble in my comic books–there's enough to worry about already.

They think I like nursery school, but I hate it. One day, I hit my friend Bobby in the stomach to demonstrate the principle that when someone does that to you, you can't breathe and fall over. His dad died of cancer. His mom thinks the Beatles are cute, but I prefer the Monkees. His sister Elizabeth taught us to spell "f-u-c-k" and when I asked my dad what it meant, his face went stormy and he said, "It's a bad word and you're not to use it," so now I write it on the floor with chalk during story time, then move to one side and point it out to Mrs. Montgomery. She says, "Yes, I *know.*" (One day in the far future, a colleague will tease, "Amazing: then you became a journalist!") All the same, I have noticed that words have power, even though, or maybe because, quite a few people around the Village don't have them. Richard Raffeto's mother, who has the voice of a traffic jam and hips like the Hoover Dam and always a huge vat of spaghetti boiling in the kitchen, doesn't; neither does the little Puerto Rican boy I've met, though his beautiful sister *does* and appears before me like the Madonna, inviting me to his birthday party, or walking me home when I fall off my bike and crack my white skull on the pavement, and there's a tiny corner of me that will stay in love with her for the rest of my life.

Not that I could do anything about it. The Puerto Ricans live across a big road, which Bobby and I are specifically forbidden to cross. We stand and gaze over there sometimes, can see that the streets are narrower and darker and more cluttered than ours. Sometimes I feel as though there's a little gray cloud following along a few steps behind me, or a dog with a big, drippy yellow tongue. The world is confusing, or maybe just confused. On the evidence so far, I'm not sure that I like it all that much, though the coconut ice cream in the park is nice.

I WAS BORN into 184 West Fourth Street in the week that an unknown Bob Dylan moved in at 161. My English parents had

arrived there in 1957 and my mother still describes her trance-like first stroll down Fifth Avenue, stroking the buildings and breathing, "I can't believe I'm in America." It was the New York street-life yarns of Damon Runyon that drew my father to the city, and my mother, a plasterer's daughter from Acton Town, London, with him. Dylan later described the place in his *Chronicles* as "like some uncarved block without any name or shape and it showed no favoritism . . . everything was always new, always changing." To my working-class father, New York felt like a frontier, a place in which the past had no purchase and there was nothing outside of himself to constrain him. No wonder he loved it so much.

Home was so gray by comparison and you could feel it in the culture's every pore. While angry young playwrights and authors and British New Wave film directors like Karel Reisz and Tony Richardson raged against their decaying, class-bound nation, caught between a putrefying old order and a new one it didn't have the guts or imagination to join, the Hollywood dream factory of Monroe, Dean and Brando was at its peak and the New York art scene was a rebuke to Paris; Kerouac had put the Beats on the map with *On the Road*, and *West Side Story* was about to revolutionize the performing arts. Europe was war-drawn, stately at best, clutching at a veneer of sophistication, while America, so young and brash and *out*, drank cocktails and danced the night away. From any angle this looked like a roller-coaster ride to the future and it was no coincidence that the only thing really beloved of Jimmy Porter, the protagonist in John Osborne's landmark play, *Look Back in Anger*, was jazz.

Better yet, the year before Sputnik, in 1956, Elvis Presley released "Heartbreak Hotel" and "rock and roll" launched itself at an enervated white world. Always Elvis-sceptic, I once asked the photographer Alfred Wertheimer, one of the last to be allowed real access to the singer, why the girls in the crowd were crying–whether the tears were part of an act. He told me:

"Well, I think it was the fact that we'd been through this rigid Eisenhower era. Everything was cutsie-pie crinoline skirts and 'How Much Is That Doggy in the Window?'; the girls knew their place and they weren't women's libbers yet; everything was very

tightly organized. Then along comes a guy like Elvis . . . he'd go onstage into a darkened auditorium, where there would be maybe 4,000 people—mostly young ladies, a few boys and then a few police, who were there just to make sure nothing 'dirty' was happening. From the very start, Elvis is focused on the girls and they're in love with his hair and the way he curls his lip. And he talks to them and then he begins to sing and he lets it all hang out. His hair, which was immaculate, starts coming down and the sweat comes down—and do you think he stops to mop his brow or sweep his hair back up? No. He gets down on his knees, then gets back up: he is so revealing, so unconscious of his own body movements that all of a sudden the girls look at each other, after all the years of holding everything in, and they cry.

"They're not putting it on the way you'd see girls doing in later years: they're not screaming or jumping up and down, just holding each other and crying. The boys would be wondering what the hell's going on and the cops couldn't figure it at all. They're going, 'Is this something dirty? Why are the girls crying?' "

After that, I felt that I understood both the 1950s and the 1960s a little better. I felt a mix of awe and envy for the Baby Boomers who defined the Space Age: for the Brits who had escaped the drabness of their parents' world through fanatic devotion to that visceral black American music, the voice of a southern underclass who—like them—hadn't yet tasted the lily-white prosperity of the Eisenhower years, who, as members of the Beatles, Rolling Stones, Who, Yardbirds, Animals, Kinks, Cream, Fleetwood Mac, Derek and the Dominoes, Jimi Hendrix Experience, Velvet Underground, Faces, Led Zeppelin, Deep Purple, Pink Floyd, Free, laid down so much of the sound track to the Space Age; and also for the American engineers, because, while the lunar astronauts were older than commonly imagined, the average age of Gene Kranz's Mission Control team at the time of *Apollo 11* was twenty-six. So I'm beginning to see why space and the counterculture have always seemed connected to me, why von Braun's Saturn V and the white Fender Stratocaster guitar with which Hendrix skewered the national

anthem at Woodstock less than a month after the first Moon landing sit in my mind as the two most potent icons of the second half of the twentieth century. They were America's yin and yang, symbolic of the ways in which it chose to spend its incredible wealth and vitality. Someone said that Apollo represented "the triumph of the squares," but the great good fortune of squares and freaks alike was to be involved in something that they could–had to–make up as they went along. Gene Kranz told me: "Everything we needed to go to the Moon with, we had to create–and this joy of creation was a marvel to behold ..." When we draw on the Sixties for music, movies, fashion, fiction, this is what we're after–which is ironic, because innocence is the one thing you can't re-create, can only parody.

I'm also starting to feel an affinity with the astronauts, whose birth dates mostly fall between 1930 and 1935, because we both trailed in the wake of era-defining generations (they the World War II defenders, me the Baby Boomers), looking up to and taking our values from them, and ultimately paying for some of their delusions. And I suspect that this is why the astronauts are shaping up to be more complex than expected: by the time I'd reached junior high, flying in the military meant dropping napalm on little girls–only an amoral fool would choose to do it–but to them, flying was about the daring pilots who saved the world from fascism. Charles Lindbergh was their Hendrix, Amelia Earhart their Grace Slick. Of course they wanted to fly. Of course they wanted to climb onto rockets and fling themselves at the heavens. Yet, as we've already heard, the astronaut thing was an accident.

Here's how Apollo happened.

John F. Kennedy was a perfect expression of his time. One of his more august biographers, Richard Reeves, suggests that the most significant thing about him was not anything he did or said, but his *ambition*. With little experience and no principles to speak of, "he believed (and proved) that the only qualification for the most powerful job in the world was wanting it." He didn't wait his turn and, after him, no one else wanted to wait theirs, either. He was the Pop Idol president.

The thing is this: prior to taking office, Kennedy had no more

interest in space than did the man he wanted to replace, the D-Day choreographer General Dwight Eisenhower. In fact, "Ike" resented the very thought, because the launch of Sputnik in 1957 ruined the final years of his second term. He knew the satellite represented no serious military threat and had been comfortable with what one historian characterized as the superpowers' "tacit agreement to treat the Cold War as a Cold Peace." What he hadn't seen was the way his enemies and vested interests within the aerospace industry and military would be able to use Sputnik as a stick to beat him with. Throughout the Cold War, fear of communism had been exploited less by governments than by self-serving minor politicians and bureaucrats like Senator Joseph McCarthy and the Machiavellian FBI director J. Edgar Hoover, but suddenly the venerable president found congressional big hitters wading in. And some of this stuff was colorful. The bluff Texan Lyndon Johnson, Democratic leader in the Senate and soon to be vice president, for instance, chimed:

"The Roman Empire controlled the world because it could build roads. Later—when it moved to the sea—the British Empire was dominant because it had ships. In the air age, we were powerful because we had airplanes. Now the communists have established a foothold in outer space . . ."

And what had the House Speaker John McCormack had for breakfast the morning he declared that the U.S. was facing "national extinction"? Or General Curtis LeMay, when telling Johnson's subcommittee on U.S. preparedness in technology, space and security—hastily convened after *Sputnik 2* hurled Laika the unlucky dog into orbit—that "it is doubtful in my mind whether we could catch up before we have a general war." *A what?* And if that wasn't enough, Wernher von Strangelove weighed in with the appalling possibility that Sputnik could lead directly to an orbiting bomb, even though he must have known that such a thing would be of no tactical advantage.

On and on, the subcommittee heard endless hand-wringing testimony to American technological torpor, while a symphony of detonating U.S. rockets played in the background. Tom Wolfe describes the humiliating televised "launch" of the first U.S. satellite on a Vanguard rocket, which rose six inches, caught fire,

then sank to the ground like a fat old man–Ike might have fa-
vored Lyndon Johnson–exploding. The tiny satellite was after-
ward found bleeping under a bush and the Kremlin actually
sent condolences. Then another exquisitely embarrassing Red-
stone groaned four inches up, sank back, popped its parachute
and sat on the pad like a Victorian lady with her skirts blown
round her ears, and the media and public wanted to know why
this was happening, because they'd believed the story that
American science was to be the bringer of a promised new
world where there would be plenty and better of everything, and
no poverty, no hunger, no germs ... *GE über alles!* When Lyn-
don Johnson eventually acceded to the presidency he'd always
coveted, his vision of the "Great Society" would be founded pre-
cisely upon this notion–equality and harmony through techno-
logical advancement. But American science wasn't working. In
this context, space acquired a symbolic urgency.

So Eisenhower, *Ike*, was shocked. He woke up one morning
feeling like a reluctant dad at school sports day: it seemed that
someone had put his name down for the Space Race–but what
the blazes was it? He hadn't even known there was such a thing
until everybody started telling him that he'd already lost. In his
memoirs, Eisenhower confided that during this period his main
concern "was to find ways of affording perspective to our people
and so relieve the current wave of near-hysteria." A noble senti-
ment, but he couldn't do it, and when the time came to leave of-
fice, he delivered a farewell address which stands as one of the
most bizarre in his country's history. In it, he warned of the
creeping influence of a "military-industrial complex"–a phrase
that would have sounded easier on the lips of Noam Chomsky or
Marshall McLuhan, or for that matter Chairman Mao, than com-
ing from this Republican ex-military man with little apparent
taste for drama.

The thing I love about this story, though, is how badly the
agitators underestimated Ike. His public image was of a nice
guy who was no good at politics, but people close to him say the
opposite was true. To him, this military-industrial complex ap-
peared to be less a conspiracy than a condition arising sponta-
neously from the U.S. economy, rather as class does from the

English education system. So before he left, he acted, making perhaps the most important decision anyone ever made in relation to a space program that Ike never cared for. He took the insignificant National Advisory Council for Astronautics (NACA) and turned it into the National Aeronautics and Space Administration, NASA. Then, while the generals watched in impotent rage, he kicked space into the offices of this new, civilian organization, which would unravel its secrets for the glory of science and the good of humanity. He planned to cede military applications to NASA, too, but was dissuaded. He also wanted to announce that "manned" activity would end with the Mercury program.

Next up, in November 1960, John F. Kennedy beat Richard M. Nixon to the presidency by the slenderest of margins, polling 34,226,731 votes against 34,108,157. The appointment of Lyndon Johnson as his running mate enraged the new president's brother Bobby, but was convenient politically, despite rather than because Johnson had turned himself into the prime cheerleader of space and technology. It was months before any member of the new administration saw fit to give NASA administrator T. Keith Glennan a call.

Then two things happened: the global celebration of Yuri Gagarin's orbital flight on April 12, 1961, closely followed by the Bay of Pigs debacle just four days later, when a U.S.-sponsored force failed miserably to dislodge President Fidel Castro from Cuba (conspiracy theorists and novelists such as Don DeLillo and James Ellroy had the president's refusal to sanction air cover costing him his life at the hands of an enraged CIA/Mafia). With racial tension striking fear into the hearts of Americans and the accelerating involvement in Laos, which would lead to Vietnam, JFK desperately needed to renew his dynamic image. Particularly irksome to him was the fact that Alan Shepard had been scheduled to preempt Gagarin, but last-minute safety concerns caused his *Freedom 7* flight to be delayed. JFK's close friend Hugh Sidey, a *Life* magazine journalist, described being present at a crucial meeting in the wake of these disastrous first six months in office, where the most romanticized and overrated American president of the twentieth century displayed a charm-

ing ignorance of space matters, before wailing in reference to the Soviets. "Is there any place where we can catch them? What can we do?" Science and exploration don't appear to have been the issue. Pride, vanity, political expediency *do.*

Yet there is an alternative version. Three weeks prior to the Bay of Pigs, Kennedy had resisted calls for an acceleration of rocket development. Now he prophesied that the conquest of space would become a symbol of the twentieth century and so he called a meeting with Manned Spacecraft Center director Bob Gilruth and his NASA colleague George Low. Afterward, Gilruth told Chris Kraft that the president asked about their plans for the future, so they'd told him about Mercury and an ambitious but vague idea of circumnavigating the Moon at some point in the distant future. According to this account, Kennedy interrupted, wanting to know why, if the aim was to defeat the USSR, they weren't considering a landing. As quoted by Kraft, Gilruth said:

"I didn't want to sound negative, so I told him that landing on the Moon was probably an order-of-magnitude bigger challenge than a circumlunar flight. But he didn't let it go."

The two NASA men had no idea that Kennedy was already asking his vice president to conduct a study into the proposal. But as far as some of JFK's advisers were concerned, there may have been more to this than is commonly acknowledged. In a book published in 1969, the journalists Hugo Young, Peter Dunn and Bryan Silcock spoke to Willis H. Shapley, "a reflective intellectual who sits rather oddly beside the enthusiastic pioneers of space" and happened to be in charge of space and defense affairs at the Bureau of the Budget in 1961. As Shapley told it, "People [within the administration] realized that space was the answer. It was a way of keeping up the aerospace economy and responding to the demand for more missiles without escalating the arms race." If this is true, the race to Luna really was conceived as the sublimation of a third world war which nobody wanted. All the same, NASA's Gilruth claimed to have woken screaming in his bed on the night after Kennedy announced his grand plan for space. Not only had the president bragged that they were going to sail "this new ocean" all the way to the Moon: he'd promised to do it by the end of the decade.

There were objections, of course. Dwight Eisenhower came out of retirement specially to proclaim Apollo "just nuts." Others complained that such a vast government program would lead to a proto-command economy, in which the state had too much influence, and that it would drain brains from teaching and academia, waste money which could be better spent on social problems and distract attention from security here on Earth. Such concerns were surprisingly muted, though. For one decade, and one decade only, Americans appeared happy, even eager, to place their trust and tax dollar on the collection plate of big government and its scientist priests. In his speech to Congress on May 25, JFK had called for a lively national debate on this bold but reckless proposition. It has been conjectured that he was rather hoping someone would talk him out of it, but no one did. The "debate" in the Senate lasted an hour, with only five of the ninety-six senators even feeling a need to speak.

THE NEXT YEAR, in 1962, Kennedy and Khrushchev danced a samba with the security of the planet through the Cuban Missile Crisis; then a year later came Dallas and the grassy knoll and JFK was just one more piece of Sixties lore. Now this tangled mess of dream and expediency was going to the Moon, and I'm dwelling on it at 25,000 feet on a 737 to Reno for a reason–because two other icons of that era did significant things in 1962. First, Marilyn Monroe, actress and assumed lover of JFK, committed maybe-suicide; then the crack test pilot Neil Armstrong, having spurned an invitation to apply for the Mercury project, joined the second group of astronauts and his own idiosyncratic contribution to the mythology of the Sixties was ready to begin. Reno holds the promise of an extremely rare chance to take a look at, and possibly even meet, the astronaut who holds himself most aloof from the public. The space grapevine has been buzzing with it for weeks.

From what I've heard and read, trying to describe Armstrong is like driving through a night mist: there are outlines and hints of something solid behind it, but any light you throw at him comes straight back at you, until, in the end, you see just

what you imagine you see: the reflected glare of your own expectations. And I wonder what I'll see—if anything at all? The hard-bitten Reg Turnill saw something arrogant and "taciturn," and when he'd finished showing Norman Mailer around the Cape, Mailer wrote a book called *Of a Fire on the Moon* in which he got no nearer to Armstrong than anyone else, but offered some interesting observations of his bearing at press conferences. As per the longings in his soul, the novelist saw something mystical.

"He spoke in long pauses, he searched for words," Mailer said. "When the words came out, their ordinary content made the wait seem excessive . . . as a speaker he was all but limp—still it did not leave him unremarkable. Certainly the knowledge that he was an astronaut restored his stature, yet even if he had been a junior executive accepting an award, Armstrong would have presented a quality which was arresting, for he was extraordinarily remote. He was simply not like other men . . ."

Mailer later acknowledged that Armstrong's parsimony with words, perversely, "became his most impressive quality, as if what was best in the man was most removed from the surface, so valuable that it must be protected by a hundred reservations, a thousand cautions." Mailer also spoke of the astronaut's down-home public demeanor, "that small-town clearing he had cut into his psyche so that he might offer the world a person." Wonderful. Yet it seems as likely to me that Armstrong sat at those press conferences knowing that, for the men and women chewing pens in front of him, his wretched smear across on the Sea of Tranquillity would provide just as exciting and profitable a denouement to all this as would the successful conclusion of his beautiful mission, perhaps more . . . in fact, *unquestionably* more. They asked him what would happen if the ascent-stage engine failed to ignite as he sought to break Selene's ethereal embrace and there is a temptation to laugh at his reply, which was: "At the present time we're left with no recourse should that occur." But what was he going to say—"Oh, well, then I guess we die"? In fact, the question Mailer asked his reader was much more amusing: "What if Armstrong were to take a step on the moon and simply disappear?" The entire works of Monty Python

would have been rendered obsolete. And it could have happened. One NASA employee, asked about the possibility of the LM slipping on ice, commented, "There might be giraffes up there for all we know, so why not ice?" while members of the public wanted to know whether the Moonwalkers would be armed as they stepped out of the spacecraft. Mailer's pronouncement in the early stages of his book that "the administration had decided to embark upon a surreal adventure" looks about right.

Insiders confirm this impression of Armstrong. From Michael Collins, we learn that "Neil never admits surprise," while Guenter Wendt muses that he was "clearly not the conventional astronaut . . . most would agree that he did not make friends easily." *Apollo 11* flight director Gene Kranz says that the astronaut's silence took time to get used to and complained that at meetings to formalize the mission rules, which governed when to continue with a problematic landing and when to abort, "Neil would generally smile or nod [and] I believed that he had set his own rules for the landing . . . I just wanted to know what they were." No one ever did, but Kranz strongly suspected that while there was the remotest chance of setting down, the commander with the Mona Lisa smile would go for it, whatever Mission Control advised.

Reg Turnill suggested that a contract negotiated with *Life* magazine, which gave the journal exclusive rights to the astronauts' personal stories in exchange for an annual cash lump sum, had exacerbated Armstrong's truculence with the media. The payment was regarded by the early astronauts as a substitute for danger money and was split evenly between them, but as the cadre grew from seven to over sixty in the decade between 1959 and 1969, a windfall which started out at $18,000 per annum wound up amounting to little. Worse, the stories that appeared were asinine and there was an air of propagandism about the fairy-tale American families that could be found within the pages of arch-patriot proprietor Henry Luce's organ. Reg and the rest set out to undermine these stories by preempting them, but an unfortunate side effect of this effort was to ruin what trust had existed previously between spacemen and media, particularly once the postflight divorces started happening.

Some of the astronauts, this new breed of real-time celebrities at the center of the first global media event, understandably began to get sensitive about the attention given to their relations with their families.

"So there was a clampdown," Turnill explained, "because instead of appearing as gods who were to be worshipped for their perfection, they were being presented as ordinary men and they resented this."

He then recited a formula which has echoed through the corridors of celebrity for thirty-five years now, but was new then.

"Although they liked being icons in a way," he said, "it started to ruin the fun of it."

Some of these men never recovered from their encounter with the new fame that rained down like mortar from satellites in the sky. How unfair it must have seemed, this great quest being assailed by trivia and prurience, infected with other people's fears and fantasies. Armstrong was particularly resentful of this, according to Turnill.

"Of course, Armstrong was a great, great pilot," he admitted, the sour taste still fresh in his mouth after all these years. "But he must be very vain and insecure inside, because he could never deal with the press. We could never talk to him. You ruffled his feathers as soon as you spoke to him, because he'd resent you asking that question—or almost any question. I've encountered this with many great men."

The situation didn't improve after the first Moonwalker returned to Earth. Newspaper reports suggest that he was inundated with offers from agents and movie producers and companies eager to sign him up to sponsorship deals, all but a few of which he rejected. A museum in his hometown of Wapakoneta, Ohio, was already being planned and his image was everywhere: he received tens of thousands of letters, including love letters and hate mail, while gossip columnists busily linked him with Hollywood starlets. Instead of cashing in, he took a NASA desk job, then a master of science degree from the University of Southern California, before returning to his home state as Professor of Aerospace Engineering at the University of Cincinnati,

where he stayed until 1979, commuting from a farm he bought in nearby Lebanon. After the teaching, it was business and a list of anonymous corporations which found value in his profile and gift for precision at boardroom level. For a while, he took part in press conferences once a year, but gave no general interviews, *ever*, and his public presence eventually faded away. The former *Life* reporter Dora Jane Hamblin spoke of Armstrong being capable of "cold, tight-lipped rage," but added that it was mostly reserved for people whom he felt were trying to exploit him. In 1976, a *Cincinnati Post* article headed "Cincinnati's Invisible Hero" reported his anguish over an advertisement for the university's Earth Day celebration, which promised the attendance of "our spaceman." "How long must it take before I cease to be known as a spaceman?" he is said to have snapped.

By the twenty-fifth anniversary of the first Moon landing in 1994, the *Cincinnati Post* was running another piece, this time headed "In Search of the Man in the Moon," which claimed that "to most of his neighbors, Armstrong may as well be the man on the Moon." The *New York Times* went with "In Rural Ohio, Armstrong Quietly Lives on His Own Dark Side of the Moon." As if to confirm as much, almost no one had noticed when he and Janet, his wife of thirty-eight years, divorced a few months earlier. By July, there were rumors that he had already remarried, but no one could be sure, because the court records were sealed. The *Times* reporter found that the people of Lebanon wouldn't talk to him, but when a weeklong celebration of the anniversary took place in Wapakoneta, some townsfolk expressed annoyance that he refused to attend. Even NASA staff are recorded as taking offense at his refusal to sign autographs. All the same, the very few people who can count themselves as friends of the First Man on the Moon insist that he is warm, loyal and friendly, and I hear intriguing rumors of him playing ragtime piano at family gettogethers, which no one seems able to confirm or dismiss.

You don't need to be an amateur psychologist to find seeds of all this in his childhood. Armstrong was the eldest of three children, with a mother who looked after the home while his father worked as an auditor for the state of Ohio. This involved inspecting the books of individual counties over the course of a year, af-

ter which the family would pack the car and move to the next county, where another rented, furnished apartment or house would be found. Making close friends must have seemed pointless and painful, especially when the family appears to have provided a secure, stable alternative. His mother was a lover of books and music, who taught him to read before he hit school and arranged piano lessons when the family could afford it. He also had an attentive father, who allowed his boy to skip Sunday school for a first plane ride when a visiting flier was in town and became an assistant scout master when Neil joined the Boy Scouts. In the early years, his passion was model airplanes, but by the time high school came, the family had finally settled in Wapakoneta and the available records suggest that he thrived. When he got a job at a local bakery, he used the money to buy a baritone horn and joined the school band; he was on the student council, took part in drama, sang in the "Glee Club" and, for a brief time, played in a jazz group called the Mississippi Moonshiners. His teachers later recalled an excellent student, a perfectionist with an enthusiasm for math, science and astronomy. A neighbor whose telescope the young Armstrong borrowed remembers him as polite, bright, intensely quiet.

He got his pilot's license and graduated high school at the age of sixteen, then won a U.S. Navy scholarship to study aeronautical engineering at Purdue. There is a story that when the acceptance notice came, his mother was so surprised by his shout of joy that she dropped a jar on her toe and was hobbling for days. Thereafter: he was called up to Korea, where he bailed out once, had part of a wing torn off yet wrestled the plane home, and won three air medals; returned to Purdue and met Janet in 1952, but took two years to ask her out ("Neil is never one to rush into anything"); then landed a job as a research pilot for NACA (soon to become NASA) at Edwards in 1956. A son, Eric, was born in 1957 and a daughter, Karen, two years after that. When NASA took on the first astronauts in 1959, he fell for the "Spam in a can" line and didn't apply, because in an airplane, he was an artist, able to control a twenty-ton machine at Mach 1.5 with the delicacy and grace of a painter applying his brush. Instead, he stayed at Edwards and flew the now leg-

endary X-15 rocket plane seven times, coaxing her to 200,000 feet and almost 4,000 miles per hour. When the next intake of astronauts was announced in April 1962, though, he applied and was selected from a field of 253, one of two civilians in his group, the other being Elliott See, whose death gifted Buzz Aldrin his place on *Gemini 12*. That must have been a strange and unsettled year in the Armstrong household; three months earlier, on her parents' sixth anniversary, Karen had died of an inoperable brain tumor. Another son, Mark, was born in 1963.

In 1966, Armstrong became the first civilian to fly in space, on *Gemini 8* with David Scott, by which time he was already riling reporters. One grumbled that "He disdains all talk about people. He prefers to talk about ideas and hardware." Immediately prior to *Apollo 11*, the *Journal Herald* of Dayton, Ohio, asked how he felt about his chance to be the first person on the Moon and the gods of language ran screaming from the room.

"I'm certainly not going to say that I'm without emotion at the thought," he confessed, "because that wouldn't be factual . . . I don't think very much about the emotional aspects."

Son Mark was more eloquent, with his "My daddy's going to the Moon. It will take him three days to get there. I want to go to the Moon someday with my daddy." Like the rest of us, Mark would never get the chance.

It's reckoned that almost 600 million people watched the landing, in a world containing a fraction of the number of TV sets that it does today. The most curious thing about Armstrong then was the fact that even at the age of thirty-nine, he looked no older than twenty-six. As Mailer said, "something particularly innocent or subtly sinister was in the gentle remote air." And I know how Mailer felt as I rattle into Reno on a casino courtesy bus, then pick my way between the slot machines in a lengthy search for the elevator and my room at the Sands Regency.

The place is heaving because the National Air Races are in town. Last time, they had to be canceled because of the still-unfolding disaster in New York, but this year they're pugnaciously back and on Saturday something special is scheduled: an Apollo Astronauts Reunion Dinner, featuring a lineup of Apollo and Skylab spacemen who will attend as honorary race

marshals. Buzz will be there and so will Dick Gordon, and interest among Apollo buffs was politely enthusiastic until a rumor got out that "Neil" might appear, at which point chat-room roofs were raised and a mad scramble for seats began. The difficulty was that single places were not for sale. The only way to make it was to buy a table, starting at $1,000 and rising to $5,000, and it took me a hair-tearing week and five hundred bucks to track down a spare seat at the table of a kindly space-nut dentist named Bill. He told me that the race authorities had made it as difficult as possible for him to buy his table, because the dinner had been shaping up as a nice industry jolly until word got out about Armstrong—at which point the fans descended in pestering droves, as if pouring from some embarrassing rip in the fabric of the race-jock universe. But I got my ticket. Now I'm here.

I HAD A FANTASY as a boy, born of being marched through casinos longing to stop and bathe in the sights and sounds and smells, the flashing lights and falling coins and free whiskey sours distributed by smiling waitresses in costumes that remade breasts as satin warheads, but not being allowed to because of my age and the strict Nevada gaming regulations, which didn't even sanction you to stop and look. When I grew up, I said, I was going to get a Harley and drift through the mountains to hit the tables in this town, and I suppose what I had in mind was the posters that hung in the shopping mall of Dennis Hopper, Peter Fonda and Jack Nicholson astride their choppers in *Easy Rider.*

A few years after that film's release (within months of Armstrong's touchdown), we sneaked into the local cinema to see it and the scene I remember most was where the hippy drifters sit around a campfire, licking their wounds after a brush with some local rednecks, and Nicholson drawls, "Oh, yeah, they gonna talk to you and talk to you and talk to you about individual freedom, but they see a free individual, it's gonna scare 'em" (he's right, too, because that night the rednecks sneak into the woods and kill him). Clearly, in my boy's imagination the casinos of Reno represented the kind of freedom Jack was talking about, but now, through jaded grown-up eyes, I see only squalor, the

most melancholy place I've ever been—more so than Helsinki in winter or Colombo in Sri Lanka, which has the excuse of a long-running civil war. The one-armed bandits pall quickly and the gaming tables sit in a fug of desperation, yet at nine in the morning there are people with beers in front of them, shoveling money as if in a trance. I've never seen pawnshop superstores before, nor corner shops selling Devil's Food Cake *lite*.

So on Friday morning I'm pleased to be in the open air, or at least riding a bus on my way to some. The Stead airfield nestles in the feathery hills just north of Reno. The astronauts did their survival training near here, and the notorious Area 51, where the Roswell alien was purportedly held and hoax theorists claim the Moon landings to have been filmed, is a rocket's flight into the scrub and powder soil. Some of the fighter pilot astronauts learned to fly combat here, too: in *Carrying the Fire*, Michael Collins notes that twenty-two of his classmates died on the eleven-week course. Today, his heirs, plane enthusiasts, speed junkies, thrill-seekers to a man (and occasionally a woman), will skim tight circles around a series of pylons erected in the high desert, so close that they could almost reach out of their canopies and high-five each other, and low enough to the dust devils on the plain that you feel as though you're right in there among them. It's a dangerous business, an American pioneer thing that would have safety officials throwing themselves off cliffs in the U.K. or anywhere else, but by God, it's exciting to watch. This year, for the first time, they have a jet class, with eight pilots flying old Czech L-39s, which have been cheap to buy since the fall of the Iron Curtain.

What makes people fly jets or climb into rockets? I went for a twirl with a pilot from the Royal Air Force's Red Arrows display team to find out. His name was Dicky, he was twenty-seven and, like the other pilots I met that day, he had a calmness and sense of containment about him that was impressive. He'd grown up near an airport and from the age of about five would stand in his garden noting the times of the planes' passing and what kind they were. It was a given that he was going to fly when he grew up, so he joined the Royal Air Force and there

was a strange intimacy in his relationship with his plane, as though they were lovers rather than man and machine. Dicky told me that he had no desire at all to drop bombs on anyone, though of course he would if ordered to. He also taught me about the constant calculation that goes on in the mind of a pilot in relation to speeds and heights and angles, noting that it's perfectly possible to reach the top of a low-level loop and suddenly apprehend that an unfortunate miscalculation moments ago makes it a mathematical certainty that you will be hitting the runway in 4.3 seconds, at a speed of 358 nautical miles per hour. In fact, one of the Red Arrows had done just this the previous year.

What I learned, though, is that Ed and Dick and Buzz are right about fast flying. It takes no effort on my part to recall the sensations. The British Aerospace Hawk is a trainer plane, meaning that you sit in an elevated position behind the instructor, with your own joystick and throttle. On takeoff, the cramped cockpit gets imposingly hot, but with only glass and air surrounding you, you seem to be hovering, to be part of the sky–an experience more akin to riding a magic carpet than flying in the back of a commercial airliner. When you turn, the wing dips through a full ninety degrees, until you're perpendicular to the ground and intuition insists that you are about to plummet like a stone to meet it. You think that no one can hear you scream up there, but Dicky absolutely heard me. He also heard me giggle like a tickled infant when he flipped the Hawk over and we were powering along upside down, lifting our eyes to the homes and lives of all the not-pilots below. Dicky showed me how to do a loop and I flew my own, sliding the throttle full forward and pulling back on the stick in a way so counter to instinct that it takes a real effort to do it–but the thrill was indescribable. Coming over the top, I had what the pilot afterward described as a gray-out, where the capillaries at the back of the eye are compressed to the point where vision blurs and momentarily dissolves into a gray vortex, and on the way down, we pulled four "Gs," which is a sensation like no other: an inescapable, stifling physical presence that pins you to your seat and takes your

breath away, as though you're being crushed by some misanthropic phantom. One "G" is equivalent to the force of Earth's gravity: four "Gs" are four times that force.

But there was more. Red Arrows planes are fitted with smoke pods for use in displays and Dicky's "Red 7" had a new one which needed to be tested for stability at speed. To do this, we swooped down to 1,000 feet at 500 knots, then pulled back the stick and shot directly upward, exactly like a rocket, to 17,000 feet. The maneuver took seconds, but felt like aeons and as the plane gradually slowed I was left with a disorientation so complete that my mind simply abandoned ship. I was seated, but there was no pressure anywhere on my body, just a sense of floating in a horizonless, uniform, azure void, with nothing to provide perspective or evidence of where the world was, or even confirmation that it existed outside of myself. It occurs to me now that this is what Kubrick was trying to suggest in the closing scenes of *2001;* an approach to nothingness or infinity, a state in which the mind dissolves into everything, no longer grasps itself; a foretaste of the unimaginable, *the end.* Still the most intense and extraordinary sensation I have ever had, when I told Dick Gordon about it, he enthused, "Hey, you'd have experienced some zero G there!"–just like in space. Bloody right, I said, and on the way back, having tumbled out nose-first and dropped down like a brick, we made six Gs and I blacked out properly, to wake with no control over my limbs. Pilots call this "lock-in" and it typically lasts about ten seconds. If it happens to one of them while flying solo, they're unlikely to survive it, though of course they train hard to make sure that it doesn't. A little later, after a succession of aggressive "skid and rolls" at 200 feet, I was finally sick. I got the feeling that Dicky wouldn't have been satisfied until I was. My respect for pilots is absolute.

SO THEY'RE RACING vintage Mustangs and Sea Furies and Yakovlevs as I step off the bus and move across a sea of tarmac to the runway. More vintage planes are being readied by loving mechanics, all bright chrome and dancing enamel paint; perfectly proportioned and unquestionably beautiful in the gleam-

ing sun. There are some lackluster aerobatic displays in be-
tween heats, but the rampaging heats are enough, like watching
all the chariot scenes from *Ben-Hur* spliced together and run
back to back as the planes jockey and joust and scream around
the pylons within feet of each other. I take a bus to the center of
the field to get the even more thrilling view from the "home" py-
lon, and I am there when the "Sport" class planes take to the air.
These are the aviation equivalent of hot rods, mostly built from
kits and extremely powerful, with ungainly features–like im-
modestly short wingspans and attenuated tails. They're small
and light and fast, with an agility that comes from being funda-
mentally unstable and they bob and weave scarily for a share of
the $46,000 purse.

And that's when everything changes. As a quartet screams
toward us and banks to turn left, the lead plane wobbles, then
steadies, then begins to vibrate, its tail "porpoising" violently in
the rough air thrown out by the other craft, and something
seems to fall off–*shit, part of the tail*–at which point it simply
turns to the ground, like a man turning away from a conversa-
tion he's no longer interested in, and piles straight into it with a
sickening crunch and show of dust; the dust rising slowly, al-
most tenderly, as if forming a shroud.

The race is halted. One of the other pilots, shaken, crashes as
he tries to land and his plane is totalled but he's unhurt. The
craft which was lost was doing over 300 miles per hour and
what remains of it is no more than a hundred yards from where
I stand. I can hear an announcer speaking in a low voice on the
other side of the runway, but I can't hear what he's saying. A
hush descends. As so often with death, the shock is its lack of
ceremony. There was no explosion, no fight with the controls, no
tantalizing offer of redemption. No drama at all. As the jeeps and
fire engines and ambulances arrive redundantly, we're hustled
back into a bus and returned to the public area.

During the hiatus which follows, I find myself drawn to the
media center, where half a dozen camera crews and forty or so
reporters drink Pepsi and coffee from huge silver urns and kill
time waiting for news. The gruff race president, Mike Houghton,
won't confirm the identity of the pilot at first, because his father

and two sons have just arrived in Reno, and a committee consisting of the pilot's team leader, the race chairman and chaplain have gone to meet them. He says he'll tell us more once they've been informed; then he disappears, leaving the media to stew in the heat. As he marches away, a young woman from the local TV station, good-looking and bizarrely well groomed, bellows into a mobile phone: "I'll give him my script and then we can cut a bite . . . and then you're gonna–oh yeah, 'cos someone's died. Yeah, he broke into lots of pieces. There's virtually nothing left." I watch, thinking of the icy weather-girl-turned-reporter Nicole Kidman played in *To Die For,* then move into the shade of the near-empty press Portakabin, where a retired Air Force colonel is holding forth on Korea and Vietnam. I ask him for his strongest memory of those conflicts and he says:

"You know, in those days, the most effective weapon we had was napalm. The most upsetting thing I was ever involved in was one day when we were ordered to drop some on a horse-drawn artillery unit. It was horrible, I couldn't eat my sandwich afterward, those horses were jumping around all over the place, just burning up. That was terrible to see."

And he never saw it fall on people? I ask.

"Oh, sure. It's funny how, in a war, you don't mind killing people, but hate to see animals getting hurt."

A bomber-jacketed local reporter, whom I take to be a vet himself, nods solemnly.

The colonel goes on to tell us that he thinks these planes are inherently dangerous, and I can't help noticing that the reasons he gives for this are all the reasons pilots think they look cool.

"People are too concerned with appearances these days," he concludes with a frown and shake of the head.

Outside in the public area, everyone's saying the same thing. *At least he died doing what he loved.* And I suppose they're right, it's better than being run over by a bus. But I keep thinking about the pilot's sons at the check-in desk of their hotel, turning to see that whey-faced committee walking toward them, and I won't be going back to the races. In the morning, the Reno *Gazette-Journal* front page carries stories about Colin Powell trying to build support for a U.N. resolution on Iraq, and a pugnacious

Bush speech being angrily denounced by an official of that country... about an al-Qaeda cell being discovered in Buffalo, Bill Gates's fortune falling from $54 billion to only $43 billion and a collection of Leonard "Mr. Spock" Nimoy's "fine art" photographs hitting town. It also reports that the crashed pilot's name was Tommy Rose and that he was from Hickory, Mississippi. He had a father called Elmer and his plane was known as "Ramblin' Rose." What's more, as they'd flown more than four laps of his race, the result was deemed to stand. Tommy won.

ALL SATURDAY, this is what I'm thinking:

If a pilot can go down so abruptly and without warning, in less than the time it takes to deal a hand of blackjack, then how on Earth do we explain the fact that Neil Armstrong is still with us?

We know about his near misses in Korea. Now add to them the time his X-15 rocket plane's engine refused to fire after being dropped from a great height by its B-52 bomber host. More serious still was the occasion in 1966 on which he and his partner on the *Gemini 8* mission, David Scott, attempted to rendezvous and dock with another craft for the first time—a maneuver that even the Soviets had failed to pull off up to then, because the logic of rendezvous in space bears no relation to that which applies closer to Earth. For instance, if a pilot wants to catch up with another plane, he or she simply increases thrust. It's obvious. But increasing thrust in orbit will just push a spacecraft into a higher orbit—and higher orbits are slower because their circumference, the distance an object must travel in order to arrive back at the same place, is greater, and gravity weaker. Thus, through increasing your speed, you've ended up further behind your target than you were in the first place—which means that, bizarre as it sounds, the solution for an astronaut who wishes to catch up with another craft is to *decrease* velocity, so sinking to a lower, shorter, faster orbit, then to gradually transfer back up to the original one at precisely the right point to meet the target. This stuff is called "orbital mechanics" and it manifestly *is* rocket science.

All of which means that Armstrong and Scott were feeling good about catching and connecting with a specially adapted

Agena rocket which had been fired into space for precisely this purpose. In fact, they'd made it look easy, and as they entered a part of their orbit where they would be out of contact with NASA's tracking stations on the ground, everything looked fine. The next time Mission Control heard from the astronauts, however, all hell broke loose, because during radio silence the *Gemini*/Agena coupling had started to spin, then to roll, then tumble. David Scott tried to describe what was happening, but his voice was stressed and the words unclear. NASA had been concerned about the reliability of the Agena from the outset, but when the pilots undocked from it, the problem unexpectedly worsened. Soon they were tumbling at one revolution per second, banging heads as they were buffeted about the craft and suffering from "gray-outs" like the one I experienced with Dicky and there was a real danger of them losing consciousness. As *Gemini 8* passed out of contact again, it looked as though America was about to offer its first sacrifices to space, but the next thing they heard on the ground was Armstrong telling controllers that he'd brought the ship under control. According to flight director Chris Kraft, his voice had stayed "amazingly calm" throughout. The problem was eventually traced to a faulty thruster, but they say that few NASA staff could watch the cockpit film of the incident without feeling sick. It's unlikely that many people would have made it through that one, but Armstrong did.

And we're still not done. More notorious even than *Gemini 8* was the incident with the Lunar Module trainer, a terrifying piece of kit dubbed the "flying bedstead" because that was what it looked like: a bed with shrill jet engines and rockets screaming at the posts, which enabled it to hover as the LM would do over the Moon. The trainer was ungainly and unstable and the management didn't like it, but the pilots did, until one day in 1969 Armstrong was at the controls several hundred feet off the ground and it began to tilt. He tried to steady it, but couldn't . . . stayed, stayed and finally, with the contraption on the brink of upending, ejected, his chute opening just in time to save him. The trainer was consumed in a fireball and careful study of the now famous film of the ejection suggests that NASA was no more

than two-fifths of a second away from requiring a new *Apollo 11* commander.

And we're nowhere near the Moon yet. America never lost anyone in flight until 1986 and the space shuttle *Challenger*, but the Russians did. The three-man crew of *Soyuz 11* suffocated when their spaceship suddenly depressurized on reentry in 1971, but earlier, in April 1967, a few short months after the *Apollo 1* fire, the popular and vastly experienced Vladimir Komarov hit trouble as soon as he reached orbit in *Soyuz 1*. Cosmonauts and engineers had known the craft to be dangerously flawed and Komarov had told a friend after an evening out with their families that "I'm not going to make it back from this flight."

"Of course he kept his emotions in check in front of his wife," said the friend, "but when we were alone for a moment, he collapsed completely."

Asked why he didn't refuse to fly, Komarov replied that then his friend Yuri Gagarin, as backup, would be killed instead. Gagarin, for his part, did everything possible to take the other man's place. Both knew that Brezhnev and the Politburo were determined that the flight should take place as planned, probably so that it could perform a symbolic docking in space to mark the fiftieth anniversary of the 1917 Revolution. The launch was successful, but once up, a solar panel refused to deploy, diminishing the power supply to the guidance computer and thrusters and causing the craft to tumble out of control. Komarov had twenty-six hours in which to contemplate his death as the malfunctions mounted, then to bid his wife, Valentina, farewell by videophone. Workers at an American listening post in Istanbul heard him advise her on how to handle their affairs and discuss the future of their children. When the hard-bitten future Soviet premier Aleksey Kosygin came on the line, he was in tears, too, and although Komarov flew what by all accounts was a brilliant reentry under the circumstances, he was spinning violently as he reached Earth's atmosphere, causing his parachute to tangle, followed closely by its backup. His final moments were spent careening into the steppes at 400 mph, conscious and cursing bu-

reaucrats to the last, and it's said that Gagarin never recovered from the loss: a year later, having become an open critic of the program, he, too, was killed when the jet fighter he flew spun out of control. Conspiracy theorists like to imagine that he was assassinated.

Finally, a year after Gagarin's death and just three weeks before *Apollo 11* flew in July 1969, a gigantic N-1 Moon rocket, the largest ever built, exploded twelve seconds into its flight, finishing off Soviet lunar ambitions for good. The rocket stages and fuel tanks of leftover N-1s were reportedly hammered into storage sheds and playgrounds for children. The Space Race had a winner.

The point is that there was nothing inevitable about the safe return of Armstrong's *Apollo 11* crew. Most of the astronauts privately rated its chances of success at between 50 and 30 percent, with a 30 percent likelihood of the unthinkable happening. The doyen of newscasters, Walter Cronkite, had asked how a society "which seems to have difficulty building a reliable washing machine dares to build a spacecraft to land on the Moon?" This seemed a reasonable question and NASA had a prearranged plan to cover disaster, which involved instantly cutting communications with the rest of humanity, while retaining their own lines to the doomed men. President Richard Nixon had a speech prepared for such an eventuality and Wernher von Braun had publicly hoped America could be mature enough to accept such an outcome. Not only were there the fears of the Lunar Module landing on icy slopes or molten lava; of falling through a thin surface crust, catching fire, blowing up, being consumed by insectlike aliens or the disgruntled grandparents of Nepalese schoolchildren; there was nightmarish *stuff* involved. For instance, the LM has been compared to a Stradivarius violin in the artfulness of its design and construction, but its fuel oxidizer was one of the most corrosive substances on Earth. A minuscule leak and the *Eagle* would eat itself. Indeed, fearing the prospect of a stranded crew, its manufacturers at Grumman Aerospace experimented with making the LM's skin edible, but the result tasted so bad that starving seemed preferable.

All this undoubtedly had something to do with the mytho-

logical aura that surrounded *Apollo 11* even before it took off. Chris Kraft admits that he felt his legs shake the first time he met the crew in a corridor following the announcement that they were "it." Their launch was attended by roughly 20,000 "VIPs," 1 million members of the public and 3,500 accredited press men and women. Up to 1 billion were claimed to have followed it on TV, at the end of a countdown that had lasted five days. Some say that one in seven of the world's population would see the first step when it came and the crew felt the tension, too. Mike Collins remarked privately as he made his way to the near-deserted pad on that hot, close day: "There are one million visitors here to watch the launch, but I feel closer to the moon than to them . . ." His wife, Pat, expressed her fear through a poem, which asked: "Can you love me, and still choose whispers that I cannot hear?"

According to everyone I've spoken to who was there, most people were crying at liftoff. At a press conference afterward, Wernher von Braun called it humanity's biggest moment "since life first crawled out of the slime." As they approached the Moon, a magnificent and intimidating sight, even Armstrong sounded excited, and once they'd landed, no one knew precisely where they were–although it was known that somewhere nearby, the Soviet *Luna 15* probe, sent in a last-ditch attempt to grab a first clawful of lunar soil and make Apollo look silly, was assaying some wild moves in a prelude to crashing. The whole thing had an air of hallucination about it, so perhaps it's unsurprising that you now hear stories of Armstrong never having walked, or gone at all; of Islamic Web sites claiming that he secretly converted to the faith after "hearing the *adhan* [call to prayer] on the Moon"; of his tribute to Mrs. Gorsky. A passage I particularly love from John Updike's *Rabbit Redux*, which is set in 1969, has Rabbit, marriage failing, gut spilling, life a smudge of failed expectation, meeting his father in a bar after another day's mindless work. It goes:

> Pop stands whittled by the great American glare, squinting in the manna of blessings that come down from government, shuffling from side to side in nervous happiness

that his day's work is done, that a beer is inside him, that Armstrong is above him, that the U.S. is the crown and stupefaction of history. Like a piece of grit in the launching pad, he has done his part.

BILL, THE HOST of my table, pulls onto the grit of the Sands car park in a big black SUV. With his sandy hair and toothy smile, he looks a little like Ron Howard's dentist cousin—and might be, for all I know—but that's not the first thing to strike me about him: what I notice first is that he's wearing a neat polo shirt and beige jeans. This is significant because an apparently reliable source at an LA space auction house told me that the Reunion Dinner called for "business attire," meaning that I've been standing in the still-hot late-day Nevada sun, trying not to sweat in my suit, *unnecessarily, AGAIN,* and am surely now doomed to reprise my role as the uptight, overformal Brit for the rest of the evening. I consider drawing an "Actually, I'm (half) American" badge, but settle instead for a resolution to launch my gin and tonic at the first person who tells me that I remind them of Hugh Grant. Waiting in Bill's car are his girlfriend and her brother, and Bill's teenage son, who probably thinks he's humiliatingly overdressed because he hasn't been allowed to wear his Puddle of Mudd T-shirt. It's not fair.

Bill's your card-carrying Really Nice Guy, mild in manner and sharper than he lets on at first, and he's really excited. Thirty miles south in Carson City, he has a wall full of autographed astronaut photos and memorabilia, and he invites me down to see it tomorrow, explaining that this is a really big deal for him, because you don't often get the chance to see Apollo astronauts, and you *never* get within snapping distance of Neil Armstrong. He adds that Armstrong has a reputation for not showing up, so we shouldn't count our chickens, and we gossip space on the single block drive to the Golden Legacy, and park next to a poster advertising next week's appearance by the Doobie Brothers. Inside, we pick our way through the thousands crowding the tables and slots and finally find the escalator to the exclusive predinner cocktail reception.

Human static fills the air. Flashbulbs flash. The room is the size of a basketball court, with a raised podium along one side and a bar and buffet running the length of either end, tended by men in white jackets and bow ties. In between are tables, but hardly anyone is sitting at them. Most guests either stand scanning the room or spin in little constellations across the floor, constantly moving, dissolving and reforming somewhere else. It takes me a while to notice that, out of perhaps two hundred people, a few wear matching green shirts, and that the constellations revolve around them. Then I see the green-topped figure of Charlie Duke, tall for a pilot and rocket-spined, surrounded by people with cameras exploding light, tilting his head to hear questions and comments and smiling happily, easily, handsomely with drink in hand—a different man from the somber one I met in London after the loss of Pete Conrad. A short distance away, Dick Gordon yuks and winks through his milk-bottle glasses; Roy Orbison leprechaun. And Buzz is there, tanned and serious, with Lois on his arm and a crowd of men hanging on every word. I recognize Gene Cernan, too, who's turned himself into a one-man space nostalgia industry and is with a very attractive, much younger woman. If you had to capture his mien in a single word, there's only one that would do. *Erect.* Gene Cernan is erect.

There are others I don't immediately recognize—not Moonwalkers—and some who flew Skylab rather than Apollo. But no greensleeved Neil Armstrong. The room is full now. So we hit the bar.

And that's where I am, waiting my turn, when I hear a voice rear up behind me, a woman's voice, gushing like a burst water main.

"Hey! Are you Neil?"

I turn and see a large woman in shiny purple-and-black cocktail dress, just a few feet away, facing a bespectacled man in a blue pinstripe suit and discreetly patterned tie. Business attire. It's strange what time does to a face, discarding some features and cultivating others, until you end up with a kind of benign caricature of a younger self, a soft reopening of channels to the infant. Again the surprise: I wouldn't recognize him in a crowd.

He's tallish, perhaps five-ten, and thicker than he was thirty years ago, but not so very much. He'll prove to be the only astronaut here tonight not wearing a green shirt and I wonder what inspired his decision. He fixes the woman with a steady gaze and speaks quietly but firmly. Is he Neil?

"Yes."

Another shower of words.

"Great! Then wait right there—I gotta go get something for you to sign . . ."

The steady gaze.

"No, I don't . . ."

"Oh sure you do!" comes the reply, and she shifts her weight to move.

Neil doesn't say anything. He just tightens his lips and shakes his head, wearing an expression of such utter expressionlessness that it becomes extraordinarily expressive—as elegant and unequivocal a means of saying "fuck off" as I've ever seen. Unfortunately, I don't catch the return response, because another woman is talking to me now, asking with some urgency whether she can borrow a pen. She casts an eye back at the astronaut and I tell her that I don't think he signs. "Oh, if you shove something close enough in front of his face, he'll sign," she replies confidently. I give her a pen, interested now in seeing what happens to it, but by the time our attention has returned to Armstrong, he's slipping away, followed by a trail of jostling people. As he moves, I can see others converging on him from the side, creeping through the channels between tables with the fixed gaze of cobras on their prey. Periodically, someone manages to place themselves directly in his path and he has to stop. He bows his head as they shout something in his ear—"So, Neil, what was it *really* like on the Moon?"—then he nods and squeezes a little smile, shakes off the crowd, trudges on, but finds another one clinging to him like ants to a mantis.

I say hello to Dick, and find Lois and Buzz sitting at a table in front of plates full of untouched canapés. I tell Lois—truthfully—that she's looking glamorous and try to say hi to Buzz, but he seems to be in some sort of trance. He's clutching a small piece of paper and holding a pen to it, but his hand appears frozen. He

can barely utter a greeting and I'm not sure whether the glazed look in his eye indicates concentration or fear, because he knows–I don't–that he's going to be called up to the stage later. In contrast, Charlie is relaxed and welcoming. We chat for a while and arrange to meet again in October, after which I go looking for Bill, and am enjoying a moment's peace on my own at the bar by the entrance when I see the First Man, Armstrong, coming toward me. Involuntarily, I start. Our eyes meet and I fancy that I can see some sort of assessment going on–"How likely is this person to shout some demand in my face, or tell me at length where he was on July 20, 1969, while I was a quarter million miles away in the sky?" Then he cuts right and slides between two tables and, quickening his pace, saunters through the exit, leaving a contrail of people holding cameras and autograph books to gaze after him. He's gone. A few beats pass and the fans melt back into the room. In my imagination, Armstrong is whistling like Huckleberry Finn, ready to break into a run the moment he gets round the corner.

And so it goes that ten minutes later the astronauts are being summoned to the front to receive yet another gratuitous award. Each member of the corps is called individually, in reverse alphabetical order, rising to a peal of applause. Second to last, the name "Neil Armstrong" soars through the whiskey-sour yonder, followed by a brief salvo of clapping, then . . . nothing. He appears not to be with us. The MC coughs, throws a glance to the wings to see if anyone knows what the hell's going on, then recovers quickly, with a resounding "Buzz Aldrin!" at which cue Buzz obediently ascends. Upstaged, even here. As it happens, someone I later meet in Houston is passing through the upstairs casino to use his mobile phone at this precise moment and finds the First Man on the Moon perched on a stool in front of a one-armed bandit, just sitting, silently on his own, staring at the cherries while the casinogoers hustle and bustle around him with no notion at all of whom they're bustling past.

Dinner is served in a larger hall on the other side of the building. On the way, my party chatters about what we've seen so far. Bill is like an eight-year-old again. His son is puzzled and politely bored: he tells me about skateboarding and the punk

metal music he likes and I tell him about a time I found myself in the back of a stretch limousine (long story) on the night that a Bon Jovi concert was taking place in a provincial British city. Unaccustomed to seeing limos on their streets, citizens of the town assumed our car to contain Jon Bon Jovi himself. So what did they do? Some just waved or screamed, but many others strode over and pressed their faces hideously to the smoked glass, or tried to open the door, or shouted abuse, or dropped their trousers and waggled their arse, in ways which shocked and baffled me. Neither was this any kind of aesthetic protest– which I could have understood and perhaps even applauded– because many of them were on their way to the show. And I thought: if this is how humanity presents itself to a celebrity, no wonder celebrities are inclined to go a bit odd.

We talk about why this is and I think it's something to do with ownership. Old-fashioned fame was acquired, but celebrity is bestowed: it only exists in relationship with the audience-jury we supply and comprise. Thus, we're the arbiters. They owe us. We voted them in and we can vote them out, more immediately and effectively, in fact, than the politicians who themselves look and behave more like celebrities every day (perhaps in an effort to revive our waning interest in *their* show). Of course, Neil Armstrong is not a celebrity in the strict sense; because he did something to earn his status, his *fame* has a hinterland, but the boundaries between the two conditions have become so confused that we no longer recognize this distinction. *So you'd better sign the autograph, sucker. You're lucky I even ask.* A widely reported study in the U.K. found that people who earn more than £35,000 ($65,000) a year feel more deprived than those who earn less, because they feel licensed to compare their lives to the more fabulous existence of their democratically appointed stars, and they wonder when their turn's coming. Is it possible that our adulation of the famous is no more than a Trojan horse for our own disappointment and anger? Is this what Armstrong runs from?

We've arrived. Only purchasers of more expensive tables were admitted to the reception, so the dinner hall is larger, with a raised stage. There are more drinks beforehand, then a meal

whose every mouthful is forgotten before it's swallowed, save for a space-shuttle cake at the end (we don't know it yet, but by this time next year celebratory space-shuttle cakes will be a rare thing indeed). Then the bearlike race president, Mike Houghton, marches to the lectern and calls the astronauts one by one to the stage again, in forward alphabetical order this time. There's wild applause. Armstrong shows up now and is whooped. Charlie beams and the other spacemen all hug Dick. They sit behind a long table and wait for Houghton to initiate the proceedings, which he does with a defensive post-9/11 appeal to patriotism ("in recent years, it's become unfashionable to call yourself a patriot of this great nation") followed by an invitation to stand and pledge allegiance to the flag like schoolkids.

Those opening words:

"I pledge allegiance to the flag/of the United States of America . . ."

Jesus. The room disappears and I'm wheeling back into myself, because the last time I did this I was in sixth grade and my antiestablishment teacher was smirking because the pledge was about to be banned for its reference to God. Then a silver-haired male choir arrives to barrel "The Star Spangled Banner" and I'm surprised to find a little shiver running up my spine, for this awkward song that tells such a romantic story, of a time when America was the underdog and inspiration to dreaming republicans everywhere–real republicans; radicals and idealists–even if it took two centuries for reality to even pretend to the dream, and in the meantime gave us Reno. They follow up with "Anchors Aweigh," at which the Navy men in the hall shoot to attention stiffly–Gene Cernan, I note, being the quickest and stiffest. The same happens with "Off We Go (into the Wild Blue Yonder)"; then Dick Gordon comes to the microphone and asks us to remember those who lost their lives in the push to space, without mentioning poor, heroic Komarov or any of the Soviets, to be followed by "The Apollo Story," a glib presentation by the former TV anchorman Hugh Downs, in which we are told that "Kennedy was looking for a way to lift U.S. spirits as the U.S. wavered in the Cold War," without so much as hinting that he was also looking for a way to save his own political hide. In this ver-

sion, the official version, Apollo was a victory march, shorn of all doubt and ambiguity and dull as a government requisition form. I wonder why they like it so much?

The only thing to raise the temperature is a question-and-answer session with the astronauts, for which audience members have been invited to write questions on a piece of paper and hand them in so that the interesting ones may be identified and discarded. Even so, there are some revealing moments, as when Armstrong is asked, "How were you chosen to be the First Man on the Moon?" at which he places an arm around his former partner's shoulder and smiles, "Actually, it was the pair of us." It's a warm gesture, which Armstrong might have been waiting years to make, but Aldrin doesn't respond in any way, doesn't turn to look at him, squeeze his shoulder, shake his hand or smile . . . he just continues to lean forward on his elbows and stare stonily ahead. Next, someone asks Cernan, "When are we going to get the next generation to Mars?" and he begins, apropos of nothing, "Well, I somewhat differ from Buzz on this . . ." going on to insist that we should go back to the Moon first. Two contributions leave an impression: first, Rusty Schweickart's modest admission of "how lucky I was, because I didn't deserve it and none of us up here deserves to have gone where we went—we lucked out, were in the right place at the right time, with the right set of taxpayers"; and second, Bill Anders's interruption of Hugh Downs as he waxes about the pioneer spirit and idealism of the enterprise, to blurt, "Look, Apollo happened because the farmers in Iowa didn't like them dirty Commies." He laughs. I laugh. Otherwise you could hear a pin drop. At this stage, I don't know much about Anders, except that he circumnavigated the Moon for the first time with *Apollo 8* and took the spectacularly beautiful *Earthrise* photo, which enchanted everyone who saw it and became the emblem of the first "Earth Day" in 1970, then never flew again. I make a mental note to try to catch up with him later, because he sounds intriguing.

Outside in a smaller chamber, where guests inspect and make written bids in a charity memorabilia auction, it doesn't take long for me to find what I'm looking for. Neil Armstrong stands, surrounded like Custer at Little Big Horn, patiently explaining some aspect of his thirty-three-year-old adventure for

the four hundredth time this evening to a forty-something who looks as though he's about to combust with joy. Finished, the astronaut turns, and begins to move in my direction. I want to ask whether we might speak privately some time. There are so many questions I've never heard him answer. So I place myself in his path, as I've watched others do all night and he stops, along with the gaggle of followers. He glances at my hands, probably noticing that I don't carry a camera or autograph book, and I take advantage of the pause to introduce myself. Suddenly, I feel us being surrounded by a crowd of people, heads bowed to hear what's being said, as I explain that I'm writing a book and wonder whether he might be available for a talk sometime. I tell him that I know he gets many requests for interviews and he looks me straight in the eye and smiles in a manner that strikes me as fatherly, nodding his head slowly and smirking "many, many, many," in such a way that I can't help but smile, too. Turnill saw the arrogant hero, Mailer the mystic technocrat, but I'm seeing Atticus from *To Kill a Mockingbird*. There's a warmth in his voice that I wasn't expecting.

He asks what my book's about and I tell him that it's about the *idea* of Apollo, but suggest that, if he'll provide me with an address where I can be confident of reaching him, I'll write with a fuller explanation. He hesitates, then looks around, leans forward and speaks his address very quietly for me to write on the rolled-up commemorative poster we've all been given. We shake hands and he's off. When I tell my host Bill about the address, his eyes light up and he exclaims, "Did he write it himself?!" Then he tells me that he just found Buzz and Gene Cernan chattering away at adjacent urinals in the restroom. He doesn't mention whether they were also seeing who could pee highest, but I'd like to think they were.

I DID CATCH UP with Bill Anders, whose *Apollo 8* flight with Frank Borman and the future *Apollo 13* commander, James Lovell, over Christmas 1968 gets more fantastic the closer you look at it. Not only were these the first three people to swing out to the Moon, they were the first to accelerate out of Earth orbit

and head for Deep Space, and thus the first to see the Earth as a tiny sphere, alone enough to bring a lump to the throat, and to experience the frightening onrush of the Moon.

As with subsequent flights, *Apollo 8* bowled along sideways like a silver rolling pin, spinning slowly to distribute the sun's intense heat. From the craft's angle of approach the Moon was in darkness, so for the first two days the astronauts saw only the Earth shrinking behind them and a coy black void ahead, bereft of stars and growing, until finally they were drifting engine-first around the far side, preparing for the "burn" that would slow them into lunar orbit. Still they saw nothing—until suddenly and without warning an immense arc of sun-drenched lunar surface appeared in their windows and the three men got the shocks of their lives, as the ethereal disc they and the rest of humanity had known up to then revealed itself as an awesome globe, cool and remote, without sound or motion, magisterial but issuing no invitation whatsoever. So shocked were the crew that commander Borman was forced to rein in their excitement for the sake of the burn, and while the astronauts have forgotten much about the journeys they took, none has any trouble recalling this dramatic moment: indeed, those who are temperamentally disposed to acknowledging fear will tell you that it was an eerie and intimidating sight, which the crew of *Apollo 8* seemed haunted by. Upon their return, they described a forbidding and inhospitable world. It was the Earth that sang to them from afar.

To Anders's sharp and independent mind, the flight didn't change him, but witnessing the first Earthrise broadened his perspective on everything, forever, seeming to capture all the fundamental truths about life and our place in the Universe in a single, startling view. That doesn't stop him from being a realist when it comes to Apollo's origins, however. He asks me how old I am and I tell him.

"Well, yeah, you see, it's hard for people even older than you to realize the seriousness of the Cold War. The funny thing is that when we look back at it now, the Russians weren't such a bad bunch of guys—some of our allies were much slimier! At least the Communists were doing what they could for their people, unlike the fascists we tend to choose every time. So you can

argue about whether it made sense, about whether it was right or wrong, but it was a fact, and it scared people. And that's why we went to the Moon, to demonstrate American technological preeminence in competition with the Soviet Union. The thing is that NASA was a civilian organization, and I think they were embarrassed at being seen as part of the Cold War, so they started pushing exploration as the motive–and soon I think they started believing their own PR. When Neil Armstrong and Buzz Aldrin planted the American flag on the Moon, the program was over and NASA didn't realize it. Ever since, they've been operating on a false premise."

Anders lives on an island off the coast of Washington State now. He's had one of the most economically successful post-NASA careers of any astronaut, which included several important government posts, a stint as ambassador to Norway, and a series of business appointments that culminated in his becoming chairman and chief executive officer of the huge aerospace contractor General Dynamics Corporation. I ask whether he thinks some of the post-NASA travails of his ex-colleagues may be attributed to this misapprehension? If so, it must have made the ending harder to foresee and more painful to bear.

"Well, not only that. I mean, we were *rock stars*. It was like being a rock star who's suddenly had his vocal chords pulled out. Unfortunately, the bulk of the astronaut group . . . they're kind of struggling. The reason why is that they had people welcoming them and wanting to make them vice president for corporate relations, or motivation, that kind of thing, and that stuff burns out in a hurry. A few of us went out and got real jobs, but most came back and found that they were curiosities and celebrities, but that there wasn't much future in being an aging celebrity. It's sad, but probably inevitable."

Anders laughs as he ascribes his own relatively agreeable ride to "being low enough down on the totem pole" that he had no option but to get a proper job afterward, though I think he's being modest here. Like Schweickart and Cunningham and Aldrin from the third group of astronauts, he wasn't trained as a test pilot and knew that he was different from most of the rest. Quickly realizing that "these people didn't get there

because they were stupid–they weren't wise, but they were smart," he kept his head down and eventually got his chance to fly. I wonder if this pragmatism also accounts for the fact that he is still with the mother of his six children, as indeed are the other members of his crew ("Maybe we just weren't as quick on our feet as the others," he chuckles). Like Armstrong, he doesn't sign autographs, having in the past responded to letters purporting to be from sick children, then seen them turn up in auction a few months later. Not long ago, someone from the U.K. wrote calling him "a piece of scum" for declining to sign.

He thinks that Apollo was "an extremely positive experience" for everyone, demonstrating what could be done by people working together on a common, nationally supported goal, and admits that he would love to have landed on the Moon ("Apollo was a wonderful experience for me, more than I ever dreamed or deserved, but that doesn't mean I'm not greedy"). However, on the Astronaut Reunion Dinner, he offers:

"I'm a little jaded about it all. I actually race at Reno, but the race authorities are using the Apollo astronauts as a table decoration. Some of us have tended to be turned off by the reunion affairs, because some guys go thinking it might be fun, but others go because they think they're rock stars. It's those people I probably don't see as much as I used to. Reno couldn't care less about Apollo, but they're hoping that a bunch of old-age astronauts being driven up and down in old cars will increase the gate. I mean, I have friends in Reno saying, 'Hey, I got an invitation to have dinner with you for five hundred bucks,' and I tell 'em, 'Hey, look, you pick up the check and I'll only charge you a hundred bucks!'"

And on Armstrong:

"He's been accused of being a recluse, but I just think he's realized that this stuff is short-lived, that you can squander it, that just because you went to the Moon doesn't mean you're an expert in everything. If he traded on his celebrity, you could expect a little quid pro quo signing, but he doesn't. The stuff he has to deal with goes way beyond what's reasonable."

And here is where Armstrong's predicament gets peculiar, because—and this is a little-known fact—all the evidence is that his elevated place in history is an accident. Deke Slayton wanted the first step to be taken by one of his Mercury 7 buddies, favoring Gus Grissom. Then, after Grissom died in the *Apollo 1* fire, it was Wally Schirra—but Schirra's grouchy command of *Apollo 7*, the nervy first manned flight after the fire, ruled him out. Mike Collins thought it would be Ed White, America's first spacewalker, who unfortunately perished alongside Grissom. Collins also mused: "It is interesting to note that Neil Armstrong was the last in his group to fly. Were they saving the best for last, or was his selection as the first human to walk on another planet a fluke?" The evidence suggests that it was. Had Thomas Stafford's *Apollo 10* Lunar Module been ready to attempt a landing, or had Stafford and his crew been prepared to swap their beloved LM (which they'd been working with and refining for months) for the lighter one being prepared for *11,* it could have been him. At the same time, many within NASA considered Pete Conrad's *Apollo 12* the most likely candidate, although had the technical bugs bitten harder, it could as easily have been *13* or *14.* As it turned out, *13* got the bugs. It was like an Agatha Christie yarn. Twelve Little Astronauts. In the end, Armstrong was chosen by Slayton's rotation system, the *Apollo 1* fire, the impossible brilliance of the engineers and the nasty head colds which plagued Schirra's *Apollo 7* flight (snot: no fun at all in a weightless environment). However well he rose to the challenge, no one ever took a decision that he was the only one, or even the best one, for the job. It just happened that way.

And the thought hits me—and I'm astonished to find myself associating Monty Python with Neil Armstrong for a second time—that he must feel a little like the reluctant savior Brian in *The Life of Brian.* A repository for the rest of us and our childish dreams.

I'll write to him when I get home. I won't expect to hear back.

BILL THE KINDLY DENTIST'S memorabilia is in the dining room of his big modern house in Carson City, spread across a wall adjacent to the open-plan kitchen, opposite a pair of sliding glass doors which lead to the garden. Today the place is filled with him and his son and Erin and her kids and his friend Doug, whom I met and liked at the Apollo dinner last night. As Bill presents me to the corpus of the collection, everyone gathers as to a shrine, then gradually melts away, smirking, as he begins my tour with a disarming mixture of pride and sheepishness. Most people don't understand the obsession, he says, they think he's nuts. When I ask what happens if they do understand, he laughs and tells me, "Well, then *they* go nuts."

I can see why.

There are framed photos with colorful mission patches, signed by the astronauts on those missions. There are old is-

sues of *Life*, also signed, and heroic signed etchings. A signed snap of Neil Armstrong is particularly prized ("'cos those are tough to come by"), even though his favorite Apollo guy is John Young from *Apollo 16*, who's almost as hard to meet as Armstrong. In the center are two big *pièces de résistance*–one a large photo of a Mercury launch, signed by the Original Seven, the other a cheesy montage of illustrated scenes from the Space Age, but anointed by all twelve Moonwalkers. As if that wasn't enough, he also shows off a collection of signed memoirs, including a first edition of Aldrin's *Return to Earth*, which I wouldn't mind having myself. What he'd really like now, he explains, are the signatures of Gus Grissom, Ed White and Roger Chaffee–the luckless trio who died in the *Apollo 1* fire–but they're hard to come by, too, for obvious reasons. He has got Chaffee's dad, however.

We gossip about the reunion dinner and Bill reveals that he met Buzz once before, when the ex-astronaut opened an observatory that the local community had raised funds for, with Bill active on the committee. "He said no autographs, but it was nice of him to come out." He smiles. To which Doug, also on the committee, snips, "Yeah, for a nice big fee," and names a high five-figure sum as Bill squeaks, "Is that what it was?!" I ask how much these things on the wall cost and am told that the two centerpieces were $1,500–$1,600, though size isn't everything: he paid $250 for the little scratchy Dave Scott signature alone. From last night, Charlie Duke is getting the rave reviews. Doug marvels:

"He would talk to you, that's what amazed me. It wasn't like 'I'll shake your hand and now get out of here.' Armstrong brushed me off. I went up to him and he turned around and walked away. He doesn't like doing this stuff at all."

During the ceremony, I'd asked Bill how the collecting started and was surprised to find that it only began a couple of years ago. Like me, he'd been fascinated with the Moon adventure as a child, but had then forgotten about it. I was curious as to what changed two years ago to draw him back. Now he tells me.

"You know, you were asking about some of this stuff, and it's

kind of weird. I went through a divorce and started spending more time on the Internet, and I'd go to these sites and just keep looking at them, and eventually started looking at the prices and dreaming of having them here. And that's how I really got into it. I'd been interested in them before, but . . ."

There's a pause and a shadow seems to pass across his face.

"I mean, I hope you never go through a divorce or anything like that, but when you do, it affects you. I, actually, kind of . . . I actually closed myself in. I didn't keep in touch with friends and kind of just wanted to be by myself. And this is what I did."

Surrounded yourself with astronauts. Did it help?

"I guess maybe it did. It was an outlet, something to do. I guess I coulda done worse things. Now, if I could just get a Roger Chaffee and an Ed White . . ."

Bill's father died two years before the divorce, and this may be fanciful, but in my mind's eye I see him unconsciously gathering the astronauts to him in his time of doubt; a committee of the last untarnished heroes from a time when Bill's world seemed safer and more certain. People to trust and admire and be reassured by, gazing steadily out from the wall. With apologies to Updike, now Armstrong is always above him.

AFTER BILL, I drove further south to Lake Tahoe, the deep, deep glacial lake which had seemed magical to me as a child, but now offered only an odd claustrophobia, was too built-up and hemmed in. So I wound up going back to Reno that night, arriving late and staying at a cheap motel next to a lap-dance club, a place where they only took cash and people hung flushed and furtive-looking around the two slot machines in the foyer, where the trembling receptionist appeared to be on a cold-turkey-in-the-community scheme; where signs notified clients that they would be held responsible for any new stains found on the carpet and the mattresses had what felt like—and might actually have *been,* come to think of it—speed bumps. I didn't leave any new stains, but made a point of catching the first plane out of town the next morning all the same. I didn't know it yet, but things were about to look up. I was headed for Tucson.

From the age of four, pop lyrics have been telling me that love at first sight only happens when you least expect it (so it must be true), but with Tucson it was love *before* first sight: driving in from the south, a sign confided that if I cared to change my mind, I could always swing left to Phoenix, or right on the road to El Paso. A thousand songs and books and movies seemed to dance above that fork in the road, but I ploughed straight on into the dusky high desert plain, between dramatic hills that looked like they were throwing shapes for the camera—could have been sculpted by Giacometti—and were protected by tall, mute armies of saguaro cactuses. After a happy hour lost in backstreets, the one-way system coughed me up outside the Congress, the oldest building in town, near to where mile-long trains still groan through the center of town. I took a room with banged-up Victorian furniture and a big fan helicoptering over the bed, and found that the food was good and one of my favorite bands was playing in the courtyard that night. After the madness of Reno, Diana was smiling again.

Tucson is home to a space art gallery and memorabilia emporium called Novaspace. Bill bought most of his collection here, but more important to me is the fact that Novaspace are main agents to Alan Bean, the *Apollo 12* Moonwalker-turned-painter with a deep and un-astronautly love of Monet. The great painters pretty much left the Moon alone—and if the poets are any guide, this was wise, because if you trawl through the anthologies, what you find is endless florid paeans to her beauty and mystery, few of which add anything to the experience of simply looking up at the sky most nights. But Bean is different. He *only* looks at the Moon. In a sense, he's still up there. I've heard that he can take months to complete a painting, which then fetches up to $50,000 a shot and most of them are in private hands. If I want to see some of his work before meeting him, this is the only place to come.

Luna and the arts go back a long way and have an interesting relationship, expressed most strongly through novels and movies. The earliest Moon trip fantasy is thought to be the work of a Syrian astrologer named Lucian of Samosata in the second century AD, but the ones that still resonate are Jules Verne's re-

markably prophetic *From the Earth to the Moon* (1865) and H. G. Wells's *The First Men in the Moon* (1901). The Victorians had a yen for lunar fantasy and it was here that an intriguing dialectic began to develop, leading all the way to Apollo. On the most obvious level, the respective fathers of German and American rocketry, Hermann Oberth and Robert Goddard, were both obsessed with Verne's tale as children (and not just them: Neil Armstrong named his *Apollo 11* Command Module *Columbia* after Verne's "Columbiad"). Oberth, in turn, acted as adviser to one of early cinema's great directors, Fritz Lang, on his 1929 epic *Frau im Mond* (*Woman in the Moon*), whose first realistic depiction of spaceflight helped to make the idea fashionable among the German intelligentsia, also establishing the convention of the reverse countdown to launch. One of Oberth's students, that Prussian aristocrat's son Wernher von Braun, caught the rocket bug from science fiction, too. Quoted in *The New Yorker* in 1951, he trilled of his first story: "It filled me with a romantic urge. Interplanetary travel! Here was a task worth dedicating one's life to!" Further down the line, there would be speculation that President Nixon approved funds for the space shuttle because Kubrick had already shown him one in *2001*. It had looked good down at the Odeon, even if it made no sense in real life.

It was in the Fifties that space gripped the American imagination, as shown by the long streams of paranoid genre movies, many of which have weathered surprisingly well. At this time, space and the Moon were still blank canopies across which you could spread the psyche (sometimes explicitly as in the classic *The Forbidden Planet,* a Freudian remake of Shakespeare's *The Tempest*). Later, in the Sixties, some feared that Apollo would destroy the Moon's value as the most elastic symbol or metaphor since God. In 1963 (by coincidence the same year that his poet wife Sylvia Plath committed suicide) Ted Hughes published a book of children's poetry called *Moon-Whales and Other Moon Poems,* in which a menagerie of apparitions lies waiting to repel any assault on Luna's sovereign mystique. There is something wishful about "The Burrow Wolf," for example, in which Hughes warns:

Many a spaceman in the years to come
Will be pestled with meteorites in that horny turn
If he does not dive direct into those jaws
He may well wander in there after a short pause

For over the moon general madness reigns–
Bad when the light waxes, worse when it wanes–
And he might lunatically mistake this wolf for his wife
So the man in the moon ended his life.

The imminent Moon landings also functioned as a backdrop and philosophical engine for the playwright Tom Stoppard's *Jumpers,* which looked dated and irrelevant when I first saw it in 1985, but was asking interesting questions again in a 2003 revival. Interviewed in the *Sunday Times,* Stoppard explained what had been on his mind when he wrote it.

"The inspiration for the play," he said, "was my private thought that if and when men landed on the moon, something interesting would occur in the human psyche, that landing on the moon would be an act of destruction. There is a quotation when the first landing occurred from the Union of Persian Storytellers ... they claimed it was somehow damaging to the livelihood of the storytellers. I understood that completely."

He worried that the landings would ruin the Moon as a "benign metaphor," the chaperone of romance and unspoken feeling, and also that once we could see ourselves from such a distance, all the absolute ideas of what is good and bad would come to look like "local customs coming from a finite place," and a kind of moral paralysis would occur. That neither of these things happened is fascinating. That it seems to have had the *opposite* effect on some of the few who actually went is doubly fascinating. The first thing you notice when you watch *For All Mankind,* the Oscar-winning collection of Apollo footage which the journalist Al Reinert spent years assembling, then set against a wondrous Brian Eno sound track and lunar astronauts talking about their trip, is that the magic *never* left for them. The second is how similar Deep Space talk is to psychedelic Sixties drug talk. If these cats had been allowed to pack beards and bongs in

their "personal preference kits," you couldn't have improved upon:

"When the sunlight shines through the blackness of space, it's black. But I was able to look at this blackness: I mean, what are you looking at? Call it the Universe, but it's the infinity of space and the infinity of time. I'm looking at something called 'space' that has no end, and at 'time,' that has no meaning. You can really focus on it, because you've got this planet out there, this star called Earth, which is all lit up. Because when the sunlight strikes on an object, it strikes on something called 'Earth.' And it's not a hostile blackness. Maybe it's not hostile because the view of Earth gives it life . . ."

While you could get arrested in some states for saying:

"I know where I am when I look at the Moon . . . stars are my home."

People have suggested that these similar vocabularies stem from the way drugs and space both promise shortcuts to nirvana (for Edgar Mitchell, this may have been true). Others hold that they both represent attempts to escape our eternal foe, *gravity*. It works both ways, too. In 1966, the Byrds were hit by a radio ban of their single "Eight Miles High" because it was assumed to be a "drug song." In fact, band members David Crosby and Roger McGuinn were space and flying enthusiasts who spent hours lying on the bonnets of their cars watching airliners take off and land at Los Angeles airport. Like "Mr. Spaceman" from the same classic *Fifth Dimension* album, the song really was about flying.

NOVASPACE IS UNIQUE, yet nestles in a parade of shops as archetypal and unassuming as any in America. Its gray walls are hung floor to ceiling with fantastical renderings of Jovian landscapes and hypothetical planets with chlorine-fluorine atmospheres that glow emerald green at twilight, and future-realist spacecraft that look perversely old-fashioned, as the future invariably does these days. I look around for a while; then proprietor Kim Poor appears and ushers me into his spartan office.

Poor is tall, about six foot four, with graying hair and a neo-Zappa beard that sets off his angular face. He has a ready smirk

and a dry wit and walks with a cane and slight limp–the consequence, he explains, of a rare congenital disorder called Machado-Joseph disease, which affects his motor functions and equilibrium. It forced him to stop painting in 1994, which wasn't as hard as he'd expected ("I think I enjoy scenery a lot more now that I don't have the burden of trying to paint it"), but two years ago he had to give up playing guitar in bands, and that did hurt. I look up and notice that there are autographs of Paul McCartney and George Martin among the astronauts' on the wall. On his flickering computer screen is an e-mail circular warning space collectors about a con man who's on the loose selling fake Moondust. By U.S. Government decree, no one is allowed to own pure Moondust, not even astronauts. A few people have already been stung.

The place has been in business since 1978, after Poor gave up pursuing his music and political science degree at the University of Arizona to be a painter and musician, and the market led him to space art. It took off straightaway and a few years later he helped to form the International Association of Astronautic Arts, which brought together space artists from both sides of the Iron Curtain. They'd convene for two-week summits "and drink like crazy," until the Curtain collapsed and state funding for the Russians dried up.

"They could never understand that American artists, in this rich country, had to pay for everything," Poor chuckles, "where the Russians, the *Communists,* were being subsidized. They'd apply for a grant and they'd get the money . . . it's hard to imagine! I can see a bunch of them working at McDonald's now."

Soviet space art always had a different flavor from the American stuff, says Poor. They didn't have access to the same detailed information, which is why he thinks their work was more heroic, less illustrative. The fact is, though, that the Soviets always had a more romantic attitude to space. Yuri Gagarin's first words to his public after his craft's recovery were: "The feelings which filled me I can express with one word: joy." You could have coached Alan Shepard till his head exploded and never persuaded him to say something like that. The godfather of American space art is Chesley Bonestell, who lived from 1888 to

1986 and was claimed as an influence by both von Braun and Arthur C. Clarke, but Poor tells me that most of the successful Americans and Europeans are boomers like him and work to a style only half-jokingly described as "hypothetical realism." This involves photorealistic renderings of places and things that you can't get photos of.

"The real good space art makes you want to go there . . . it scares some people, too," he says.

And this is what makes Alan Bean so different. Bean paints Apollo scenes, endlessly, over and over, but he's an unreconstructed Impressionist who has studied under an impressive range of contemporary artists. Bean didn't stumble into this any more than he stumbled into being a test pilot, and meeting him at a Houston art show was "a real apocalyptic thing" for Poor, because not only did he acquire the work of an artist who would become more commercially successful than anyone thought possible, he gained access to the other astronauts and the burgeoning memorabilia market, which has become the most lucrative part of his business. His face cracks into a grin as he remembers the first day of their acquaintance.

"He took me back to his place that night and made me critique his stuff. It was a tiny, tiny condominium, two point five percent bigger than Skylab–he figured that out . . . you ask for directions to his house, he'll tell you in tenths of a mile. But he was also the inspiration for the Jack Nicholson character in *Terms of Endearment.*"

"You're kidding!" I exclaim.

"No," laughs Poor, employing a delightfully obscene colloquialism to indicate that Bean, in his younger days, was attractive to women, and that the feeling was self-evidently mutual. "He drove a Corvette then, but he's settled down now. And his wife, Leslie, raises Lhasa Apsos [tiny, fluffy dogs], so there's ten of those little hairy things running around in this tiny little place. And Alan painted in the living room: I like to say that Alan spelt sideways is *anal*–and he is, too, boy! Most painters have their stuff everywhere, but he'll have his brushes laid out, his paints all laid out, and he can paint on a shag rug and not get a *drop* on it. In a suit! I mean, I've got paint on my socks–when I

wear white pants is when I feel the urge to paint. Alan's not like that, everything was laid out perfectly. It was almost ridiculous. It's the engineering, you know. Anyway, it all started from there."

The *For All Mankind* director Al Reinert will also be laughing when he describes Bean's home as "the lair of a fanatic." I'm not sure if Poor's right to blame the engineering background, though, because the LM engineers used to grumble about Bean (and Conrad–"a party animal, he was hilarious") not taking them seriously enough. Anyway, when the spaceman artist came to Novaspace to sign copies of a book about his art, the queue ended up snaking all over the car park, because he insisted on having conversations with every one of the hundreds who turned out, where most signees don't even make eye contact. And while he's intense about his work, he's no diva. Poor recently returned a painting of Pete Conrad clicking his heels on the Moon because he didn't think it was working and he says that Bean didn't even complain. Much.

The hypothetical realists don't do much for me. My own taste in art is almost exclusively modern, something I'm much less proud of since discovering that it may be no more than a manifestation of the cult of the New I was born into–the same one which got Kennedy elected, bundled a nation to the Moon and shipped a ton of vacuum cleaners. Either way, I can't respond to the hypothetical realists. Poor was right about Bean, though: his work couldn't be more different. On the pages of a book, his paintings looked amiable enough, but up close you can see the intensity of feeling that has gone into them, the intricate texture and attention to detail. Sometimes he mixes fragments of a pin or patch he wore to the Moon in with the paint, adding part of his real, physical self to the scene.

The one I'd most liked to see isn't here and I hadn't expected it to be. *That's How It Felt to Walk on the Moon* was painted in response to *that* question and has Bean standing on the lunar surface in a reflective haze of greens and violets and golds, a palette which no one will ever see on the Moon, because these are the colors of the euphoria he felt as he stood there. I'm still not sure whether I *like* what I see in front of me, and I resent the way that the Stars and Stripes intrudes on one picture, but I find

it easy to respect them. Eventually, I'll track down a book called *In the Stream of Stars: The Soviet/American Space Art Book* and be astonished at the difference between the two schools, because the Soviets, including the astronaut Alexei Leonov, the first person to walk in space and a very fine painter indeed, clearly see themselves as coming out of a tradition—out of a modernist tradition which they've been schooled in—and their work is rich and dynamic and constantly surprising. It seems to me that Bean has more in common with them than with the Americans. Yet this only serves to intensify a question I've had in my mind all along. Why is Bean, clearly a skillful artist, restricting himself to painting scenes from Apollo? Whenever I think about this, I get an image of Richard Dreyfuss in *Close Encounters of the Third Kind*, wallowing in mud in his living room, obsessively trying to build a copy of the mountain from behind which an alien spaceship will ultimately emerge.

Is this Bean? An unholy cross between Dreyfuss and Naughty Jack Nicholson?

HOUSTON WOULD NEVER win a beauty contest, but Bean's neighborhood on the edge of town is lovely, like a series of causeways cut through a friendly forest, saluted by all manner of towering, weeping trees, no one's idea of Texas. Then there's a gate with a guardhouse and a mazy network of Hansel-and-Gretel roads on the other side, onto which houses peek through the shrubbery. Dusk is falling as I find the simple two-story building for which Bean swapped the condo six years ago, when he must have been sixty-four. I make to park opposite and suddenly here he is, beckoning me into his drive and inexplicably admiring my hire car (a Dodge Stratus!) in his eurythmic Texan drawl as I climb out. He wears a candy-striped Ralph Lauren polo shirt and brown trousers, standing about five foot eight with a round dome head (the hair was receding even before he flew), round wire specs and trim but still somehow *round* physique. The first thing he reminds me of does me no credit at all: it's Laa-Laa the Teletubby—even though I'd have recognized his Cheshire cat grin anywhere. Bean is seventy but looks

scarcely older than me. From just behind him comes an enthusiastic yapping of dogs.

What do I know about him? That his ancestors were "MacBeans," reputedly banished from Scotland after one of their number, John, bore arms against Cromwell. As Alan tells it, the most important formative influence on him was his mother, Frances, who had an inexhaustible reservoir of encouragement and love for her only son, whose confidence could be fragile. When he was a small child in Fort Worth, his parents had taken him to watch airplanes swoop in on Mecham Field, and he was enchanted by them. He joined the Naval Air Reserve in high school and spent weekends cleaning planes and talking to pilots. When he heard about naval scholarships to study aeronautical engineering at the University of Texas, he enthusiastically decided to apply. He remembers the morning of the exam clearly, because he woke up convinced that he hadn't a chance of passing, but his mother coaxed him out of bed and drove him downtown. This was a rare gesture, because Frances preached self-reliance to her children, but she knew how badly he wanted to fly. He cites that day as a turning point in his life, because he won the scholarship and eventually a place at the test pilot school at Patuxent River in Maryland, where one of his instructors was his future *Apollo 12* commander, Pete Conrad. He didn't make the second selection of astronauts in 1962, but was included in the third and every photo of the Astronaut Corps thereafter included an image of him smiling, always smiling. He looked like the happiest man on Earth.

He remembers the aura surrounding the Mercury 7, whom you'd pass in the corridor and almost not dare speak to. They lived like movie stars, drove Ferraris and Lamborghinis, partied with millionaires, played touch football with JFK. And the people in the later groups, people like Ed Mitchell and Bill Anders, were *smart*. He claims often to have felt out of place and inadequate, and was at first cold-shouldered by Deke Slayton and Al Shepard, who helped assign him to a dead-end tributary program. Then a slot unexpectedly became available on Conrad's crew, when—and we've heard this before—a T-38 trainer jet being flown by his Lunar Module pilot, C. C. Williams, inexplica-

bly went into a violent roll over Florida and crashed before he could eject safely. Conrad, an influential member of the corps by now, insisted that his former student fill the space. Slayton later denied underestimating Bean, but, like Armstrong before him, he was the last of his group to be assigned a flight and that time in the wilderness, he later admitted, had been "difficult and frustrating . . . I constantly felt I didn't measure up to the other astronauts and that's why they were flying before me, and I wasn't sure why." He has said that every time he thought about Apollo in those dark days, "it hurt." But he was lucky. By his account, Conrad and Gordon taught him most of what he's since learned about life.

My spirit leaps as he walks me through a dark hallway into the living room, a light room with a vaulted ceiling and crisp wooden floor. At the far end, sliding doors lead out to the small garden, but just in front of them are three easels holding a trio of large paintings, one of which shows Pete Conrad clicking his heels . . . it's the one Kim Poor sent back. In front of them is a long table covered with palettes, brushes, tubes of paint and small models of spacemen in suits, and on the wall to their right hang a dozen or so of his other paintings, moving from early, relatively monochromatic efforts, which appeal to me much more than I'd have thought, to more colorful and boldly Impressionistic later works. Best of all, *That's How It Felt to Walk on the Moon* is propped against the wall. He offers me a cup of coffee in his bright Texan drawl and gently cautions against hanging my leather jacket on the coat rack, because that's Lhasa Apso territory and my incursion upon it would play havoc with the house social order, from whence it would be but a small step to anarchy. So I sling the jacket on a chair as Alan introduces the dogs by names which would make Tinky Winky blush.

APOLLO 12, the second mission to the Moon, flew in November 1969, at the end of what had been a strange couple of years. The hippies of Haight-Ashbury in San Francisco had failed to pacify 1967 by declaring a "Summer of Love," but 1968 was ter-

rifying to most people. Thanks to the new satellite TV technology, the world now watched in real time as student protesters were beaten all over the U.S. and in Tokyo, Nairobi, Dacca and Prague, where Soviet tanks crushed Alexander Dubcek's experiment in liberalization. Mick Jagger wrote the Rolling Stones' "Street Fighting Man," about the first violent anti-Vietnam demonstration in London, which he'd attended, while in the U.S. Robert Kennedy and Martin Luther King had been assassinated, finally tipping the balance away from nonviolence in the struggle for racial equality. The word "black" replaced "negro" that year and Palestinians were spoken of as a distinct people for the first time; full-scale war in the Middle East looked probable. Most Americans also heard the term "women's liberation" for the first time when feminists stormed the Miss America Pageant.

Johnson's War was now costing $30 billion *a year* and the humiliating success of the North Vietnamese Tet offensive suggested for the first time that American technology was not the answer to everything. A bitter presidential race was intensified by the brutality shown young antiwar protesters at the Democratic National Convention, which looked to TV viewers like Saigon on a bad day. The only victors in Chicago were the Yippies, whose brilliantly absurd threat to dump a ton of LSD into the Chicago water system and keep the whole population high for a week had made the overreacting authorities look ridiculous (where would *anyone* get a ton of LSD from?). Across the Atlantic, the BBC banned "A Day in the Life" from the Beatles' *Sergeant Pepper* album for the line "I'd love to turn you on" and the coming vice president Spiro Agnew demanded the same treatment for "A Little Help from My Friends," because it spoke of "getting high." Even without the heightened racial unrest following a Supreme Court order that school segregation in the South must end, the country looked to be splitting into two warring factions. When Richard Nixon finally took office in January 1969, the outgoing deputy attorney general, Warren Christopher, handed over a big package of martial law declaration orders, which he suggested be kept "on hand all the time," ready to be signed by the president on a city by city basis. One member of

the public commented in a letter that the first journey of humans into Deep Space, as Anders, Lovell and Borman circumnavigated the Moon aboard *Apollo 8* at Christmas, had "saved" 1968.

By comparison, the summer of 1969 had looked much better. Abroad, British troops went into Northern Ireland, Yasir Arafat became leader of the PLO and India and Pakistan were squaring up over Kashmir again, but *Apollo 11* and Woodstock struck an optimistic note at home. The most telling vignette from Michael Wadleigh's entertaining film of the latter was his interview with the Portosan toilet man, who, on being asked how he felt about cleaning up hippy shit, grins, "Glad to do it for these kids. My son's here. And I got another in Vietnam, too." Nixon had entered office making all the right noises about peace and the environment, had withdrawn tens of thousands of troops from Vietnam and brought U.S. casualties down dramatically. Racial incidents in the cities were also reported to be running at a third of the rate of the year before and the economy still appeared robust. That summer, the United States was beginning to look like one nation again, illusory though this impression proved to be.

Nixon was also the first president to attend a space launch and he seems to have been genuinely excited by *Apollo 12* and its prospect of a second American landing on the Moon. We'll never know if that's why the decision was made to launch Bean and Conrad and Gordon into a storm, but it led to one of the most hair-raising incidents of the whole Apollo program when, after a textbook takeoff and rise into the gray sky, Conrad saw a flash in the corner of his eye and felt his ship shiver, then heard static fill his headset, followed by the angry bark of the master alarm. On the control panel, almost every light connected to the electrical system was ablaze and in months of rehearsing crises in the simulator, neither he nor his crewmates nor anyone on the ground had seen so many warning lights lit at once. The "8-ball" altitude indicator through which the Saturn's orientation could be gauged was spinning crazily.

"Okay, we just lost the platform, gang," he told Houston. "I don't know what happened here—we had everything in the world drop out."

They could be headed in any direction now: Bean briefly

wondered whether the computer had detected a problem some-where and ejected them to theoretical safety, but quickly dismissed that idea, because the violence of such an event would have felt like hitting a brick wall. And the first stage of the rocket still seemed to be drawing electrical power—though at less than optimal voltage.

The young flight director, Gerry Griffin, was conducting his first mission and couldn't believe the list of apparent problems Conrad now read out to him. It already seemed obvious that he was going to have to abort the flight, but before making such a drastic announcement, he called John Aaron, the twenty-four-year-old in charge of the electrical system.

"What do you see?" he asked evenly.

The trouble was that Aaron could see nothing that made any sense on his console, which was supposed to contain information about the performance of the spacecraft—there were only random patterns of numbers, as if the screen had been possessed by an alien intelligence. And yet, as he looked at it, he realized that he'd seen something similar in a simulation the year before and that the telemetry had been recovered using an obscure switch labeled Signal Condition Equipment. He announced, "Flight, try S-C-E to Aux," and although neither flight director Griffin, nor capcom Jerry Carr as he relayed the advice, nor commander Conrad as he received it knew what this meant, Alan Bean *did*. He flicked the switch and the data returned. Conrad glanced up and saw sunlight, indicating that they'd risen above the clouds, that the problem with the electrical system hadn't affected the rocket engines or guidance system—though this still left the possibility that he would wind up in orbit with a dead command module and little hope of returning to Earth. He waited until the Saturn's first stage had spent its fuel and dropped away, then instructed Bean to reset the fuel cells and watched as the command module came back on line, reanimated.

Now, with the emergency having passed, Conrad could say it: "I'm not sure we didn't get hit by lightning." As indeed they had been—twice, thirty seconds after liftoff and then again at fifty-two, causing the command module to shut down as defense

against the huge electrical surge, then knocking out the navigation platform for good measure. Only when ground-based footage of *Apollo 12*'s launch was examined would the truth be known for sure, but in the meantime, Conrad, Gordon and Bean continued into space like a trio of lucky urchins, with Conrad laughing, "Was that ever a sim they gave us!" and the others chuckling along. All the same, Bean was once again lost in admiration for his commander's ability to calmly and instinctively make the right call, for that way he had of making things look easy, which fascinated Bean the trier, the space rookie who, during the training period, had developed a fear that he had a finite mental space to work with and that if he allowed useless information to come in one ear, something important might fly out the other. Duly intimidated, he found himself going to parties and saying to himself, "I'll concentrate enough to be friendly, but don't learn anybody's name; don't remember their face." On the way home, he'd congratulate himself with "Great, I don't remember a thing about that!"

Unsurprisingly, Bean gives us more detail about the feeling of a lunar landing than Armstrong or any of the others do. He jumped when he first heard the loud bang of the LM's reaction-control thrusters, which were only a couple of feet away through the skin of the craft and were being much more active than in simulation. He and Conrad were aiming for a specific series of craters called the Snowman, near which they would expect to find the *Surveyor 3* probe that NASA had sent up a few years before: one of Bean's tasks was to recover the probe's camera. He recalls glancing out of the window at 900 feet and seeing the Ocean of Storms racing toward *Intrepid* at 100 feet per second, and feeling scared; then another shiver of fear when Conrad, realizing that his intended landing site was too rough, took over from the computer and started swinging and jerking the craft around, searching for a better place. Fuel was down to 10 percent as they dropped into a dust cloud that was like a boiling sea, much worse than Armstrong and Aldrin's. It gave Conrad the illusion of drifting backward, but he resisted the temptation to nudge forward, taking his bearing from the tops of boulders.

They made it down and when the dust cleared, there was *Surveyor 3*, winking silver on the other side of the nearest crater.

Bean confesses regret that he never stole a chance to just *be* there for a few minutes, to register the feelings, but time was tight and there was work to be done.

"Neil Armstrong's first thoughts might have been 'This is one small step for a man . . ?'" he says, "but I remember vividly that after climbing down the ladder and stepping on the lunar surface my first thought was 'We're twenty minutes behind now and we've got to catch up.'"

All the same, the surface suggested to him "sculptures in a garden of stone." He fought to keep his attention focused on his cruelly relentless schedule of tasks as he watched the Earth wax and wane in the sky "like a blue-and-white eye opening and closing." Every now and again, he'd grab hold of something solid and look up, muttering to himself, "This is the Moon, that's the Earth: I'm really here, I'm really here." Years later, the whole thing would seem "unreal and perhaps a little like a dream," and I've wondered whether this is why he's trying to capture it in paintings, to tie it down and make it into something he can more easily embrace–something solid and comprehensible, identifiable, *real-seeming.* There isn't even any TV footage to confirm that it happened, because Bean broke the camera by inadvertently pointing the lens at the sun: all we got of *Apollo 12* was excited cries and the sound of Conrad cavorting. They discovered green rocks and tan dust and Bean became the first person to eat spaghetti on the Moon ("spaghetti is all he eats on a trip," marveled Michael Collins), and the Surveyor camera led to one of the most unsung yet mind-blowing revelations of the whole program. When the thing was being assembled, one of the workers must have sneezed into it, leaving traces of streptococcus bacteria, which were found to have survived their stay on the Moon. This opened the theoretical possibility that life could have originated elsewhere in the Universe, then ridden to Earth on a lump of rock. The "Panspermia" hypothesis was viable. We Earthlings might not be Earthlings at all.

After Apollo, with crewed forays into Deep Space gone for

good, Bean went on to Skylab, a primitive space station, commanding the second mission and setting a record by staying fifty-nine days in space. He'd been a gymnast in college and now went outside the craft and held a handstand through a whole ninety-minute Earth orbit. Then he trained other astronauts and geared up for shuttle duty, but never flew. When he left NASA, he was one of the most experienced active astronauts in the world, but by then he'd decided that space wasn't enough. He'd taken night classes in painting when he was a test pilot at Pax River and had kept it up when he could. When no missions were in sight after the Cold War–busting Apollo-Soyuz Test Project of 1975, he resumed classes at the Houston Museum of Fine Art. He remembered a promise he'd made to himself on the way back from the Moon–his equivalent of Ed Mitchell's epiphany–in which he said, "If I get home, I'm going to live my life the way I want to." In 1981, at the age of forty-nine and with the first shuttle flights in view, he announced to colleagues that he was leaving to become a painter. It was a different kind of fear he faced now. For all the uncertainty on the way to the Moon, he had a team behind him then. Now he was on his own.

He loves talking about painting, losing himself in the work as he shows you around it. He speaks of color the way a fencer might discuss a particularly slippery opponent, describing his ongoing battle with the lunar surface, starting with grays and tans, moving through blues and greens on to reds, oranges and yellows as he gradually negotiated the transition from literal to emotional verity. Even so, most of the paintings tell some kind of story, relate to a particular episode from the landing sagas, which he's always calling the others to discuss in order to get the details right. In a corner of the room are some scale models he commissioned to help with form and proportion, because even though his paintings have grown further and further from literal portrayals of what happened, he wants them to be formally accurate.

Gazing at the work on the wall, I comment on the fact that most things one has a romantic attachment to start to pall eventually, but that he seems happy to live in the experience forever. Does he never get bored with it? Or feel sated by it?

"No," he says. "And I think one of the gifts that a person gets . . . you know, they claim what a great gift is talent, but I'm not sure that talent is a nice gift. I'm not sure the biggest gift isn't that somehow you care about these things so much, for some reason not known, that you're willing to devote the time it takes to learn to do it. And then when you do know how to do it, you want to do it better and you like to do it. 'Cos you could quit liking it halfway through. So I think that when people say to me 'Gee, you're lucky, you've got a lot of talents—you can fly airplanes and spaceships and do this—'"

He waves dismissively at the canvases around him and laughs.

"I just think, 'You know, none of it ever came easy.' I was never the best guy in class. I was never the best pilot. I was always *trying* to be the best pilot, but I was never the best. I was never the best artist in any class I've been in. If I went to a class now, maybe I would be, but it wasn't that way then. I just always cared enough that while they slept, I was toiling away, doing those things right over there, and liking doing it—it wasn't like drudgery."

I ask whether he gets the urge to paint other stuff occasionally—a loaded question—and he takes me into a small adjoining room which contains a couple of long, cream sofas and on the wall, a vast painting of a lily pond, which I recognize immediately as the one Monet spent the last years of his life contemplating, or one very much like it. Bean went on a pilgrimage to Giverny in France to see it and when he came back, he did this. I remind him about his fantasy of going back to the Moon and stealing a few minutes to himself, just to take it all in and screw NASA and their ledger of tasks. Could his paintings be an unconscious expression of this desire or frustration or grief, or whatever it is—an attempt to claim that space for himself retroactively? He thinks for a moment.

"Well, maybe I am. My primary goal is to preserve this great adventure, in this way that no one's doing. But I am looking for that, to preserve that feeling, too, if I could find it. And it's thirty years ago, so at the same time I have to be careful not to stray too far from it. So I'm always talking to other astronauts and looking

at the pictures and all that, trying to make sure that I don't turn it from what it *was* into what I *wish* it was."

We go back to the studio and stand in front of the troublesome Conrad for a while as Bean remembers him with a fondness it's hard to remain untouched by. At Conrad's funeral in 1999, Armstrong, not a man given to hyperbole, referred to him as "the best man I've ever known," and everyone seems to agree on that. He'd failed to make the Mercury 7 only because of his irreverent attitude to the tests and my favorite story is that when a psychiatrist held up a blank piece of paper and asked him to describe what he saw, he replied, "But it's upside down." He is thought to have been Tom Wolfe's main source for *The Right Stuff* and was the kind of man other men either wanted to follow or *be*–more like Ken Kesey or Tim Leary than other astronauts.

I can see the problem with the picture, too, because depicting a man clicking his heels in a space suit is difficult without making him also look like he's toppling over. Bean asks me for my opinion on it, which he would certainly never do if he'd seen the paint scheme in my study, and we fall to talking about the trip back, as he describes the intense sensation of slamming into the Earth's atmosphere at 24,000 miles per hour–the point at which they understood how fast 24,000 miles per hour really is . . . twelve times faster than a high-speed rifle bullet . . . and they hit six and a half Gs. A fraction of a degree off course and they would have skipped off the atmosphere and joined Major Tom, tumbling away forever, watching the Earth get smaller and then disappear entirely as they sped into the blackest black of an absolute void, blacker than any dye or pigment or mere absence of light could ever approach on Earth. We tend to discuss space as though it's something. Actually, space is *nothing*. Such a strange idea. Bean talks about the lessons Conrad taught him and the home truths he cared enough to tell when the younger man's troubles with Slayton and Shepard were at their peak and he was feeling persecuted or ignored. When I express sorrow at having been denied the chance of meeting Conrad, he sighs and simply says:

"Yes, he'd have been one you'd have remembered. They come along every once in a while."

Bean smiles as he shows me the Moon tools he uses to give

the pictures some of their texture; the boots he stomps across them and the geology hammer "which really belongs to the American people, but I'm using it right now." He'd been searching for more beautiful–and there, he says it!–more *feminine* colors in the face of "this rugged Moon," when the tools came to him as a way of resolving the conflict.

"Why was I using these tools?" he asks, holding up a paintbrush, "when I've got tools of my own!"

He'd also dreamt of scattering Moondust on the works, but didn't think he had any. Then one day he looked up and saw his old mission patches, which were filthy with it.

"So I said, 'I could cut those up.' Then I thought, 'No, I don't want to do that, those mean a lot to me.' It took me three or four days of thinking about it to decide that, well, I really was devoting the rest of my life to doing this, so that was a good place to put them. Rather than just leave 'em for somebody to sell one day and somebody else buy 'em and put 'em on their wall . . . it'd be better for me to put them in these paintings."

It had sounded like a gimmick in the catalog, but it doesn't when he talks about it. He shows me some of the tricks he's discovered for improving the texture of the work.

"You wish that you'd think of these things right away," he concludes.

You can't think of everything right away.

"Well, you could," he smiles, "but it wouldn't be art. That's what I tell myself when the colors don't come out right or something hasn't worked like I thought it would: 'That's why they call it art!'"

We discuss the problems of painting something that's the same color all over, surrounded by a uniformly dark sky. Other artists can put a tree or some grass in if they want an injection of color, but Bean can't.

"There's only a few colors you can use on the Moon and make it look real; you can use reds and oranges–which are becoming my favorite–and yellows. But you use almost anything else and it doesn't look right. It took me years to understand this, but being an art lover, it can still be frustrating. I keep thinking, 'Well, maybe there's a way.' And I spend hours trying."

Did he understand the extent of the risk he was taking when he quit NASA to become a painter? I ask. Hardly anyone makes a living at it.

"Well, partly. But I had the advantage that I've always believed you should follow your dream. And I've always been like that. I knew that somehow I could work it out, you know? I didn't know how long it would take, so I had the advantage of staying with NASA and trying to save my money. And I moved into a little apartment that was, like, 1,100 square feet, a little-bitty apartment, and I'm sure that, among astronauts, I had the littlest place. But I said, 'Who knows how long I'll be living on my savings here? I don't know how this is going to go.' And then when I got there, I discovered that I wasn't as good as I thought."

He chuckles softly. Bean radiates a rare kind of peace, seems—there's no other word for it—*happy*. I suspect that he would attribute this to the fact that he's lived his "dream," but my experience is that people who've lived dreams tend to be more discontented and *un*happy. On the other hand, perhaps Bean just hides his shadows well. He seems to have such a positive outlook, I find myself saying aloud . . .

"I do. That's the thing I'm most proud of about myself, is that I'm productive and not thinking about the good old days and I'm not griping about stuff. I think one of the things I've learned in life is not to get trapped into needing too many things. I don't . . . I'm not driven by a lot of things that some people are. My aim was not to get rich, although I've got lotsa stuff. Some of my friends have got airplanes or better cars. I've got a nine-year-old car out there. I mean, I've got the money, I could go buy a better car today out of my checking account, but I wouldn't be any happier if I did. But I would be happier if I could paint a better painting tomorrow. And the stuff you like, if it breaks or someone takes it away, then it's gone—it doesn't matter. But if it takes you twice as long as you think it should to get to work every day, that *does* matter. I understand this for me: I'm not saying it's true for everybody."

Ed Mitchell had a similar outlook. It's unusual among people who've been high achievers.

"Oh, I think it is. Of all the astronauts, I'm maybe the most that way. I feel good every day."

He must feel blue sometimes, I insist. What does he do then?

"First of all, I feel like it's me. If I feel like that here, I'll quit doing it and go . . . the thing I like is eating, so that's not good." He laughs and pats his actually quite modest stomach. "But I'll say, 'I'm gonna have a big lunch today, I'll have spaghetti at my favorite restaurant.'"

Now I'm laughing. Spaghetti–*still!*

"And I'll have some garlic bread! I had that today. And I can't do that every day, so I'll be eatin' leftovers tonight to make up for it. So I'll do something like that. There's not too many days like that, though. I mean I got as much ups and downs, as much good and bad that comes in, as anyone else."

He asks what I do, because "you seem real content." I tell him that I'm not sure about that, that I get easily frustrated and even more easily bored and have a tendency to make things harder work than they really need to be. That said, I've gradually learned to trust these feelings, to see them as indications that something's wrong and needs changing. Though, obviously, this is not always convenient.

"I agree," he enthuses. "Now, when I was an astronaut, I was the last one in my class to fly. And that was very frustrating to me and those were kind of unhappy periods, right when they'd announce the new crew and I wouldn't be on it, even though my friends would be. And some of 'em, you know, I knew they were better astronauts than I was, could fly better and seemed to be smarter than I was . . . they would get selected for crews and I could kind of accept that. Then they'd begin to pick people where I knew I could fly better and knew I was smarter than them–"

Suddenly, there's a commotion in the kitchen area and Bean dashes off to see that the Lhasas haven't eaten the dog lady who's come to feed them, then comes back and we go off on a tangent about my minidisc recorder (he's never seen one) and a recent trip I made to Intel to hear about the new kinds of computer processors they're working on, which might be like little

organic puffballs, little *brains* that will store information three-dimensionally, and Bean is thrilled by this. Throughout our conversation, he asks a lot of questions and listens attentively to the answers. It would be hard to overstate how unusual this quality is among the alpha-male scions of the Space Age. All the same, when I remind him where we were, he picks up the thread in exactly the right place, with nary a pause for breath.

"Yeah, well, I was disturbed about the fact that I wasn't being selected. And I spent my time blaming my bosses, Al Shepard and Deke Slayton, for not recognizing how wonderful I was and giving me a flight, as opposed to those guys over there. And I put a lot of effort into that and it was nonproductive. And also, probably my attitude toward them when I was with them was not good.

"And I began to realize that if he [Deke Slayton] didn't like me—professionally, as an astronaut, which is the way I interpreted it, since he didn't give me flights—that it was up to me to find a way to make him think of me better than he was at that moment. And that clicked, almost like a binary, that it wasn't his job, it was my job. Then I was standing around not knowing how to do that and realized that I had no skills to do it, because I'd never thought that way. I'd always been in little groups, like a squadron, where, if you could do it better, your boss saw it. The skipper knows who can land aboard ship. So I could do that, but I discovered at NASA that that wasn't enough. My friends would know it, but the boss who was somewhat removed had no idea of this. So I had to learn how to do that, how to let him see me in an advantageous way, without bragging and stuff. Some people are really good at this. And I noticed that the guys whose fathers were generals and things, they knew how."

I haven't heard him say this before. I assume that he's referring to the likes of Buzz, Dave Scott, John Young.

"Then you had to think of the ethics of it."

You mean in relation to negative campaigning, badmouthing competitors, I ask?

A note of distaste enters his voice for the first time. He frowns and shakes his head.

"Naw. I don't do that. Never did that once and I'm proud of it.

People did that to me, but I didn't do it back. You have to find ways that fit your personality. It's an advantage to be more ruthless than I am, no doubt about it. But I ain't gonna do it."

"Surely success gained in such a way will be less satisfying in the long run?" I pipe, astounded by my own naïveté even as I speak.

"Well, yeah, but I think you can be just as happy and even more successful if you're able to cast aside the rules. I mean, I'm not gonna do it. But my feeling is from looking at it, that if you can be ruthless, lie, and all those other things–and be smart about it–that's a big advantage, because then you can take short-cuts. It's like football: if you didn't have referees, and you could clip and push and grab face-masks, well, you're gonna win the game."

A question asked of ethics students is what do you say to the cheating, lying bastard who reclines on his deathbed insisting that he is happy, content and would do it all the same way again? The astute student soon learns that there is nothing to say to this person: placing matches between his toes and lighting them is about the best you're gonna do, though Kant wouldn't necessarily approve of this.

"Well, I don't think they think they've done it," says Bean. "I think they think–as we all do–that they did what they needed to do. So that's my take on it."

I'm keenly aware by now of how rare it is to hear astronauts talk like this. I wonder whether the feelings Bean has just expressed still color his relations with his former colleagues?

"I think, probably . . . it doesn't with me. Ahm. I think that to get here you have to be very competitive, 'cos it *is* competition–the world is competition. And I think that's one of the reasons I'm an artist, by the way. I don't want to do that. I don't like to do that. I'd rather perform and see if it works out. If it doesn't, I'll try to perform better. That's good. And other people perform better than me, so I'm not saying that I'm the best performer, I'm just saying that there's a lot of ways to do this . . . but some people don't ever get over it. Some of my astronaut friends have a different attitude. I feel friends to all of 'em, but I can see they don't. I didn't recognize this as a younger man, but I can see they're just

as competitive now as they were when we were really in competition."

He pauses for a moment, raising his eyes until they're focused somewhere just above my head. I get the feeling that he's weighing whether to say something or not.

"I went to an astronaut reunion here in Houston last week, and some of 'em would try to one-up you when they hadn't seen you in three years. You know? That's the way they are. They want to . . . they want to . . . give you a hassle. It's just them. It's just the way it is. And I feel bad for them, kinda. But they like it. On their deathbed, they're going to feel that that's the way the game is played. Everybody on their deathbed thinks they did the best they could. Adolf Hitler thought that he did the best he could. I've read that he said the German people let him down, they didn't have the intensity and devotion that was required. And that allowed him to flood the subways when they were in there, to stop the Russians, and feel justified in doing it. But in my philosophy, which I've read a lot of, though I never took it, everybody feels they did the best they could under the circumstances. And so we have to be careful."

Bean doesn't sound angry as he says this. He sounds like a man engaged in a conversation while trying to dig a thorn out of his foot.

Then he returns to Wernher von Braun, extolling his ability to talk to anyone on their own level, in a way that they could connect with, without being condescending or patronizing.

"I'd never seen anybody do it like that. And he did it effortlessly. He had this ability."

Which is rare in a person with great theoretical facility . . .

"That's because they always want to move on. I always felt that in meetings we'd be talking about stuff and he already knew the answer, but didn't want to interrupt because he wanted to build a team. And as a result he had to sit in meetings that were boring even for me, not because I knew the answer, but because it took so long to get to the solution. And I think he often knew the solution before we started, but would patiently sit through the discussions because of the need to be there and provide leadership, so that in the long term, when he wasn't there, they

could still go out and do the things that needed to be done. Let's assume that I had the IQ he did, which I don't; I don't think I could have been that patient."

Yet military historians have claimed that, had Hitler's regime clung on for another six months, the godfather of Apollo and his V-2 rockets might have won him the war. I'm about to throw this spanner in the works when Bean does it for me.

"Yes. And if you read his history, then you're also left with the problem that he did a lot of bad things—but if he wanted to be in that society, and a leader, then he had to use slave labor, he had to accept that people were getting killed and starved and strangled with their belt because they took some leather to hold their pants up and they weren't supposed to."

People say he didn't know.

"Of course he did. He was a genius. We knew, so I'm sure that he did. Now, here's the question for philosophy: What does this all mean to a guy like von Braun? He must know the workers are not humanely treated. He can't believe, I don't think, that they're subhuman. Hitler thinks that, but I imagine von Braun thinking, 'They're unfortunate humans, just like me.' I don't know that. But if it is the case, what does he do? He's not going to stop it. What does it all mean? Thank God we're not in that position, you and me, 'cos we could have been born in it, and we might not know what to do any more than von Braun did."

Which is something no one can deny until they've been in that position, but still . . .

"So how does it all fit together? Say I was at Exxon, I would probably leave. I would try to tell the president what I thought and if he wasn't interested, I think I personally wouldn't stay. I wouldn't blow the whistle and do all that other stuff, 'cos I wouldn't want to spend my one life on Earth doing that— even though I might wish somebody would. I'll tell my friends why and then I'll go. That would be my approach. It's probably not a good approach, because then it keeps going."

Afterward, I wonder whether Bean actually meant Enron: in October 2002, there's not much to choose between the two corporations in terms of popular image. I tell him about a dilemma I recently faced, in being forced to choose between one organi-

zation whose macro politics I dislike, but who treat actual people well, and another whose professed outlook I'm more comfortable with, but who treat their own people with contempt. He laughs delightedly.

"Well, there you go! You see, it's the real world you're living in. It's the dance that you're learning to do as you go through it! Yeah. That's interesting. It's good. I just think we should all be moving toward positions where we can shine our light on things that are important to us. That's what I feel like here. I don't have a boss. I spoke to astronauts the other night and told 'em exactly how I felt about things—which is very positive, mostly—but I didn't have to worry about how my boss would take it or any of that. I like that and that's one of the reasons why I'm here. If my life gets screwed up sometimes, I know that I've screwed it up and I can undo it. Nobody is forcing me to screw up."

And as he speaks, the fact that Bean survived the Astronaut Corps and even learned to thrive in it strikes me as the most remarkable thing, a real cause for celebration. Then he's talking about the Lhasa Apsos, which are said to have been traditional companions to the Dalai Lama and are good watchdogs, because they have keen ears and are terrified of everything, and he's saying:

"The thing I like about 'em is that their hair is not like dog hair. It reminds me of the hair on my children when they were little. And when they were little—do you have children?—you rub their heads and you're kissing them and petting them and that's something you can't do when they grow up. You know I can't go patting my daughter's head—I'd like to, she's thirty now, but I can't do it. So I like that with the dogs, because it brings back good memories.

"They smell good to me, too. They smell like a dog to everybody else, and they did to me at first. I think that's what love is all about. They're also good role models for growing old. We've had three grow old and die and they never complained about it. One had cancer and had to have one of her legs removed, but she came home and couldn't do much for a while, but never complained and did the best she could. Another one went senile, couldn't see much, remembered nothing and would bump into

all the furniture, and I'd say to myself, 'You got to get up courage to take her down to the vet and get her put to sleep.' But I realized that she was happy doing that, that I was the one who had the problem–the dog didn't. So I've learned a lot from these dogs about growing old. I mean, I'm seventy."

We talk for a while longer about his father and sister, and my father and brothers, and he asks about the pets I kept as a kid, and we discuss Vermeer and Wittgenstein and Britney Spears and Bianca Jagger and his daughter and the first marriage that ran out of steam soon after he returned from the Moon, and his second wife, who was supportive of his change of career (having little option *but* to be, I suspect), and what books I'm reading and what books he's reading, and space suits and Houston, and he asks me again what he should do about the Pete painting, despite the fact that only in the spheres of navigation or timekeeping should any opinion of mine be taken less seriously than my opinion in regard to form and color, and eventually I notice that it's late. Hours have passed, and Bean doesn't look like a man to be kept from his dinner for so long. I apologize for detaining him and start to gather up my belongings, being careful not to tread on any dogs. He says: "Don't apologize. You didn't keep me. I kept myself." I ask if he's thought about the day when all the Moonwalkers will be gone?

"Oh, for sure. And it won't be very long. There's only nine of us left. And I knew that when I left NASA. I loved being an astronaut, but I said, you know, there are young men and women who can fly just as good as I can, or better, but there's nobody who went to the Moon who can tell the stories about Pete and the others that I can, that's interested in learning to do this sort of thing. When I think about my life, I'm always thinking, 'I hope I live long enough to do all the stories I know.' And I know I'm not gonna, 'cos I got a list over there and it keeps getting a little bit longer."

As if guided by someone or something else, our attention turns to *That's How It Felt to Walk on the Moon*. It's a question which twelve men struggled to answer for varying portions of three decades, which Bean tried to answer with his brush.

"It was an image NASA took of me. And I wanted it to have

more emotion about it, so I didn't paint it like those others. And I painted it gold—'cos I felt like I had a glow up there, you know, really excited . . . I didn't know how I felt! But you had the best day of your life. But I looked at it and I said, 'I didn't really feel the way that looks.' So I said, 'Maybe it's more like a rainbow,' and then it began to feel more like I felt. And those colors go well together, which is why it looks so good. And I wanted to keep it. I can't remember what that sold for at the show, but I said to myself, 'I can't afford a painting that expensive.' And later on when I could, I tried to buy it back, but I couldn't."

They were asking more than you sold it for?

"No, they wouldn't sell it!"

He explains that he's borrowing it right now because he wants the painting of Conrad to be a companion piece to it. I tell him that I'd have trouble parting with something that I'd put so much of myself into.

"You do," he smiles, "but you're either in business or you're not."

On the way out, Bean invites me to a talk he's giving for an education charity at the Houston Museum of Natural Sciences. He also lets me try on his space gloves, which are unexpectedly stiff and clumsy and as I'm tugging them off, I suddenly hear Naughty Jack's voice in my ear, delivering the best speech from *Terms of Endearment* to Shirley MacLaine, who has just agreed to go on a date. He's oozing:

"Now, Aurora, since you've agreed, why don't we just forget about the rest of it. I mean, I know how you feel, you know. There were countdowns when I had my doubts. But I said to myself, 'You agreed to do it. You're strapped in. You're in the hands of something bigger and more powerful than yourself . . . so why don't you just lay back and *enjoy the ride . . .*'"

And I have to ask: Can this really have been based on Alan Bean, even in the wilder days of his youth?

"Oh, nooo," he assures me; "they just came round to get the feel of what an astronaut is really like."

So we'll take that as a "yes," especially once we know that Ron Howard and Bill Paxton also came over when they were making *Apollo 13,* and that at the film's Hollywood premiere a

stream of people came and told Bean how puzzled they'd been to find that Paxton's portrayal of the *Apollo 13* Lunar Module pilot, Fred Haise, reminded them so much of *him*. I watch it again and they're absolutely right.

THE MUSEUM DISTRICT comes on like a pleasant afterthought to the city, manicured green and–with no reason for anyone to go there other than culture–*quiet*. It's nice, though, and the gathering at the Museum of Natural Sciences is an intimate thing, with cocktails preceding a "VIP dinner" attended by educators and Houston philanthropists, the theme being "Make Space for the World's Kids." I arrive late and sit at the back, watching chicken bones being cleared away until, lo and behold, those familiar ascending chords come spearing from the PA system. *Also Sprach Zarathustra.*

Bean steps to the front of the circular room in brown trousers and a pale blue, long-sleeved cotton shirt with a NASA logo on the pocket, and a big smile on his face. "Hello, Earthlings," he says into the microphone, which erupts into feedback. He steps back and someone fiddles with a knob. A slide show begins and Bean's words start to tumble out as the images flash by. There's one of the computer room at Mission Control, which contains all the computing power of several modern mobile phones (the onboard LM computer had a memory of 36k), and another of a strange harness designed to simulate the one-sixth gravity found on the Moon, which appears to be suspending Bean by his testicles. "We realized that not only did we not know how to git to the Moon, we didn't know how to train to git to the Moon," the former astronaut deadpans. "You'll see that I'm not smiling here." The audience dissolves into laughter. There's a picture of a reluctant Bean being taught geology and another one with his crewmates Conrad and Dick Gordon, where he points out that he went all the way to the surface precisely because he was the least experienced of the three; because Gordon had been into space before and could be trusted to tend the Command Module alone; and I realize that I've never heard or seen any of the other LM pilots acknowledge this. It wasn't a

"single-shot thing," he says as a slide of Aldrin on the Moon appears. They hadn't assumed that the first attempt would be successful, had half expected that it might take two or three to get it right.

"We were stunned, we were amazed when that happened," he admits. "We came back and thought, 'This is amazing that we did this'–the same feeling that all the people on the planet had at that time."

Bean tells us that he called Neil Armstrong on the phone when he started to paint the *Apollo 11* commander planting the first flag, and that Armstrong had declared this to be the scariest part of the mission, because lunar soil is like dust mixed with coral–sharp and hard because there's no weather to erode and smooth it–and he couldn't force the flagpole more than a couple of inches in. He became convinced that when he let go of the staff, it would fall and everybody around the world would see the American flag collapsing suggestively into the dirt. So he leaned it back and tried to balance it. He put a little soil around the base and the thing stood up, *just,* but he and Buzz made a point of steering clear of it thereafter. And I'm thinking: these people find fear in the strangest of places. This is followed by a photo taken through the LM's window on the way down, and the observation that the Lunar Module pilot, which is what he was, should really have been called the Lunar Module engineer, because the commander, in this case Pete Conrad, was responsible for flying the ungainly contraption.

"And I remember looking out the window and saying to Pete, 'Wow, this is scary.' When I was in orbit around the Moon, I had a feeling I was in an animation. It was like orbiting a ball, because it's so much smaller than the Earth and you can see the curvature and it just seemed magical that we would keep going around this little ball in this little spaceship, without drifting off into space. But I remember looking out and there'd just be craters all over the place and I'd be scared and I remember saying to myself, 'Well, I can't do my job scared,' so I'd look in and I'd pay attention to my computer screen, which looked just the same as in the simulator, and I calmed down. But I didn't want to miss the trip, so I'd look out and get excited again, then look

in . . . astronauts aren't fearless. Well, some are more fearless than I was, but it's a case of trying to find a way that you can manage your fear and still do the job at hand. And the thing to remember is that we couldn't do this when we began: we gradually learned to. I tell young people all the time, as part of their education, 'You're not born brave: you gotta learn to be brave. You got to find a way.'"

He addresses the post-Apollo hiatus in Deep Space voyaging, pointing out that it was 127 years between Columbus stumbling across America and the founding of Jamestown. He gives us a flash of the famous tabloid mock-up of a Nazi bomber on the Moon, using it to tell us that he doesn't think we've been visited by UFOs, then shows his painted version of Al Shepard hitting that golf shot on the lunar surface.

"If I was going again," he maintains, "I'd take a football and I'd get Pete to go deep . . . we were so focused on doing the science that we missed out on the humanity," even though some people disapproved of that particular stunt. "One of the things I love about being an artist is that when you want to do something, you don't have to call a meeting. And also it doesn't have to make sense."

We laugh at that. Can Apollo be said to have made sense? I'm still not sure.

Then there's the famous *Whole Earth* photo, which *Apollo 17* brought back after NASA had all but given up hope of getting one, and which is still the most reproduced image on Earth.

"And I'm not a religious person, but I do know what the Bible says, and I think the people that wrote the Bible, when they said 'the Garden of Eden,' and they thought it was the Tigris-Euphrates river valley, 'cos that was all the writers of the document knew about, but I think, really, the whole Earth is the Garden of Eden. We've been given paradise to live in. I think about that every day. Now, think about this for a minute: we've been looking out of telescopes for three hundred years; we've been sending probes out into space, and we have never seen anything as beautiful as what we see when we walk out the front door. That's why, when I came back from the spaceflight, I was a different person."

During fifty-nine days of orbiting in Skylab, he looked down and saw rain over Houston, and wished he were there. What struck him when he came back from Deep Space was the movement and change all around us here, where in space you just have "a sunny day then a sunny night then a sunny day then a sunny night." He remembers going to the shopping center two or three times, after splashdown and just sitting there eating an ice-cream cone and watching the people go by, as thrilled and fascinated by this sight as by anything he'd seen on the surreal adventure. A photo of Bean, Conrad and Gordon in the Command Module on their way home reminds me of Kim Poor telling me, "I know other missions where the guys don't even talk to each other... but I was with those three at a signing three weeks before Pete died and they were just amazing... they were finishing each other's sentences, just *so* close," and out of the blue, I find myself wondering whether the most powerful part of the journey for Bean might have been the relationship formed with these two other men? Gordon made some wisecrack about not messing up his tidy module when his friends returned to him safely from the surface, but once, in an unguarded moment, he did admit that what he felt was love flooding through him.

To Bean, the image also brings back the sudden understanding that they were invisible at that moment to even the most powerful telescope on Earth, which in turn showed "how inconsequential we are in the grand scheme of the Universe." It dawned on him that with the right computer program, it would be possible to know precisely where everything else in the Universe will be ten, or a hundred, or a hundred thousand years from now.

"The one thing in the Universe that we can't predict," he concludes—and we know what's coming, yet that doesn't diminish the thought—"the one thing that we don't know where it's going to be even ten years from now, is *us*. We may be small, but we've been given the most extraordinary gift in the Universe."

I walk away feeling fascinated by Alan Bean and his charisma. I realize how few people I know who might be described as *happy,* and how much time I've spent being unneces-

sarily less than that myself, and I'll still be considering this when I see a story in tomorrow morning's paper about how a new object has just appeared in Earth orbit, at about twice the distance of the Moon, and how astronomers at the University of Arizona have become convinced that it is the third stage of the Saturn rocket which hove *Apollo 12* into the sky. Third stages, remember, carried the Command and Lunar Modules into Earth orbit and then pushed them toward the Moon, and when they'd completed this task and been discarded, they were supposed to swing over to the sun, though some crashed into the lunar surface instead. By contrast, this one had seemed to have a mind of its own, loitering in Earth orbit, unable to tear itself away, until finally it did and went wandering for thirty years, only to return now, this week, to resume its silent vigil through the dark of space. I'll think of Alan Bean then, wondering how he'll feel when he opens his morning paper.

I find my car in the car park, climb in and put the key in the ignition. The radio comes on and I find myself laughing uncontrollably. Floating from the speakers is "Space Oddity" by David Bowie. My first thought is: "There's not a person I know who's going to believe this." And I'm absolutely right.

MANY MONTHS LATER, I call to see how Bean's getting on and he tells me that he's finally cracked the problem of adding color to the Moon. He talks animatedly about the day it happened; how the reds and yellows and oranges suddenly gelled and he knew that he would now be able to make that other world look as beautiful on canvas as it seems to him when he thinks back to his time on the surface, on what he'll still describe as "the best day of my life." As a result, he thinks his work might be about to enter a new phase, and with the sun shining in Houston and spaghetti on the cards for launch, I can't help feeling that there's a lot to learn from Alan Bean.

AS THE FAMILY settles down to watch New Year's Eve on TV, the things I remember about the second half of 1969 are these: the first flight of Concorde; the Beatles in beards and Afghan coats on the roof of the Apple building in London, looking cold and sounding gray as the English sky; the murder of an actress named Sharon Tate by members of a hippy cult whose leader, Charles Manson, had eyes like pits—and then of a black Rolling Stones fan who was beaten to death by Hell's Angels security guards at their huge concert in Altamont, California, not far from where I live, filling my living room with articles about whether the Stones are Satanists.

The summer had seemed exciting and full of hope, a prelude to the new decade that would be coming along soon, bringing with it a new world of promise. *Apollo 11* was closely followed by the Woodstock Festival, which, even according to the super-square *Time* magazine, "unfolded without violence

in an Aquarian instant of communion and discovery." For a few days, the newspapers were all full of hippies dancing naked in the mud and looking a little silly, but when the album came out and all my friends' older brothers and sisters bought it, we loved listening to Country Joe McDonald getting the crowd to shout "Fuck!" and singing a hilarious antiwar song called "The I Feel Like I'm Fixin' to Die Rag" with a chorus that ended: "Well, there ain't no time to wonder why–whoopie! we're all gonna die." Two things I've understood from 1969 are that satire is everything, and that people's genitals are hairier than at any other time in history.

Perhaps it's the drugs.

In the summer, everyone said the war was going to end, but it doesn't look that way anymore. In November, President Nixon, who'd promised to stop it (hadn't he?), came on TV and said that it was all North Vietnam's fault anyway and that he wouldn't countenance "the first defeat in our nation's history." Like everyone else, I hardly noticed *Apollo 12* that same month, only sixteen weeks after the wonderment of *Apollo 11,* because a series of huge antiwar "mobilizations" were grabbing most of the headlines. In Washington, hundreds of thousands of Americans stood in the Mall singing "Give Peace a Chance"; then on the second day of the "Mobe," news broke that in March 1968, some American troops under Lieutenant William Calley Jr. had massacred hundreds of Vietnamese civilians at My Lai. Spiro Agnew, the vice president who radiates a weird, goofy anger and always sounds like he's trying to juice a lemon with his sphincter muscles when he speaks, accused the students of being irresponsible, drug-addled hippies–like my teachers–and a lot of grown-ups seemed to agree with him. Trade unions have supported the war: in some places, workers have been turning up to fight with student protesters.

Weirdest of all was the first "Draft," where a huge fishbowl was filled with 366 blue capsules, which were drawn out one by one and if your birthday came out, you were sent to the war. Mum had the TV on that morning and I asked whether I was going to have to go when I was older, but she said no–if that happened, we'd move back to England. Other mothers say the same

thing and it's become a kind of game at school, boasting about whose parents will move furthest away in the event of their sons being drafted (not everyone plays, mind: John Schaeffer's dad, who makes his kids call him "Sir," says that John'll just have to go and damn well fight). They still announce the number of American dead on the news each evening, but I've been hearing the numbers for so long that they don't mean much to me anymore. A poll on the news says that President Nixon's "approval rating" at the end of his first year is "eighty-one percent, rising to eighty-six percent in the South . . ." so I guess that means he's doing a good job.

What of this new dawn? Before 1970 is done, the Beatles have angrily split and Hendrix and Joplin will be dead, with the Doors' Jim Morrison to follow. Bill Anders's *Earthrise* picture has fronted environmentalists' first "Earth Day," four students have been killed by National Guardsmen at Kent State University and a house which blows up down the road from where I used to live in Greenwich Village turns out to have been a bomb factory for a shady group calling itself the Weathermen. The big movies are *Catch-22* and *M*A*S*H* and *Patton*, about the World War II general, which Nixon screens for himself in the White House whenever he feels in need of inspiration, clearly missing the archness in Francis Ford Coppola's script; and biggest of all, the weepy *Love Story*, which critics panned but fearful Middle America is eating up like Devil's Food Cake *lite*. There are signs that the economic Golden Age is losing its luster, but they're subtle as yet. Public opinion is turning against the war, though– not because, to quote *Newsweek*, "the combat forces are now manned by bitter draftees [who] get killed at nearly double the rate of non-draftee enlisted men," but because so many of them have been returning as drug addicts. Getting our boys killed in 'Nam is one thing: bringing them home as hippies quite another. Nixon's chief of staff, H. R. Haldeman, will one day admit that the new president could have halted the war in 1971 if not sooner, but chose to wait until the election year of 1972. By the war's end, the death toll will include 58,000 Americans, nearly a third of whom have gone down on his watch, with a quarter of a million wounded.

A new decade? No. From where I stand, nothing's changed. We're on the cusp of an era that will drift steadily beyond the reach of satire, but for now, it's business as usual. We're out of the 1960s, but the *Sixties* aren't done yet, and if Marvin Gaye doesn't know what's going on as he floats into my room on KFRC, that's because no one else seems to either.

IN THE DAYS since I last saw Alan Bean, I've been surprised by a number of things. The first is that I drove away from him thinking not "I wish I could go to the Moon," but rather: "I hope I can be like that when I'm seventy." I'm beginning to see patterns again, like I did in the old apartment on West Fourth Street, and if it's becoming clearer to me that the astronauts' journey wasn't really about the Moon, it's also dawning that neither is mine.

Another surprise is how much I'm growing to like Houston, which, for all its rubble jungle of vacant lots and parades of traffic-choked, twelve-lane flyovers, is full of vitality, seems to be in a permanent state of invention, and I'm unexpectedly pleased to be staying for another week. And I'm staying because of the final surprise, which is that, in three days' time, the spectacularly retiring *Apollo 16* commander, John Young, has agreed to receive me at NASA's Johnson Space Center on the road to Galveston, where he still works, the last of the Moonwalkers to do so, a Space Age heirloom at the age of seventy-two. Before it was renamed, the Johnson Space Center was called the Manned Spacecraft Center and when astronauts referred to "Houston," this is what they meant. So I'm meeting John Young at Mission Control.

It gets better, too. By priceless coincidence, the World Space Congress is also in town this week and I am registered as a delegate. The congress happens on this scale just once a decade and here Apollo's legacy will be laid out like a banquet in the big tin hangar of the George R. Brown Convention Center. In fact, as I take my seat for the inaugural ceremony, the eighty-five-year-old veteran broadcaster Walter Cronkite is already hailing the presence of over one hundred Nobel Prize–winners this week. He talks up the forbidding program of lectures, seminars and

events, then launches into a series of tales about his time report-
ing the space program, the best of which concerns being in the
studio when Armstrong and Scott started to tumble in *Gemini 8*
and it looked like they were going to be lost, at which moment
his team had "seized the air" and started to breathlessly report
the episode–not a story Cronkite enjoyed reporting but his duty
all the same–and the station switchboard had been instantly as-
sailed by so much traffic that the phone company strained to
handle it . . . calls sparked not by anxiety or alarm or concern for
the astronauts, but because Cronkite had interrupted a broad-
cast of *Lost in Space*. *That's right*, Armstrong and Scott were
cramping the style of my foily friend, Major Don West. This will
be a theme I hear often this week: how the fickle public would
rather be spoon-fed fantasy than pay for awkward and unpre-
dictable reality. Then Cronkite introduces a celebratory collec-
tion of space clips from Hollywood blockbusters and TV shows
and I seem to be the only one to find this riotously ironic.

Downstairs in the cavernous hall, the congress looks like
two different conventions sharing the same space. There are
dozens of small stalls concerned with satellites, or trumpeting
technologies and programs aiming to catch NASA's eye, because
they're the only ones with money to spend. Then there's the
monolithic NASA, which dominates and is here to persuade the
public and media that it's exciting, necessary and value for
money. This is a tough job, because no public in the world is
more shrewdly skeptical of (real) space than the American pub-
lic at the end of 2002. In Europe, India, China, Japan, it can still
fire the imagination and inspire pride, but to most Americans it's
history–expensive, tax-inflating history. Space people complain
about this, even though the original push was presented to the
people as a race which needed to be won, then was: and once a
race is won, only a fanatic keeps running. This is in no way
NASA's fault (remember Bob Gilruth's screams in the night?),
but they've had to live with it ever since.

Which is not to say that NASA is blameless. Old-school engi-
neers will tell you that the bureaucrats started to lose their nerve
and their way long before Apollo was over, while bureaucrats

blame politicians, the public and the media for their lack of re-solve, a little like Hitler and the people in the subway. Before I came here, I was pleased to track down the English engineer John Hodge, one of a visionary four-man team who designed Mission Control and went on to be the unflappable flight direc-tor on Armstrong and Scott's near-fatal *Gemini 8* mission (wit-nesses describe him pacing the floor in his tweed jacket, smoking a pipe as he issued instructions). Almost unknown in his country of birth, Hodge lives in Virginia now and his story is telling in a number of ways. To begin with, it's another little-known fact that he was part of a tranche of twenty-five crack British engineers who'd been recruited from the Canadian air-craft makers A. V. Roe when it suddenly went bust in 1959. They'd been working on a super-advanced jet fighter called the "Arrow," and when NASA heard of the company's collapse, they hurried over the border with a checkbook and signed up the de-sign team. It was a smart move: flight controller Chris Kraft en-thuses that "In one bunch, we got engineers who would make major contributions to getting us into space." Thus, when Hodge arrived two months after NASA's formation, 50 percent of the en-gineers were Brits like him. Yet according to Hodge, there was more to this than met the eye.

"The interesting thing about it was that they couldn't get people in America," he told me with a note of amusement in his voice. "People in the States thought it was just a fly-by-night thing that wasn't going to go anywhere. So when we came down here, we were about twenty percent of the total organization! We were a big part of the program at that time."

He talked for a while about being part of the team that dreamt Mission Control into existence and how exciting those early years were. Then he spoke of how NASA ossified through the Sixties, as the bureaucracy became more top-heavy and en-trenched and remote from the creative engineers. By the end of the decade, he was working on shuttle and space station de-signs, but the crafts which struggled through endless committee meetings and political compromises weren't what he'd imag-ined or hoped for.

"No, the space station they built is not the space station I designed," he mourned. "It's a very bad space station. And of course we need a new shuttle. That was not a good design either."

Neither was money a key factor in this, in the engineer's opinion.

"No, I don't think it was about the budget, because we spent thirteen billion or something like that. It had to do with the attitude of the people in Houston. They really knew what they wanted and it wasn't the right thing. They're very precocious down there . . ."

So now I'm "down there," looking directly at them; at the expansive stands displaying all sorts of speculative designs for sexy space planes and new propulsion systems that run on air itself, and socially conscious schemes for generating clean energy in space. The trouble is that everything's on paper, backed by an occasional scale model, and almost nothing looks likely to be realized anytime soon, save in response to some so far unseen threat or tragedy. No one in the hall knows that, fourteen weeks from now, in February 2003, the shuttle *Columbia* will provide just such a spur when it breaks up in the clear morning sky right above this place, as if on some mean cosmic cue. Like everyone else, my first thought then will be for the crew and their families, but my second involves remembering that *Columbia* had been the first shuttle to plummet back from space at twenty-five times the speed of sound in April 1981, and that the pilot who placed her triumphantly on a desert runway at Edwards that sunny day was the Apollo hero John Watts Young.

AFTER THE TRIUMPHANT landings of *Apollos 11* and *12* in 1969, 1970 was as rough on NASA as it was on everyone else. No one reached the Moon that year and the public's attention was already draining away. Budget cuts, which had begun as early as 1963 as President Johnson struggled to protect his beloved lunar program from the spiraling costs of Vietnam, now bit hard: *Apollo 20* was canceled in January, followed by missions *19* and *18* (Dick Gordon's flight!) in August, and no one could be quite sure where the slaughter would stop. Some media people claimed

that Pete Conrad was to blame, had committed the one sin for which the emerging postmodern mind held no forgiveness–he had made the business of landing *Apollo 12* look easy, *undramatic*. Lunar-hoax enthusiasts will try to convince you that this is why NASA changed the script for the April launch of *Apollo 13*, naming the LM *Aquarius* after Fifth Dimension's hit single from the musical *Hair*, and writing in a crisis which blew the landing and would have–even *should* have–killed the crew but for a heroic show of ingenuity and courage.

Apollo 13 is worth looking at because it's instructive in a number of ways. The mission began with a successful launch and acceleration out of Earth orbit, but as the crew and their two spaceships drifted toward the Moon with just 45,000 miles to go, they heard an explosion. Moments later, Command Module pilot Jack Swigert noticed oxygen pressure dropping in one of the Service Module's two large oxygen tanks which supplied the crew and the Command Module fuel cells; shortly after that, the mission's courtly, forty-two-year-old commander, Jim Lovell, saw gas leaking into space. Although the minor electrical fault that sparked this drama was not immediately understood, the gravity of the situation was. One of the oxygen tanks had ruptured, crippling both and meaning that the ship had no means of continuing to generate oxygen, electrical power or water, and no sensors or instruments, while no one could be sure whether its engine would fire or explode if switched on. And all of this 200,000 miles from home. With hindsight, the only good thing about the situation was Lovell's response, expressed with an understatement and timing which the combined writers of *Friends, The Simpsons* and *Six Feet Under* would have struggled to better: "Okay, Houston," he said as if addressing a dry cleaner who'd left a stain on one of his shirts, "we've had a problem." The truth was that many dire scenarios had been written and played out in preflight simulations, but never any as dire as this. Flight director Gene Kranz chillingly recalls watching "the Command Module's life-sustaining resources disappearing, like blood draining from a body . . . the controllers felt they were toppling into an abyss."

A glimmer of hope lay in the fact that the Lunar Module was

still intact, even though it was only designed to accommodate two people for forty-four hours. Furthermore, the crew were able to maneuver themselves on to a "free return" trajectory, meaning that if nothing changed, the two conjoined craft could swing around the back of the Moon and use its gravity like a slingshot to speed home. Calculating that this would take four and a half days, which was longer than the available electricity and oxygen would last, controllers instructed the astronauts to burn the LM descent engine around the back side—a hairy undertaking for which the Lunar Module hadn't been designed—so reducing the return journey by twelve hours. The next four days were thus spent improvising makeshift solutions to problems that had never been imagined, much less addressed, the most celebrated being the fabrication of a life-saving air filtration system out of cardboard, plastic covers from checklist books, storage bags and anything else that happened to be available to the crew. Meanwhile, the astronauts froze, starved, thirsted, tried to function on no sleep, and the whole world watched: in Rome, Pope Paul VI prayed for the crew's return; in India, 100,000 pilgrims at a Hindu festival did likewise. Throughout, NASA officials told the crew's wives that the chances of a safe return were 10 percent, and this was considered to be looking on the bright side.

There are three things to note about this episode: first, that the now-received perception of the *Apollo 13* save as "NASA's finest hour" dates no further back than Ron Howard's eponymous 1995 film of the mission (when coscriptwriter Al Reinert went looking for Jim Lovell in the late 1980s, he found him running a tugboat company, the forgotten commander of a "failed" mission . . . it was Reinert who wrote the "finest hour" line); second, that while crowds flocked to see the *Apollo 13* movie, the space shuttle *Atlantis* was making real-time history overhead by docking with the Russian Mir space station, while hardly anyone bothered to notice; third, that the team which designed the makeshift air filter was led by none other than John Watts Young. And it *was* a remarkable save. When the capsule splashed down after an agonizing period of radio silence, watched by what European networks claimed to be the largest worldwide TV audience ever assembled, a visibly faltering Walter Cronkite all but

announced that the crew had been lost to their damaged heat shield. No one expected them to make it, yet they did.

After the close call of *13,* Alan Shepard and Ed Mitchell's *Apollo 14* flight was postponed from July 1970 to January/February of 1971, closely followed by the July launch of *Apollo 15,* which was commanded by the elusive and scandal-prone David Scott, who we will come to later. By the time *Apollo 16* was ready to fly in April 1972, everyone knew that the jig was up, that commander John Young and his rookie Lunar Module pilot, Charles Duke, would be flying the second-to-last spaceship to the Moon.

What of this man Young? He was born into a military family in San Francisco in 1930 and raised mostly in then-rural Florida, which makes the origin of his Okie drawl uncertain; it's said that engineers often patronized him because of it, only to feel like fools when their Ivy League assumptions were demolished with a few choice words. He evidently had an unremarkable childhood, about which little detail is known, because by all accounts he is extraordinarily reserved and reluctant to offer much of himself to the world, even to colleagues and friends. Childhood neighbors describe him as a quiet boy with a passion for model airplanes and there are reports of him giving a talk on rockets to his eleventh-grade classmates. Subsequently, a degree in aeronautical engineering from Georgia Tech led to the Navy and test pilot school, where he established himself as an uncommonly brilliant pilot and set two time-to-climb records. Then it was on to NASA, where he became the first member of the second group of astronauts to fly (and was thus chosen over peers who included Neil Armstrong and Pete Conrad). Indeed, by the time he commanded the shuttle's first space flight in 1981, he was the most experienced astronaut in the world, having been up four times previously on *Gemini*s *3* and *10,* and *Apollo*s *10* and *16.* I've noticed that Apollo freaks view him as a kind of Thinking Man's Armstrong; the one they want to meet and dedicate their Web sites to, despite being the least showy or voluble of them all. Pad *Führer* Guenter Wendt renders him thus:

"A sharp-witted one . . . he spoke with a drawl and was a man of few words, but what he said was always right on target . . . he did not care if you wore a badge that identified you as

an engineer or a vice president. He called it like it was. Some people didn't like him, but if they were honest with themselves, they would readily admit that his contributions were tremendous."

Although a more gregarious astronaut remarks drily on Young's "bizarre behavior," by which he means the commander's laconic bearing, it was mostly bureaucrats who didn't like him. He was in charge of the Astronaut Office when the shuttle *Challenger* broke up in 1986, meaning that the seven lost crew were *his* people and it is said he had nightmares about the disaster for months afterward, then turned his anger and grief on what he saw as the complacency of Agency pen-pushers. At one point, he formulated a list of potentially serious safety problems which management had ignored in the face of a crazy launch schedule and straitened budget. When the memo was leaked to the press (amid suspicions that it had come from him), he was removed from his post and kicked into a less controversial corner of the organization. He'd been expected to fly the Hubble Space Telescope into orbit, but there would be no more flights for him, even though he continued to hope that there might be. He's the only one of the first wave of astronauts still with the organization. NASA administrator Daniel Goldin has been quoted as saying that John Young "had the right stuff before we even had a name for it." He did know how to have fun, though: a 1967 issue of a Manned Spacecraft Center newsletter has an impromptu group calling itself the Fearsome Foursome parodying two rewritten Broadway hits on an anniversary of Alan Shepard's Mercury flight, with the four being Pete Conrad, Dick Gordon, *Apollo 10* commander Thomas Stafford and Young. He reportedly also liked to draw cartoons of his colleagues in action and many of them agree with Guenter Wendt that he possessed a wit as dry as the driest martini.

THE JOHNSON SPACE CENTER looks like any postwar red-brick university campus, except for the rusty old rocket lolling on the grass out front. I stop at the visitors center first, where the usual collection of used capsules and clapped-out simulators is

supplemented by a video presentation about crop circles, which asks ominously whether strange atmospheric conditions or something more "otherworldly" is responsible for them and I make a note to let John know that it's actually a bunch of stoned dudes with boards and rope. Once past the security building off Saturn Lane, a maze of covered corridors is paced by people in jeans and casual shirts. How different it must have been in the days when Buzz Aldrin could speak of these same paths churning with "earnest young engineers, their holstered slide rules slapping against their belts." *Holstered slide rules!* But that's right, this was the new ocean then, the frontier. Quirkily, Norman Mailer found a connection between these people and the hippies when he visited here, because "both had no atmosphere surrounding them . . . their envelope was gone," by which he meant that they'd lost their connection to the Earth, had become ethereal and sexless, but it doesn't sound like that when flight director Gene Kranz talks about what they did. During a flight, he told me, the atmosphere in this place was "basically a controlled fury: these people know that in the next few seconds, they might have to be making a decision which is going to alter history." Never leaving the present tense, he described how, as the time approached for *Apollo 11*'s lunar descent, he gave his staff a break to fetch coffee and go to the bathroom, and then when they came back into the control room, he locked the doors and delivered an emotional oration in which he reminded his young team—average age twenty-six, don't forget—of how much he loved them all and how confident he was of their abilities.

"I felt that I had to tell them something, that I had to tell them how I was feeling," he said, "'cos their guts must have been boiling inside . . . because when you lock those doors, there are only three outcomes that day: you're either going to land on the Moon, you're going to crash, or you're going to abort the mission."

Incredibly—uniquely in my experience of astronauts—Young is half an hour late, but I don't much mind because the NASA public affairs officer has plonked me down in the tiny Lyndon Johnson Room, which is set up as a shrine to the late president and space advocate. On the way in I walked underneath one of

the creepy "flying bedstead" LM trainers which nearly killed Armstrong, and past a huge mural in which I was surprised to see the loose cannon Young to the fore, but the presidential pens and desks and documents in here are far more mind-blowing than those. Take for example the framed NASA budget decrees from the 1960s. The one for 1967 is headed "Ninetieth Congress of the United States of America" and contains a list of figures that begins:

1. Apollo $2,521,500,000
2. Apollo applications $347,700,000

and carries on in a similar vein all the way down to twenty, at which point the "facilities costs" kick in. I've never seen anything like it. By the time it was finished, the total cost of the Apollo program would be $24 billion and I'm trying to work out how much that would be in today's money—about $100 billion, in fact—when I become aware of a gentle tapping of leather on linoleum and look up to see a slight man in a gray jacket and maroon turtleneck, with ash-flecked hair and bowed legs and unusually broad shoulders ambling down the corridor with his eyes trained on the floor as though he's counting ants or trying to avoid the cracks. Kacy, my young host from public affairs, later tells me that he'd felt unable to leave a meeting he was in, but that when she'd gone to drag him out, his words had been, "Thanks for saving me from that stupid meeting." She adds that this was the most she'd ever heard him say in one go. "It's funny," she muses, "because I see him just walking around the campus and every now and again I think, 'God, that man has been to the Moon.'" Nothing in his bearing would suggest that if you didn't know it. He could just as easily be a particularly fastidious janitor.

He looks a little like the *Silent Running* actor Bruce Dern in his younger days and the sharp cheekbones are still there, bookending his arrowhead nose and darting eyes. His frame is small and wiry, with not an ounce of excess anything on (or *in*) it, and this distilled, rarefied leanness seems to hover in the air around him like a force field: throw anything nebulous or unnecessary

into this field of exactitude and it simply drops to the floor at his feet, where it lies embarrassingly until you can find something else to send in. This becomes apparent, almost comically apparent, the moment I sit down at the rectangular conference table in the center of the room and he sits down, too... so far so good... except that John Young doesn't sit opposite me as people have been doing since tables and discussions were invented–rather, he places himself two chairs along, which wouldn't seem so disquieting if he didn't then proceed to stare fixedly at the wall behind me... just sit... and stare, *staring even when he speaks,* as though the wall has just voiced the question which I thought I'd asked, and before long this is starting to seem really, really odd. As the conversation progresses and he loosens up, he occasionally flicks his eyes in my direction, like a chameleon hunched on a branch (and, Christ, there is something reptilian about him!). Sometimes he offers an atom flash of smile, which I come to recognize as a sign that he's made a joke.

Hmm. I'd assumed that the NASA geology instructor Lee Silver was being flip when he described Young as "the archetypical extraterrestrial." But no.

So I tell myself, "All right, I'm experienced, I've been here before," and in my mind I run through some difficult encounters from the past. What to do? That's right: lob an easy one across the net to start with. And here it is. The Chinese have recently expressed an interest in going to the Moon. I wonder how he feels about this in relation to the future of space exploration? It turns out that he hadn't heard these reports and there's a brief pause while he considers a response. Finally he drawls:

"Good fer them. I'll tell you, it's a tough job and they'll find out how tough it is when they start doin' it."

A flick of the eyes and flash of buttery teeth and I'm thinking: "That went well." Great. But then I notice that John hasn't stopped. Not at all. More is coming in an accelerating stream, like a geyser of words that's been waiting to blow for eons and now here it is and here am I, an innocent and unprepared bystander, flapping around trying to catch the jetsam in a saucepan. This is how I hear what he says:

"I think human space exploration, particularly with respect

to the Moon, is the key to the future of the human race, and I'll tell you why . . . scientific evidence has shown us, just this last year, that in the last four major extinctions, they've got iridium layers or they have helium-three buckyballs–"

Did he say *buckyballs*?

"–or they have big holes in the ground; and they show that the last four major extinctions were caused by impacts and we also have super volcanoes around the planet Earth–you know there's a lot of volcanic activity all over the solar system, there's hundreds of volcanoes on Venus and some on Mars and the Moon has a bunch–there's no active volcanism on the Moon right now, but it had a lot of old volcanism on it and right in the United States there's three potential super volcanoes; Long Valley Caldera and the big crater there, that Los Alamos sits on top of, and Yellowstone . . . theoretically Yellowstone goes off every 600,000 years, and it was 640,000 years ago that it last went off, and when it did that, it put two and a half meters of ash in Nebraska, 1,200 kilometers away, so if you get a super volcano it causes the same thing that impacts cause . . . nuclear winters, wiping out life–"

And from here I pretty much lose it, just registering odd phrases.

"–and the last one, Toba in Sumatra, put 2,800 cubic kilometers of ash in the stratosphere and wiped out–"

"–I mean, that's why we all have the same DNA pretty much, because Earth's population went down to several thousand people and that's not me talking, this is scientific evidence–"

"–the statistics right now for impacts are 1 in 5,000 chances that in the next hundred years we'll get an impact that'll wipe out civilization–"

"–the chances of a super volcano occurring, which are independent events, are 1 in 500 in the next hundred years, so if you take those two together, the chances of a civilization-ending event occurring in the next hundred years is 1 in 455."

And as abruptly as Young started, he stops. He's done. I realize that I've been holding my breath for some time: we both exhale and sit in silence for a moment, like a pair of strangers

who've just had reckless sex and now don't know what to say to each other. Later research reveals "buckyballs" to be a recently discovered form of molecule, named after the brilliant thinker/inventor/engineer/cosmologist Buckminster Fuller. And if I can't quite remember what the question was by this point, I have managed to grasp that I'm being asked to contemplate the near-certain extinction of my species through something other than boredom or stupidity, possibly in my own lifetime, or even next Tuesday.

And now my mind reels back to the previous evening and a fund-raising dinner for Buzz Aldrin's National Space Society. The event felt a little as though it had been directed by David Lynch: there were blue velvet drapes and women singing dolorous synth music, and pop-eyed space-nut journalists and a Russian speaker who looked like Leonid Brezhnev and lectured us on why women aren't fit for space travel–which didn't impress the watching *Star Trek* actress Nichelle Nichols or the statuesque African American shuttle astronaut Mae Jemison one bit. It was nice to see Buzz again and even more thrilling to meet Nichols, aka the glamorous Lieutenant Ohura, whose clinch with Captain Kirk led to the first interracial kiss on American television, but what I recall most clearly at this moment is chatting to the author Andy Chaikin, whose book *A Man on the Moon* provides as enthralling an account of the lunar landings as I can imagine, and happening to mention that I planned to sit down with John Young the following morning–only to see an amused grin spread out over his face. When I'd asked what was so funny, the grin had simply broadened and the eyes lit up a little as he chuckled, "Oh, you'll see."

And I guess I do see. This is going to be different. A 1 in 455 chance of humanity failing to see out the next century, was that?

"Yeah, it's a very high risk," Young warns the wall direfully. "It's telling you that you're about ten times more likely to get killed in a civilization-ending event than you are of getting killed on a commercial airline flight."

He breathes more deeply than usual, which I think might signify great amusement.

"So it's high risk, but the Moon can save us, literally and figuratively, 'cos if we can learn to live and work on the Moon, the same technology that'll allow you to do that will allow you to survive on Earth when bad things happen."

But doesn't that just mean that a few politicians and rich businesspeople get to survive while the rest of us perish? I've always felt that I'd rather take them with us, to be honest.

"Not necessarily . . ." he says, and proceeds to make a case for setting up a base on the Moon, from where you could ship guilt-and-pollution-free solar electricity back to Earth. He favors the South Pole–Aitken Basin, because there may be water there, which would make living viable and moving into Deep Space twenty times easier, and there's a crater that enjoys near-perpetual sunlight. Energy could be beamed back or shipped back.

"Human activity in the next centuries is going to be horrendous," he concludes in the same toneless drawl. "Some people are starting to get very concerned about the increase in the number of people on Earth that are gonna be using larger amounts of fossil fuels. If the Chinese get to the stage where they want a car in every garage, boy it's gonna be a big deal."

Obviously, he's right. This is an appalling thought. He goes on to describe some of the good works NASA is involved in, like developing special methods of recycling water for the poor people who live along the Rio Grande and developing super-high-yield crops that may be grown in artificial environments. And it's all very interesting, but I have to admit that by now I'm feeling more than a little unnerved by this talking-to-the-wall thing. He speaks in long, uninterruptible strings of sentences, which proceed in a monotone and end as abruptly as they start. I briefly wonder whether I'm doing something wrong; whether I've offended him; whether he doesn't like my suit. But I don't think it's any of those things. No discernible arrogance or judgment comes from him, just a sense that he's having to drag every word out of himself. There are times when I could swear that I'm talking to Peter Sellers playing Chauncey Gardiner, the autistic gardener whose innocent homilies propel him to the White House in the film of Jerzy Kosinski's book *Being There*.

Then I remember Deke Slayton characterizing him as "one of the unsung heroes of the astronaut program, before going on to suggest that "the only thing that held him back was that he was not comfortable with public speaking; he tended to freeze up and give one-word answers . . . I don't know that he ever got over it . . ."

All of which makes it even harder to explain what happened to John Young the moment he set foot on the Moon.

Of the six completed missions, *Apollo 16* probably came closest to losing out on landing at the last moment. Morale at NASA and among the contractors to the program was low by April 1972, with jobs going and talented people leaving amid accompanying fears of shoddy workmanship. There were problems all the way to the Moon, a minor one being the constant interruption of communications by a Spanish man wooing his girlfriend over the phone. Then a problem with control of the Command and Service Module engine prompted Mission Control to actually announce, "Anticipate a wave-off for this one," and start to make plans for converting the LM into a makeshift lifeboat, as per *Apollo 13*. Amazingly, after a six-hour delay the problem was solved and the Lunar Module *Orion* set down in the mountainous Descartes region, which the geologists hoped would provide crucial clues as to the extent of Luna's past geologic life, in the form of volcanic rocks. Young's pulse rate at landing was an outrageously low 90 bpm and, exhausted from a hundred hours of troubleshooting, he and his copilot actually managed to sleep before their EVA. Then the fun began.

Duke's first words upon touching down had been, "Wow! Wild, man, look at that!" closely followed by, "Boy! I nearly had apoplexy, that *program alarm . . .*"–which set the tone for what followed. In his BBC dispatch, Reg Turnill described them as "fairly tumbling out onto the Moon." Young's first utterance, after being shooed out of *Orion* by an excitable Duke ("Hey, John, hurry up!"), was: "There you are, our mysterious and unknown Descartes highland plains . . . *Apollo 16* is gonna change your image," while his partner followed with, "Good Lord! Look at that hole we almost landed in!" The hole turned out to be a twenty-five-foot deep crater, gaping next to one of the lander's

legs. So this was not going to be Son of Buzz and Neil, in which no one was allowed to admit surprise–in fact Andy Chaikin laughingly refers to what followed as the "John and Charlie Show," though when I listen, what I hear is Deputy Dawg and Droopy. Chaikin will have me in stitches when he acts out one of his favorite exchanges, where the pair are collecting rocks and Duke remembers an earlier plan to bring a carrier bag to put them in, saying, "Knew ah shoulda bought that bag at the supermarket, John"–to which, after a suitably reflective pause, he received the reply: "Charlie, ah think they give you 'em free at the supermarket."

Over three Earth days and nights in the Moon's central highlands they did their science and geology work, diligently collecting 200 pounds of rock, after which despairing medical staff watched Young take the Lunar Rover car on a "Lunar Grand Prix," followed by an impromptu session of "Lunar Olympics" (*how had the others resisted this?*), during which Charlie fell down and winded himself. In fact, TV viewers saw Charlie hit the dust at least six times, then finally disappear into *Orion* covered head to toe in it, because he'd found that the best way to regain his footing was to roll into a small crater. As Young waited to climb aboard the LM, he enthused to Mission Control: "Man, you don't know how much fun this has been." A chuckling voice said, simply, "We concur, John." Later, with the "talk" button on his microphone unknowingly stuck in the on position, he could be heard groaning: "I got the farts agin. I got 'em agin, Charlie." The *Washington Post* wasn't being rude when it headed a column "Two Klutzes on the Moon." Young and Duke worked harder than anyone else to get there and once they did, their joy was tangible. Certainly, a change seemed to come over Young. He was like a different person.

So here's the mystery of John Young. His *Gemini 10* partner, Michael Collins, pegs him as "the most uncommunicative" of the astronauts he flew with, saying, "I don't have any idea what flying in space has meant, or will mean, to him" (and lest we forget, Collins flew with Neil *Armstrong*). At the same time, *Apollo 16* Command Module pilot Ken Mattingly described him as one of the best-read people he'd ever met, while the geologists will

tell you that he delighted in their tutelage, where most of the fighter jocks thought it was for girls, and that he was similarly transported by astronomy. Indeed, when one of the science experiments went wrong on the lunar surface after he accidentally pulled a wire loose, he appeared genuinely, touchingly upset.

In the face of all this, it seems reasonable to conclude that Young does have an inner life even if he pretends that he doesn't, leaving me with an embarrassingly strong compulsion to find it. The next hour is thus spent trying every way I can think of to encourage a response that goes beyond the literal, superficial or blandly factual. I ask when he experienced the most fear, how he felt when he thought the landing was off, about his reaction to being there and of coming back and whether he felt any comedown afterward, and why he thinks some of his colleagues left the path. I wonder whom he was closest to in the Astronaut Office and which side he stood on in relation to the various schisms that developed, and whether he thinks he changed. After a while I give up trying to engage him and resort to deliberate provocation in the hope of producing a spark. I note that I'd heard he was angry about his divorce from his first wife of sixteen years, the first preflight divorce, being featured so prominently in Tom Hanks's *From the Earth to the Moon* series; I suggest that Apollo was clearly not worth the money it cost or havoc it wreaked on the participants' personal lives and that the danger of an asteroid hit has been exaggerated by vested interests within the space community (as some astronomers have claimed) and wonder whether staying with NASA had represented the easy and least challenging option for him. Yet all of these lines and others are met only with humility and good grace. And remarkably few words.

I give up and return to nuts and bolts, and the irony is that only in this realm will Young start to betray any kind of animation or emotion, even if it is mostly still directed toward an inanimate object (the wall). Among the people who debate these things, there's a heated dispute about whether a giant new leap to Mars might be a better idea than going back to the Moon, which we've already been to and abandoned. As we sit here, this debate seems as useful as discussing whether

Martha Stewart or Skippy the kangaroo would make a better president of the United States. Would Young like to go to Mars, I ask? He smiles.

"Well, there's a lot of people'd like to send me to Mars and leave me there, but I think the Moon is the place right now."

A flick of the eyes. Lightning smile. I know who he means: he means the NASA pencilnecks who are forever grinding their teeth at his implied accusations of timidity and lack of vision—sentiments which most space enthusiasts heartily agree with, but which are impolitic of him to express so openly. As associate director of the Johnson Space Center, Young has been supporting the dissident dream of a return to the Moon since the mid-Eighties. From the beginning, this involved sticking his neck out and annoying the brass, because in official circles the idea was considered preposterous, utopian—and of course it was. What everyone has realized in the intervening years is that, unless something extraordinary happens, taxpayers are not going to foot the bill again; that if it's ever to happen, it's going to have to pay its own way. Thus, Young is compelled to make a rational case for returning (mining, energy, protection from asteroids), but there's an ardor in his arguments that hints at something more than cold reason. One of his former colleagues commented that the 1960s was like "a decade from the twenty-first century transported to the twentieth," and to me it seems that the further away Apollo gets, the stranger it looks. I wonder whether his regret that it stopped so abruptly has increased, or turned to resignation? A hint of something like feeling, of *wistfulness,* enters his voice as he says mildly:

"Well, I really thought by now we'd have a base on the Moon. But all the big guys decided to quit. I think they were scared of it 'cos it's pretty high risk and they didn't think what they'd get from it would be worthwhile."

Then he seems to relax as he turns to the Moon he experienced, which no one seems to give a damn about anymore. When I listen to the recording of our conversation afterward, I think that when he talks about the Moon here, the tone of his voice sounds like that of someone who's *in love.*

"I think the Moon'd really tell us a lot. I mean, I was up there and we flew around, and there's a lot of interesting craters up there that are really strange-looking, and once you explore 'em, we'll find out stuff. I mean, we had eighteen people up there for twelve days, so we don't really know beans about the Moon."

It'd be different if we did it again now?

"Oh, yeah, drilling and looking for water, and doing all the things you need to do at the South Pole . . . and picking up very old rocks. They say that there might be rocks from 120 kilometers down in the South Pole–Aitken Basin, which would tell you a lot about . . . I mean, it's the biggest crater in the solar system–2,500 kilometers across. So it would tell us a lot."

Now seems the time to repeat my mantra about there being only nine Moonwalkers left, and one day there not being a single human being who's seen us from that perspective. To my surprise, he breaks into a broad grin when he hears it.

"Yeah, I'm sure–there's not gonna be too much longer before the rest of us kick the bucket!"

Well, that wasn't quite what I meant, I start to assure him, before realizing that, actually, it was. I ask if he ever feels discouraged by the fight to move space back up the agenda, expecting a heroic dismissal of the idea, but it doesn't come. Instead, he confesses:

"Yeah, I feel discouraged a lot of the time. You propose to do something and people tell you what an idiot you are. But, you know, making progress is never easy. You gotta keep at it if you want to really do it. And you got to take risks to make progress, so, you know"–and here he not only smiles, but jerks his head back almost playfully and exclaims–*"to heck with 'em!"*

We both laugh. These are the people who would send him to Mars. He always seemed to shun attention, status, celebrity, I note. Why?

"Oh, yeah. I'm not a celebrity. I'm definitely not a celebrity. When I go to the grocery store, I have to show my ID card and my driver's license to cash a check. My wife walks in the grocery store and everybody says 'Hey, Susy' and she can get anything she wants."

Was that because he'd seen what happened to the others?

"No, I just never thought about it. Actually, working for NASA on technical things is really interesting."

I wonder if there's even a small part of him that would like to have been first and I believe him when he says no, because it would have meant having to play that game, and because then he wouldn't have been able to fly the shuttle: the first men on the Moon were too politically precious to be risked on further space-flight. Deciding to try flattery, I venture that to have found some-thing to so absorb him over the course of a lifetime is a blessing, but he just says, simply and modestly:

"Well, I don't know if it's a blessing or not. I just think hu-man space exploration is the most important program going on in the United States right now. So every chance I get, I tell folks. But it, uh, doesn't always come out that way."

A sheepishness mingles with the smile and flash of teeth this time and only afterward does it occur to me that he's apologizing here for his ineloquence. He knows he's not in his element right now, the way he is in a flying machine. I ask what he's learned–recalling the way this one threw Dick Gordon–and he starts talking about asteroids. No, I say, I mean *as a human being*, one with such a vivid life: what are the things you know now that you wish you'd known at twenty, thirty, forty? . . . and there fol-lows a meditation on the fact that the lift-to-drag ratio was 30 percent lower than predicted on *Gemini 3*, leading to a splash-down sixty miles short of target. That's one thing he'd like to have known about, he concludes. For a moment I feel quite sure that he's toying with me.

Frustration is mounting. I'm not making him see what I want, which I suppose is for him to tell me something that's true, that might fill in another piece of the jigsaw sky, help gather the hem of chaos into order. Then it strikes me: it's just possible that when John Young looks at the world, order is what he sees first. Perhaps he pities the likes of me, who don't, won't, can't: the ones who come in and overcomplicate things which have a nat-ural elegance and beauty of their own. Perhaps once you've watched a whole planet sweeping imperiously through space, our human existential dramas look like nothing more than nar-

cissism and vanity. And when I review our conversation, it strikes me powerfully that (a) I've met few people with less apparent vanity or narcissism than John Young, and (b) it's hard to imagine any modern astronaut being so quirkily lacking in presentation skills as Young is and still finding a place in the program, however brilliant they were. The truth is that he probably wouldn't make it now and, frustrated as I've felt trying to communicate with him, this thought strikes me as ineffably sad, evidence of a world which is shrinking and homogenizing; where nothing is done for its own sake and nothing exists until it can be sold; where everything and everyone becomes a commodity with a brand identity and the maverick Young, product of a different age, doesn't fit.

I try to address the politics of this situation directly with him and get nowhere, which is amusing in itself when you think about it. He tells me that he's always just thought there were more interesting things to consider than himself and if I, child of the hang-it-out-there Sixties, don't necessarily agree with him, I've grown to respect the sentiment. I try macro politics, too, wondering whether he thinks Ronald Reagan's aggressive "Star Wars" proposals of the 1980s damaged the image of space, but this only brings a frown such as you might see on the face of a friend you've just shot in the arse with a dart gun, followed by a shocked-sounding "I have no idea."

I ask whether he would have done anything differently in his life?

"No, I can't think of anything. But you never know. Everybody makes mistakes. You just try to keep on going."

Sigh. Has he ever felt content?

"I don't know. I don't know. Contentment is just sorta like . . . I think just being here is . . . well, I think there's so many problems to work on and be thinking about making improvements and making progress. I think scientific and technical progress is very important for human beings."

I try to recall the last time I heard the word "progress" used in this way. After 1972 or so, no one trusted it—or maybe it was just the people who'd been using it most that we no longer trusted. The Bomb had been progress, as had Thalidomide and

DDT and the chemicals shoveled into our Sixties baby food so that it could sit on supermarket shelves until the asteroids come, even though they made some of us sick. There were good things, too, but no longer anything self-evidently *right* about progress. It's a lost faith, which Apollo grew out of, but also helped to destroy by revealing the Earth as fragile and rare.

I want to know whether the surreal adventure ever feels surreal to him, but again Young hears the question literally and again I wonder whether this is deliberate as he assures me:

"No, no, it was real. I saw a TV program that said we didn't do it, though."

I tell him about Buzz and Bart Sibrel in LA and the eyes flicker with amusement.

"Oh, yeah. I saw him out in Las Vegas. He tried to get me to do that as well."

And Ed!

"Yeah, he got Ed and he got Bill Anders. Jeez, he's been around!"

Now he laughs, clearly not angered or offended the way Charlie Duke and Buzz Aldrin were. However laconic Young is, there's no self-importance about him. I ask what happened with Sibrel and him?

"Oh, he wanted me to swear on the Bible that I'd been to the Moon. I told him I didn't swear on the Bible. He said he wanted to talk about *Apollo 16,* but he didn't."

He cracks up properly, a full, joyful laugh, and I resolve to redouble my efforts to find this man, who turns out to have made a film called *A Funny Thing Happened on the Way to the Moon,* based on "previously unseen downlink footage" of the *Apollo 11* crew horsing around in low Earth orbit while they were supposed to be on their way to the Moon.

I ask John whether he still sees Charlie Duke much and he says about once a year, when Duke comes in for his medical and he and Dotty stay over. They live a few hours away in New Braunfels. "It's always good to see 'em," he says casually, and I find myself wondering what on Earth they talk about.

I ask about the postmission personal crises and he launches into a treatise on adrenaline depletion. So, giving up on the

search for anything the rest of us might identify with, I ask him whether he still flies and he says, "Oh, yes," leaving the way open for me to run Arlo Guthrie–like through the tale of my brief jet-fighter flying career–puking, passing out, four-part harmony and all. His face lights up, just as Dick Gordon's did, and he looks directly at me for the first time in an hour.

"Yeah, well, 6 Gs without a G suit–unless you're experienced or very tough–is pretty . . . actually, we rode the centrifuge in Apollo and went up to 15 Gs, but that's through your chest, it's not your sit-down Gs . . ."

Young has been with his second wife, Susy, since their marriage in 1972 and she's always the first thing he mentions when he talks about his post-Apollo life and career. Naturally, we don't get far on the subject of his relationships, though he laughs self-deprecatingly when I ask if he's difficult to live with, confirming that he thinks he probably is. When I inquire after his children and how they experienced his career, though, he surprises me for the first time as he begins, "Well, I think they appreciate the work, but I'm sure I probably . . ." and then allows his voice to trail away into a mumble.

Sorry?

"I said I probably neglected 'em way too much. You know, 'cos you have to work twenty-four hours a day when you're working on a mission. Especially those lunar missions. That's when they were affected by it most. You didn't have much choice. They'd send you places and you'd have to be there for so long."

His voice is very quiet now.

"There wasn't anything you could do about it . . ."

We've been talking for much longer than we'd agreed to in the first place and I'm exhausted from the effort of the conversation. I thank John for his time and suggest that perhaps I could call him at a later date if any more questions arise and the really peculiar thing is that I'm sure a trace of disappointment flashes across his face. People who know Young will try to convince me that I've experienced him at his most loquacious today. Either way, for the first time he offers something spontaneously. Mild rhythm enters his voice.

"Actually, I got to go to a meeting right now where we're talkin' about gettin' back to the Moon."

I'm stunned. "Really?" I say. "Seriously?"

"Well, I hope it's serious. We been talkin' about it off and on for the last ten, fifteen years."

But as a political reality? How has that happened?

"Human beings have changed. People that run the space program have changed."

That's right, I remember. There've been changes at the top of NASA. So you could be talking realistically about going back?

"Well, yeah. The technologies are easy to develop, but they're pretty expensive. But still the benefits would be remarkable. They could probably revolutionize the way we live on this planet."

He rails briefly against "bureaucratic inertia," confessing that "We're looking at 251 improvements to the space shuttle, but it's slow work . . . in the old days, we discussed stuff at meetings, then went away and did it—now we have meetings to arrange more meetings . . ." I tell him that a senior executive from a NASA contractor admitted to me privately that the risks taken with Apollo would be unthinkable today, and when he speaks, to ask who said that, there's an edge to his voice, the spark of anger that I couldn't find earlier. Fearing that I've got someone into trouble, I hurry to a question. Would it be safer today?

"Well, hopefully." His voice is calm again. "But you either accept a degree of risk or you don't do anything. We reckoned to have about a one in two chance of getting back from the Moon at first, but by the time I flew, it was about five to one. I think it's always gonna be high risk. Be worth it, though."

We stand up. I thank him again. He says: "Thank *you*, sir. And good luck with yer book," then turns and adds, "It's hard," but before I can ask whether he means writing a book or going to the Moon, he's rolling slowly back down the corridor. In my imagination, he's looking for his horse. The perplexing thing is that when I see him the next morning, at a ceremony to mark his induction into an "Astronaut Hall of Fame" (which really is a hallway at the conference center with a few pictures in it), he greets me like an old comrade, is friendly and warm and happy

to stand around chatting with no minidisc to mock him, until he is called to face a scrum of photographers and reporters. Then he nods bashfully, blinks away the camera flash, says hardly anything at all. And I think that maybe the Apollo-nut fascination with him stems from the fact that neither they, nor I, nor anyone else, has ever really known what he felt about anything–save for three days out of his life which he spent on the Moon, during which no one could have been in any doubt about what he was feeling, because he was just so full of *joy*. And for all the difficulty of sitting (not-quite) opposite John Young, some of that joy must have rubbed off on me, because whenever I think about this eccentric, elemental man hereafter, I can't stop myself from smiling.

ONLY MUCH LATER do I notice that John Young is the first of the six mission commanders I've spoken to at any length and it will be longer still before I understand the significance of this. In the meantime, there are several things to think about as I join the traffic vomiting into Houston from the I-45.

I'd started out wondering where you go after you've been to the Moon, but from what I've seen so far, the answer is that *you don't:* I've met five Moonwalkers now and each seems in a different way to remain in its spell. There's Ed Mitchell, still roaming the benign and beautiful Universe he touched, and Buzz and John Young with their compulsive dreaming of a return; a similar inability to let go. There's Alan Bean with his equally compulsive efforts to capture what he saw and felt, make it somehow solid and communicable; and Neil Armstrong, who wants to live quietly with whatever it was he experienced or didn't experience, but can't because we won't let him; who's spent thirty-five years running from us and *it* and will probably spend the rest of his life doing the same.

I'm also seeing that there is a more practical side to my own interest in these men, because they seem to symbolize, even embody, a question that I and most people I know find themselves asking at regular intervals. Do I stick with life as I know it, be happy and content with the considerable challenge of appreciat-

ing and improving that, or shoot for the Moon and risk being dissatisfied, finding that it wasn't what I expected, or that nothing else can ever match it afterward (as per Michael Collins's "earthly ennui")? Indeed, it's possible to see the whole of Apollo, not as a metaphor for this condition, but as a solid expression of it at the most fundamental level, which the Moonwalkers *lived* and had to try to make sense of afterward, fermented into that eternally nagging question which Ed Mitchell first raised: "Who am I and why am I here?" At this halfway stage, I'm not ready to draw any conclusions on that yet, any more than I am about whether going actually changed anyone or whether the adventure was worth the cost, or even what that cost was. But I feel sure that answers are here, buried in these nine men, who've been far more exotic and in their different ways impressive than I'd imagined they would be. As to what it was like to stand on the Moon, I'm beginning to think that the sensation was either too complex or too primitive to describe, or that the weight of expectation, of that "Earth's collective dreaming," paralyzes those who could. My initial instinct that the most powerful part of the experience was about returning to Earth—and that we're as much a part of the dynamic behind this paradox as the spacemen are—seems to have been right, though. That no one can easily say what it was like to stand on the surface simply makes the question all the more interesting.

AFTER YOUNG, I thought my job here in Houston was done, but some inner voice persuaded me to stay and by the end of a lunatic week I'll be very glad I did. I wanted to know more about the ways in which perceptions of Apollo have changed, and in which it's been internalized by the culture. I wasn't expecting anything tangible by way of evidence, but here in Houston, I've found some; a group of people who prove as unexpected and compelling to me as the astronauts themselves. Apollo's children.

Way back in LA, as I dragged myself shattered from Buzz's place to my hotel, a soft-spoken man who looked like a kindly

plainclothes detective from *Hill Street Blues* was waiting for me in the bar. His name was Gene Myers and he'd come to tell me about his company, Space Island, which hoped to construct a hotel in space from discarded space shuttle fuel tanks just as soon as they'd scraped together ten to fifteen billion dollars in investment. It sounded fantastical to me, but he said they could do it in five years and recited a list of possible uses for such a facility, which included science and tourism, and medical and artistic activities. He said you could leave Earth orbit and go to the Moon in three days if you wanted and that he'd like to run a competition to send up a songwriter, and when I ventured that the world might not thank him for the sort of tunes that came back–but that if they were going to do it, they might as well cut to the chase and send David Bowie–his eyes lit up. Perhaps when I got home, he enthused, I could get word to the pop star that, should he choose to accept it, there's a free spaceflight waiting for him. I promised to let the former Mr. Stardust know.

The thing about this is that Gene Myers is not alone. There are all sorts of organizations planning all kinds of more or less extravagant projects. Some are run by billionaires such as the hotelier Bob Bigelow, who's spending five hundred million of his own dollars on manufacturing an inflatable space hotel in the desert outside Las Vegas, while others, like Armadillo Aerospace, run by the über-computer-game-designer John Carmack, coauthor of the mega-selling *Quake* and *Doom* series, are part of an expensive race to develop the first low-cost spaceships. The one problem they share in 2002 is NASA, and behind NASA the federal government and its tight regulations. And so it was that after meeting Myers, I turned left off Sunset, went up the hill past Mulholland Drive and down to Studio City, where just off Ventura Boulevard I found the offices of the Space Frontier Foundation and Rick Tumlinson.

I took to Rick instantly. At a local bar, he told me about his English mother and Texan serviceman father and his speckled past as a video maker and twentysomething bong worshipper. Like Andy Chaikin, he was born in 1956, but looks much younger, like a character from *National Lampoon's Animal*

House, in fact (most specifically John Belushi). He wore a goatee and had just cut off his ponytail and we talked for a while about the Foundation's aims, which boil down to wresting control of space from NASA's bureaucratic paws so that the space frontier can be opened and the people might get up there themselves, as per Apollo's promise, and at a certain point the penny dropped and I found myself exclaiming: "So wait–you're a space activist!" to which he replied:

"Oh, yeah. Hard-core! Space advocate and activist. The opening of something as big as the space frontier is not a thing that can be left to a few bureaucrats and corporations. It's a much bigger change and challenge that's facing us and a much bigger set of possibilities than should be guided by government agencies."

He talked about the "Lewis and Clark" model they see, where NASA, like the trailblazers of the western frontier, goes over the hill and tells us what's there, leaving others to settle; and how, when he started, "there were no space groups of any size and credibility who actually disagreed with NASA." When I got worried and wondered whether we really want WorldComs and Enrons chomping up the Moon in glorious privacy, he countered:

"Yeah, but what we've had here, particularly in relation to the space station, is a combination of some of the worst aspects of both. You have giant corporations working with a very elite insider group that has a quasi-militaristic leaning. You have to bear in mind that, in the beginning at least, NASA was a partial fig leaf to cover the Cold War antagonisms of the Fifties and Sixties. There was all that 'We came in peace for all mankind' stuff, but they literally were part of the military-industrial complex–it was the same companies designing and making the military hardware and all that. If you were an antiwar hippy protester, they looked like the same group of people."

So I seemed to have happened upon a space Country Joe McDonald, who went on to tell me about the Foundation's recent "Return to the Moon" conference and their sophisticated "jujitsu" lobbying model (an idea I first heard being used by environmental groups in Naomi Klein's antiglobalization tract *No Logo*); about being part of MirCorp, the private, Amsterdam-

based company partly run by people who'd marched against the war in their youth, which actually managed to lease the Mir space station from the Russian government for a brief period, only to be brutally "taken out" by the dark forces of the space establishment; about testifying before Congress and meeting high-level Russian officials in Moscow; about the various flash-points within the organization, and all in a language that I understood.

He said: "Before it became unpopular to be such, we called ourselves the Mujahideen. We were the guerrillas of space!"

And: "When we created MirCorp, we went over, sat down with the Russians and said, 'We're not like those aerospace companies or NASA, who come over here and go, "We're better than you are"—we represent a different part of American culture.' And it's true! The Russians have done amazing things in space, with no money and incredible common sense."

And: "I used to wave my ponytail around in front of the military guys, just because I knew that if there was a military guy who could deal with my ponytail . . . then I could work with him!"

He said: "You have to be like water. Water is unstoppable, it finds the cracks."

And: "Some of us are more predisposed to wander further away from the ants' nest than others . . . I say this because I've got an ant problem on my porch right now . . ."

I sat there and hadn't a clue whether a word was true, but it came at the end of a draining day and made me homesick for the more imprecise and elastic everyday world that I'd unwittingly left behind a couple of months previously, where reality doesn't hide behind NASA-speak and there are worse sins than extravagance and incaution, and where a little iconoclasm never hurt anybody. So when I heard that Rick Tumlinson was going to be in Houston, I was pleased. When I heard that NASA had reluctantly agreed to give him a platform on the main floor of the World Space Congress, I was overjoyed. A window was opening onto something that I hadn't even known to exist—the colorful realm of the "Space Movement," for whom John Young, Buzz Aldrin and Jack Schmitt, and, above all, Pete Conrad are heroes of an entirely different order.

This is a relatively recent phenomenon and chimes with something I noticed when tracing Luna's passage through the pop cultural sky earlier—that by the 1990s, the lunar program was reacquiring a romance and mystique that had been absent since the early 1970s. Was this because the *Challenger* shuttle disaster of 1986 restored the Moon's *hauteur*, the sense of distance and unattainability that had once been attached to her? Or was the Moondust merely beginning to sparkle from a distance? Now there could be movies like *Apollo 13* and the Australian homage *The Dish*, and songs like PJ Harvey's "Yuri-G," which was about a girl obsessed with the Moon, to which the chorus runs, "I wish I could be like Yuri-G"—not Alan B or Neil A, because Gagarin died the young, troubled martyr, as rock and roll as James Dean or Jim Morrison by now.

I wondered whether some of this was nostalgia on the part of a generation who watched the adventure with innocent eyes and now found it bubbling to the front of their imaginations again? It struck me that Bowie included a tune called "Gemini Spacecraft" on his *Heathen* album of 2002 and that the sleeve to Led Zeppelin's greatest hits CD depicts the group in Apollo space suits, reminding us that their portentous first four albums fell in those weird years from 1969 through 1972. It also struck me that in the year prior to this trip, characters as diverse as the Amazon.com founder Jeff Bezos, the actor Vincent Gallo and musician Moby all told me, with no prompting, that the first thing they could recall wanting to be was an astronaut. They all remembered where they were when the first landing happened, but Wayne Coyne, singer with the Flaming Lips—born in 1961, the same year as Apollo—had the best story.

"You know, it was a big moment," he mused, "because most of your life passes into a kind of blur—there's like first grade, high school, NOW . . . but that was a big summer, when they landed on the Moon. I remember my brother and mother sitting on the porch, talking some stuff I couldn't really follow, but I'd watched a lot of *Dragnet* on TV and so I knew what LSD was, and I remember my brother telling my mother while they were landing, 'No, you don't understand, the reason I'm like I am is

'cos I'm taking LSD,' and her going shock-white. And I did, too–like, 'Oh my God, my brother's doing that stuff they talk about on *Dragnet*!' But that was just the way that people lived."

He had me in fits as he riffed on a line from one of his most beautiful tunes, "Do You Realize?" which simply asks, "Do you realize/we are floating in space?" but when I said that I found it soothing, he cried:

"No! I don't mean that line to relax you! We really are. We're on some fucking insignificant speck in an endless cold vast sea of nothing. I mean, it's just hanging . . . I don't even know why it works! It wouldn't surprise me *that* much if I woke up one morning and someone said to me, 'Hey, you know how the world was turning? Well, it's stopped.' Why wouldn't it? I have dreams sometimes about shit like that, but it could be real. That part of outer space, I *love* that, the way it's full of mysteries. It seems to encapsulate the way that the more you understand, the less meaning things have. One of the things that happens as you get older is that you realize that things don't have to have any reason or meaning. The more knowledge and understanding you have, the more you see how random and meaningless everything is. People die and people are born and some wonderful people die when they're twenty and some horrible ones will live to 110 . . . no one is sorting this stuff out."

Then Coyne drew a surprising conclusion, saying:

"But that's the way it should be. Goodness is not something that exists in the Universe and that's why, when it happens, when someone comes up to you and they love you and care for you, you can say, 'Fuck! That's a big deal.' If it was the natural order to love and care, as the hippies would have you believe, then what would there be to celebrate?"

And I suspect that this is where those magic *Whole Earth* pictures, fed into the imagination of a seven-year-old, had led Coyne. I also suspect that, like me and most of our contemporaries, he owes more to the hippies than he cares to admit.

Afterward, I began to wonder whether you needed to have been there for any of this to make sense, whether you had to experience real fear that the lunar fantasy could drift into horror in

order to feel any attachment to it? But then, working late two nights before I left the UK for Florida and Ed Mitchell's grown-up flower children, a tune came on the radio which set what appeared to be a recording of Ed White's ecstatic first American spacewalk to a lolloping techno backing. That stroll in space happened in 1965, as hippies flocked to Haight-Ashbury in San Francisco; racial tensions prepared to erupt across LA; *Time* magazine declared "Swinging London" the locus of world hip and predicted that one million doses of acid would be taken in the next year. The tune turned out to be "Space Walk," by a group called Lemon Jelly, and it went on to establish them as a major act in Europe.

I called to ask what had led Lemon Jelly to Ed White and the group's Fred Deakin told me that they'd found an old album called *Flight to the Moon,* which contained recordings from the space program, and they'd been struck by how emotive they still were.

"'One small step' leaves me cold," he said, "because it was so obviously scripted. But the spacewalk . . . even after hearing it so many times, it's so vivid. Rather than being a technical achievement, it's a human thing and we've found that very few people can remain unmoved by it."

And he's right. It is moving. The best bit—and this is one of my favorite bits of the whole space program—is when CapCom Gus Grissom, the voice of Mission Control that day, orders White back into the craft and the spacewalker just can't bring himself to go. Broadcast live to radio at the time, the exchange captivated listeners. The third person involved is Commander Jim McDivitt, speaking from inside the spaceship. We come in at the end, which goes like this:

GRISSOM: *Gemini 4*–get back in!
(*White pretends he hasn't heard. He's looking at the Earth.*)
WHITE: What are we over now, Jim?
MCDIVITT: I don't know, we're coming over the west now, and they want you to come back in.
WHITE: Aw, Cape, let me just find a few pictures.
MCDIVITT: No, *back in.* Come on.
(Pause.)

WHITE: Coming in. Listen, you could almost not drag me in, but I'm coming . . .

(*A few more minutes of stalling by the reluctant spacewalker, who finally relents.*)

WHITE: This is the saddest moment of my life.

MCDIVITT: Well, you're going to find a sadder one when we have to come down from this whole thing.

WHITE: I'm coming.

(*Not coming.*)

MCDIVITT: Okay . . . Come on now.

The saddest moment of his life! Who wouldn't feel for him? But he had to go back in, because NASA didn't yet know what floating in space would do to a human being. That he and Grissom had the breath snatched from their lungs in the *Apollo 1* fire only months later gives his words an added poignancy. He didn't have long to live, but he had *this,* and that it should become music is not so very surprising: Story Musgrave, the experienced shuttle astronaut who trained with the Apollo crews and developed a mystical bent afterward, claims to have heard music up there. "It was a noble, magnificent music," he told a space.com reporter in February 2000. "I was a little on the margin . . . I was walking the edge." Three years after that, scientists in Cambridge claimed to have found the deepest note ever detected, a B-flat emanating from a black hole, fifty-seven octaves below the one in the middle of a piano. Is there a siren song calling us to space? My next couple of days will be spent with people who think there is. In the meantime I'm reminded of the welling in the eyes of visitors to the exquisite "Full Moon" exhibition of Apollo photography at the Hayward Gallery on the South Bank of the Thames in 1999, for which artist-photographer-curator Michael Light had to develop a special ink to convey the intense black sheen that astronauts saw; and of a recent revelation by ITN that the first Moon-walk is still the most requested clip from its TV archive service, with JFK's assassination running a distant second. When the fashion giants Dolce e Gabbana declare "astronauts, sailors, ancient Rome, the Sex Pistols" as the prime influences on their spring 2003 collection (illustrating their claim with a photo of

Buzz Aldrin on the Moon), they're using Apollo in an entirely new way: as a symbol of decadence, transgression, impetuosity, hunger. All the elements of which are most assuredly there.

SO IT IS THAT I walk into the busy lecture theater in the main hall of the Space Congress just in time to hear Rick Tumlinson, now in a smart black suit and with freshly combed hair, cry: "Good afternoon and welcome to the revolution!" A few sentences later, I'm squealing with laughter as, through a semantic contortion of such daring that Dr. Johnson himself would have stood and cheered, he quotes a few obliquely instructive lines from Nirvana's "In Bloom" at the bemused throng. He talks for a while about the Earth being at the center of an expanding bubble of life and the challenge of redefining the boundaries between public and private endeavor in this new realm. Then he slickly hands over to a panel of experts, the first of whom is Dennis Tito, the mathematician who traded NASA for Wall Street, then chose to spend some of the millions his skills there brought him on becoming the first space tourist. Against NASA's wishes, he went up with the Russians and stayed at the International Space Station for a fee that the papers reported as $20 million, but was in fact more like $12.5 million. Small and bald and sixty-two years old, he tells us that he got interested in space as a kid when Sputnik went up, joining the nationwide rush to engineering that followed. Then he talks about his trip.

"The experience I had was much, much better than I ever thought it might be," he says, adding that the training was easier than expected. "The one thing I learned about flying in space was that anyone could do it."

The problem, obviously, is the price.

"Costs have to come down. But I have to say that, at the current price, it's a bargain. It should cost $50 million, but doesn't because we have the remains of a command economy, meaning that the systems are already paid for. As they degrade and labor costs go up, the present opportunity will disappear."

He advises those of us with twenty million to spend (the Russians have now set the price there, as people have got used to

it) to go now. The other thing he says is how surprised he's been by the public's ignorance of the area.

"People, even my own age, come up to me and say, 'Hey, you're that guy who went to the Moon!' They don't realize that nobody's been to the Moon for three decades. The level of understanding is terrible."

That night, Rick and I meet for dinner at a lively Mexican restaurant in the Melrose district and the place is heaving and margaritas flowing by the time I arrive and am introduced to our fellow diners, who include Richard and Robert Godwin, proprietors of the space publishing outfit Apogee Books, and at the far end of the table, the aged and much admired Pad *Führer*, Guenter Wendt. Before long, I am trying on the black-faced Omega watch that Neil Armstrong gave the German prior to boarding *Apollo 11* and hearing about the transformation of the Apollo-struck Godwin brothers—who turn out to be from Liverpool—from publishers of rock music books to innovative chroniclers of the Space Age. Afterward, I stand blinking in the car park as Wendt, who flew *Luftwaffe* night fighters during World War II, hears my accent properly for the first time and proceeds to regale me with a succession of wartime Britisher jokes, while I wonder whether someone's spiked my drink.

Rather than go straight home, Tumlinson and I decide to go see a band some friends of his play in, and over sangria margaritas squished out of Mister Softee ice cream machines—a bad idea on every level, when you think about it—he gives me his take on Wernher von Braun ("He was playing whatever card he could to get into space"); on Chinese lunar ambitions ("The first thing that'll happen is that America will try to sabotage it in any way possible . . . Rockets will blow up strangely, stuff won't work, shipments of technology will be stopped; that's just how they work"); on his overbearing Texan sergeant father and youthful disappointment at the sudden disappearance of the space program. Afterward, we climb to the top of a big hill to have a smoke and look out over Houston so that Rick can show me my route home. I ask him what he expects to get out of all this? I can see that the heart's engaged, but is the head involved at all? Well, he says, no one's making rational business decisions

to be involved in space at the moment. It's all about the dream he was given as a kid and you're either a believer or you're not. He has 1 percent, 2 percent, 3 percent shares in a lot of companies, but they may end up as historical documents relating to visionary but failed companies; floggable on eBay as curios, but not worth anything more. Truth is, he's not quite sure how he's going to pay the rent next month. Then, as we gaze up at the progressively blurring stars, he says:

"There's a paradox, called Fermi's Paradox, which states that, if there is intelligent life out there, it should already be everywhere. Statistically, we should have been contacted. At the very least, we should be seeing clues all over the galaxy, just because of probability. But we're not. See, I think there might be a lot of ways that life can be killed off, leveled. There might be life everywhere, but on the other hand there might be very, very few—or even *no*—places where it made it past all the hurdles and got to the sentient stage. There's a million things that can wipe a planet out, or destroy its top level. If that's the case, the human species might be *it*. We might be alone. We might be the only planet with an evolved ecosystem and life. And if that's the case, not only does the cockroach you stepped on today have much more importance than you thought, because it's the only one *anywhere*, ever created, but so does this planet. And that puts us in a very different realm from the military-industrial approach to space. The stuff that's here might be unique, a kind of miracle, and too precious to confine to one planet, in case we take a hit or something happens . . ."

And it may be because my head's starting to spin by itself anyway, but I find this beguiling as we float under the stars: a beautiful synthesis of Zen Buddhism and *2001: A Space Odyssey*. If you could wedge Uma Thurman in there somewhere, you'd have a belief system that even I might sign up to. But I also think that here in Houston I've found something unanticipated but logical—the faintly glowing embers of a generation who grew up being promised the Moon and more, then had all that cool expanse of sky whipped away and replaced with clammy earth. In this realm of inversions, the theoretical future thus has a curious

identity with the past, and living in one is not so very different from living in the other. Hardly surprising that, much as I've enjoyed Houston, I wake up in the morning with one of the worst hangovers I can ever remember having. I'll drive away hoping that Rick makes it to the Moon one day.

APOLLO WAS THE GREEK god of sun, music and poetry; the twin of Artemis, goddess of the Moon, from whom the Romans derived their own Moon goddess Diana. Indeed, one classicist goes beyond this to suggest that the Moon had a sophisticated, threefold identity for the Greeks and Romans: that she was respectively Selene/Luna when in the sky, Artemis/Diana on Earth, and Hecate in the underworld– sometimes also addressed as Trivia, keeper of the places where three things come together (which is why the great bluesman Robert Johnson is said to have been at a *crossroads* when he sold his soul to the devil). And it's Trivia I hear call- ing as I skim the featureless road from Houston to New Braun- fels to see Charlie and Dotty Duke, knowing that it's really Dotty I want to speak to. People have different names for Trivia's haunts, like crossing places or passing places; those twilight regions of our lives where established rules disappear

and uncertainty holds sway and the ground seems apt to crumble beneath our feet, which contain adolescence and midlife crises and so many of the trials which define us as human. Most of the time we trust that these torments are leading us somewhere new, but very occasionally they don't. Sometimes they're simply *between*. States to be endured. Then all we can do is survive.

This is on my mind right now because it seems to me that Dotty spent six years, from 1966 to 1972, in one of these between places. Through these years she, like all of the Apollo women, lived with the spaceflights, with the danger and the sacrifice and none of the compensations. The astronauts got euphoria, fame and a place in history, whereas the best the women could expect was relief when their men made it home: they were involved, but not; they watched, but not the way we did. One of the astronauts told me that as far as he was concerned his wife was the brave one, because he couldn't get insurance–who on Earth would insure an astronaut?–meaning that she lived daily with the prospect of raising a bunch of kids alone, on no money, should her husband be carried off like Gus, Roger, Ed, Vladimir, Georgy, Vladislav, Viktor, Yuri . . . Worse, the wives had all seen the way Betty Grissom was left high and dry and isolated after Gus's death in the *Apollo 1* deflagration, how she'd become progressively more bitter at her treatment by the bureaucrats and ended up suing just to get NASA's attention. Martha Chaffee had been trying to reach Roger in the Astronaut Office at precisely the moment news of the fire arrived, while Pat White committed suicide in 1983, in the middle of trying to organize an Apollo wives' reunion. It would be a bad mistake to assume that the staggering number of postflight breakups were all, or even mostly, instigated by the men.

Intuition says that it can't have been easy for the kids, either. They had their mothers' fear, the media frenzy, their fathers' absence or preoccupation to deal with. It won't surprise anyone that the son of acerbic flight director Chris Kraft dropped out and became a hippy. On the other hand, children are flexible, and they must have felt as though they were at the epicenter of the Universe for a few years. Then and now I've wondered how

it felt to have that and to lose it. In Houston, I was lucky enough to track down someone who knew better than most.

I had to call Andrew Aldrin repeatedly on his mobile phone before he answered and agreed to meet over a coffee, but when we did, I liked him. He was bright, affable and interesting, if a little guarded at first. Of all the NASA brats, he was the one I related to most readily: we shared a name and looked remarkably alike as kids. I could sense the same battles with his mum over hair length down the years, and could see from news photos that he eventually won them, whereas some Apollo kids had to wear crew cuts even when it meant squaredom and social death at school. I also know that he and his elder brother and sister were a source of tension between their parents. When Joan Aldrin presented her husband with the demand that he stay at home or move out after their post–*Apollo 11* PR tour, the spark for the row had been an important football game of Andrew's, which the couple had been forced to miss. The funny thing is I recall Buzz's sad expression as he rued his own father's absence on such occasions. Buzz also remembered his unease at watching Andrew sign autographs on their front lawn at the age of eleven. Dotty Duke will tell me that her own two boys were petrified by the reporters on the lawn.

Andrew was at the Space Congress because he recently took a job in business development at Boeing. He got there by an unconventional route, though, and doesn't look or talk like either an engineer or a career businessman. He inherited his parents' good looks and is at times strikingly like his father, with short but stylishly cut hair, wire-rimmed specs and a casual confidence about him, and I noticed that his conversation was sprinkled with one of the year's Sixties-resuscitated buzzwords–"*cool.*" I began by asking whether he'd been aware of the unusualness of his surroundings as a kid and he told me that, no, he hadn't. In Houston, the Aldrins lived in a cul-de-sac, right next to Alan Bean and Charlie Bassett. Within his own stone's throw were four astronaut homes. It was all right that his dad was a spaceman, but much cooler that he could pole-vault. Only when the family moved to California did he realize that people looked at him differently. Jill Irwin, daughter of *Apollo 15* LM pilot Jim,

will tell me that moving away to Colorado after Apollo was a turning point for her, too, because for the first time kids she hardly knew at school would come up and snarl, "Hey, gimme five dollars, 'cos you're all rich." Which was the more galling for being so profoundly untrue.

I asked Aldrin whether this proxy celebrity ever felt like a burden to him and his eyes drifted skyward as he weighed an answer. Eventually, he said:

"Well, sometimes, I'm sure. You know. It can be a burden in the sense that I would always get a little bit more attention, for better or for worse. It can be a burden in the sense that people tended to assume that maybe I got favored treatment—and then, no doubt I did on occasion, but then on another occasion I got unfavorable treatment for exactly the same reason. So, no. It cuts both ways."

I noted that the media didn't seem to scare him the way it did others and he threw back his head and laughed.

"Well, bear in mind I'm, like, eleven years old when my dad flew to the Moon. And not shy. So you've got a bunch of guys hanging out in front of the house, whose job it is to find somebody in the family to take a picture of. And they have ... *doughnuts!*"

That's how they did it?

"Yep. So for me, it was great fun. My mother was terrorized by the whole thing, though. Probably even more so with me out there running around and playing football with the reporters. You know: 'Oh my God, what's he going to say?' I don't think either my mother or my father was really prepared for what happened. In fact, they were *exquisitely* underprepared."

It seemed that the LM ascent engine was the chief focus of anxiety for him, because Andy understood that if it didn't start, his dad wasn't coming back. He remembers lying awake at night worrying about that. In fact, there's a famous photo of his mother crumpling with relief when the engine did work and *Eagle* leapt back into space. Andrew feels more fear now, in retrospect. His biggest worry at the time was that Dad would fall over and embarrass him.

"The danger was something I thought about then," he ex-

plained, "but now that I understand more about what really goes into developing space vehicles and what really did *not* go into sending us to the Moon, the risks that we were taking . . . I'm . . . *appalled*. No, not appalled, that's not the right word . . . in retrospect, it's very frightening. And the flip side of that is that if you talk to the old engineers, they're just like, 'Jeez, we're not willing to take those risks anymore.' Well, we're not. And maybe that's a good thing, maybe it's a bad thing—I don't know. We need to be risk-averse right now. Any kind of an accident would just be catastrophic to the program."

Asked whether either of his siblings went into aerospace, Aldrin offered a wry smile and "No, I'm the mutant." His dad's absence bothered him, but his elders were better able to appreciate the significance of what was happening and so might have been more deeply affected by it. Buzz and Joan were obliged to attend therapy sessions with their eldest son, Mike, soon after the Moon trip, but who knows whether that had anything to do with the extra pressure of Apollo? Adolescence is a pig we all have to ride. The thing is, the family has never sat down and discussed those years, *ever*.

"It just happened. It's just *there*."

Then Andy described how he became fascinated with the Soviet Union as an undergraduate and went on to become a specialist in Russian and East European studies at a couple of research institutes. Part of what gripped him about the subject was the question of how "this country that was so dark and murky and seemingly underdeveloped was capable of competing with the United States on that level." He did that for a long time, then "just by happenstance" fell into a job in aerospace. I asked whether he's ever felt in his father's shadow—you know, in that primal, Oedipal sense, but the question found no purchase with him and when I think about it, I can see why. Andrew Aldrin had no faux-Olympian patriarch to measure himself against, the way Buzz and so many of the rest of us did: he couldn't avoid seeing his father as a flawed human being like himself, rather than a saint or superman. Perhaps by accident Buzz Aldrin became the best kind of father. This half-formed thought drew a rueful chuckle.

"Right! I certainly get to see my father as a human, probably more so than anyone else, and learn from his successes as well as from his failures. And that's . . . that's the way it oughtta be. I love hanging out with my dad, he's a really cool guy."

He said that he'd lost touch with most of the other Apollo kids when he moved to California and that his favorite astronauts were Gordon Cooper of the Mercury 7 ("'cos he raced boats!"), plus Bill Anders and Michael Collins for their humor and humility. I asked whether his view of them has changed since he was a child and he told me:

"Oh, absolutely. I notice the differences in how their lives have gone since the missions. People have gone to industry. People have become very important. People have become very *self*-important and people have become reclusive. It's interesting. Fascinating."

Fascinating, I thought, the way one experience can produce such a spectrum of consequence, like light refracting through a prism.

I was glad to have caught up with Andy Aldrin. We said our farewells and I left for New Braunfels.

THE HOTEL WAS QUAINT, full of comically decrepit Victorian furniture and groaning lifts, but the morning was bright and the sidewalk rustled leaf gold, and it felt good to be here, like I'd come full circle, back to the source, the place where it all started for me—Charlie and Dotty.

New Braunfels is a pretty town, divided into an "old" half of cafés and craft shops and a generic new one of malls and fast-food franchises, fringed by housing developments and dozens of concrete churches with crossword-clue names. Charlie gave me very detailed directions to his house, but I got lost anyway and had to ask for guidance at one of these churches, where a young woman knew there was a famous astronaut living in town somewhere, but couldn't recall his name. I joked that she'd probably recognize his voice at least, because he played "Houston" when the *First Man on the Moon Show* ran all those years ago: John Updike described him as having "that Texan author-

ity . . . as if words were invented by them, they speak so lovingly," even though Duke was from South Carolina. Chris Kraft recalls watching him gulp two deep breaths of air before saying, "*Eagle,* Houston, we read you now. You're go for PDI," which meant they could begin their descent and try to land. The woman looked at me blankly, perhaps thinking, "My dad says it was a fake anyway."

The Dukes live on a nice estate on the outskirts of town, looking out over Landa Park. The Stars and Stripes is everywhere and "God Bless America" signs skewer flawless lawns, but their garden is secluded and uncluttered. A black mailbox at the end of a long drive croons: "Duke." A basketball net is folded down. The rear of an SUV peeks from a garage and the house seems to float on wood decking. I park and climb out of the car, but before I can ring the bell, Charlie's opened the door and is shaking hands and beaming welcome. Guenter Wendt said, "You'll be hard put to find someone who doesn't like him," and unlike some of the others, you don't ever wonder how he expects to be addressed, because there's something so essentially *Charlie* about him. Again I'm struck by the contrast between this tanned and smiling host and the sunken, gray man I met that curious day in London, the day Pete Conrad died; and also between this and the mean-minded tyrant Duke describes himself as having been when he returned from the Moon. He makes it sound as though he left a part of himself up there, or brought back some insidious malaise. Then Dotty appears with her beatific air and the offer of coffee.

Women got a hard time from the space program in all sorts of ways. Even as the Mercury wives struggled to adjust to their new lives in 1960, a woman pilot, Jerry Cobb, was being put through the same battery of tests that the men took at the Lovelace clinic in Albuquerque, New Mexico. Cobb owned four altitude records and flew everything from trainers to four-engined bombers and passed the tests so impressively that she was asked to find some sister aviators to try out for the program. Eventually, twelve more made it through the selection process—yet none would fly in space. The Soviets sent Valentina Tereshkova up in 1963, but NASA would wait until

1983 even to put a woman on the shuttle, and it would be 1995 before one flew the thing; 1999 before that same woman, Col. Eileen Collins, became the first female commander. Any way you look at it, it's a shocking record and the "Mercury 13" are now a cause célèbre in some sectors of the space community. There has even been a campaign to send Jerry Cobb up belatedly.

All of which leads us into even messier regions. In *Carrying the Fire*, Michael Collins confessed to relief that there were no women on his crew, because the privacy on those tiny craft was nonexistent. I was surprised to find this coming from so subtle a man as Collins, because it seemed to me that anyone capable of contemplating the myriad nasty ends available to an Apollo astronaut could probably learn to bare his arse in front of a lady without bursting into tears. But when I ask Duke, he says the same thing–that he thinks it was the lack of privacy that kept women off the crews–and I try hard to make myself remember that the Sixties hadn't happened for these people yet. Then we talk about the earthier aspects of Apollo life and even I find it hard to imagine men and women of his generation sharing these experiences.

It's mostly children who worry about toilet procedures in flight, but not exclusively so. According to the Lindbergh biographer A. Scott Berg, the first question King George V asked after that solo transatlantic flight in 1927 was "How did you pee?" (The answer involved sympathy for the Frenchmen who'd hoisted him onto their shoulders after thirty-three hours in the air.) Naturally, the astronauts had more sophisticated systems– we know that they made use of condoms which channeled their urine into receptacles on the early flights. The trouble was that if anything leaked, you ended up with little bobbling globules of piss reeking around your ears. This happened to Gordon Cooper on his Mercury flight and all he could do was herd them together every so often, so that he knew where they were. The rubbers on Apollo had the same problems, but were connected through a hose and valve directly to space. Not only was it easy to catch yourself in the mechanism, but opening the valve brought the hungry tug of absolute vacuum and at this point,

you understood that you were connected directly to the void, uniquely, as no human had ever been before, via your penis. This thought alone was enough to shrivel the steeliest resolve, leading to leakage and yet more piss reeking around the cabin, an additional hazard for which your fellow space lords would not thank you. There were compensations, mind: one of the best Gemini stories concerns Wally Schirra's beautiful photo of a "urine dump" at dawn, where the liquid ejected from the craft instantly atomizes and crystallizes, simulating a firework display in the sunlight.

Legend holds that a NASA astronomer found it among pictures of stars.

"Wally, what constellation is this?" he asked excitedly.

"Jocelyn," came the deadpan reply, "that's the constellation Urion."

But that was all pissing in the wind. Defecation was the real deal. To do this on Apollo, you had to climb to the lower right side of the craft while your crewmates moved as far away from you as they possibly could—which anyone who's seen one of the capsules will appreciate *wasn't far.* There, you got completely naked, removing rings, watches, everything, because you couldn't be sure what was going to happen next; then you positioned a special plastic bag as best you could, and *went,* hoping that everything went in it. Remember that you're floating; the bag is floating; your shit is floating. Charlie says: "Anything you can imagine happening . . . happened." Thus there is the tale of a stool that went freelance on one flight, causing a panic that must have been something like the famous scene from *Caddyshack* where someone accidentally drops a chocolate bar in a holiday camp swimming pool. So unspeakable was the hour-long process of dumping and getting cleaned up afterward that I heard rumors of one astronaut dosing himself with Imodium, which enabled him to hold it in for eight whole days. I'd rather suspected this to have been Alan ("anal" spelled sideways) Bean, but gossip finally suggested another candidate.

Anders was standing in line at an airport check-in desk when I called him on his mobile phone. He came clean straightaway.

"Haha—yeah," he hollered above the background noise. "I set

the world's longest distance no-bowel-movement record... three-quarters of a million miles! Everything was looking a little brownish to me when I got home..."

He went on to point out that you can verify this by watching the way he waddles across the carrier deck in the post-splashdown footage. Later, I notice the curious fact that when his crew addressed Congress shortly afterward, he was the only person in the building wearing a brown suit, leading me to wonder whether his space "brown-out" left a permanent mark on his psyche. As Charlie says: "We had a lot of laughs with the old waste-management system." None of which lets NASA off the hook about mixing genders on Apollo, because they could have sent an all-woman crew, but this was the 1960s: the times, they weren't a-changing. There weren't many girls in rock groups, either.

The obvious irony of this is that the Moon has tended to be identified with women down the ages, perhaps because her twenty-nine-and-a-half-day cycle roughly corresponds to a regular menstrual cycle. No one knows why this is: Darwin thought it might stem from our oceanic origins, from the fact that the highest tides occur at full and new Moons, making these the best time for reproduction. Either way, the word for "Moon" and "menstruation" is related or interchangeable in many languages and it's easy to see why some women might have felt unease at her symbolic assault by men (and precisely as feminism prepared to enter its most militant and influential phase). The colorful TV astrologer Sybil Leak, for instance, sided with Tom Stoppard in complaining of science "ripping the veil of mystique from the Moon" when Apollo went up; of her dignity being stripped away by Buzz and his pals tromping over her in their size thirteen boots. Polls consistently showed the space program of the Sixties and Seventies to have far more support among men than among women.

Compensation comes from hoping that somewhere there is a parallel universe in which Rene Carpenter, the first of Mercury-flier Scott Carpenter's four wives, was the first Moonwalker. It's reputed that in 1966 Neil Simon based an entire play–the romantic/political comedy *Star Spangled Girl*–on a

lively exchange he witnessed between her and the *New York Post* columnist Paddy Chayefsky at a party in his house. She was bright and magnetic then, and it's clear that not much has changed when I catch up with her in Denver, where she treats me to a characteristically burlesque account of the early days of the program: of the women's excitement at having a semipermanent place to live for the first time; of arriving in south Texas to find a nowhere of sagebrush and swamp, with no stores or supermarkets (or to begin with even *houses*) within an hour's drive; of supervising the building of their first homes having never owned property before and winding up with floods whenever it rained, or air-conditioning systems connected to fireplace chimneys, so that the units billowed smoke whenever a fire was lit; of the men soon spending all their time at the Cape, preparing in all probability to be blown to smithereens while NASA ran flight tests, including one with Ham the chimpanzee (who lucked out and returned safely). Rene remembers that part well.

"You know, I was on the beach with Jo Schirra for the last Atlas test firing," she says, "and it blew up right in front of us! It was terrifying, but there was fatalism among the wives, a lot of gallows humor. You'd say 'Oh, thank God the monkey wasn't in that one.'"

Carpenter speaks of the way their lives changed in Houston, how they suddenly had people camping outside their doors and tour buses turning up, and how they trained local kids to misdirect the gawpers somewhere else. Uniquely, she wrote her own stories for *Life*, which would then be edited by the reporter Loudon Wainwright–father of singer-songwriter Loudon III and grandfather of Rufus–whom she adored, sighing:

"Oh, he was a doll-baby, so sensitive . . . always crying. *Life* was the one thing I trusted, because you couldn't trust NASA."

When Scott flew his one mission, she had to sneak herself and the children to a safe house at the Cape, telling the kids to keep their heads down in the back of the car as she passed the TV scouts posted at every junction to intercept her, because the wives' reaction was part of the story they wanted. Had they found her, they'd have asked the same coded questions, before the flight, about impending widowhood and afterward expected

the same response to the avoidance of widowhood, which usually boiled down to "I'm proud, thrilled, happy." Later, when *Apollo 12* splashed down, Sue Bean, Barbara Gordon and Jane Conrad mocked this ritual by appearing in identical dresses with bouffants you could hide a Saturn in, holding aloft three cards with these very words scrawled on them, but the little-lady act was a joke among the women long before that. One wife who was asked by a female reporter how she felt when her husband was up is said to have blinked and answered, "Honey, how do you feel when your husband is up?" at which the interview time was judged to be up. In *The Right Stuff,* Tom Wolfe recounts a skit Rene used to do with the other wives, in which she played the TV correspondent Nancy Whoever, interviewing Primly Stable, wife of the famous astronaut Squarely Stable, on the front lawn of her "trim, modest, suburban home." It would end with Nancy observing that, obviously, with her man safely home, Primly's greatest prayer had already been answered, but wondering what her one other wish might be, to which Primly would reply, "Well, Nancy, I'd wish for an Electrolux vacuum cleaner with all the attachments . . ."

Some women struggled with the glare, but Rene loved it, loved the media work, the political engagement, visits to the White House and getting to know Jackie Kennedy well ("she was so warm, had such charisma") and the bond formed with the other women–"all my sisters"–to whom she still feels close. "We were dead certain that we had to remain close," she says. "We had to be above the competition that was going on among the men."

Even so, life was different for the space sisters as the 1950s turned into the Sixties. Their social lives were still confined, with days organized around *teas,* and certain clothes to be worn at certain times of the day. Twice a week, on Tuesdays and Thursdays, they had to call at the house of superior officers' wives and leave little embossed cards in accordance with some nonsensical military tradition. Yet this maniacal attention to propriety wasn't confined to the forces: women's magazines were full of articles on whether toilet rolls should be placed on the holders with the trailing end *in* or *out,* and on the correct

way to pour and receive a cup of tea ("You remove your right glove and place it in your handbag so that the fingers just flop over the edge, then proceed . . ."). Still, it was a picnic next to Navy deployment. I ask whether she blames the program for her split with Scott in 1967.

"No, no–it probably made it last longer," she laughs. "You know, divorce was considered a terrible thing then. But over the course of the Sixties, all the veneer seemed to fall away from everything."

After the breakup, Rene campaigned for Bobby Kennedy in the presidential primaries, until he was assassinated. She claims to have been with him when news came of Martin Luther King's murder a few months before, and in common with most of Bobby's heartbroken supporters, she stayed away from that year's notorious Democratic Convention in Chicago.

"I don't know whether Bobby would have made a good president or not," she muses when I ask whether he might have done a better job than JFK. "It was very difficult for him because he was so shy–not like JFK, who was going to be a journalist and was surrounded by journalist pals and speechwriters . . . and Bobby could hold a grudge, but at the time he was more dedicated to civil rights than JFK was: he had a lot of black friends and was braver."

Post-Bobby, she forged her own career in TV while raising the four children she'd had with Scott. She remarried in 1977. Asked whether it had been a wrench to leave NASA, she almost falls out of her chair, exclaiming. "Oh God, no! I could hardly wait to leave NASA!" Nevertheless, she says, they were wonderful times.

But not always. Valerie Anders has fond memories, too, but draws an exhausting picture of lugging babies around while she readied the elder of her five kids for school, sorted out and cleaned the house, mowed lawns and tended gardens, drove miles to get shopping and tried to look glamorous enough to represent the program at functions in her husband's absence, when they couldn't afford babysitters and she had only one smart dress (the green one you'll find her wearing in all of the post–*Apollo 8* proud-thrilled-happy pictures).

"It was very difficult," she states finally. "Everybody tried to make a joke out of all the difficulties that we had. We just thought that was the way life was. Then again, when these flights came up that were so risky, we also knew that if we weren't there, we would have been on a base and our husbands would have been flying in Vietnam."

Strangely, that hadn't occurred to me.

"Oh, absolutely. All our friends were there. And I felt that it was an exciting adventure that humanity had embarked on–for whatever reason, whether it was about beating the Russians or not. At least this was something that stretched us, instead of miring us in the mud of Vietnam. At least there was a fifty-fifty chance he'd come back from this one."

Jan Evans, de facto coordinator of biannual Original Wives gatherings, describes the hate mail and calls she received when her late husband Ron, CM pilot on *Apollo 17,* was flying in Vietnam prior to NASA. After that, the Apollo years seemed wonderful to her. She laughs with the revelation that she volunteered her husband for the Astronaut Corps while he was away, but not as she recalls the time word came of another marriage breaking up and Ron, genuinely upset, slammed his fist on the table and said, "Damn it, don't any of these couples ever talk to each other?!"

Val Anders had particular reason to linger on the danger of *Apollo 8,* which carried the first human beings around the Moon, because there was a feeling that it had been rushed following intelligence reports that the Soviets were preparing their own circumlunar flight. NASA administrator James Webb's response to the suggestion that the first crewed Saturn V flight should leave Earth orbit is reported to have been "Are you out of your mind?!" Even the flight directors seemed anxious.

"And I'd never seen them nervous before, which made me nervous. But on the other hand, it was such an exciting step. When you started to think about the possible consequences and what it could mean for the rest of your life, you simply turned off that thought. You couldn't move beyond what was happening at the moment."

She stops and sighs. She reminds me that death was a part of

the women's everyday world. When Bill was training in San Francisco, their sister squadron went through a bad patch, where they were losing about one pilot a week, "and you'd see the little black car coming to the housing area, wondering where it would stop. We all went through that." So while they might not have talked about the fear, they felt it. A week after the *Apollo 11* crew was announced, Joan Aldrin wrote in her diary: "Broke out in blotches last night, which still persist today. I'm covered in pancake makeup and jumpy. Nerves. If I'm like this now, what will I be like when it really happens?"

I ask about the children and Valerie Anders says that her eldest son, who was eleven when Bill flew, was notably excited by what was happening. He was protected from any negative consequences by the fact that most of his friends had parents in the program. Like everyone else, she didn't understand what a blessing this was until afterward.

"When we moved to Washington, D.C., I think it was very hard on our second son, who wanted to be part of the crowd in sixth grade, but then stood out because his father had done this. Only then did he begin to realize that it was quite extraordinary, and he didn't deal with that well. I don't think the girls had as hard a time as the boys. My personal feeling is that the sons were trying to live up to what their dads did, whereas the daughters could go a different direction and feel no need to compare themselves."

Valerie sighs again, more deeply this time. It is an awesome thing to feel a need to live up to. Another of the women told me:

"There have been quite a few cases of problems with the sons, 'cos they just couldn't compete with the legend. Michael Collins lost his only son. That was just . . ."

Then she trailed off. Rene Carpenter told me that her eldest son developed schizophrenia in his late teens. I remember Collins writing about his six-year-old boy, the youngest of his three children, being interviewed on TV.

"'What do you think,' Michael is asked, 'about your father going down in history?' 'Fine,' says Michael; and after a considerable pause, 'What *is* history, anyway?'"

In retrospect, that question might be read many different

ways. Apollo was an awe-inspiring enterprise, but it came with a high price tag in more ways than one.

THE LIVING ROOM of the Duke residence is plush, but not ostentatious, with a central well approached by stone steps and containing a modern, beige sofa suite and glass-topped coffee table, and with beautiful views over the park through sliding glass doors at the back. It's a cool, deceptively masculine room, decorated with ethnic souvenirs and photos of grandchildren and their two sons in stripy Seventies flares, but afterward I can't recall seeing any evidence of Charlie's astronaut career. He emerged from the fug of the 1970s calling his Moonshot "the dust of my life," and I'm wondering whether he still feels that way as he waits for me to settle in an armchair before draping himself over the end of the sofa opposite. Dotty brings coffee, then perches next to him, leaning forward with her arms on her knees. She's in a neat black skirt and white blouse. He's chiseled Clint Eastwood handsome in jeans and unbuttoned blue cardigan over a casual white-striped shirt. They both look slim and fit and healthy and Charlie would probably beat me in a race to the mailbox and back. NASA knew how to pick 'em.

Born in October 1935, Duke is the youngest of the Moonwalkers and was recruited in 1966 as part of the nineteen-strong fifth group of astronauts. For all his modesty, he must have impressed the power brokers to get anywhere near a flight, and in fact wouldn't have flown but for Gene Cernan's astonishing decision to turn down the *Apollo 16* LM pilot's job in favor of commanding *17*–an act of will made possible only by his throttle jockey rapport with Deke Slayton. Duke's parents were South Carolinians who met in New York, where they'd gone looking for work during the Great Depression. When a child loomed, they returned south, and in October 1935 took delivery of identical twins, Charles and Bill, but after the Japanese attack on Pearl Harbor drew America into World War II on December 7, 1941, Duke Senior volunteered for the Navy and was sent to the South Pacific. This was classic Greatest Generation stuff and Charlie did everything in his boyish power to help the effort, collecting

aluminum foil and raising money in his spare time. His heroes were the cowboys and pilots he saw at the Saturday matinees. By the time the war ended, he knew he wanted to go into the military.

One of J. G. Ballard's stories contains the striking line: "The best astronauts, Franklin had noticed during his work for NASA, never dreamed . . ." But before his flight, Charlie had a dream that he and John Young were driving the rover across the lunar surface, when they found another set of tracks. They asked Houston if they could follow them and wound up confronted by another rover, in which sat two people who looked exactly like them, but had been there for thousands of years. The dream was so pure and so vivid that Charlie is apt to call it "one of the most real experiences of my life." In the event, however, the reality was exciting for Duke but not mystical or spiritual as it was for some. On the flight before (*Apollo 15*), Jim Irwin had found the crystalline "Genesis Rock," a 4.15-billion-year-old relic of primordial crust formed in the Moon's infancy–in geologic terms, mere *moments* after the solar system itself was born. It just sat there on a rocky pulpit at the edge of a crater, as if it had been waiting for him all that time and he said he felt the presence of God then, heard *His* voice, and upon returning, he quit NASA to found the High Flight ministry. A year later, he embarked on the first of several expeditions to search for Noah's Ark on Mount Ararat in Turkey, which the novelist Julian Barnes used as a template for one of the short stories in his book *A History of the World in 10½ Chapters.* He almost died after a bad fall on Ararat's slopes in 1982, but lived on until 1991, when a second massive heart attack finally took him. The thing was, everyone had known this was coming, because NASA medics discovered alarming irregularities in his heartbeat while he was on the lunar surface. Despite all the monitoring and all the tests, these had never shown up before. It seemed that the Moon, with her bardic sense of mischief, was playing the equivocator again, revealing Irwin's calling while simultaneously foretelling his death.

Duke had none of that. He felt so at home up there that he

had to resist an urge to take his helmet off, because if he did the vacuum was ready to seize his insolent body and turn it inside out. It was when he got back that the strange stuff started to happen. There were the parades, the White House meetings, congressional addresses and appointment to the backup crew for *Apollo 17*. He was only thirty-six and for a while, "was sort of floating like I was back in orbit again," until he began to hear that same whisper as everybody else: What do I do now? A highly compromised shuttle had been approved, but was way down the line. And he felt bored. The light had gone out. So he took his excess energy and decided to make some money—just decided to—and *did*. The thing was, the astronauts, though poor, found themselves sitting at the peak of the manhood steeple and were to powerful businessmen what the Spice Girls would be to eight-year-old girls one day. They were always being courted by the moneymen and now Charlie used one of the connections he'd made to set up a beer distribution business in San Antonio. It was hard work, but soon the cash was rolling in. Charlie was a success all over again.

Meanwhile, as Dotty tells it, she was slowly falling apart. The pair had met in August 1962, in Boston, where Charlie was taking a masters in engineering. Like so many aspects of these stories, the facilitator was chance, even if Charlie purports to have known instantly that she was the one.

"I was coming up twenty-seven and I'd had a lot of experiences, I'd dated a lot of girls in Germany. But she just captivated me. When I went home the next day to South Carolina, I told my mom I'd met the girl I was going to marry."

He stops and laughs.

"Even though I think she was not looking for an Air Force officer–slash–engi*neer* to settle down with."

Dotty was five years younger, from a comfortable family in Atlanta, Georgia. She'd just completed an art degree and spent the summer touring Europe, so Charlie must have been different for her.

"Yes, in a way I probably worried that he might be square. Not square in the sense of being a *nerd* type of square, but in the

sense of not being free, 'cos I was a kind of free spirit. And I put him to a test on that, to see if he could accept that in me. And he did fine."

I ask what the test was and Dotty smiles.

"It was rolling down a hill. It was in the fall and I wanted to see what his reaction was."

What did he do?

"He just rolled down with me. It was very good. So he passed that test."

Charlie courted her assiduously and they were engaged in November, then married in June but married life disappointed Dotty straightaway. Her new husband's studies were being funded by the Air Force, who insisted on a B grade-average. The problem was that MIT was a tough school and with all this dedicated courting, his grades had slipped to the point where he found himself on probation and forced to focus on his studies. Dotty suddenly found that even when he was home, his head was in books. She hoped that when the master's was won, they'd move and things would get better, but they wound up in the desert at Edwards and he was studying just as hard–and now she was also competing with airplanes for attention. Looking back, Dotty thinks that her expectations of marriage were based on the fairy stories she'd been told as a girl, and therefore doomed from the start, but she sees a generality in them, too.

"I think our marriage was typical of so many women of my generation who entered a marriage thinking that this was the beginning of a wonderful closeness and romance and fulfilling each other's needs and this sort of thing. And I've probably come to see that most men enter marriage with more of this hunter instinct, which I think is ingrained, which is 'You've caught her and you're married and so now you can get on with the rest of your life.' So where the woman sees the marriage as a beginning, he sees it as something which is done. And that certainly happened–as soon as we got married, the courtship, the romance, the beautiful close relationship that we had with each other kind of–ha!–stopped."

They struggled through, but it was rocky. Like everyone else around the Astronaut Corps, they'd somehow understood that

breaking up would mean the end of an astronaut's career and were surprised when the first divorce occurred in the home of Donn Eisele in 1971, and nothing happened. Still the Dukes made it through, but by the end of the 1970s, Dotty says that she felt directionless and suicidal, while Charlie had turned into what he himself characterizes as a remote partner and a brutal, alcoholic father. His brother, Bill, who'd grown up to be a doctor, disapproved of Charlie peddling beer, feeling that it was a betrayal of his responsibilities as an American hero and role model to the young. But Charlie didn't care. He was making good money. He liked beer and if he didn't sell it, someone else would. Only in quieter moments would he admit to himself that he was bored, as he had been at NASA after Apollo.

Dotty tells me that during this time, she tried everything to reinvigorate, then sedate herself. There was an exciting career with a travel agency, some rewarding charity work, self-help books, alcohol, flirtation with other men, even–*get this*–drugs, in the form of marijuana. The list is so exhaustive, so *neat*, that at one point a little lion tamer in my head is forced to grab a chair and fend off that song of the Seventies, "I've Never Been to Me" by Charlene. But clearly, Dotty was very unhappy. She thought about divorce, but couldn't face it. Charlie didn't know what to do with her depression and pulled away, which made her feel lonelier.

"It seemed like all he wanted from me was to cook his meals, take care of the children, and stay out of his way until called upon. My life was to revolve around his needs, but my needs weren't being met."

What fascinates me most is that her decision to seek resolution in Jesus was just that–a *decision*. There was no Mitchell/ Bean/Irwin-style epiphany. There was no emotion at all. She'd always been to church, but in the routine way of the conservative South. Her religion had been about the laudable aims of being good and helping other people. In essence, the Golden Rule. Now she said:

"God, I don't know if You are real; Jesus, I don't know if You are the Son of God. But I have made a mess of my life, and if You are real, You can have my life. If You are not real, I want to die."

So she handed over her skepticism, her will, her *life,* just like that. She says that she kept it to herself to begin with, but over the coming months a kind of peace descended and she found herself able for the first time to forgive Charlie his drunken rages and rejections and insensitivity–because as any over-worked marriage counselor will tell you, this is the biggest challenge to repairing any relationship. Yet it was so simple once the decision was made. She says God told her not to try to change or save or chastise Charlie, just to be bold enough to love him with no conditions attached. So she did, then felt better, and the love now flowing through her faith seemed to lift some of the burden on her husband's love. He saw the transformation in Dotty and eventually asked God to give him the strength to love his wife, and he duly found it. The beer was still an issue, but Dotty dealt with that in her own inimitable way, praying, "God, if you want Charlie in the beer business, give him peace . . . but if you don't, make him so miserable that he sells out!" And so it came to pass that one night, Charlie poured a drink and it might as well have emanated direct from Gordon Cooper, it tasted so bad. He sold his share of the business for a tidy sum and gave up the booze. He started a commercial-real-estate development company and set about repairing his relationship with the sons he'd terrorized. His disappointment at being Earthbound forever after Apollo vanished. Things were on their way to getting better.

I have no religion and probably never will, so I don't know why I enjoy hearing all this so much, but I do. Perhaps it's the idea that you can make a smart decision to suspend the faculties that we most associate with intelligence: skepticism and independence . . . the idea that under certain circumstances, dispensing with intelligence might be the most intelligent thing a person could ever do. Charlie smiles when I ask if he still thinks of the Moon trip as "the dust of my life"?

"Well, that was probably a little bit exaggerated," he says, "but I tried to use the analogy of the Moondust, you know, and kicking around in the dust. No, the Moon flight was a *big* experience for me, a great adventure–and I'd do it again, Andrew. So it wasn't inconsequential for me–I didn't mean it that way–it's more from an internal sense."

But he'd choose his faith over it?

"Oh, yeah, definitely."

The singsong voice of Mission Control. I remark that it's hard to reconcile this Charlie with the despot he describes after the flight. It's as though he's talking about a completely different person.

Charlie and Dotty both laugh knowingly.

"Oh, totally," Charlie explains. "Oh, yeah, God changes us on the inside. I mean, I have an explosive temper and I was a very stern father and I was a big flirt, you know, and that frustrated Dotty."

"He was critical," says Dotty.

"Yeah, I had a critical spirit, you know."

They're funny together like this, trading lines from the same story, the Lord's Sonny and Cher. Was he really that bad as a father?

"Well, I mean I wanted to be a good father, because I did love my children. So my motives were good, but my method was madness."

In what way?

"I was trying to spur them on. In the military, a lot of times you spur people on with criticism. I learned that in the Naval Academy. My father was very critical. My parents fought a lot in their marriage. They stayed together, but had a very contentious relationship."

Charlie talks of coaching his two boys at soccer and Little League baseball when Apollo was done and he had more time on his hands; of how he was absurdly demanding, "not only with my kids, but with the whole team–'cos I wanted victory." I suggest that this isn't surprising, because he had just come from the most competitive environment on Earth; then Dotty nods her head vigorously and goes "uh-huh, mm-hmm" as I relate what Alan Bean said about some of the guys still engaging in one-upmanship when he bumps into them. Charlie breezes past this, saying that it was all "just good, healthy competition," but Dotty sticks up for Bean, saying:

"I can see how someone would think the way Alan thinks. Charlie was not introspective. He did not think about feelings

and try to figure people out or anything like that. He was just positive–gonna be great, let's do it. Alan's not like that, he's more sensitive and he would look at people's feelings and think about those things a lot more. There's a different personality there."

Charlie nods doubtfully.

"Fortunately, our kids don't remember much of the hard times," he says. "And I thank God for that; I think it's a miracle. As for forgiveness, the boys said, 'Well, that's okay, Dad.' And then I found that it's a fine line between discipline and discouragement as a father. I prayed a lot about that, asking, 'How do I do that?'"

We talk about that idea of "finding the strength to love my wife," which seems a radical notion to me and most of my Fifties/Sixties/Seventies-born friends. We've come to assume that love just *is* or *isn't*, is true or not. That it's irreducible.

"Well, yes," says Charlie. "You have to have that strength, but first it was a decision, 'Lord, I want to love my wife, I want to make this marriage work . . . please give me the strength and the guidance and the wisdom to do that.' As Dotty says, love is a decision. You decide to love somebody."

The very opposite of what the songs say.

The doorbell rings and Charlie announces that the "gutter guy" is here. He goes off to meet him, leaving Dotty and me alone. She hands me a copy of a pamphlet she wrote telling the story of her conversion, and flashes her eyes.

"Of course, I was thinking of your book in terms of trying to help people. That was why I was talking about women going into marriage, 'cos I thought that people could relate to that."

I tell her that I'm sure they will, one way or another, then ask whether she thinks her trials were common to the other wives? She sighs and shakes her head. Her face combines smile and grimace in a way that few could manage.

"We didn't talk about it," she says.

Was it as difficult for the women as people tend to assume?

"Well, look at the divorces. I know that one woman divorced her husband and she's sorry now that she did, but I think she was, 'Well, he's done his thing, I want to go do my thing now.' So she reacted that way. I'm sure there was this feel-

ing of being abandoned. So a good number have divorced in that situation."

We move on to the "Original Wives Club," Dotty explaining that the ones who generally come are the ones who are single now, because it's their only remaining contact with the program.

"So they really love to come. It's a neat thing. They can get that support and that encouragement. Not very many of them have remarried, not very many at all."

She names a couple of the women who've remarried then broken up again, and some more who never wanted to try again. The high divorce rate is much commented on, I note, wondering whether it was to do with dissatisfaction on the men's part when they got back to real life, or the "rock star syndrome," or just the pressure of an absurdly demanding job?

"I think it was just the typical thing. The lack of attention that the women were given. The men were held up as heroes, while the women were doing the hard work at home. But I guess that, really, most of them were because of the affairs that were going on."

Gutter guy seen to, Charlie's returned now.

"Well," he says, "you have to look at what causes the affairs, too. Most of the time, the affairs were the symptom. The cause of that was—"

Dotty interjects with some urgency.

"But there was a lot of temptation. Every wife had to deal with the knowledge that her husband was a hero and considered prize game by good-looking women wherever they went. And it was accepted, I think, that the idea among the men was, 'Sure.' At least that's how it seemed to me: 'We got this availability . . .' It didn't seem to be frowned on."

In 1977, the *Life* interviewer Dora Jane Hamblin wrote: "I think *Life* treated the men and their families with kid gloves. So did most of the rest of the press. These guys were heroes . . . I knew, of course, about some very shaky marriages, some womanizing, some drinking, and never reported it. The guys wouldn't have let me, and neither would NASA."

It wasn't so much that these things happened, because they

happen everywhere, in every occupation, in every part of the world. What made them uncomfortable was the Boy Scout image that NASA sought to project. And I know that at this point I should ask whether Charlie succumbed, but I can't bring myself to pick over such old wounds, should they exist.

I ask Charlie if he enjoyed the reunion at the Reno Air Races and he says yes, it was nice to see the guys and they were treated well and there "weren't too many people bugging you." Which isn't how it looked to me at all. He's still interested in space, but doesn't campaign the way Buzz does.

"I mean, Buzz has some real far-out ideas," he says, quickly adding, "some *good ideas.*"

The settlement of Earth-crossing asteroids being my current favorite.

We talk about Jim Irwin and Ed Mitchell, others who had big experiences up there, both of whom were Lunar Module pilots like Charlie. In fact, Ed acted as his backup on *Apollo 16,* so the two got to know each other well.

"Ed's more of a New Ager, I call it," explains Dotty, keen to distance herself from that version of spirituality. "It's spiritual, but it's not really the *Holy* Spirit, so much as ESP and cognitive stuff."

It turns out that Charlie was aboard the noetics bus for a while.

"Yeah, after Ed left the space program, he convinced me that this was all real and maybe I oughtta try it on my flight, so I was planning on doing that, but I was so tired that I could never concentrate, so never did anything with it. Ed then started this Institute of Noetics out in San Francisco, and it was basically to scientifically prove the existence of God."

Dotty's not going to let this one lie.

"But it's not the same God," she says firmly.

"Well, I mean . . ." Charlie starts.

"We've tried to talk to him about what we believe is the Truth, but he's really going a different way."

"But we're still good friends," Charlie returns.

I comment on the way that, the further we get from Apollo, the more avant-garde it's coming to seem and Charlie agrees.

"Well, to me, I think the wind was taken out of the sails of manned Deep Space missions because we didn't discover any life out there. If we'd turned the camera on Mars and there'd been little green men looking back at us, we'd have been there by now."

We so badly want to believe that we're not alone, don't we? With a pang of envy, the thought occurs to me that the Dukes are lucky, because they don't think they are. I tell Charlie that a few weeks ago there was a huge gold harvest moon and I spent ages trying to imagine standing on it. He listens, then scrunches up his eyes.

"Yeah, I still do that, too," he says. "Yeah. *Wow.*"

Then he has to dash back to the gutter guy, while Dotty and I talk about her boys. I ask whether she thinks the relationship between them and their father healed completely? She says that she thinks it did, that the three of them just got back from a golf trip together and that they're very close. One son is now an airline pilot, the other in business, so both followed in their father's footsteps to a degree, but I wonder whether the unhappiness surrounding their early years had any long-term effects?

"Well," she says, "I know they made decisions, both of them, to be a more present father than their father was. And they've followed through with that, really wanting to be there, so that affected them some. And I think that they . . . neither one of them do I see raising voices or getting angry with their children like Charlie did, so that was probably a decision, too. So even though these were negative things, the boys took some positive things from them. And I don't see any effect on them with their relationship with their daddy at all."

We talk about the time toward the end of the Seventies when she hit rock bottom and tried so many different ways to pick herself up, including drugs. Only with great difficulty can I picture Dotty toking on a spliff, I tease. Is that part of the story true?

"Oh, yeah, it's true. I say that to help some people identify. It was more a part of the party life, which most people realize is not really going to bring you deep fulfillment either. Then came the money. I think that's really why women went into work, because your worth was judged by how much money you made

and so women keep fighting that and getting more money so they can be worth more. I feel sorry for the women who are where I was, so pulled in different directions, always striving, striving."

I know she's talking about a struggle which hasn't gone away for most women, the competing pull of children and work. Dotty and her contemporaries were in the front line of that one. With Charlie gone, I now ask for her feelings about the Moon.

"Well, I can see lots of benefits from going to the Moon. But for me, the most important benefit was to open doors for Charlie to be able to speak about God. I mean, if you go out and just speak about going to the Moon, you could start getting prideful and think, 'Oh yeah, I'm better than everybody else, look what I've done.' And that's not good, you know, to build that ego. But when we had a purpose in speaking about the Moon–*to lead people to the Lord*–well, okay, I can support that. That really gives a value to it. Walking with God, and especially the joy of bringing someone else to God, is like walking on the Moon to me."

Michael Collins noted the way he avoided discussing danger with his wife, admitting, "I suppose I was afraid to measure the depth of Pat's resentment and hostility toward this Apollo which held us both captive." In the course of our conversation, there have been points where Dotty's own resentment has threatened the Madonna smile. And this may be presumptuous, but it seems to me that she's found the most ingenious way of bringing under her own control this thing over which she had none, and which ruled her life in the most callous possible way. Apollo is still a part of their lives, but now it passes through her, and takes its meaning from her.

Charlie comes back and catches the end of his wife's last thought, and I'm amused to note the slightest hint of impatience in his voice as he asks, "What was that?" and receives his lecture on the pridefulness of talking about the Moon with no higher purpose. He cocks his head to one side, not quite ready to sign up for this one.

"Well, I . . . no," he says evenly. "There's an opportunity to share that experience, darling, 'cos it motivates people and it gives them an opportunity to dream and think and set goals."

He pauses for a moment, then continues.

"There's nothing wrong with setting goals, nothing wrong with having objectives in life–but if your goals are your God, *then that's a problem.* If money's your God, then you'll never have money enough. And there's nothing wrong with money. I mean, God gave us all that stuff. But if your focus is wrong and you put that above God, then that's where the problem comes."

Now Dotty's the dissenter. Her jaw sets slightly.

"But if you just talk about the Moon and nothing more, it would get to be like a Hollywood star or something and your ego would build up more and more and more and more. If your whole life revolved around what you did thirty years ago, I think that your ego would be affected tremendously."

I just manage to slide in with the question "Have you seen that happen?" and receive a terse answer:

"Yeah. *Mm-hmm.* I have ..." before Charlie shamelessly changes the subject, drawling more rapidly than usual:

"Well, anyway, here are the book and the tape ..."

He hands me a tract he wrote about his experiences, along with a video entitled *Walk on the Moon. Walk with the Son.* Then we're finished and I'm in the yard explaining my plan to take in some sounds in swinging Austin before heading back south. Charlie's a fan of country music and gets excited, giving me some advice on where to find a good "juke joint" when I get there, and I'll spend the drive listening to Rufus Wainwright singing Leonard Cohen's "Hallelujah" on a compilation I bought in Starbucks, and to my favorite country singer, Jimmy Dale Gilmore, who comes from up the road in Lubbock and owns the most heartbreaking song title of all time, "Have You Ever Seen Dallas from a DC-9 at Night?" When I get back to London and call Brian Eno to talk about his strange and beautiful sound track to *For All Mankind* (much of which is found on his *Apollo* album), he tells me it was partly inspired by learning that each astronaut was allowed to take one music cassette with them, and that most chose country and western.

"I thought that said something interesting about how they saw themselves, which was as frontiersmen," he says. "I also wanted to make something that didn't seem to be coming from

anywhere, that wasn't rooted in the Earth–I wanted the roll with no rock, I guess! All the harmonic pieces I wrote for the film have a kind of unearthly country-and-western feel."

He adds that he loved the way one astronaut described the Moon as gray, then elaborated, "but until you've been there, you have no idea how many shades of gray there are." He remembers being in a friend's flat in Camberwell, South London, when the *Eagle* landed.

"It was a full Moon that night and we looked out the window and saw it and thought, 'My God, this is really happening.' It was a magical moment. It just seemed incredible at the time."

Strangely, I remember there having been a full Moon that night, too, but an Apollo expert assures me that what we actually saw was a crescent. Either way, that was eighteen months before Eno joined Roxy Music, one of the groups who would embody the shift from Sixties to Seventies. He says he's not surprised that a lot of young people no more believe in the landings than they do the Easter Bunny.

"It's one of two redundant technological advances from that time, the other being Concorde. I know that one day I'll be saying to my grandchildren, 'Yes, we used to go to the Moon–and it only took three and a half hours to get to New York!'"

I take Charlie's advice in Austin and spend an enchanted evening listening to a local star named Toni Price wail the best country blues I've ever heard. I also have time to consider how different I was with Dotty and him, asking far fewer questions than usual, happy to simply ride the tale as though it were a wave breaking toward the sun. And now I know why I enjoy listening to them so much. To me, their story is like a grown-up fairy tale, in which the world goes wild and dark, then turns out okay. I believe it in the same way that Dotty chose to believe in God–because I want to–and in the end it's as true as anything else is true: with nothing more than Herculean effort and her own creativity, Dotty made everything all right. She's happy. He's happy. The other astronauts call her Lady Macbeth, but fuck 'em. She took on Luna and won.

THOUGHT I CAUGHT a glimpse of a faith like Dotty's in the inner sanctum of a Hindu temple in Pune once. It felt less like a flash of light than the lifting of a veil, a stirring which was later traced to incense fog and the appealing way in which worshippers tended a big brass Shiva Lingam. I was disappointed then, because I knew that this wasn't what anyone else in the place meant by enlightenment and that, like it or not, I'm a product of my time and specific circumstance: or to put it another way, what I know is television and rocket ships. When one of Andy Warhol's friends asked him whether being shot in 1968 had changed him, he replied, "Have you ever seen anyone *really* change?" That question, so fundamental to what we are or aren't as human beings, is finally drawing into sharper focus as *Apollo 17*, and the end, nears.

. . .

ONE OF THE GREAT advantages God has over NASA is that, un-like the space agency, He can see you on the back side of the Moon. So when Jack Schmitt wanted to land on the uncanny far side, it was NASA who raised the objections. They understood that such daring might recapture the long-lost public imagina-tion in December 1972, but with radio contact impossible it was too dangerous to countenance. Instead, the ship would set down in the stunning Taurus-Littrow Valley, on a flight billed as "Man's Last Mission to the Moon." The new ocean had become a pool of melancholy.

Schmitt had fought like the devil to make sure that if a scien-tist flew it would be him, but there must have been times during training when he was tempted to ask *"Why am I here?"* in the most prosaic and Earthly sense. The scientist group of trainees had been recruited in 1965 under political pressure, but no one intended them to go anywhere, least of all the old-school fighter jocks Deke Slayton and Alan Shepard—who was known to geol-ogy tutors for his insolence and inattention on field trips. Then, with the glorious irony that pervades Apollo, it was Shepard's golf-playing shenanigans on *14* that helped to take the decision out of their hands, as the labcoats rebelled, complaining loudly through the media that they were wasting their time; that great opportunities were being blown on the Biggles boys NASA kept puking into the sky (no less a figure than Eugene Shoemaker, the father of astrogeology, labeled the agency's approach to sci-ence "completely miserable" while commentating for the BBC in London). With the organization catching flak from every an-gle now, the NASA brass buckled. Schmitt was in.

The flight control staff were delighted for Jack, as were a few of the more thoughtful astronauts. Slayton, on the other hand, was livid: according to Chris Kraft, "he didn't like any of the sci-entists," regarding them as interfering eggheads who compli-cated missions and compromised safety—and also as the people who'd grounded him upon discovering that he had a minor heart complaint. A bigger problem still was the fury of Schmitt's new commander, Gene Cernan, who raged against one of his crew, the luckless Joe Engle, being yanked from *Apollo 17* in or-der to make way for the Caltech- and Harvard-educated geolo-

gist. In *Last Man on the Moon*, which was coauthored with the journalist Don Davis and published as recently as 1999, Cernan reveals that he wishes he'd tried harder to have Ed Mitchell bumped from *Apollo 14* in favor of Engle. He also alleges that Jan Evans's reaction to hearing of Schmitt's arrival in her husband Ron's crew was, "We have to put up with *that* asshole?" (When I call her about this, she tells me that she has no memory of saying it, and told Cernan so before publication.) Neither does the *Apollo 17* commander leave it there.

"On a first introduction," he adds, in case we're not getting the picture, "he usually came across as unlikable, and his taciturn nature and brashness made it hard for people to get close to him. He didn't seem to care a whit. That was part of our problem, for Jack just wasn't my kind of guy."

In Cernan's view, it didn't help that his new LM pilot wasn't a career aviator, "didn't have the pilot gene," even though Schmitt had been put through jet fighter training and finished second in a class of fifty. It also didn't help that he was a bachelor with "as far as I could tell, no diversions whatever." One of the jocks recalls inviting the geologist to a favorite Cape strip joint and watching in amazement as he spent the night trying to discuss rock collecting. As far as I can tell, no one even thought to suggest that he might be gay (he's not)–that was too far off the scale. The aces just thought he was weird. In Cernan's words, borrowed from the title of the hit movie and TV series from that time, this last flight was a case of "The Odd Couple Goes to the Moon."

ALBUQUERQUE SITS ON THE magical southwest stretch of old Route 66, casually slung between the Rio Grande and the Sandia Mountains of New Mexico. Before I knew that Dr. Harrison "Jack" Schmitt lived here, the place meant little to me beyond Bugs Bunny and hot-air balloons, but to would-be astronauts of the Space Age it was the Lovelace Clinic, where prospective astronauts were pushed to the limits of endurance with arcane psychological tests and needles as long as Deke's cigars, and armies of implements to be insinuated into the anus,

as per the famous scenes in the film version of *The Right Stuff*, for reasons that no one could quite explain. Just up the road is Santa Fe, and near that Los Alamos, where they made, *make*, The Bomb and seem proud of it. But that's all in the future for me. Right now, I'm sitting in the pueblo-style bar of an Old Town hotel, waiting for my second-to-last-man-on-the-Moon.

I've been looking forward to this, because it seems to me that if anyone's going to have original things to say about going to the Moon, it'll be this "dour Sherlock Holmes" academic outsider with the luminous CV. More intriguing still is the fact that since reading Cernan's view of Schmitt, the former flight director Gene Kranz has described him as "one of the few astronauts who really put a few away at our parties," a man who "seemed to have no limit to his interests, and no end to his enthusiasms . . . an intellectual with the soul of an adventurer . . . an instigator who dropped a few well-chosen words in receptive ears and then let events roll on to what he knew would be a stormy, noisy, and wild conclusion." Not the person Gene Cernan saw at all–more Indiana Jones than Holmes–and I'm wondering how to account for this disjunction.

Schmitt didn't marry until 1985 and has no children, but his career details are something else. He was the son of a mining geologist, raised around rocks and Indian reservations not far from here in Silver City. He was a key figure in geology training at NASA, helped to design many of the tools Moonwalkers took with them, and assembled some of the early composite photos of the lunar surface. He trained as a pilot, went to the Moon as an astronaut, then served as a Republican senator for New Mexico from 1977 to 1982. He'll tell me that his politics were galvanized in the graduate school at Harvard, where he did time with Timothy Leary and any number of faculty radicals whose activities he disapproved of. Word is, however, that he was no more impressed with the myopia and short-term-ism he found at the heart of government, and by the end of his first term, the Moondust had worn off and he was voted out. Since then, he's served on a number of official commissions and committees, was a member of the International Observer Group for the 1992 Romanian elections, and now makes his living through speaking,

acting as a consultant and serving on the board of various small companies who share his enthusiasm for free enterprise in space—and in particular for mining helium-3 (He-3), which is deposited on the lunar surface by the solar wind and considered to be a potential source of clean energy for Earth. No one has demonstrated the viability of He-3 fusion technology yet, but Schmitt's working on it with a group at the University of Wisconsin–Madison, where he also does some teaching. Whatever happens, he wants us to go back up there.

Apollo's ravishing last leap into the night of December 7 was bizarre for many reasons. Nineteen seventy-two had turned into a strange and eventful year, despite a familiar-seeming lead-in, with Vietnam still topping the news agenda as the media tried to paint the South Vietnamese troops' chopper-hugging retreat from Laos as victory, while also reporting that 40,000 U.S. soldiers were now junkies. Concerned about his standing among students, President Nixon had sent the Apollo men Collins, Anders, Borman and Lovell out to speak to them and when they came back saying that the only hostility they'd faced was from young professors, Nixon exploded, flashing into a rage which startled his audience. Nevertheless, by the end of 1972, the president had manufactured rapprochement with China, an end to the war and a second term courtesy of the greatest electoral landslide in U.S. history. He'd also bathed the world economy in uncertainty by unilaterally dumping the gold standard, and in June, though we didn't know it, had approved the burgling of the Democratic National Committee headquarters at Watergate. Yet the effects of these things weren't immediately felt. What a child sensed was the deracination of Vietnam edging closer to home, imported by organizations like the Weathermen and the rock star–styled Baader-Meinhof Gang and by the IRA in Northern Ireland, where the British government had just introduced internment, and the Black September group, who killed nine Israeli athletes at the Munich Olympics.

So it was that the abundant pathos of *Apollo 17*'s launch was shot through with paranoia when Black September threatened to sabotage it. A metal-piercing bullet from the beach is all it would have taken. There was anger, too, with aerospace work-

ers protesting job cuts outside the MSC. Two years before, Brevard County, Florida, had been the fastest-growing county in the USA, but now it was officially classed as an "economically depressed area," while Cocoa Beach seemed to be crumbling back into the sea. Yet still the Cape was crammed with more people than came to watch *Apollo 11:* the public had steadily lost interest in the program after that successful first landing, but now they scrambled back to catch its last gasp. The sci-fi master Isaac Asimov described watching this surrealistic spectacle from a cruise liner in the Atlantic, among guests and speakers who included Robert Heinlein and the omnipresent Norman Mailer. There were big delays in the launch, but when the fuse was lit just after midnight, the sound took forty seconds to reach the boat, then felt like an earthquake.

"It lit the sky from horizon to horizon, turning the ocean an orange-gray and the sky into an inverted copper bowl from which the stars were blanked out," Asimov gasped.

Schmitt thereafter made an unwitting nuisance of himself by jabbering nonstop observations on the appearance of the Earth and its weather systems all the way from 100 to 180,000 miles out. This might have endeared him to the Briton Reg Turnill, but even he rolled his eyes and told me that Schmitt, for all his enthusiasm, was "a complete pain" on the early part of the trip. Nevertheless, he and Cernan managed to be civil with each other all the way to the surface, and if the commander has since bemoaned his LM pilot's impassive, scientific responses to what they found there, that doesn't mean the geologist wasn't privately rapt with what he saw. Command Module pilot Al Worden had first spotted the Taurus-Littrow valley as he drifted above the Sea of Serenity nineteen months earlier and he'd been excited, because the site looked like a geologist's paradise; an ancient basin nestling between the ghostly domes of the Taurus Mountains, seventeen miles southwest of the big crater Littrow and dusted with darker soil than could be found anywhere else on the Moon—which might provide evidence of much more recent volcanic activity than had previously been supposed, perhaps dating back only half a billion years. In addition, rocks found at the foot of the mountains and among the knobbly

Sculptured Hills promised to reach back almost to the formation of the solar system. After the disappointing lack of geologic drama Young and Duke had encountered in the Descartes highlands, Taurus-Littrow held great promise and Schmitt felt awe when he trained his expert eyes on the stark beauty of a landscape such as could never be seen on Earth, with the fluid plain rolling between steep-sided mountains, glittering with crystalline rocks and small craters, each with a shiny bead of fused glass at its center. Light reflected from the slopes of the mountains, making them appear spotlit and creating crazy shadows on the floor below, and a bright blue Earth hung above as if set in black velvet. No wonder that by the end of his third excursion into this alien terrain, Schmitt was spontaneously bursting into song, leading his commander in a hearty rendition of "I Was Walking on the Moon One Day."

The pair stayed three days and collected 240 pounds of rock. For their second outing, they drove ten miles through this exotic land to reach the base of the 7,500-foot-high South Massif, one of the two largest Taurus mountain peaks. Jack's discovery of orange soil, which appeared to suggest the possibility of water and perhaps life at some point in the distant past, was one of the highlights of the whole program. Then he and Gene came home knowing that the whole thing was over.

HE SAUNTERS IN UNOBTRUSIVELY. Not for the first time, I want to laugh at the sight of everyone else going about their business—chatting and checking in; asking directions or buying drinks or waiting in the lobby for traveling companions to show ... unaware that standing quietly in their midst is someone who lived on the Moon for three days. Most of the time I forget how strange what I'm doing is, but every so often it hits me like an Arctic wind. It does now.

Schmitt is dressed simply in slacks and a white shirt with rolled-up sleeves, and wears round, gold, wire-rimmed specs. At sixty-seven, he's tanned, swarthy, solidly built, perhaps five-nine and 180 pounds, with a head of curly hair that's still mostly black and the confident physicality of someone who's spent a lot

of time outdoors and knows how to look after himself. I'll find it hard to hold his face in my mind, because he projects no image, is curiously quirk-less and frill-less. In conversation he fixes you steadily with his eyes and bowls his gravelly Lee Marvin voice at you, speaking with the same meticulous diction as Ed and Buzz and Neil, as though precision has its own karma and even a loose vowel might invite chaos. He chuckles good-naturedly as I apologize for my shabby attire, because my bag got stuck in Denver: today–it had to happen–I am *under*dressed.

Jack doesn't soften his intellect the way that Alan and Charlie do and I wonder whether this is what rubbed Cernan the wrong way. Jack knows stuff, *lots* of stuff; stuff you don't know and didn't even know it was possible not to know until he told you, and when you stray onto a subject he doesn't like or isn't exercised by, he'll issue a blunt "What else can we talk about?" You can tell he was a politician, too, because he is as interruptible as a herd of stampeding wildebeests and very ready to tell you when he thinks you're wrong, with questions not so much answered as addressed. For a long time, I'm struggling to find a gap between him and this vast reservoir of *facts*–I find that I like him, but feel, as Neil Armstrong did when landing the *Eagle,* somewhat *behind the airplane.*

A comment on that extraordinary CV draws a smile.

"I've been fortunate. Lots of opportunity. Can't hold a job, so . . ."

A little laugh, then two and a half hours of trying to work out what going to the Moon meant to Jack Schmitt, while he goes off in every kind of direction and I try to wrestle him back and pin him down, and it's fascinating, but not what I was expecting at all.

Topics we deal with in passing are: the political situation in Turkey; the wonder of capitalism; the parlous state of the education system and abdications of the media, whom Schmitt blames for the abandonment of Apollo (where the Nuts tend to blame 'Nam). There's the importance of minerals to the human metabolism and evidence that, in the brief time since lead began to be smelted in Europe, an adaptive process has taken place whereby the metal becomes attached to red blood cells–"So we're keeping

lead out of sensitive organs and more firmly fixed in the blood, *and that's just in 6,000 years!"* And all before we even reach the Little Ice Age, which gripped Europe for four hundred years from the mid-1400s and may be implicated in the persecution of witches, the French Revolution and the mysterious sublimity of Antonio Stradivari's violins, and Schmitt's unsettling doubt about the theory that global warming is human-induced. (He thinks we might have more to fear from the fact that periods of warming are often followed by rapid cooling: interestingly, current NASA scientists profoundly disagree with him.)

We roam at length through the looming pensions crisis–the world's most unsexy issue back in 1980 when Jack tried to bring it to a reluctant Senate's attention (precipitated by our old friends the Baby Boomers, who will die with the rare distinction of having royally pissed off their parents and progeny in equal measure); and over the careerism, venality and bias toward incumbents that Schmitt encountered in the Senate, where "there's no competitive races anymore . . . the *gerrymandering* . . . if an incumbent decides to run for reelection, they've got a ninety-eight percent chance of winning, and it's been that way for decades." We also discuss the elections in post-Ceauşescu Romania, which Schmitt observed with Al Gore's former running mate Joe Lieberman and a British MP, and which Schmitt was alone in refusing to ratify finding the experience disturbing and "very emotional in some respects." During our time together, this will be the only occasion on which he refers to an interior process or *feeling*. It's all very interesting, very educational, and not about the Moon. The aggressiveness of European autograph hunters, whom Schmitt insists are even worse than American ones, and the fact that he doesn't do signing shows and all that lucrative celebrity stuff, is the nearest we get to the subject for a while.

We do manage to settle on the Schmitt childhood, which was spent around mines, steeped in geology. His mother was a teacher and amateur botanist and zoologist, he tells me, "So we had a very active household in terms of natural phenomena." He has two sisters; one lives in Arizona now and one in California. I wonder whether he ever had even a faint urge to fly like the

other Apollo guys? No, he says, although if he hadn't gone into science, he might have ended up in the marines.

"But who knows what I would have been doing? I mean, you can't run two lives simultaneously as an experiment when you're a human being. As opportunities come, you look at them and say, 'Is that one you'd regret not grasping?' That's sort of the way I've run my life."

There follows a little lecture on the importance of a grounding in maths for all citizens and an insistence that he suffered none of the postflight letdown others experienced, because he had his science to go back to, even though he never returned to the life of a full-time academic and looks to live by an absorbing but precarious combination of activities. There'd been no delayed reaction?

"No."

None? No *What do I do now?*

"No, I don't think so. *I* never felt that I did. All I had to make sure of was that I could pay the mortgage."

Which can be daunting enough.

"Well, it scares me—every day. It still does. That's why I keep working."

We eventually arrive at the Moon and wander briefly through the Chinese ambitions relating thereto. Schmitt correctly speculates that Earth orbit is within their grasp, but doesn't place much store by that. He notes that "Earth orbit is relatively routine now"; that over the past two decades the human environment has expanded up to a couple of hundred miles above the surface. If someone has the right booster rocket—he shrugs—they can get up there.

"Into Deep Space, though, is another kettle of fish. There is a requirement for discipline and competency that is far above what is now available to *any* Earth-based space program. No one, including the United States right now, has the kind of agency, or discipline, or competency necessary to operate with minimum risk in Deep Space."

But isn't the lesson of Apollo that it's mostly about determination? I ask.

"No, no—you can be determined as hell, as we were prior to

the *Apollo 1* fire, and as the Russians were prior to their debacles. But unless you've got that number of things working appropriately, particularly competent management and discipline in that management, you probably won't succeed. One can in a sense say that there have been three space programs with the goal of going into Deep Space: one was the Russian effort and the other two were ours. The first one the United States put together failed, and it failed spectacularly in the *Apollo 1* fire. And it wasn't until that fire showed the flaws in the management system that a new program was devised, primarily under the guidance of people like George Low and Sam Phillips, Chris Kraft and people like that, that we then succeeded."

It strikes me for the first time that, for all their brilliance and determination, the Soviets never managed to break Earth orbit; that not a single cosmonaut left the planet behind and saw it from afar. That the difference between near space and Deep Space is like the difference between climbing a hill and flying, and only Schmitt's fading cadre of twenty-four Americans was privy to this most profound of sights and experiences. The world won't be different without them, but the idea of the world will; the collective imagination a little impoverished. Getting out there is hard, he reminds me—the Chinese can boast that they're going, and if they don't mind losing a few people on the way, they might eventually do it. If they want to go safely and repeatedly, though, there's a lot to learn.

I tell Jack that I've been surprised at how little time the lunar astronauts spent contemplating the loneliness of a death out there, and ask whether this was out of confidence or aversion. He exclaims:

"No! Of course we considered it! The whole design of the spacecraft considered it. It was in the initial, conceptual design, and ultimately in the hardware used in these missions. You wouldn't be successful if you left people on the Moon—the Kennedy challenge was to return them safely to Earth. That was built into the design. So the reality was always there, but the fear of it was not there. There was much less probability of that happening than of you encountering trouble on your flight back to England."

He chuckles as I contemplate this claim in more detail, because he knows that while it's misleading, the statistics are on his side. Twenty-seven left, twelve landed, all came back. Something I've said before: the more you consider what Apollo did in so little time, the more unbelievable it seems. Another chuckle.

"Yeah, we could get things done. But that was a combination of a number of things. One was extraordinarily motivated twenty-two-year-olds almost everywhere in the program. The vast majority of the people were just out of engineering school and highly imaginative—basically, they didn't know how to fail, they hadn't been around long enough to know what failure was like, so they didn't worry about it."

We talk about the politics that led to Apollo for a while and Schmitt seems keen to credit the Republican Eisenhower with more enthusiasm for space than seems reasonable to me. When we get to JFK and I mention the Bay of Pigs as a factor, he shrugs, "Well, who *knows*?" with a glance that I take to mean "You woolly-headed liberals will say stuff like that" and makes me smile. We embark on a jolly conversation about the philosopher John Locke and Winston Churchill and the erosion of freedom and encroachment of government on our lives, which I find enjoyable, even if the couple eavesdropping in silence at the next table in this hotel bar look ready to hang themselves. Of particular interest to Schmitt is the way that "the existence and the creation of the United States allowed Europe to survive *itself*, and if you really want to look off into the future, it may be that settlements on the Moon and Mars will ultimately allow the world to survive itself. The idea of a new birth of freedom every now and again isn't a bad thing. We tend to wear freedom out."

He adds that "the frontier is a great catalyst for freedom. And the frontier now is no longer on the Earth. It's at the Moon and Mars. That's where you're going to see, I think, a rejuvenation of freedom, probably within this century."

I think: "Well, who *knows*?" Loaded and ambiguous words like "freedom" make me uneasy.

Then we're racing through Black September and the ease with which someone could have destroyed *Apollo 17* with nothing more than a rifle, and NASA's self-interested obstruction of

private leaps of faith into space, by way of Eric Jones's extraordinary *Apollo Lunar Surface Journal,* a massive work of oral history about the lunar landings which is available on the Web and being added to daily by people from all over the world. Schmitt helped Jones elicit contributions from some of the astronauts, which is a lovely thing to know, but *still* not what I was after.

I tell him how struck I was by the differing assessments of his personality on the part of Kranz and Cernan. He hasn't read Cernan's book, but betrays no surprise upon hearing what his former colleague said. There is an uncharacteristic pause, though, prior to the inscrutable response:

"People see what they want to see, I guess, huh?"

Was it a thrill jockey versus egghead thing?

"Well, I have no idea what was in his mind. I wouldn't know. I spent a lot of time with the flight controllers. They were a good bunch of people. Your life was in their hands as much as it was in your own. We became very close friends, a lot of us. Still are."

I try again, suggesting that it must have been difficult for a scientist to fit into the military milieu.

"Well, I don't think so. Of course, I would have a different view from a lot of the others who didn't get a chance to fly. A lot of luck figured into it, but if you're not ready to take advantage of luck, luck doesn't do you much good."

Another question I've asked previously: Have the relationships between Space Age astronauts changed over the years, as they do with siblings? Another pause.

"No, for the most part, whatever relationship we had has disappeared, because we're very independent, we're not joiners—you don't find an astronaut alumni organization, *not really.* There is this Association of Space Explorers that was formed a few years ago [by the idealistic Rusty Schweickart], and most people are dues-paying members, but it doesn't act as a . . . at least my sense of it is . . . well, I never go to meetings and not very many people do. They're just not joiners."

Does the thought that someday soon there won't be anyone left who's stood on the Moon mean anything to him?

"Hahahaha. Well, we'll see what we can do. We'll see what we can do . . . What else can we talk about?"

Interesting: Schmitt didn't like that question.

We talk about helium-3 and "how, ultimately, it might get us back to the Moon"—a revealing choice of words, I think, because it suggests that the urge to go back precedes the justification. I note that the other lunar astronauts came back in awe of the Earth more than anything else, and wonder whether Jack's view of it changed?

"Well, I think what they came back with is an awareness. Geologists always have an awareness of the Earth."

And a respect, presumably.

"Well, yes, it's what you've been studying all your life. So I think I had a different perspective, understandably. But most people don't pause and think about the Earth as a globe in space. And when you finally see it as that, against an absolute black background, it gets your attention."

You can only see it as such from the verge of Deep Space. Only twenty-four people have, ever. Everyone describes its seeming fragility.

"Well, the thing is, I think the pictures make it look a lot more fragile than it is. The Earth is very resilient. Again, geologically, I see that. I know what blows it's taken, *environmentally*, before humankind ever appeared. And *survived* it. And even since humans have been here, the things that have happened . . . such as ice ages. And humankind has survived it, too. And in fact those rapid changes on Earth may well have been what forced human evolution to where we are today. You had to adapt, particularly during these cold periods, or you didn't survive. And so there was a very, very strong selection process. And human beings have probably had a much faster evolutionary forcing function than people realize."

We pass through money and families and end up at Schmitt the scientist's different take on the divorces, with him pointing out:

"Because it was obviously *frowned* on for a long time, there were no divorces at first. And then there was some pent-up demand, of course, that finally occurred. But remember, you're dealing with a fairly *specialized selection* of Americans. Most of them were only sons or eldest sons in Apollo, and they almost *all* exhibited what psychiatrists, I think, would call 'Type A' person-

ality traits. And so you have to *evaluate* everything that they've done since or during that time against that kind of a general personality background."

And I say: My God! Why didn't I notice this earlier? When I get home, I call some psychologists and they recommend a book called *Born to Rebel* by Frank Sulloway, who sees families as "ecosystems in which siblings compete for parental favor by occupying specialized niches." In his view, the strategies required of these niches become major influences on personality formation. It's a startling fact that *every Moonwalker I've met* has been either an eldest sibling or only son. More astonishingly still, this will turn out to hold true for them all. Is that what brought them here? Driven, work-obsessed, time-obsessed, fiercely competitive, prone to stress-induced heart disease... *Type A.* As the eldest of three sons, this produces a particular queasiness (bordering on panic) in me. At any rate, the Type A thesis would chime with the competitiveness Gene Cernan and others have described in the Astronaut Office–though Schmitt, another only son, takes a typically rational and somewhat different view of this, too, averring:

"It wasn't so vicious, because nobody quite knew how Deke Slayton picked his crews."

Yet some people think they do, and among them is the Mercury 7 icon Scott Carpenter. Carpenter was different from the other Mercury 7 pilots to begin with. Unquestionably the finest physical specimen, he was the only product of a single-parent family, the only non–fighter pilot, the only instinctual Democrat (a trait inherited from his maternal grandfather, the progressive liberal editor of the *Boulder County Miner and Farmer*). He dug folk music, played guitar and sometimes went out at night just to gaze at the stars through his telescope. The space historian James Oberg tells me with real feeling that "Scott Carpenter was the only one of the seven who appreciated the significance of where he was and what he was doing," which makes the controversy surrounding his command of the fourth Mercury mission in May 1962 all the more important.

Whereas other Mercury pilots fought to keep the science geeks and psychologists away from their roster of in-flight

tasks, Carpenter embraced them and their experiments until the flight plan was extremely tight; then, when he looked out of his window and beheld swarms of the little sparkling "fireflies" which had so excited John Glenn on the previous mission, he was enchanted and intrigued and spent valuable time trying to work out what they were or might have been, at the expense of more prosaic objectives. Later, it would be claimed that he squandered fuel by swinging his *Aurora 7* ship around to get a better view of the Earth, leaving too little to negotiate a safe reentry into the atmosphere—although a recent memoir penned by Carpenter and his daughter Kris Stoever blames a hitherto unacknowledged guidance system malfunction for the pilot's liberality with his fuel. What we know for sure is that there were fears for his safe return, with Walter Cronkite ashen-faced on CBS, and that the acerbic engineer-turned-flight-director Chris Kraft was incandescent at Carpenter's perceived failure to follow instruction from the ground. We also know that someone subsequently circulated a rumor that the Mercury man had panicked (the ultimate throttle-jockey sin), despite overwhelming evidence to the contrary. Afterward, Deke made it clear that he wouldn't get another flight, and with a heavy heart he turned to undersea exploration, later parlaying his experiences into a pair of novels, the second of which, *The Steel Albatross*, turns out to be a decent page-turner in the Clive Cussler mode. He also tried to establish a company that converted industrial and agricultural waste into energy, but he wasn't as good a businessman as he had been an explorer.

When we speak on the phone I hear a modest and engaging man, still sharp at seventy-eight, and our conversation ranges from his itinerant father and mixed business career to relations between the Mercury 7 ("we have a bond that I think is probably unequalled anywhere"), how a man explains going through four wives ("I don't know what to say: it's one of those things . . ."), and the mystery of his eldest child, Scotty, who was a bright, brilliant kid, but developed chronic schizophrenia and now lives in a little studio on his own. When I confess mild disappointment that his seat-of-the-pants reentry aboard *Aurora* might

have a practical explanation–that it flowed from something other than his own rapture–he laughs delightedly, then becomes animated as he reminds me how little they knew about space in 1962, exclaiming as if it were yesterday:

"Well, we thought they might be creatures out there! To find out that they were in fact ice crystals was a eureka moment."

Ice crystals catching the light. The next flight, captained by Wally Schirra, contained no science, contemplation or passion at all.

Another one to suffer was Rusty Schweickart, who helped test the lunar module in Earth orbit on *Apollo 9* with Mission Commander Jim McDivitt (last heard coaxing Ed White in from his spacewalk) and the future *Apollo 15* commander, David Scott. Mike Collins casts Schweickart as "a blithe spirit with an eager, inquisitive mind, not appreciated by the 'old heads' . . . mildly nonconformist, with a wide range of interests, contrasting sharply with the blinders-on preoccupation shown by many astronauts," while crewmate Scott pegs him as "a really cultured man" who took quotations from Elizabeth Barrett Browning and Thornton Wilder into space, along with a cassette of Vaughan Williams's *Hodie* cantata, which Scott, no fan of classical music back then, claims to have hidden until they were ready to come home ("he never forgave me for that"). More seriously, flight director Gene Kranz notes that he was "probably the most liberal guy in the office" and that his wife was probably the most liberal person some in the office had ever met–meaning outspokenly antiwar–and that this may have "caused him problems." Schweickart, now a practitioner of Zen Buddhism, laughs this off and betrays no ill feeling toward anyone in the program when I locate him in the Netherlands, where he is based during an extended stay in Europe with his wife. The fact remains, however, that he flew no more after *Apollo 9,* because he'd suffered badly from space sickness, a form of motion sickness that some astronauts fall prey to and others don't. An expert in space medicine explains to me that space sickness is still not fully understood, but seems to arise from sensory conflict, from the fact that "four out of five of your senses will tell you that you're free-falling," with only the eyes insisting that you're stationary (a

current astronaut describes the sensation of holding on to the International Space Station during a spacewalk as "like hanging on to a cliff that's already falling"). The expert then explains that as far as equilibrium goes, human beings fall into distinct groups, with two different balance paradigms: those who trust to their internal mechanisms for orientation and those with an "external frame," who take their bearings from the world around them. The latter tend to get sick in space, because nothing makes sense, and it won't surprise anyone to learn that Schweickart was in this outward-reaching, *exocentric* group. Susceptibility to motion sickness on Earth is a poor predictor of what will happen in weightless conditions, but most people adapt to the new conditions within forty-eight hours anyway.

Against expectation, Chris Kraft offers a sympathetic view of Schweickart's travails, pointing out that the crews carried medication for sickness. Had commander McDivitt let go of an otherwise laudable desire to protect his crewman's dignity and informed Houston of the problem earlier, Kraft suggests, medical staff could have helped. Then he complains:

"The astronaut image had always been one of physical strength and fortitude. Now Rusty's space sickness made him seem weak, and his reputation never recovered. Deke didn't help. He exercised his sole authority to keep Rusty from flying again. That kind of authority bothered me . . . Deke's flaw was that he accepted it all and acted accordingly."

Despite never leaving Earth orbit, Schweickart became one of the most vivid communicators of the space experience. If we were unnecessarily deprived of a chance to send the likes of him and Scott Carpenter to the Moon because one man's prejudices were given too much weight, that would be a great, great shame. Kris Stoever goes so far as to maintain that in the wake of her father's Mercury flight, Kraft and Slayton staged a coup d'état within the program, "remaking [it] so that there would be no more Scott Carpenters and John Glenns." She tells me:

"I think there was a sense after Dad's flight that we had the wrong type of astronaut going up into space, so it was a coup. They built it in accordance with their vision, which had more to

do with machines than exploration, and in time, of course, they lost the hearts and minds of the American people."

Chris Kraft declines to comment on this view of events when offered the opportunity, but it chimes with an impression which has been growing, and which I'm beginning to take great pleasure from: namely, that while Bill Anders is obviously right about the Cold War impulses behind Apollo, the more you look at it, the more there seem to have been two sharply delineated space programs running parallel within the program—an official one about engineering and flying and beating the Soviets, and an unofficial, almost clandestine other about people and their place in the universe; about consciousness, God, mind, *life*. Reluctantly cast as the hippies of the piece, scientists were known around the MSC as "the long-hair-and-tennis-shoe types." One of them says, "All they [the engineers] wanted to do was get to the Moon and back without a thought as to why they were going or what to do when they were there." An engineer retorts that if it had been left up to the scientists, no one would ever have gone, because they'd still be talking about it. The possibility exists that both were right. Still, there's something glorious about the fact that, hard as anyone might have tried to sift imponderables out of the venture, they couldn't do it.

I ask whether Schmitt thinks that going to the Moon changed him, repeating Alan Bean's view that all the Moonwalkers came back "more like they already were," and his face lights up. He says he didn't know that Bean had said that, but it's exactly what he, too, has felt for the last thirty years. The only one who went in a direction no one could have imagined, he suggests, was the *Apollo 15* commander, David Scott, whose lustrous career was destroyed by the "stamp scandal" which overtook him a few months after his return: a storm which broke over NASA's discovery that he and his crew (LM pilot Jim Irwin and CM pilot Alfred Worden) had smuggled 400 commemorative envelopes to the Moon, then sold them to a stamp dealer for a profit of around $6,000 per man. There was nothing illegal in this, but it was against regulations and the crew were canned, with the incident following Scott like a toxic cloud ever after, because he was the

commander and thus forced to shoulder the responsibility. Over the three decades which followed he would become the most evasive of all the astronauts, including Armstrong. I find his story intriguing and a little scary.

"Dave just made one very bad decision," Schmitt says, grimacing.

Did Jack feel bad about that?

"Believe me, everybody felt bad about it, 'cos everybody liked Dave. It was just a dumb decision. And unfortunately, his crew was immersed in that as well. So it's too bad. It certainly stopped his military career."

I tell him that Scott now lives in London and was splashed over the U.K. tabloids not long ago, following a liaison with the beautiful newsreader Anna Ford. To my surprise, Schmitt looks aghast.

"What, is he not married to Lurten anymore?"

Uhm, I don't know. I guess not. Anna Ford took the newspapers to the Press Complaints Commission for running paparazzi photos of her and Scott on holiday.

"Ooooh. I thought they were still married, so I . . . so Lurten . . ."

It turns out that Schmitt had been trying to contact the Scotts about a reunion and even he, a Moonwalker, couldn't make contact. So thanks to Dave Scott I'm seeing something I never thought I would see: Jack Schmitt caught off balance.

"Well, Dave is an extraordinarily bright guy," he concludes. "He was probably the best trained of the pilot astronauts up to his flight. He was very, very cooperative with the geology program I put together for the later missions and I had great respect for Dave as a professional. It's an unfortunate decision that he made in respect of the envelopes and I wish him well. I hope that he's doing fine."

I wonder if he is? At this point, I don't expect even to clap eyes on Scott, but we'll see.

JACK SHAKES MY HAND warmly and drifts back to the tiny office that he didn't want me to see, as I ghost away up the

Turquoise Trail to Santa Fe harboring a sense of dissatisfaction which I'm at a loss to explain. Schmitt has been interesting, instructive, helpful, yet some unvoiced expectation of mine hasn't been met and this unsettles me, because if there's one thing I've learned so far, it's that expectations are the enemy; I try not to have them. So like Alan Bean and geriatric dog, I can see that the problem is mine and am thus drawn back to a question I left lying like a discarded cigarette butt in the Mojave Desert sand. What do I want from these people? Why am I here?

And plowing through the autumn dust to Santa Fe, I realize that I know.

The Moonwalkers are interesting because of what we've invested in them. For me, this means that here we have nine men, nine left from twelve, who will eventually crumble away to eight, seven, six, five . . . none . . . who traveled further, saw and sometimes felt things that perhaps no one ever had before, or will again in quite the same way; who then had to come back and dissolve their queer odyssey into some kind of Earthly existence, trying to make peace with us and the everyday. They had to relearn how to live a life, try to find new meaning in it and in this tiny corner of a vast cosmos which it had been their obscure fortune to confront. And just as they traveled to the Moon only to find the Earth, I've come to find them, but what I seem to be seeing is myself and everyone else reflected *in* them, finding that the thoughts and questions the Moonwalkers provoke when we look at them are more valuable than any answers they might attempt to provide; that our fascination is not about them, it's about us. I also understand that for me, there may be a heightened dimension to this exchange, because although it took me a while to notice, when they got back nearly all of them were about the age that I am now.

THE DRIVE TO SANTA FE is beautiful and I love everything about New Mexico, which feels somehow secret and discrete, even though there are times in the high desert when the earth and sky seem to spark and commingle and you could swear that it goes on forever. They say that in the badlands to the south you

can even now find spots to stop and feel sure that no other human being is within thirty miles of you, and that some areas are still being settled, while to the north and east are mountains which glow so red at sunset that wandering Spaniards called the range Sangre de Cristo, *Blood of Christ*. Fewer than two million people live in a state of 122,000 square miles and a Republican lawmaker recently introduced a bill to establish an annual "Extraterrestrial Culture Day" in commemoration of the Roswell incident. And that's still not the most unusual thing you'll find here.

For, halfway up the Turquoise Trail is the tiny hippy village of Madrid, where shacks-turned-craft shops offer "Navajo, Tibetan, Aboriginal" souvenirs as if these words referred to near neighbors, while also meekly announcing themselves as "FOR SALE," and homespun 9/11 memorials beseech "May we know peace one day." I spend a long time looking at a notice board which advertises meetings of the "Madrid Free Forum" and the First Church of Science, and discussions on "alternatives to water" (if they crack that one, I hope they tell NASA) and gigs by crusty bands sporting David Crosby mustaches, who look as though they've not only heard a few Grateful Dead albums in their time, but smoked them. As a stringy old boy in a washed-out Quicksilver Messenger Service T-shirt sways down the middle of the road with a coil of rope over his shoulder and a Bud in his hand, tourists in SUVs like armored personnel carriers slow down to gawp, point a camera, then speed off as if the inhabitants were bears in a wildlife park. Places like this flinch in backwaters across the globe, harrowed little sanctums where the hippies sought refuge when the Sixties finally ended in 1972.

Early that year, a United Nations report on the health of the global economy saw no reason to doubt the foundations of our charmed lives, but there was change blowing in the wind. As so often, we knew before the economists: the evidence was there on Friday night TV, where *The Brady Bunch* and *The Partridge Family* turned the collapse of the nuclear family into whimsy, and in the cinemas, where Kubrick's *A Clockwork Orange* and the eco-parable *Deliverance* were shocking audiences with their

bleak assumption of humanity as an essentially destructive force. Meanwhile, my radio brought new groups like Steely Dan, who were named after a dildo from a Burroughs novel and sounded so acid and detached that you couldn't imagine them ever believing in anything, while Neil Young's *Harvest*, which all the older kids owned, seemed to ache with some unspecified disappointment. In fact, not long before, I'd saved up for months to buy the album of George Harrison's Concert for Bangladesh, which was designed to raise money for Bengali victims of the continuing hostility between India and Pakistan, but turned into a pop presentiment of Watergate when all the money disappeared in expenses and tax. Poor George: he'd had to coax Bob Dylan out of sulky retirement and book a smack-addled Eric Clapton on every flight out of London for a week before the guitarist known as "God" managed to catch one. Rock had an aristocracy now; the fun was gone. The concert also introduced the image that would replace rockets launching and napalm falling as ubiquitous in the Seventies and Eighties–that of the starving exotic child victim–because, incredible as it seems now, we hadn't seen it before. Civil war and political madness aside (as in the Biafra region of Nigeria), there had been no mass famine through the 1950s and 1960s.

In my world, however, it was David Bowie who most effectively tapped into what was happening. Thirty-four years after his career began in earnest with *Space Oddity* (a flop first time around in '69), he passes up Gene Myers's offer of a promo flight to Space Island, but on the subject of his early Seventies work, says:

"For me and several of my friends, the Seventies were the start of the twenty-first century. It was Kubrick's doing, on the whole, with *2001* and *A Clockwork Orange* . . . There was a distinct feeling that nothing was true anymore and that the future was not as clear-cut as it seemed . . . everything was up for grabs."

Thus, Ziggy Stardust was a parody of a rock star, herald of an era in which everything began to look like parody, and the satire I'd cherished in my *MAD* magazines seemed redundant.

Kubrick had made *A Clockwork Orange* between 1969 and 1972, precisely as Neil and Buzz, and Pete and Al, and Alan and Ed, and Dave and Jim, and John and Charlie, and Gene and Jack were making their landings on the Moon. There's a famous scene at the beginning, where Alex and his droogs confront a tramp under a dark railway arch. Reviewing it again, I remembered the old man complaining that "it's a stinking world," but not his reasoning:

"There's men on the Moon. And men spinning around the Earth. And there's not no attention paid to Earthly law and order no more."

This seems to enrage Alex. He and his droogs kick the drunk senseless. Only now do I see how much their white uniforms look like space suits.

I'd always wondered whether my sense that everything changed with the end of Apollo was a figment of a child's imagination. But no: the venerable historian Eric Hobsbawm is merely formalizing academic orthodoxy when, in his masterful *Age of Extremes: The Short Twentieth Century 1914–1991*, he divides the era extending from the onset of World War I to the fall of the Iron Curtain into three distinct periods. The second, which he calls "The Golden Age," runs from the end of World War II, accelerating in the late Fifties, to–*precisely*–the end of 1972. The greatest period of economic expansion the world has ever seen. Like our fantasy of a space-faring future, the assumption of a world in which growth was inevitable proved sorely mistaken.

"Yet it was not until the great boom was over, in the disturbed seventies, waiting for the traumatic eighties," says the historian, "that observers–mainly, to begin with, economists–began to realize that the world, particularly the world of developed capitalism, had passed through an altogether exceptional phase of its history; perhaps a unique one."

When Gene Cernan left that last footprint in the Moondust on December 14, he was leaving behind everything we thought we knew about the context to our future lives. It's easy to see why the generation which followed the Baby Boomers and includes some of their offspring had a propensity to be so much

more cynical, or at least less idealistic, than their parents. The Canadian writer Douglas Coupland called us "Generation X," supposedly the first to reach adulthood with broadly lower material expectations than their parents, and while this is a blunt and unwieldy label, it contains a core of truth. Social scientists have often identified Gen X with people born between 1961 and 1972 and if many of us grew up sneering at hippies, it was because we felt that the hippies let us down. The ultimate weapon of mass destruction: failed expectation.

So the 1960s may have been three years gone, but *The Sixties* died as Cernan clambered up the spaceship *Challenger*'s ladder, ending an adventure which perfectly embodies the candescent era in which it took place—the upheaval, uncertainty, optimism, energy: the feeling that a world could be, was being, remade. This, I think, has something to do with the aura that still surrounds Apollo. It will be many months before I'm able to quiz Cernan on his bittersweet place in the Moonwalker canon, but when I do, the setting couldn't be more fortuitous or bizarre.

ELEMENTS OF THE SPACE AGE world that Cernan left behind linger on, of course. The day I drove to Los Alamos, there was a story in the local paper about forestry workers being banned from thinning ponderosa pine in some areas, because the trees are still radioactive from Cold War nuclear tests carried out up to 1961.

In a Santa Fe bar one night I met an English scientist who worked at the nuke-producing National Laboratory in Los Alamos. He told me that the facility there is run by the University of California, because it used to be secret and scientists didn't want to work directly for the government, and that the place contains the highest proportion of PhD's in the world, with average earnings four times those of Albuquerque. (I checked and it was true.) He said that his own work was on an energy conservation project, although I wondered whether this might be a front, and over a couple of beers we chattered about the town and the lab and The Bomb and the ever more threatening noises around Iraq at the end of 2002, then turned to space and a

piece of insider information that I hadn't previously heard: that Shuttle astronauts are given a 1 percent chance of dying on a flight; that, statistically, this is given as their chance of failing to return. To this he added a further observation that the International Space Station, that hymn to narcotic space, was expected to require 150 flights before reaching completion in 2010. Then he frowned and took a slug of beer as the Appalachian blues singer we'd come to see wailed in the background.

"And that means that they expect to lose at least one of those," he said.

On February 1, 2003, it happened. The shuttle *Columbia* broke up as it reentered Earth atmosphere, killing its seven crew and prompting a period of soul-searching in space circles. My Space Frontier Foundation pal Rick Tumlinson will suggest that the reaction to *Columbia*'s loss owed much to 9/11; that before, opprobrium would have rained down on NASA even as the debris was settling over Texas, but in this climate the astronauts were seen as martyrs and their deaths borne stoically as part of a bigger national picture. For the first time in a decade, questions were asked about America's space program and the people who ran it. The constant mantra has been *Where are we going?* And now, if rumor is to be believed, an answer that would have been unthinkable a year ago is waiting in the wings. The "space community" is beside itself with excitement. When Gene Cernan and I finally arranged to meet, we knew nothing of this and every time I think about it, I can't help but laugh. Better yet, it's only weeks since China put its first astronaut in space. It's all coming together. If there's a good day to be meeting the self-styled Last Man on the Moon, this is it.

It's Tuesday, January 13, 2004. We'd originally settled on Wednesday, but last week Cernan got a call from the White House asking him to be in D.C. for a speech President G. W. Bush is delivering at NASA headquarters on that day. The details of the speech have been widely leaked and these leaks suggest that the president will announce a return to the Moon, followed by a crewed mission to Mars. It seems almost unbelievable and is exciting stuff, though my first thought upon hearing the underground rumblings was that Ronald Reagan and George Bush

Sr. both trumpeted similar plans, which came to nought. And that 2004 is an election year, at the start of which the incumbent's popularity ratings are poor.

Captain Cernan (always *Captain* Cernan) has been the hardest of the still-visible Moonwalkers to nail down. He's a busy man with a punishing schedule, because this is what he does for a living; he's a professional Moontalker. He is everywhere in the field of space–a signing here, an auction there, a speaking engagement or TV appearance somewhere else, stippled with promotional work for Omega watches–but he's improbably hard to meet face to face. It's been made clear that an audience with him is a rare and valuable commodity and my strong impression is that it's been granted because he doesn't want to be the odd man out rather than because he feels any curiosity or affinity with what I'm doing. Anyway, I know from the start that he's not here to pass the time of day, because Cernan doesn't mess about. It feels like getting an audience with the Pope. The Pope of the Moon.

The Captain is a first-generation American who's lived the Dream in excelsis. The only son of Czech and Slovak immigrants who toiled hard to better themselves, he saw newsreel film of pilots landing on carriers during World War II and knew that this was for him. When he took to the skies, no one knew that there were going to be such things as astronauts in the twentieth century (one of the best sci-fi films of the Fifties, *The Forbidden Planet*, begins with the words "In the final decade of the twenty-first century, men and women had landed on the Moon . . ."–it had seemed *that* far away in 1956), but as soon as the word was coined, he wanted it for himself and got it. This explains both his passion for aviation and his profound patriotism. Guenter Wendt says: "He had a one-track mind. 'I want to go to the Moon and I'll do whatever it takes to get there,'" adding that "he had no problem with saying 'thank you' when he felt you had done something well."

He manages his career with a finesse that his socially awkward old sparring partner Buzz Aldrin can only dream of, and we know that when Apollo was running, "Geno" was confident enough of Deke Slayton's loyalty to reject a copilot's seat on *16* in

favor of commanding *17*. If he hadn't, Charlie Duke would never have flown, while Dick Gordon would have got his chance to land as commander of *17*. In fact, both of these men might have had their way, because when Cernan crashed a helicopter after some ill-advised hot dogging on January 23, 1971, Deke protected him from what would have been a career-wrecking blunder for most. The way Cernan tells it, Slayton took him into his office, looked him straight in the eye and said, "So, exactly when did the engine quit on you?" Jim McDivitt, by then manager of the Apollo Spacecraft Program Office, resigned over his subsequent assignment to *Apollo 17*. According to Chris Kraft, McDivitt raged:

"Cernan's not worthy of this assignment, he doesn't deserve it, he's not a very good pilot, he's liable to screw everything up, and I don't want him to fly."

Kraft goes on to note darkly that if Slayton had told him the truth about Cernan's chopper accident, things "might have turned out differently," intimating that he would have had the showboating astronaut yanked from duty. Cernan is impressively honest about the incident in his autobiography, just as he is about his strenuous efforts to have Edgar Mitchell bumped from *Apollo 14*, citing as justification Ed's "goofy" attitude–by which he means the ESP stuff–and further suggesting that Deke Slayton was open to this idea. Fortunately, Mitchell's commander, Alan Shepard, resisted Cernan and Slayton's advances (asked why, he reportedly said, "Because I want to come back"), but Ed sounds a little hurt when questioned about the maneuvering that seems to have gone on, commenting: "I doubt that the conversations took place quite as portrayed . . . [but] Gene and I have never been real buddies, so I would never be surprised at his stories and the spin he might give them. I think I was a bit too straitlaced and too intellectual." He also notes drily that "NASA was not the proper milieu to pursue philosophy and art." For reasons that are mysterious to me, the affection I felt for Ed Mitchell when we met has grown appreciably over the months (perhaps because I now have a clearer idea of what it took to be an outsider in the Astronaut Office) and I'm trying not to let this affect my attitude to Cernan.

Even so, a writer warns me that when you speak with him, "he has a kind of tape loop that he switches on." Another Apollo astronaut dismisses him as "playing the rock star," while yet another contends darkly that "Cernan's a nice guy, but almost everything he says has been said already by somebody else"–the suggestion being that he has turned the experience into rhetoric and the rhetoric into cash and celebrity. When Rusty Schweickart saw him speak for the first time and gasped, "I didn't know Gene had that in him," he took his colleague's apparent passion as an affirmation of his own profound feelings about floating in space, but there are other ways to read this. A second writer describes him as "frighteningly articulate" and warns me not to be late for our meeting.

What intrigues me in relation to Cernan is this: In a book from the 1980s called *The Overview Effect,* a Princeton social scientist named Frank White examines the impact upon the imagination of seeing the Earth from space. It's an interesting if misty-eyed tract, but one thing which caught my eye was White's acknowledgment of the natural, human pressure that astronauts must feel to give us what we want and expect; for their own experience to be corrupted over time by our innocent longings. So when Gene Cernan tells a rapt audience, "It is one of the deepest, most emotional experiences I have ever had," or that he saw "too much logic, too much purpose" for there not to be a God, how do we know, how does *he* know anymore, whether these statements reflect what actually happened, or what we wish happened? Any writer or journalist understands this question: it doesn't require dishonesty, at least not necessarily. For instance, a particularly evocative passage from Cernan's book concerns a phone call the *Apollo 17* crew received from Richard Nixon the night before liftoff, in which "our president rattled on for forty-five minutes about how he felt persecuted and pilloried by the very citizens he was trying to serve," sounding like "a tired and lonely old man," while Gene and Jack Schmitt and Ron Evans, listening on separate phones, "looked over at each other in bewildered surprise": yet when I mentioned this to Schmitt, he just looked puzzled and said, "I remember that he called, but I don't remember *that.* I think I would have, but I don't."

When you've shared a moment with the whole world, it can be hard to know precisely where your memories end and everyone else's begin . . .

Questioned on this anomaly, Cernan declares himself "astounded" that Schmitt doesn't remember the conversation as he does.

I've been instructed to make my way to a boxy concrete office belonging to a friend of the Captain in Gemini Street, off NASA Road 1, near the Johnson Space Center. Glossy color photos of rockets hang from the white walls and I stand at reception while the owner of the office finishes his dealing with two older men in suits. I've given up trying to dress to expectation and am wearing a leather jacket, jeans and brown Italian shirt with a quiet flower pattern—nothing fancy or effete, but the three men look me up and down as though I've wigged in waving a joint and singing, "If you're going to San Francisco." I don't need a ponytail to know that these guys would fail the ponytail test, so, looking around to make sure that no one's preparing to throw tear gas at me, I tell them why I'm here and watch their jaws drop. I appear to have come down behind enemy lines. The owner directs me through a wide hall to a small end office where Gene Cernan reclines behind a wooden desk in a red-and-white-striped shirt, wiry and fit at age sixty-nine, bantering into a mobile phone about having had dinner with "The Pres" last Friday ("No—The Pres *Senior*") and a book he's reading about Japanese military culture and World War II. His pleasant assistant of twenty years' standing, Claire, greets me effusively and offers a seat. She warns that we have limited time, because the Captain is getting ready to fly to Washington. He puts one hand over the mouthpiece and leans forward to extend the other—I'm momentarily thrown by how tiny it is—and tells me that he'll be with me shortly. His voice has the same firm ring as Buzz Aldrin's, like a part of him never left the ship, but without the other man's disarming hesitancy.

He asks me to remind him why I'm here. He remembers that it was something he really wanted to do, but can't remember why or what it is. I tell him and he looks a little alarmed; falters as he tries to work out where to set the tape loop running; asks if

we're "hot," meaning is the minidisc recorder running, and launches into a spiel which sounds like it's being read from Autocue, incorporating an extended advert for Bombardier, the Canadian aircraft firm with whom he has a business relationship ("the third largest aircraft manufacturing company in . . . the . . . *world*"). Then he runs through the official story of the space program ("the president of the United States challenged 200 million people to do the impossible" etc.), including how "you have to understand that the Russians *owned* space at that point in time and America was feeling kinda flat and demoralized at the beginning of the Sixties," but won through, of course, and by the end, I wouldn't be surprised if a marching band leapt out of the cupboard playing "God Bless America." Obviously, Cernan has no way of appreciating that by now I know more about this guff than is healthy or quite tasteful, but when I try to find the gaps and gently interrupt so that we might move on to something useful, he just barrels over me. At this stage, I have the feeling of being performed at rather than spoken with. Still, I tell myself, it's early days.

He talks about the centenary of the Wright Brothers' maiden flight in 2003 and how the impact of Apollo must be traced back through that, handing me a short missive he wrote on the subject, followed by:

"The real legacy of the Wright Brothers is the inspiration and motivation that they instilled in the minds of young dreamers . . . Who would have thought a hundred years ago that that little fifty-two-minute-whatever trip across the sands of Kitty Hawk could have led to people dreaming about living on another planet? . . . and I stand here more than thirty years later, telling you, 'I called that planet my home.' I drove a car on it. It became my own private little Camelot, I worked, I did things, and I'm here to talk to you about it."

What? I avoid looking at Claire, in case she's waving a cue card instructing me to stand up and cheer. There follows all the cheesy motivational stuff, about telling young people not to be afraid to dream, or to try, "because if you don't try, you'll never know how good you could be," or to make mistakes, "and I can look 'em in the eye and say, 'I'm a good example, I went to the

Moon before your mom and dad were born.'" Which is all true, but kind of . . . irritating. I heard Alan Bean say a lot of similar stuff, but it sounded modest and real coming from him, because he made his own decision to parachute into the unknown when he became a painter. That took some courage. What Cernan did was incredible, but the imaginative drive for it came from elsewhere. He lived the dream, but the dream wasn't his and there's something about his presumption of ownership, when contrasted with the humility of the others, that jars with me. I realize in a flash that this is what I feared they'd all be like. But they weren't. They *so* weren't.

We talk about the impact of World War II on children of his generation, which was similar to the impact of Apollo on mine.

"Aviation came into the world of young kids' dreams at that point in time. Prior to that they wanted to drive locomotives and whatever else. That's where aviation entered into the dreamer's world."

Clearly, they did a lot of dreaming in those days, what with no TV or video games. Cernan's mobile rings elaborately and a long conversation about flights ensues.

"I do have an airplane, a commercial bird, leaving here at seven-forty in the morning. It gets into DCA and then . . . I have to be at NASA headquarters at one o'clock."

When he comes back, I ask about the impending Bush announcement re the Moon and Mars and he is surprisingly measured in his response, though still with a Zelig-like tendency to place himself at the center of events.

"I've been saying for twenty-plus years," he says, "that we really haven't had a space program since we came back from the Moon. There have been a series of space events, but there was no agenda, they never led anywhere."

Doesn't it worry him that we've been here before with Reagan and Bush Senior?

"Okay. Let me tell you what's different. They were both well-intended, and out of President Reagan came the space station, which has never been well-defined and never really had a purpose in life. And I think it's gonna eventually go by the wayside. You can trace it back to Vice President Ted Agnew. After I came

back from the Moon, he was very much in favor of putting a program together to get to Mars. I said back in 1972, 'Not only are we gonna go back to the Moon–you know I'm not gonna be the last human being to walk on the surface of the Moon forever– not only are we gonna go back to the Moon, we will be on the surface of Mars by the turn of the century.' That gave me twenty-seven years to be proved wrong: well, my glass is half full, it's not half empty. Okay. And what's gonna happen tomorrow sort of proves it. But there was a big letdown back then. Then when President Bush [the Elder] said let's go back into space, people started putting a price tag on it and saying it would cost jillions of dollars. And you're gonna see the same thing this time around: 'Well, we can't afford it, we can't afford it!'

"This president's not asking for a balloon down-payment to go to Mars. He is putting Mars out there somewhere, a generation into the future, twenty to twenty-five years is what I've been hearing–is what I've been *saying*. We need to put the educational and industrial infrastructure together so that we can get there from here. One of the most significant spin-offs will be the enthusiasm and excitement that it's going to put in the hearts and minds of young people. The technology we're using is twenty-five years old. We've got to take the next step. I've been advocating that for twenty-five years. At least we'll have a benchmark. Who knows, if we get to the Moon and find a way to mine helium-3, we might stay for another twenty-five years and not go further for fifty years. Mars is a challenging but reachable objective, so you build the infrastructure and work back from there."

What actually happened with the first President Bush is that he announced his bold plan before asking NASA how much it would cost. When he asked them, they came back with a conservative estimate of $400–500 billion. End of story. Plan quietly shelved. Cernan talks about the educational value of going, the way it would inspire interest in science and engineering, like the first program did for a whole generation. I mention the way that generation was let down afterward, and wonder once more whether Apollo happened too soon.

"Yeah, maybe. It's like a kid getting too much too early, as a country. We threw out a plum for these teenagers to go and

reach for, and then they reeled in a lemon. That was your promise to the future. That doesn't mean you couldn't become doctors and journalists and teachers, but that was the promise to your generation. Then you reeled in a lemon and . . . ah . . . there we are."

What about you? I ask. You reeled in a planet-sized lemon. Instead of *being* that mind-boggling future, you were presented with the midlife crisis to end all midlife crises. He softens a bit.

"Well, you know, I flew when I was thirty-two, thirty-five, thirty-eight, and I had no idea where I was gonna go or what I was gonna do. I looked at the space-shuttle program, but by that time I was forty-three, I'd had twenty years in the Navy and the shuttle was still five or six years out there into the future. And even at the age of forty to forty-two, five years is a long time. I'd like to have flown the shuttle, 'cos it's a great flying machine, but I'd been there and done that, and it doesn't go anywhere. And let me tell you, when you've seen the Earth from the Moon, staying home isn't good enough. So I had to decide whether to stick around or go out and find something new, and that's what I chose."

Which must have been hard.

"Yeah. Just 'cos you go to the Moon doesn't mean you're an expert at everything, obviously. And it's harder to find something when you're on the hot seat all the time, training for crews and backup crews. You almost take those things for granted, and then all of a sudden you get off and you look for the next mountain to climb. And you don't find one with the challenge, with the risk, with the adventure and the reward. So you keep searching until . . . you know, I guess I'm the kind of personality that can't just sit back and put up a sign saying, 'I've been to the Moon–you all owe me somethin'. "I had to go and find something else. And I guess until I grew up and hit grandkids and one thing or another . . . I'm satisfied now, although I'm still probably this type whatever-it-is personality . . ."

And I find myself thinking, "But you never did find anything else," and wondering what the difference was between those who were expanded by the journey and those left with ennui and frustration; between the trips that were good and the trips

that were bad. I wonder what I would have found and whether it's perhaps better not to know ... whether quiet, Earthly contentment beats shooting for the Moon in the end, the way a pair of threes beats an ace in poker. It dawns on me that this question lies behind nearly all of the others I've been asking in regard to both the astronauts and the Apollo program itself, and that it has a special resonance for me, because amused friends have begun to point out that when I'm finished with the Moon men, I'm going to be in a similar, if much less spectacular, position to the one they faced at the end of 1972. Where am I going to find something to absorb me the way they have? In this moment I feel a heightened empathy for Cernan, even if he maintains that he's as passionate about space as he ever was.

You still feel passionate about it? I ask.

"Oh, yeah, that's one reason why I'm tending to respond to requests like this. I'm finally seeing something come together that I've been trying to say for a long time. And that's that we haven't had an agenda. We've got a series of space events that we can't define, that we can't justify. And they're going nowhere. We need something out there to entice our kids. Claire, how long have I been saying that?"

"Twenty years."

He continues as if he hasn't heard.

"Twenty-five years. And finally we've got a president who's saying the same thing I'm saying. So that's what I'm passionate about, that's what I'm excited about."

After NASA, Cernan worked in oil, energy, marketing, and ran a small airline for a while. You don't need to be a rocket scientist to appreciate that none of those could rival the thrill of leading a species to its apparent destiny in space and in time they all palled. Like Buzz Aldrin, he wound up returning to the Moon in the sense that it's his life again; it's what he does and takes his identity from. It's where he sees himself.

"Yeah, going to the Moon in front of the whole world is a tough one to top," he confirms, leaving me to wonder whether he thinks his Moonwalker colleagues experienced the same sense of letdown that he did, reacting as he would have expected them to, or whether they surprised him.

"Some of them surprised me and some haven't. Some have gone on and decided that they've done it, don't want to be bothered, and live a cloistered life. Others are very ambitious and want to go out and do something and make something happen in business. And then others sort of, ah ... I've gotta be careful with my words here ... sort of prostituted to some degree their celebrity status. And I think there's somewhere in between where you can make use of it."

There's little doubt in my mind as to whom he's talking about here, although it seems to me that if anyone fits that third category, he does.

"You've got a lot of opportunities, but a lot of responsibilities go with it. Twelve of us traveled to the Moon. I don't have to keep telling people about it, but some guys feel they do. So there's that three categories of people."

Does he get fed up with the obvious questions–what did it feel like to walk on the Moon etc.? He smiles.

"What's it feel like? What's it look like? Did you feel closer to God? Were you scared? How do you go to the bathroom in space? What's one-sixth gravity like? I mean, you just can't get it from looking at a picture. What's it like? I can't tell you what it's like in a few words. What's it like to look back at the Earth surrounded by the infinity of space and concepts we can't even understand, like *time*. I can't tell you it's unbelievable, or it's awesome, because that doesn't answer your question. We gotta sit here and talk about it. That's what enticed me to write a book ... So do you get tired of hearing that question? Yes and no. You get tired of the fact that you can't give that person the ten-second voicebite that he wants in order to feel good about what you've said. You've gotta spend time, like I'm trying to do with you now, talking about being there at that moment in space and time and history. You feel inadequate that you can't give people the answer they want."

Suddenly I feel bad about my earlier impatience. When I told him what I was searching for, I never meant to suggest that I was expecting Kierkegaard in response, the grand answers from him alone, but that's obviously what he heard. No wonder there

was a look of panic in his eyes as he tried to figure where to start.

We talk about celebrity for a while and Cernan complains at the way its modern form fails to distinguish between "someone who's cut somebody's throat or drowned their pregnant wife," or "a ballplayer who made sixty home runs, then got kicked outta the game because he's a druggy," or Britney Spears, who's just got hitched for a day in Vegas ("she's just a bad influence on my grandkids, as far as I'm concerned"), or him.

"But we didn't put ourselves in front of the public, which is what celebrities tend to do. We just got thrust there."

He talks about his "love affair" with the Saturn V.

"Standing up at night and the lights are on it and all this oxygen and hydrogen are boiling over the sides, it's *alive*, it's moving 'cos the wind makes it sway, and that's going to take you a quarter of a million miles to another planet . . . and when you get in it, you've got control of it."

Only later do I recall Buzz's insistence that as an astronaut, one thing you *didn't* have was control over the rocket.

We move on to the Carpenter family's allegation of a coup in the Astronaut Office and Cernan holds the official line that Scott "screwed up." He's complimentary about Carpenter's best pal John Glenn, though, who flew into space once more aboard the shuttle in 1998, at the age of seventy-seven. I ask whether he'd like to go for an encore and he says that he'd be happy to take the shuttle up for a quick spin, but not to spend two weeks sliding around in low Earth orbit on the space station.

"Would I like to go back to the Moon, though? Sure I would. Because I would like to go back to a place that I once lived, to see what it's like, like going back to the old farmhouse that you grew up in when you were a kid, that you haven't seen in thirty years. You know, *What is it like today?*"

He'll repeat this thought for TV cameras tomorrow and Jay Leno will be making fun of him on *The Tonight Show* in the evening, pointing out that unless some alien civilization has sneaked up there and shifted stuff around like a frat house prank, it's going to look the same. But when Cernan adds that

"the place we lived was frozen in time before we got there and it's been frozen in time since we left, with the flag and my space-craft and the rover and my daughter's initials in the dust, and our footsteps just eternally blazed in time," I can see what he means. If it was a surreal adventure in the first place, how much more surreal it would be to go back and survey the scene again. That sensation has the potential to be felt by only nine people, but unless Bush the Younger has something very spectacular up his sleeve, it will never be felt by anyone.

"Yeah, I'd like to go back. As you get older, you get more historically minded. You go places where important things have happened and know that the only thing which separates this place from what happened then is something we know nothing about–time. How could you turn it down?"

We talk a bit about Mars and his inconvenient but valid contention that the chemical propulsion systems used today are inadequate to take us there, because "six or seven months' travel time is unacceptable" but six to eight weeks would be okay. Right now, astronauts would have to stay there for eighteen months until the planets were correctly aligned for a return flight. In my mind, Mars moves further away as he says this.

"But you've got more technology under the dashboard of that rental car you're driving than I had going to the Moon, which tells you what's happened in those thirty or forty years. And there's gonna need to be that same kind of technological evolution, that's gonna be moved forward through necessity. Technology evolves through necessity, not by accident. Now we're going to see another explosion of technology if the president's policy goes through. I mean, when I was a kid, Dick Tracy used to talk through his watch and it was, like, 'Gimme a break!' Now we can talk through 'em and take pictures and find out where the nearest coffee shop is. I mean, this is *wild* technology we have today. Anything you can imagine, you can make happen. But we do need to advance our technology in several key areas even to get to the Moon."

Yet the question remains: Why is any of this important?

"I don't know, maybe just because it's there," he muses, echoing the Everest climber George Mallory's response to the

question of why people assail mountains. Taken at face value, this is obviously the most nonsensical reason a person could have for doing anything more complex than tying a shoelace, and I assume Mallory to have meant that mountains and Moons excite the imagination for reasons we don't understand, which are irrational yet in some way quintessentially human. Viewed like this, Apollo was a decade-long spasm, the St. Vitus' dance of the twentieth century; a compelling but hubristic and ultimately pointless exercise. Cernan knows there has to be more. He retrenches.

"But it seems to be a step we need to take in order to answer some of the questions human beings have always had. Who are we? What are we? What is the significance of time? It takes on a whole new perspective in space. It's never going to be enough just to send a Mars Rover. Mankind has always followed."

As I gather up my stuff, I'm astonished to realize that he got me, that I'm feeling inspired all over again by what Cernan and the others did, and the prospect of others following one day–though it will never be the same as the first time, because we know the dragons aren't there. He seems relaxed now and we chat about the presidential speech on the Mars initiative, which I might be less suspicious of if it wasn't coming at the start of an election year. The big aerospace states like Texas, California and Florida also happening to be big *vote* states. Whatever Bush says, Cernan is already anticipating a fight to get the new policy taken up.

"We're going to listen to what the president says, and then the media's going to inundate us, you know, with all these naysayers saying it can't be done and it's too expensive–you know, 'I got my washing machine and my car and my telephone, why do I need any more technology? Why do I need to go to the Moon? What's in it for me?' I remember politicians in the Sixties saying that we should take all the Apollo money and go feed the poor. But that's like eating the seed corn. You eat the seed corn and you got nothing to plant next year. There are shortsighted people and you're gonna see a lot of them. A lot of them. I just hope the overwhelming excitement and a reasonable presentation of the cost will persuade people."

I'll watch on CNN the next day as G.W. stumbles through the speech in that distinctive way of his, as though he's seeing every word on the Autocue for the first time in his life. He refers directly to Cernan at one point and the camera momentarily turns to the Moonwalker in a prearranged set piece, but his face is hard as granite. I wonder whether this is solemnity, or anger at the smoke-and-mirrors accountancy behind the bold-sounding but empty declarations being made. The plan is based on a consolidation of NASA's resources and refocusing of its aims, common sense even before the *Columbia* disaster. In the short term, an extra $12 billion is promised toward replacing the shuttle with a more versatile craft, a real spaceship with a ten-year delivery date and goal of reaching the Moon in 2020, from which a base will be built to stretch for Mars. It's enticing stuff, obviously, except that the details already look improbable. Lest we forget, the much simpler shuttle was massively delayed: it was intended to cut the cost of firing payload into space twentyfold, but ended up increasing it tenfold to around $10,000 per pound. Can this revolutionary replacement be designed and built in a decade? You wouldn't bet on it even in Vegas.

It gets so much worse, though. With the U.S. budget deficit running at record levels and growing as Bush speaks, and the war in Iraq complicating what looks set to become a perpetual "war on terrorism," $11 billion of the $12 billion on offer will come from redirecting existing NASA funds. Sensible to some degree perhaps, but a week later anguished cries will be issuing from scientists and astronomers as it becomes apparent that this redirection will mean ditching the Hubble Space Telescope early. More concerning still, when the new spaceship is ready, someone's going to have to pay for those trips to the Moon and beyond, and only at *that* stage will an abrupt injection of untold billions of dollars be required . . . so the Chief only has to find an extra one billion dollars over five years, leaving his successors to cough up the necessary hundreds of billions—or more likely cancel the damn thing, or simply let it slide. This "plan" might just as easily have issued from the Union of Persian Storytellers.

When I ask Cernan for his reaction to the speech, he expresses himself "elated," but in effect, all President Bush has

said about going back to the Moon and on to Mars is that it'd be nice to do it one day when he's not in office and someone else is responsible. In the end, it's as I thought: for a Republican president, space is the ultimate zipless fuck. It's Vision on account in an election year, when two ingenious NASA Rovers have rekindled public interest in Mars. Almost immediately, the former NASA and now Duke University historian Alex Roland is telling CNN that this new Moonage daydream is a distraction and waste of resources. My new friend Andy Chaikin is there, too, disagreeing passionately, and I wish I could set my skepticism aside and believe along with him, but I can't.

And I'm not alone. Although it can appear otherwise, the American electorate is not stupid. Within days, a *New York Times*/CBS News poll is indicating that 58 percent of Americans think building a permanent base on the Moon is not worth the risk and cost, while 35 percent say it is. More significantly, only 17 percent of people polled felt that their nation was spending too little on space, implying that 83 percent consider current expenditure to be enough or too much—and that's not going to get anyone to the Moon, much less Mars. As the *New York Times* noted in an article about the prospective $500 billion budget deficit: "The virtue of the space mission is that Congress can abandon it long before the heaviest spending is required." In which case, NASA could spend the next decade developing another gilded rocket ship with no place to go, a ghost craft whose rationale has drifted away on the solar wind by the time it's ready—exactly like Nixon's shuttle and Reagan's ISS. A cartoon underneath the *Times* article imagines the president delivering his State of the Union address a week later. "And we know the Martians have tried to buy uranium from Neptune," he's saying. Which probably *is* the kind of thing it will take to get us there in the near future. The twelve Apollo Moonwalkers aren't going to be replaced just yet.

B Y THE TIME I've found documentarian Bart Sibrel in Nashville and convinced him that I'm not a federal agent, there is a phrase that I've come to dread above all others.

Under normal circumstances, the comment, "Oh, I'd really like to talk to you about that!" would carry little threat, might even be pleasant, but over the months its appearance has come to mean two things to me: One, that someone has just mentioned this book, and two, that sure as werewolves howl, the words "Do you really think they went? *Because I'm not so sure*" are about to follow. From any group of five informed, intelligent people, at least one is likely to punt this into a conversation, with the proportion of doubters increasing as the mean age of the group decreases.

It's not just the young, either. When I met Robert Plant in a bar in Worcester, we chatted amiably about where Led Zeppelin were playing on *that* night in 1969 (unromantically,

Cleveland) and about the unexpected success of their first two albums that year and of the solace his generation of musicians, raised on postwar rationing, found in the alien strains of black American music. I loved hearing him say:

"When I heard Chuck Berry singing, relating to a youth culture which sounded so gregarious and switched on . . . it was like a calling, like someone blowing a horn on the top of a mountain. The thing about our generation was that there was no conveyor belt that brought this stuff to us—and I think for that reason, when you found what you liked, it wasn't a casual affair, it was *intense* . . ."

When he talked about how little he enjoyed the Seventies, about how all the joy and freedom and spontaneity of making music disappeared for him as the stakes and scale increased, he sounded remarkably like the flight director John Hodge talking about NASA and space in the same period. Then I mentioned those greatest-hits CD sleeves which offer the group in Apollo space suits, wondering what they meant to him and telling him a little more about my travels, and before I'd even got to Ed's strolling dentures or Bill's space brown-out, along it rumbled like a miscued bass line . . .

"Oh, I'd really like to talk to you about that!"

No!

"Yes, I never really believed they went, to be honest with you."

Led Zeppelin used the image because they thought it looked cool, that was all.

I thought this might be a European thing until word arrived that NASA was hearing the same story from teachers—that when they bring America's Finest Hour to class, a couple of wiseacre kids always raise their hands to declare: "But, ma'am, my dad says it was all a trick." The teachers asked what they should say to this (they didn't *know*?) and NASA decided to commission a book from their former employee James Oberg, which would provide the answers. How tremendously sage, one might think—but no. When word got out about NASA's belated attempt at a rebuttal, the whole world, including the half that had always believed them, cried, *"The spaceman doth protest too much, me-*

thinks!" Poor NASA dropped the book like a hot Moonrock and conspiracy theorists hailed a great victory. The Man, it seemed, was scared.

The godfather of hoax theorists was an old bird named Bill Kaysing, who spent seven years working for the NASA contractors Rocketdyne during the Sixties and once filed a malicious libel suit against former spaceship and tugboat commander Jim Lovell of *Apollo 13* for calling his ideas "wacky." His line is similar to the one floated in the notorious 1978 sci-fi film *Capricorn One,* which starred Elliott Gould and–*oh, conspiracy joy!*–O. J. Simpson: that the space agency panicked when Kennedy set his decade's end deadline, and decided to shadow Apollo proper with an Apollo Simulation Project. Kaysing's scenario has since been developed further by a pair of Brits named David Percy and Mary Bennett in a tome called *Dark Moon.* Their central thesis is that American astronauts did go to the Moon on a secret military mission, but that radiation killed them, as NASA knew it would. Consequently, the ones we know are front men. Actors. *Fakes.* It's a great story. A full account of my attempts to meet David Percy, who now lives in France, would read like a passage from a Graham Greene novel and eventually recedes into a fog of suspicious questions and identity checks and furtive promises which are whipped away at the last moment. In the end, they issue me with a statement confirming what I already know about them and their ideas.

Bart Sibrel's video is called *A Funny Thing Happened on the Way to the Moon,* and is billed as containing lost footage of the *Apollo 11* crew preparing for a telecast which NASA sold as "en route to the Moon," but was clearly not. The claim is that this "previously unseen downlink footage" shows them setting up the illusion of trans-lunar space as they guiltily circle over the Earth. After leaving John Young in Houston, I'd managed to find a number for Sibrel, on whose answerphone I'd left a message, but received no reply. Then one day a video of the film, in European format, landed mysteriously on my doorstep. A conspiracy lord had finally stepped out of the shadows.

Some of the film is clever, if clichéd. Narrated by an English woman who sounds unnervingly like Margaret Thatcher, the

story begins with a barrage of biblical quotes and examples of human pridefulness and hubris, culminating in Nixon's excitable proclamation as he greeted the *Apollo 11* crew on the deck of the carrier *Hornet* that this was "the greatest week in the history of the world since the Creation"–a claim which had his evangelist chum Billy Graham angrily firing off a list of greater weeks, starting with the first Christmas. There follow some amusing scenes of rockets blowing up, to the accompaniment of Dinah Washington's upbeat rendition of "Destination Moon," with every stab of brass cueing another detonation. Then the famous footage of *Apollo 11* lifting off is cut with soldiers being dragged through the Vietnam mud, Biafrans starving, Martin Luther King marching, students being beaten, a Buddhist monk immolating himself in protest at the war.

Now the arguments: first, that solid lead shielding would have been necessary to protect astronauts from the allegedly lethal radiation of the Van Allen radiation belt, which shields Earth from the sun and is now believed to have been as fundamental to the evolution of sentient life as water. The narrator draws our attention to supposed anomalies in the lighting of lunar photographs, suggesting a light source other than the sun, and to the lack of a burn crater under the lunar module, before some film of the astronauts' famous loping gait is speeded up to look like people trotting. Then there's the "lost footage," which shows Armstrong, Aldrin and Collins laughing and smiling as they set up a shot out of the Command Module window. It's spooky and unsettling, but not because of anything they're doing: what perturbs is the fact that they seem relaxed and at ease, as if out of character. There follows a baroque call to arms–for "the true patriots of America" to "rise up and free its citizens" from a gangrenous and sin-laden federal government, before we're left with quotes from George Orwell ("whoever controls the past controls the future") and Shakespeare ("truth will out"), and a vision of Jackie Kennedy scrambling across a Cadillac with her husband's brain peppering the upholstery.

Sibrel turns out to be disconcertingly bright and articulate. In carefully measured terms, he urges me to see the sobriety of

his position before its zaniness, noting correctly that a faked Apollo landing would be of far more historical significance than a real one.

"That being the case," he proclaims, "the truth has still not come out and humanity has been robbed of this profound event and our nation's greatest heroes are liars. We were prideful and juvenile, wouldn't admit that we couldn't do it."

And I tell him that I think Apollo was probably prideful and juvenile any way you look at it, at which point we run through all the arguments about the flag which looks like it's blowing in the wind when there is no wind on the Moon, the discontinuity of the technology ("you can bet that if we'd gone to the Moon thirty-three years ago, we'd have bases there by now"), the supposedly inconsistent shadows cast by rocks and dearth of stars in the photos. All of these have simple explanations—wire in the flag, politics, sun reflecting from the Earth, the different lighting conditions on a relatively small body with no atmosphere—but like conspiracy theorists everywhere, when one argument is sinking, Sibrel merely hops to another, like a lumberjack riding logs on a river. Until there is a credible way of explaining why the defeated Soviets chose to keep America's guilty secret through the next three and a half decades, such niggling contentions amount to nothing in any case. Listen to Sibrel address the geopolitics of *this* problem and there comes a point where the sight of Keanu Reeves flying toward you in a long black robe would engender no surprise at all, because you are now in the presence of a global conspiracy theory that makes *The Matrix* seem like Jane Austen.

Through it all, I'm trying to gauge whether he really believes what he's saying, but there's no way of knowing. The only thing I feel sure of is that he wants to believe this story, the way Plant believed in Blues, Bean in Art, Schmitt in Capitalism, Young in Progress, Dotty in God, me in Dotty, Ed in pet psychics. Perhaps in the end, arguments don't matter as much as we think they do: what really counts is the story. And just when I think Sibrel's particular version of this story can't get any better, it does. He's talking about how things can become so familiar that you look right at them without really seeing them, when he says:

"And as Kubrick actually suggested in his last film, when that happens you've got your *'Eyes Wide Shut.'*"

Kubrick again! Like a character from Dr. Seuss, he just keeps coming back. There was von Braun and Dr. Strangelove, *2001* and Nixon and the shuttle (and *Apollo 16* Command Module Pilot Ken Mattingly drifting solo with his Strauss waltzes from the movie, having seen it six times). There was *Also Sprach Zarathustra* absolutely bloody everywhere, Michael Collins revealing that he called his simulator instructor "HAL" and the story Ed Mitchell told about one of his young daughters being introduced to Henry Kissinger and Kirk Douglas at the White House, only to blurt to the actor: "I didn't like you in *Spartacus*," which Kubrick directed. There was the disillusioned tramp in *A Clockwork Orange*. Now there's *Eyes Wide Shut*, which Sibrel takes to contain a cheeky last message from the master and supposed director of the lunar illusion.

"Something to consider," he points out in a low voice, "is that, although he died before it was released, Kubrick had contractually stipulated that that movie had to open on a particular date . . . and do you know what date that was?"

Surprise me.

"The thirtieth anniversary of the first landing on the Moon."

Remarkably, this appears to be true.

When I rake over conspiracists with the space historian Jim Oberg, he talks ominously of hoax theory as "exercise of the immune system," calling it "an intellectual bug that is attempting to infect the current culture . . . and the way that the culture handles it will tell us a great deal about the strength of the culture." He adds that the most effective argument lunar-hoax theorists have is that we don't go to the Moon anymore.

Here's what it says to me, though.

From the moment humans were capable of wondering where they came from, they must also have asked where the Moon came from and why it was there. In time, they noticed the subtle spell it cast over the Earth; that it turned the tides (though Galileo declared this a wives' tale) and influenced the mating habits of animals; that its cycle mirrored the cycle of women and sexual activity increased around its fullness; that it was beauti-

ful, like an eye winking from heaven, and occasionally did magical things, like swallow the sun or acquire a fiery halo during eclipses. At the very least, it allowed you to walk home after a beery night in the village without falling in a ditch and, for the same reason, Luna still frowns on war–when she's full, the element of surprise is lost, and there's not a military commander on Earth who can do a damn thing about it, any more than King Canute could turn the tide: generals in the last Gulf War had to obey her just as did their forebears.

She's inspired myth and legend in nearly all cultures, and when you look at these collectively, they're like a love letter from humanity to the Universe, whose constant themes are love, sex, madness, jealousy, romance, magic, treachery . . . things that we fear but are eternally drawn to anyway. She is born each month, waxes to maturity, wanes and dies: the Moon's attraction as a metaphor is not hard to fathom.

And now, the more I look at it, the more I wonder whether the conspiracy theories are our modern, technocratic Moon mythology. Unlike the ancients, we know that the light in our sky can't be the Chinese goddess Chang O mourning the mortal lover she was tricked into leaving behind on Earth, or the head of Coyolxauhqui, severed and slung into the night by her Aztec sun god brother as punishment for betraying her mother, or Europa making love to the sun. We know this because science tells us, the same way we know that it's not demons or spirits who manipulate us with Cold Wars, force our young to die as soldiers in mystifying conflicts on the other side of the world, or shoot them if they protest; or who spy on us and take our money, break into rival parties' headquarters for political advantage, or spin information to occlude its meaning. The powers which plague us belong to states, governments and their friends in business . . . so why wouldn't our modern folklore revolve around them, too? And what more evil trick could this all-seeing, all-powerful and yet somehow *utterly clueless* leviathan play than telling us that they–that *we*–did this magical thing, waltzed into the stars and set down on the Moon, when we never actually did?

From this point on, I see a fresh continuity in the story of

Apollo. Sibrel claims that "Neil Armstrong started shaking like a leaf when I asked him to swear on the Bible," but I'm not sure whether to believe this. I absolutely do believe him, however, when he admits that *yes*, that right hook from Aldrin back in LA really did hurt.

WHEN ALL OTHER ARGUMENT is exhausted, conspiracy believers inevitably draw your attention to one thing: the sullen, peevish withdrawal of Neil Armstrong from public life. It seems doubly strange to me, then, that only days after finally chasing down Sibrel, I find myself en route to Portugal and a rare opportunity to see the first Moonwalker speak—even though that's not why I'm going. In fact, the Moonwalker I'm really hoping to find, David Scott, makes Armstrong look like Robin Williams and has so far eluded me completely.

The Third Global Travel and Tourism Summit is falling on Vilamoura, one of those glaring grass-and-concrete Algarve resorts which might have been grown in a petri dish or dropped out of the sky like a meteorite, complete with its own milky population of British golfers and German yachtsmen. Identifiable only as a place with the technology to mass-produce sprinkler heads, it betrays no history or sense of time, offers no distinctive features, is in every respect the European equivalent of Reno. The Portugese prime minister will open proceedings with a dull and unnecessary sales pitch for his country, to be followed by Armstrong as the celebrity speaker. All aspects of tourism are under discussion, but the summit logo is *Apollo 17*'s *Whole Earth* photo and the theme is "The Next Giant Leap for Travel and Tourism." It strikes me once more that those words tossed into the Moondust are as famous as anything Shakespeare wrote.

Security for the gathering is tight and the accreditation process unusually strict, a fact which has caused a mixture of consternation and mirth in the media camp. This is for the simple reason that no one, not even the hoariest of hacks, had previously encountered anything like the *Armstrong Clause*, a stiffly worded paragraph beginning, "Mr. Armstrong values his pri-

vacy . . ." and climaxing with a command "not to report anything that is said by Neil Armstrong and not to publish any pictures of him." But it didn't end there, because once the Armstrong Clause had been signed by anyone capable of holding a pen, it had to be followed by a letter from their employers specifically underscoring the point and no one could recall a precedent for this: the starriest Hollywood star would never dream of making such a demand and unless you're talking about Robert Mugabe or Stalin, no head of state or monarch would either. A desire not to be harried or pressed for autographs is one thing, but this is something *other*. What on Earth is he going to say? That my pal Bart Sibrel was right after all?

The buildup is awesome. A slide show necessarily containing mostly pictures of Buzz on the Moon sets the scene, backed by Norman Greenbaum's thundering 1970 hit "Spirit in the Sky," and I'm thinking, *Fantastic: no Strauss.* Then the MC offers a rousing "I give you the man who has lived the future!" and the music changes–to, *argh! Also Sprach Zarathustra*–while a screen rises to reveal dry ice smoke and flashing *Close Encounters of the Third Kind* lights, and applause rips through the auditorium as Neil appears and 300 guests leap to a preemptive standing ovation while he saunters to the lectern. *Wow.* He looks around, waits, looks around some more, waits, blinks, clears his throat–*shit, this cat is cool*–then opens his mouth to speak and out comes . . . this squashed, hesitant, dry little voice . . . and the surprise and disappointment of the delegates is palpable. The details of what he says are classified, of course, but that's okay, because he talks for an hour without saying a single thing that might be relevant to us here; without hinting that he's ever explored anything beyond his hotel closet, let alone been to the Moon, and needless to say, this is not what an audience brave enough to negotiate the Armstrong Clause is expecting, with the continental Europeans seeming to find the spectacle particularly tedious. Why would he insist on reporting restrictions? You'll find more controversy in my mother's handbag than in this speech.

Actually, I find the talk imaginative and interesting and admire its careful composition. A couple of weeks later, Armstrong

will make me smile by confiding via e-mail that he was "very disappointed" with his performance, because a light on the lectern was broken, making it hard to see his notes. The delivery was thus "below my usual standards, though I'm told I 'got away with it.'" Even so, I'll marvel again six months later when someone sends me *Accountancy Age* magazine's review of a business convention in Manchester, at which the ex-astronaut replaced Mikhail Gorbachev (urgent business in Kazakhstan) as the star speaker. The key part reads:

"Having paid £250 [$475] a head for the pleasure [of hearing Armstrong speak], delegates at the North West Business Convention would not unreasonably have expected the great man to reminisce about his time on the Moon–'No, it wasn't faked in a TV studio in Houston,' etc. Instead, they were treated to a boring discourse on the history of manned flight. Given that big-name speakers command between £50,000 [$95,000] and £70,000 [$133,000] per engagement, he could have made a bit more effort."

Now, I'm inclined to grant *Accountancy Age* magazine a special kind of authority when it comes to boring things, and this is where Armstrong's reading of the astro-celebrity issue gets thorny. Does he really imagine that people are paying for his charisma and wit and knowledge of astronomy and aviation– that he possesses these things in such abundance that any number of less famous astronomers or historians couldn't do the job as well or better for a fraction of his fee? He is a clever, accomplished person, but he is famous as the First Man on the Moon and people come in the innocent hope of hearing about his *experience*. If he assumes that they're happy just to bask in his presence, then *he's* the one playing the celebrity game–not his audience. All the same, you have to feel for Neil. To him, the content of these speeches is the most fascinating and important stuff in the Universe, and no one wants to hear it. All they want to know is what it was like to stand on the Moon. No wonder playful Pete Conrad used to defuse the question by answering, "Super! Really enjoyed it!"

In Armstrong's further defense are grapevine suggestions that his new wife is trying to get him out of the house more, but there are still no ovations after the Vilamoura address. Over din-

ner in the evening, a French radio producer startles me by say-
ing, "I found it boring ... and it was strange to see him like that
also," to which I reply, "What–you mean ... *old*?" and he nods
grimly, reluctant to acknowledge this unsettling feeling, just as
I'd been when faced with Ed Mitchell for the first time in Florida.
By way of contrast, a young British print journalist enjoyed the
content of the speech, but still finds peculiarity in the man's ap-
parent detachment from the process of delivering it. He cracks a
joke about whether the speech really happened or not. Every
time I step into my hotel's lift thereafter, REM's "Man on the
Moon" seems to be playing, and for the first time I notice that the
chorus runs, "If you believe they put a man on the Moon, then
nothing is cool ..." If I'm not mistaken, Michael Stipe is saying
that he doesn't believe in the landings, either. Being Neil Arm-
strong can't be easy.

AND AS FOR Dave Scott, well, where to start? David Randolf
Scott, the lantern-jawed, six foot, brick-built *Right Stuff* general's
son with degrees from West Point, MIT and Marlboro Man, and
awards coming out of his *Leave It to Beaver* ears, who welcomed
geology and science and did everything right, *always*, so that
even the guys who found him too straight-edged and square for
their tastes, a bit of a *keeno* in fact, had to admit that astronauts
didn't get much better–the more so after he commanded the
most enchanting, the most perfectly realized and scientifically
rich mission of all, to one of the most beautiful places a human
ever laid eyes on, on a ship called *Endeavour,* romantically
spelled the British way after Captain Cook's great vessel of dis-
covery. Everything about the man and *Apollo 15,* the fourth mis-
sion to land, was etched in gold and writ large and those that
followed couldn't help but seem anticlimactic in a technical
sense. Sure as his eyes were blue, Scott the champion swimmer,
polo and handball player scaled the peaks of achievement, then
scaled some more, until one day, with the summit in view, he
glanced down and just ... fell off. There's only one word for this
man's career. Queer.

The eldest of two boys (we might almost say *obviously* by

this stage), *Apollo 15*'s commander was born in 1932, to a father who joined the Army Air Corps in order to win a Friday night bet that he could pass the medical. David watched him fly and knew from the age of three that this was what he wanted to do, sometimes sneaking into the old man's room to try on his flying jacket and goggles, but Tom Scott—shades of the Aldrins here—was a hard taskmaster to his naturally reserved son and brooked no mediocrity. In the astronaut's own words: "My father was a tough guy. He pushed me pretty hard." Nevertheless, Scott Senior gave the boy his first flight at the age of twelve, after returning from three years stationed near Blackpool in the north of England during the war. Later, David won a swimming scholarship to study mechanical engineering at Michigan University, but soon left for the U.S. Military Academy at West Point, where he was indoctrinated into the ways of the Cold War ("I was pretty conservative in those days, and believed that we had to get rid of Communists wherever we found them") and graduated fifth in a class of over 600. From there it was the familiar route of flight school, Europe, MIT for a graduate degree in aeronautics as a prelude to test-pilot training at Edwards Under Chuck Yeager, and NASA, where he flew *Gemini 8* and *Apollo 9* before finally riding away from the Earth on *Apollo 15*.

No one could resist Hadley Rille, winding between the Seas of Serenity and Rains. It was an ancient canyon which looked like the imprint of a monster python and was flanked by the smooth slopes of mountains, the highest of which, Mount Hadley, rose almost three miles into the ink-black sky, with the rounded peaks of the lunar Apennines in the distance. When Scott's partner, Jim Irwin, climbed down the ladder and settled his weight on the LM's footpad for the first time, the pad tilted and threw him backward, leaving him hanging on with one hand, unbalanced, unexpectedly staring straight up at the luminous Earth. He felt ecstatic in that moment, and then again as he contemplated the surrounding peaks, which rose like gargantuan, half-finished pyramids and were colored not the brown or gray of his imagination, but *gold*. At one point, as the pair of explorers climbed the spectral slope of Hadley Delta in the first of the remarkable Lunar Rover cars, Mission Control heard Scott

exclaim, "Oh, look back there, Jim—look at that!" and he was gazing down into the canyon, which was strewn with house-size boulders that looked like grains of sand—so vast was everything about the scene laid out before him. Then he said to Houston: "Man, you oughtta have a great view on your TV . . . this is unreal . . . the most beautiful thing I've ever seen." A voice back home confirmed that the view they were receiving on the monitor was "absolutely unearthly." Just eight months earlier, Irwin's wife, Mary, had been on the verge of divorcing him because she didn't like the celebrity and the absences that went with being on an Apollo crew, and now emotion welled inside him as he remembered that he'd almost resigned from the corps to save his marriage, but Scott had told him, "Everybody goes through it, it'll change." And it did. Mary Irwin and her daughter Jill both assure me that the Moon absolutely did change Jim's life, that there's been no exaggeration; that, as Jack Schmitt might put it with his trademark understatement, when you hear the voice of God over your shoulder it gets your attention.

Later that night in a Houston restaurant, a member of the U.S. Geological Survey was reportedly heard lauding the thoroughness with which the two men had examined a particularly interesting boulder. "Why, they did everything but fuck that rock!" he concluded, which got fellow diners' attention. Scott would leave behind a plaque containing the names of fourteen fallen astronauts and cosmonauts, which he'd commissioned specially from a New York sculptor, and while he did that, Command Module pilot Alfred Worden composed poetry as he glided above and took a series of startling photos of the Earth and lunar surface that would end up in art galleries. Of the Moon, he wrote:

> She is forever moving just out of reach and I sail on,
> Never touching, only watching and wanting to know.

This was in July and August of 1971. On Earth, the *New York Times* was publishing "The Pentagon Papers," which showed that Americans had been lied to by their presidents over Vietnam, while the voting age was falling from twenty-one to eigh-

teen and hot pants were coming into fashion, and up in the stars, *Apollo 15* proceeded like magic. Afterward, Scott penned an article for *National Geographic* in which he said:

"These mountains were never quickened by life, never assailed by wind or rain, they loom still and serene, a tableau forever. Their majesty overwhelms me."

What happened next looks more comic than scurrilous. Certainly, if it were a film, you'd want the Coen Brothers to direct rather than Oliver Stone, and yet it became the Astronaut Office's own Watergate, its *Stampgate*. The official version of the story goes like this:

All of the astronauts had something called a "personal preference kit," in which they could carry a small number of souvenirs and mementos into space. NASA knew that many took specially minted medallions and pins, to be handed out to friends and family afterward–at least this was the official understanding. It had been noted, however, that the number of keepsakes had been increasing over time, to the point at which they became a concern, because to crash under the weight of too many tie pins wouldn't play well with Congress. There had been a mild controversy about the crew of *Apollo 14* carrying some silver medallions which were to be melted down and mixed with others for sale to the general public. This plot was quietly squashed, but David Scott maintains that his crew heard nothing about it, because they were deep in training. Thus, when they were charged with carrying 250 commemorative "first day cover" envelopes on behalf of NASA and someone suggested they take a further 400 of their own, with a quarter reserved for a German stamp dealer who would in return establish three $6,000 college funds for the crew's children, there seemed little harm in it. They were poorly paid and had no life insurance, and the scheme might have worked well if the dealer hadn't released his flown envelopes sooner than agreed, priced at $1,500, and if word hadn't filtered back to NASA.

The trio had committed no crime in law, but if there was one thing an astronaut feared more than the law it was Deke Slayton's regulations, and these had been contravened. Now Deke hit the roof and an investigation revealed that a few other astro-

nauts had made smaller-scale yet similar arrangements, some for charity (as per Jim Lovell), some for themselves, but it was the Hadley Rille boys who caught the attention of Congress and the press, so they took the flak and were slammed; were yanked from *Apollo 17* backup duties, issued letters of reprimand by the Air Force and dragged before the Senate to apologize. Scott had been expected to make general and fly the shuttle, and none of that could happen now. The transgression was relatively innocent, yet it has come to define David Scott's otherwise brilliant career, following him everywhere like a curse, inescapable and ever-present, the first thing the Apollo-literate think of when they hear his name and the first thing journalists and writers would ask about if he let them. That he doesn't merely exacerbates the problem.

In his memoirs, Slayton twists the knife. After labeling Scott "more openly political than most guys . . . a real Boy Scout, quite intolerant of what he saw as failings in other people . . ." Deke notes his partial rehabilitation at NASA's Dryden Flight Research Center, then describes a meeting at which the two men butted heads like goats, a situation in which there was only going to be one winner.

"From that point on, Dave was on the downhill slide with NASA," he contends. "He wound up leaving in 1977, getting involved with one questionable business deal after another. He seemed to have a weakness for anyone who would throw green at him."

After NASA, Scott founded a series of space engineering and consultancy firms, and in the 1990s acted as a technical consultant on the film *Apollo 13* and TV series *From the Earth to the Moon*. Very little was seen or heard of him in public, however, until May 2000, when fifty-six-year-old Anna Ford announced her intention to marry the sixty-seven-year-old Scott. Three months later, long-lens photos of the couple on holiday in Majorca drove her to the Press Complaints Commission, but the relationship was said to have ended abruptly long before the PCC dismissed her complaint a year later. Even before that, the very day after Ford announced the engagement in fact, the *Daily Mail* ran a vicious article about Scott's business dealings and ex-

ploitation of his spaceman past. They dredged up the stamp scandal, then added an Arizona court judgment from 1992, in which he was convicted of defrauding nine investors in a partnership he organized (failing to note that the conviction was overturned on appeal). They stirred in further allegations that he auctioned unverified Moondust from his space suit in 1995–which the astronaut furiously denied–and had received money for endorsing a controversial telephone gambling enterprise which misleadingly claimed to benefit a space education and research fund. Finally, the *Mail* claimed that Scott, then commuting between California and London, had been dating Ford for a year, but had split from his childhood sweetheart wife of forty-one years only two and a half months previously. They found her moving out of the family home and reportedly upset, claiming her husband's relationship and engagement had come as "a total shock." It was as though the curse had followed Scott across the Atlantic.

Who knows what truths or misapprehensions lie behind these reports? Probably no one other than Scott, but all this intrigue adds to the impression of an American hero's precipitous, almost Miltonian fall from grace. Is that how the narrative reads to him? Paradise Lost? A life of two halves? Has he merely been unlucky, or is he the classic flawed hero? Whatever else he might be, Dave Scott is an enigma. And he's here, quietly flown in to take part in a small panel discussion on the future of space tourism, a day after the man with whom he almost perished on *Gemini 8* made headlines through his presence alone. Scott's reclusiveness is different from Armstrong's, though, because he hasn't decided against profiting from his Apollo past. He has an arrangement with an auction house in California, where he conducts "closed signings," from which the public is excluded, with each signature priced at between $165 and $400 a pop, depending upon what's being signed. It's hard to know what to make of this man. I haven't even been able to uncover an address at which to contact him up to now. The few people who might be able to provide one say the same thing: "Oh, no, David never does anything like that."

The seminar room at the plush hotel playing host to the

Global Travel and Tourism Summit is airy and bright, semicircular and walled in glass, and carpeted in rich blue, and if you listen you can hear the sea sighing in the background. I'm not surprised that only a dozen or so delegates have turned up to hear space tourism being discussed, because this is a business conference and mass space tourism is still a pipe dream. Most delegates are either in the bar or on the beach, or chatting in the pleasant sun on the terrace, or attending more practical seminars, but here are Scott and other panelists, who include Eric Anderson of Space Adventures, sitting at a long table waiting to begin. The program doesn't mention it, but Anderson was partly responsible for getting the second proper space tourist, the South African businessman Mark Shuttleworth, up to the International Space Station on a Russian rocket. The same program makes me smile by listing the Moonwalker in our midst as "David Scott, Astronaut (first Moon landing)," but now, with his ruddy complexion and white hair, astonishingly trim in dapper black suit worn with tasteful op art tie, he reminds me of the actor Tommy Lee Jones in *Men in Black*. Introduced as a representative of the Vanguard Space Corporation, a "satellite recovery" operation, he opens with a joke about a Russian astronaut boasting to an American one that it doesn't matter about losing the race to the Moon, because they're going to the sun, and when the American responds, "But it'll be too hot– you'll burn up!" the Russian says, "Ah, well, we're going to go at night." Everyone laughs, though I'm not sure that we're all laughing at the same thing, because since the loss of *Columbia*, the U.S. has been relying on those zany old Russians to get people and materials up to the space station.

Throughout, Scott seems the least passionate and most dismissive of the prospects for mass space tourism, to the extent that I begin to wonder why he came. Afterward, as the panelists and audience linger momentarily before sweeping off to a lavish lunch, I approach with no idea of what to expect. He looks me in the eye and listens as I tell him about the places I've been and people I've met and the questions I've been trying to find answers for, chiefly *What was Apollo about?* and to my astonishment he appears to leap at the idea of speaking further,

sounding full of enthusiasm as he coos, "Sure, that sounds great–be happy to!" Still not quite able to believe this, I take his address and tell him that I'll write with a few more details when we get back to London and we can arrange to meet there. "Yeah, be happy to. That's a great story. A great story!" he repeats as a very attractive young woman in a white dress appears at his side and they disappear toward the terrace with the other panelists. Later, I unexpectedly bump into him, dressed in jeans and a black leather jacket at an end-of-summit beach party, with the same woman on his arm, looking more like the Doobie Brothers' keyboard player than an aged space cowboy. He's awkward in conversation, stilted, as though his face and his voice and his thoughts are operating at tangents, but we small talk about London and Portugal and California for a while and I leave him with the words, "See you in London, then," to which he replies, "Yeah! sure!"–although when I replay the scene afterward, I see a curious twist in his features and a beading of his eyes. Back in the U.K. I write to the Hammersmith address he gave me, but hear nothing back. So I write again. And again, delivering the letter by hand this time to make sure that the address is real, and it is, but there's still no reply. I suppose I shouldn't have been surprised.

Almost a year later, there's a chance to see Scott in a more sympathetic light. A memoir of the Space Race, which he's had ghostwritten in conjunction with the former Soviet cosmonaut Alexei Leonov, has just been published and of necessity it's drawn him out of his shell. He's not submitting to any media, knowing that the first question will concern either stamps or Anna Ford, but he is giving a few talks around the U.K. and one of them is at the Natural History Museum in Oxford. As a bonus, it's being chaired by the ever-smiling Colin Pillinger, God's gift to mad-professordom and leader of the team behind the Beagle Mars probe, that monument to British pluck and resolution in the face of insuperable odds, right down to the essential clinching detail that it didn't quite work.

The odd thing is that by this time, the pre-Apollo Scott looks even more complex to me, and for an unexpected reason. Race intersects this story at every turn, but is seldom mentioned

specifically in relation to the space program, outside of noting that the first black astronaut candidate, Major Robert Lawrence, died when the plane he was flying spun out of control and crashed in 1967. However, the Kennedy administration had instructed the Air Force to find them a candidate long before that, believing that a black astronaut would help to draw African American kids into higher education, and the story of the one they turned up is like a cross between *Top Gun* and *In the Heat of the Night*. Ed Dwight is a successful sculptor in Denver now and I sit listening to him for several hours, and could sit for several more. He was relieved not to be selected for duty by NASA in the end, because he hadn't wanted to be an astronaut, but one of the things he will tell you is that when other pilots in the Air Force's astronaut training program, which fed NASA, tried to freeze him out—less out of bigotry than resentment that he'd jumped the queue, he generously maintains—his classmate David Scott was the one who broke ranks and befriended him. Dwight confesses not to know whether the other man acted out of kindness or a sense of justice, or because he knew the White House was watching and it would be good for his career, but it helped to make the situation more bearable.

Scott's talk is in a museum lecture theater. The audience is mixed, but contains a notably large portion of T-shirted men with longish hair and squarish glasses. They clap enthusiastically as Pillinger enters stage right, all beaming face and biker jacket and Einsteinian free-range hair, followed closely by a navy-suited Scott, who acknowledges the applause stiffly and sits down. Then he gets up and begins to talk about the book, *Two Sides of the Moon*.

I called the publisher and got hold of a copy before I came, so know what's in it: a juxtaposition of Scott and Leonov talking about their respective journeys through space and the Cold War, skillfully compiled by a journalist ghostwriter and especially interesting for Leonov's revelations about the secretive Soviet space effort. By his modest and likable account, Leonov would probably have been the first cosmonaut on the Moon if the Soviet program had survived the Politburo's crippling ambitions

for it. Scott delivers little that is new about the U.S. side of the race and seldom gives up much emotion, but there are a few nice anecdotes, among them his description of Richard Nixon–who was so awkward with adults–delighting as he led the *Apollo 15* crew's children around the White House "like the Pied Piper," showing off secret passageways and bestowing gifts; and of himself landing in the Bahamas after *Apollo 9*, to find his nine-year-old daughter Tracy clutching an essay she'd written for her English class while he'd been away, in which she imagined the family flying to the Moon one night, bouncing around happily with oxygen tanks on their backs. It ended:

"There was lots of dust. We decided that, next Saturday, we would go to the zoo."

Scott also admits to "a pang of nostalgia" when he looks up to the Moon and his eye picks out the largest circular marking on its surface, the Mare Imbrium, or Sea of Rains, on the eastern edge of which he spent "the three most memorable days of my life."

In the flesh, he talks about all this with a curious lack of urgency or engagement, as if debriefing a group of computer experts. At times he's amusing, as when he recounts waking after the first rest period to open the shutters and suddenly remember, "Oh my God, we're on the Moon!" Most of the time, he's repeating stories from the book, the idea for which he claims to have presented to a literary agent with the words, "I'd like to do this, but I don't want to do any work." Only when Scott sits back down and Pillinger opens the floor to questions does the evening liven up. There are still a lot of platitudes and things I've heard before, like, "I sort of look upon it [the Moon] as an old friend," and, asked about the view of Earth, "It's an oasis, very, very precious, and we've got to take care of it . . . we're doing a lousy job . . ." and, regarding millionaire space tourists like Dennis Tito, "I think people who have that much money should sponsor a fund to send an artist or a poet up there." Someone raises a hand and says:

"My five-year-old son would like to know what's it like to walk on the Moon?"

To which Scott offers a prosaic description of its pristine appearance which will have had as much purchase on a five-year-old's imagination as a command to tidy his bedroom.

He's better on solid stuff, like his excitement for Armstrong when he touched down ("that was a *tough* mission") and the way he joked to Pete Conrad, whom he backed up on *Apollo 12,* that "if Neil doesn't make it, you'd better watch your legs," because if anything happened to the *Apollo 12* commander prior to the flight, Scott would take his place. He strains to be diplomatic about the Bush plans for Mars, but his skepticism shows through.

"The problem is where do you freeze the technology?" he asks. "By the time you're ready to go, the technology you're using is ten or twenty years old. It's a difficult problem and I don't know how you deal with it."

Then there's a change in the mood, with someone raising a hand to ask: "How did life change for you after the Moon?" As Scott fumbles and fudges about its not changing that much and his search for "new challenges," I'm wondering whether the question was innocent or loaded. Moments later, I know, as another young questioner smirks: "Is it possible to buy one of the envelopes?"

Scott leans lower to the table, pretending he hasn't understood, while Pillinger, with a look of merry amusement on his face, leans back and expands with the exaggerated ceremony of a quiz show host proffering a clue. He just manages to get out: "I *think* he *means* the *stamps,* David . . ." before the now puce-faced astronaut cuts him off with a rapid "No, they're all gone," then turns and mutters something which I can't hear, but which a startled-looking Pillinger certainly does, because he snaps forward as if the back of his chair has just bitten him and sings, "Okay, let's have another question." Even now, here, there is no peace for Scott.

I decide to help out. The *Apollo 15* commander spent two days drifting home from the Moon with a man who had (or felt he had) heard God calling to him there—Jim Irwin—and I want to know whether the crew discussed this at all?

The reply comes quickly.

"No, there wasn't really time, we were too busy doing the science."

And through the pause which follows, I'm thinking, "Oh well, I tried." But then Scott continues.

"That's an interesting question, though, because Jim was deeply affected. For instance, before the Moon, he was a good speaker, but afterward he was a great one. He really believed. Something real happened to him."

He then speaks about something which he called his "left seat–right seat" theory, referring to the fact that the commander stood to the left in the lander with the Lunar Module on his right. He sounds reflective for the first time as he notes:

"The six guys in the left seat went down paths you'd have expected, but the six in the right seats went off in all kinds of unexpected directions."

And I suddenly recall Ed Mitchell saying something similar. In fact he had a name for it. I'd asked whether he thought some of the Moonwalkers had been more open to the experience than others and he answered:

"Well, one thing to note is that most of the guys who were vocal about the depth of the experience were Lunar Module pilots. It's known phenomenon, from military studies, that the guy in the rear seat of a two-seater aircraft and the guy actually doing the flying have different experiences, because they're focused on different things. It's the *command phenomenon*. The view of the guy who has to be alert and on top of things is different from the guy who's just along for the ride. So those of us coming back from the Moon who were LM pilots, we weren't just along for the ride—we had chores—but we didn't have major responsibilities, because the spacecraft was functioning well. We could take it in and contemplate what we were doing more thoroughly."

He further added:

"I think that was also true for people back home on Earth, though obviously in a different way. Those pictures of the Earth from the Moon are the most published pictures in the world.

And so one has to ask the question: Why is that so? What is that? And to me, it's because they speak to that spirit of quest that humans have. And to the question '*Who are we?*'"

Yes. Now Scott is talking about Ed and his noetic quest, and Buzz Aldrin with his postflight breakdown . . . and Alan Bean with his *Close Encounters* Moon art . . . and of course Charlie Duke and Jim Irwin, who were directly or indirectly led to their faiths by the Moon. Only Jack Schmitt followed a straight and normal path, and then only if you consider a desire to enter the Senate normal. And for the first time, I fall to reflecting on my own encounters with these men; on the LM pilots' eagerness to communicate what they'd felt up there and the way it seemed to still live inside them, as against the by-turns maddening and amusing imperviousness of the surviving mission commanders. Armstrong, Young, Cernan, Scott: I can admire them all in different ways, but wouldn't want them near me if I were a talk-show host or composer of sonnets. Afterward, I go to find Scott, because I want to know whether he thinks this postflight divergence is attributable to the different experiences of the Moonwalkers—as he seemed to be implying—or whether Deke simply assigned them roles according to character type, with focus and singularity seen as the stuff of leadership.

Disingenuous to the last, he pretends not to remember me, while being unable to suppress the spark of recognition in his eye. He nevertheless confirms the first view straightaway.

"No, character doesn't come into it," he says.

Really? I ask, but he shakes his head firmly.

"Character was never an issue."

So he agrees with Ed Mitchell that there was something primal in the experience, at least for those who had the time and mental space to be affected by it?

"I think so. Yes."

He leaves a short gap, as though considering this for the first time.

"It's interesting, isn't it?"

Yes, I agree, it is—even though by this stage of my travels I can no longer believe it to be true. I think Deke Slayton chose his commanders precisely for their rarefied focus and tightly reined

imaginations; for their relative immunity to doubt, ambivalence and vacillation—states that arise from sensitivity to one's situation, but might also delay decisions by the split second that turned success to anguish. What Slayton wanted was impregnability. Many of the commanders appear to be fine men, but it seems to me unlikely that they were ever going to become painters or preachers or poets or gurus, or have much to say about the metaphysical resonance of their journey.

THERE WAS ANOTHER, bigger, surprise waiting for me when I got back from Portugal. Before I went, I'd finally made myself write to Neil Armstrong, expecting no more than a polite brush-off. Now, trawling through my e-mails, I came across a message from an unfamiliar address which suggested another piece of spam. I opened it and giggled like a schoolboy. The name at the bottom hit me first, sitting solid and square, as if carved on a tablet of stone, avatar of an alien world. *Neil Armstrong.*

He told me that he received lots of requests from people writing books and making films, but he could see that this was a different kind of story about Apollo. He asked me to expand on what I wanted to talk about, to tell him who this thing was for and to provide a few sample questions so that he might decide whether he could "make a meaningful contribution." By this stage, I knew that he had agreed to allow an Alabama history professor who specializes in aviation to produce a first biography. The academic had spent three years courting him and I was surprised by his assent until I read that what he'd sanctioned was "a biography about [his] involvement in the evolution of flight." Gene Cernan told me that "Neil's not one to share his personal feelings with people he doesn't know, so I think his book'll have a lot of technical stuff in it about things he did, and his opinions on them, but I don't think he's gonna tell you about how his heart beat faster when he stood there and looked up at the Earth. Neil's just not like that." Charlie and Dotty Duke had said that trying to get Armstrong to speak or even turn up anywhere is "painful!" and when I'd asked why they thought that was, Charlie had told me:

"I never asked him why. I know he just doesn't like the public eye. And I think he made a decision that 'I'm not gonna use this for any aggrandizement . . . it's part of my life, it's over and I'm going to be private.' He's a really nice guy, we're good friends and I really like him. But he's just private."

Desperately unsure of how to respond to the First Man's request, I called Al Reinert, who told me that while the ex-astronaut had been supportive of his *For All Mankind* film, he had resolutely refused to add his voice to the others. A space writer whom I met in Houston recalled speaking to him briefly on the phone for a technical book about a particular airplane, and the answer to his first question being a barked, "Look, if you're just going to ask me questions you could find the answers to in other books, I'm wasting my time." Then Andy Chaikin, who put together his account of the first lunar landing with Armstrong's cooperation, told me:

"The thing you need to know about Neil is that he sees himself and his career in the context of the history of aviation–that's what he's interested in. He also thinks that interviews are not the most efficient way of getting information across."

The implication for me was that if I wanted to sit down and speak with Neil Armstrong, the best bet would be to persuade him of my interest in the X-15's landing gear. I'd done this kind of thing many times before. It's understood in the modern media and the modern world that everyone has something to sell: you talk to them about whatever that is, then guide or drag them on to the things you really want to know. Except that Armstrong isn't trying to sell anything. Even in Reno, I'd felt this–that his eyes are like windows on a lost age. What's more, by a curious coincidence I stopped off on the way back from Portugal to see that other reticent but ubiquitous Neil, Neil *Young*, showcasing a new album at the Apollo Theatre (of all places) in London. Young's late work has tended toward whimsy, but *Greendale* turned out to be an angry collection of songs about intrusion in the modern world, and a particular line about the right to "freedom of silence" had lodged in my mind. Doubly disquieting was my knowledge that the Moon has been a potent symbol for Young throughout a solo career which began the year of the first

landing, figuring in no fewer than twenty-six of his songs. I spent a long time thinking about what to do.

The truth is that this coincided with some strange feelings I'd begun to have about Apollo anyway. From the start I'd been aware of a tension between the sepia attachments of my childhood and the curiosity I felt to see beyond them, to discover what would be left of the freaky adventure if I removed bright sun and thyme-scented hills and Credence on the radio from the picture, and let reason wash through it. The issue was simple: Without its cloak of childish wonder, was Apollo worth the costs? Was it *good*? Knowing what I know now, could I have voted for it? I let the question in and immediately knew I was in trouble.

If I close my eyes and think of the lunar program, the first image I see is of the Saturn V rocket towering over the launch-pad at night, illuminated by a battery of spotlights whose beams skitter and spear into the sky at wild angles, diamondlike and imperious. Yet, over time, the image has evolved in my mind and acquired new meaning, until each beam has seemed to represent another of Apollo's contradictions—the first and most fundamental of which being that this cornerstone of the war against tyrannical Soviet communism was designed and built by a Nazi. Wondering whether I had too blunt a view of this, I e-mailed Dennis Piszkiewicz, whose biography of Wernher von Braun (*The Man Who Sold the Moon*) provides as detailed an account of his life as any has so far. I wanted to know how he'd felt about von Braun after spending so much time with him, whether he'd grown to empathize with the maverick rocket scientist by the end?

In reply, Piszkiewicz spoke of watching the German on the *Disneyland* TV series and being inspired and impressed by this prophet of modernity. He eventually learned about the V-2 and von Braun's wartime past, but no one seemed worried about this, so he didn't worry about it either. Then he addressed my question head-on.

"What do I think about von Braun now, after I have done all the research and written about him? My basic understanding of him did not change: he was a brilliant engineer, a visionary, and an American national hero. But I saw, in addition to all that, that

he was an amoral opportunist and arguably a criminal because of his involvement in the use of slave labor. I might be inclined to ignore his flaws and failures, but it is hard to forgive a man who has participated in ruining and ending the lives of so many people. He became in my mind a far more interesting person, but he was far less admirable.

"My disappointment extends to those people and agencies of the Unitied States government who hid records of von Braun's willing and extensive involvement in the crimes of the Nazis. His talent and creativity in no way justified absolving him of guilt."

His absolution was, however, entirely consistent with American foreign policy throughout the Cold War, which often employed repressive regimes and despots in the interest of countering what was seen as a greater threat. Von Braun's rise after World War II is not so surprising.

But that's not all. Jack Schmitt set off the next train of thought when he reminded me that "people like Neil Armstrong and the test pilots who flew the X-15 rocket plane were, in a sense, already astronauts." And they were! Alan Shepard was not the first American in space, not by a long chalk–that was all PR spin. The domain of space was deemed to begin at fifty miles up back then, and Edwards pilots had been taking the X-15 up there long before Shepard squeezed into his Redstone rocket–a feat for which the Air Force bestowed astronaut's wings. What's more, the X-15 was reusable and required no expensive recovery operation. Even Deke Slayton admitted years later that developing space planes had struck him as "the most logical next step." They might also have retained the support of women electors for longer, because aviation had many female pioneers. But in 1958, encouraged by space advocates like Lyndon Johnson and Wernher von Braun, a war mentality held sway, even as Boeing worked on the X-15's successor, the X-20 orbital space plane, which would have 2.5 milion pounds of thrust as against the Mercury-Atlas's 367,000. By 1962, half a dozen pilots had already been chosen to fly into orbit, and the pilots couldn't believe it when this steady approach was sacrificed to the idea of farting a man into the sky, then scooping him up from the sea as he bobbed about like a helpless infant in his turkey-foil romper

suit. Here's the rub, though. The Titan rockets necessary to the X-20 were still three or four years away, while the Mercury Redstones and Atlases were ready to go—and Kennedy, driven by his own sense of drama and the fear of Soviet progress further denting his image, had set a gratuitous end-of-Sixties deadline for getting to the Moon. There was no time to wait. Later, the space shuttle also elbowed out the X-planes for political reasons. Bill Anders, who was executive secretary for the Aeronautics and Space Council at the time, told me:

"I was involved in the decisions that were made around the shuttle, which was basically to keep the aerospace workers in California employed. Nixon didn't give a rat's ass about the space program, he gave a damn about getting reelected, and the shuttle got more votes in California than a smaller 'X' version would have. I was right there, and that was asked: 'Which one'll employ the most people—the big one? Then let's do the big one.' It couldn't have been more cynical."

And Apollo's ambiguity doesn't even end there. Once the quick-and-dirty approach had been chosen, a method for getting to the Moon had to be devised. Von Braun's first notion was to build a gargantuan "Nova" rocket, then point it in the right direction and go. When studies suggested that such a "direct ascent" vehicle would need to be the size of the Empire State Building, however, several alternatives were considered, the most bizarre of which involved sending some poor sap to the Moon and then leaving him there for a couple of years while engineers worked out a way to get him back. Alarming though this sounded, it would be cheap and fast and possibly the only way to beat the Soviets, and was still being advocated by Bell Aerospace engineers as late as June 1962. It also provided a blueprint for *M*A*S*H* director Robert Altman's first film, *Countdown,* which starred Robert Duvall and James Caan and was seditious in its way, but never got close to the surreality of what we'd be watching on TV in real time a couple of years later, because sci-fi never did catch up with Apollo.

A more palatable option was to establish a base in Earth orbit, from which to assemble and launch smaller, simpler ships at Luna. This elegantly incremental scheme became known as

Earth Orbit Rendezvous (EOR) and eventually won von Braun's support, meaning that an outsider engineer named John Houbolt who floated the idea of "Lunar Orbit Rendezvous" (LOR) was ridiculed and dismissed as a crank in the first instance. LOR was complex and would rely on a range of unproven techniques. It meant sending two ships into Earth orbit, piggybacking them to the Moon, separating in lunar orbit so that one might drop to the surface, blast back up, rendezvous and dock with the first craft, then come back together. An awkward and intimidating scheme, it's easy to see why von Braun took so long to drop his initial hostility toward LOR. When his conversion came, it wasn't about elegance or practicality, though, it was about time. One of his lieutenants, Jesco von Puttkamer, notes:

"All we had was eight years, and LOR stood a better chance, in our estimate, of being achievable in that time. But EOR would probably have given us more continuity to the future."

Earth Orbit Rendezvous would have taken longer, but would have bequeathed a waypoint in space, prepaid for and pointed out toward the stars. It could have been scaled up or down and adapted to a range of purposes with relatively little bother. It would have involved developing technologies and skills that would endure, so that when the political imperatives that drove Kennedy had gone and the lunar landings ceased, an orbital base camp would have been left behind. The Sixties-end deadline had necessitated a built-in obsolescence that was the quintessence of its time. It had also forced up the cost: during peak periods, the overtime bill for the program came close to matching the regular payroll. Kennedy had turned to his advisers and wailed, "What can we beat the Russians at?" and if someone had cried, "Backgammon!" at that point, Apollo would never have happened. Equally, if Richard Nixon had found the paltry extra 118,001 votes he needed to win the November 1960 election, Apollo would never have happened in the way that it did. Thus, it's hardly surprising that as early as late 1963, JFK was trying to wriggle out of the commitment he'd made, suggesting a joint program with the Soviet Union that would bring down costs and allow a landing to be commuted to the Seven-

ties. Part of his purpose in Dallas on the day of his murder was to bolster waning support for Apollo in the face of renewed congressional opposition.

Four days prior to Kennedy's 1961 exhortation to Congress and ignorant of its content, NASA's number two, Hugh Dryden, had been asked by a member of the Senate Appropriations Committee what practical use he saw for going to the Moon. "It certainly does not make any sense to me," he replied. Through the Iron Curtain, the masterful chief designer Sergei Korolev had also envisaged a steady, incremental approach to space exploration that could have surfed the political tides, but Khrushchev, too, insisted on pushing his program to destruction. So if the American lunar program played a walk-on part in its president creator's death, there's no way to avoid the conclusion that it also did something far more ironic and contradictory: Jack's Apollo program killed "manned" Deep-Space exploration, stone dead, for at least the next four decades and probably many more.

How's that for contradiction, for equivocation? And in this, Apollo also seems to me to be the most perfect imaginable expression, embodiment, symbol, of the twentieth century's central contradiction: namely, that the more we put our faith in reason and its declared representatives, the more irrational our world became. Sane political leaders contemplated the mutual destruction of their societies; greater wealth led to greater dissatisfaction; faster communications which should have made life easier made it harder, because suddenly we expected everything to happen instantly; more efficient food production led to poorer health . . . the list could go on and on and on. Seen in this light, Apollo has something to teach us as we enter a new century of genetic modification, artificial intelligence, nanotechnology. It's a cautionary tale about that most fundamentally human of human tragedies—the tragedies of Macbeth, Othello, Faust, Kennedy, Nixon, Aldrin . . . once again, you could list them forever: wanting something so badly that you end up destroying it. Hubris. Mary Shelley would have swooned. A century and a half after she wrote *Frankenstein,* which many consider the progenitor of modern science fiction, here was her monster made real.

And yet . . .

Through the years, the arguments used to defend Apollo changed—and have continued to change—with the political and economic tide. To begin with, there was national security, but Kennedy's advisers knew perfectly well that putting people in space would do little to make America safer and going to the Moon would do nothing. As one of them explained, "The Earth would appear to be, after all, the best weapons carrier." Afterward, the justification switched to science, but the scientists, including such distinguished figures as Dr. James Van Allen, for whom the Van Allen radiation belt is named, had been saying all along that robots could do the job just as well in the short term, at a fraction of the risk and cost. Then there was the contention that Apollo stimulated the economy; that it begat new products, technological advances and medical techniques, but if that was the idea, $24 billion (equivalent to $100 billion today, remember) could certainly have been more efficiently spent. Imagine what a group of NASA scientists might have done for kidney dialysis or alternative energy production or clean transport systems if set the task. Even the notion that it was part of America's national destiny as frontierspeople doesn't hold, because it stopped. As Jim Oberg told me: "A lot of the guys at NASA thought that the goal was space exploration and colonization of the Universe, and they all had their hearts broken."

After leaving office, Lyndon Johnson continued to paint the program as a key pillar of his Great Society dream, as "the beginning of the revolution of the Sixties." In his memoirs, he writes:

"Space was the platform from which the social revolution of the 1960s was launched . . . If we could send a man to the Moon, we knew we should be able to send a poor boy to school and to provide decent medical care for the aged."

Which is sweet, but no more convincing than the claim (false) that it was all worthwhile because we got Teflon—because, at the risk of sounding glib, it seems to me that the best way to demonstrate that we can put a poor kid through school is to put poor kids through school. How many teachers will $100 billion pay for? For the longest time, it seemed obvious to me that I was staring into the remains of the most im-

maculate folly ever conceived by a species for whom folly is a specialist subject.

But a change came one cool spring day as I stood contemplating a one-shot skinny white-chocolate cinnamon latte with extra foam in Starbucks, thinking that only Americans could turn coffee-making into a proxy branch of rocket science. I'd been trying to make sense of this enterprise which seemed to make no sense, which reason told me to dismiss, but which I couldn't. The only thing clear to me was that Apollo was none of the things it was sold to the world as being.

Then I remembered something else that John Kennedy had said in his May 1961 appeal to Congress. His people had become convinced that the Cold War was going to be won or lost in the so-called Third World, and that cultural factors would influence the loyalties of wavering nations as much as economics did. In this respect, Apollo was a performance, pure and simple. JFK wanted something to capture the global imagination, and to excite his own people, and he found it. But he didn't create the idea, the fantasy was already there, independent of the Cold War, and there's no question that Kennedy knew he was tapping into something far deeper and more primal than an urge to humiliate the Soviet Union. All those space novels and sci-fi movies and articles in *Colliers* and *Space Cadet* magazines sat at the top of a pyramid of human dreaming that stretched back thousands of years. Apollo may have been driven by the Cold War, but it was an emanation of American popular culture at that moment in time. It occurred to me that, in the end, it was *theater*–the most mind-blowing theater ever created. In fact, at around $120 per American over the nine years of the Sixties in which it ran, or $13 a year, it was astonishingly *cheap* theater. To be sure, the total bill for Apollo added up to $24 billion, but the U.S. was spending $30 billion on the Vietnam War *annually* at its peak. According to figures quoted by CNN, that conflict cost over $809 billion in today's money. Next to 'Nam, $24 billion doesn't look like much. By 1980, Americans spent more playing Space Invaders than they did on the space program–a perfectly reasonable choice under the prevailing circumstances.

At this point, consideration of Apollo's practical worth be-

comes redundant, because it was never about that. And here we come to the final contradiction: that this product of scientists and engineers and their lean rationality should, like a great work of art, have the special ability to transcend the logic at its core, and to take us with it. As the astronaut Joseph Allen said, "With all the arguments, pro and con, for going to the Moon, no one suggested that we should do it to look at the Earth. But that may in fact be the most important reason." The one that nobody foresaw: a unique opportunity to look at ourselves. How madly, perfectly human. For all Apollo's technological wonder, it was as primitive as song. It meant nothing. And everything. I left Starbucks and went outside and stared at the unusually big, bright, opalescent Moon which hung above shoppers as they scurried between sales. I realized that I hadn't looked at it, really looked at it, for a while. I tried to imagine floating through space toward it. Was Apollo worth all the effort and expense? If it had been about the Moon, the answer would be no, but it wasn't, it was about the Earth. The answer is yes. The only thing I can't see in all this is a rationale for going back. Unless we could find a way to take everyone.

Reviewing all these thoughts, I knew what to do about Armstrong, this intensely private man who's worn his special place in our mythology of ourselves with such dignity, who's had the decency not to crowd our imaginations or diminish our fantasies by fixing them with words he struggles to find. Who's refused to auction himself to our idolatry or give in and tell us what we want to hear; who sees the worst of us, but still allows us to look at him and see the best of ourselves. So I told him what I wanted to know: the fourteen minutes he spent on the lunar surface on his own, utterly alone, staring out at a meticulously shifting Universe, full of unimaginable forces and giant, inscrutable, unstoppable bodies, but no *mind* like his . . . was the feeling like any he'd had before? Like sex? Like swimming in the sea at night? Going out without your parents on Halloween for the first time? Like he'd imagined all along, with no surprises? Did he feel alone, like a representative of the Earth, or closer to the stars? Did he leave us just for a moment and feel like Dave Bowman in *2001*, or want to tell Houston to fuck off and shut up

and let him just be there for a while? Did he feel adrift, or cosseted, or get the urge to do anything mad, like when you're standing waiting for the subway and get a fleeting impulse to jump and test the truth of mortality? Did he feel nothing at all?

And when he got back, did he feel longing? Relief? Irritation? Disappointment? The astronauts' nurse, Dee O'Hara, spoke of a kind of rage the early astronauts felt at being back in the realm of gravity, how they were always looking up and bumping into Earth's piteous furniture. Does Armstrong know what he thinks and feels about the adventure which asked for eight years of his life, then stole the rest? Does it make him want to scream? Cry? Smile? Laugh? Was it worth it? Does he wish he'd done something else instead, the way the iconic actor Paul Newman (on the screen as Butch Cassidy that year) wishes he'd become a marine biologist? Would he like to go again? Having had a privileged view of infinity, how does he feel about joining it when his time comes?

And I knew that Armstrong wouldn't, couldn't, answer these questions, but was struck by the pleasure I took in this knowledge, as in the realization that my "childish wonder," far from being an impediment to understanding Apollo, had been the whole point of it; that perhaps it should be the point of more things, more often. Hours passed as I sat at the screen and it felt like a catharsis, the purging of a year spent finding different ways to ask the same question—because I could now see that in the end, everything boiled down to this: What was it like to stand on the Moon? I hit the send button and it was gone.

NEARLY THREE DECADES have passed since I last gazed down from the steep hill upon which my junior high school once sat. It's a bright, cool January day and the sun is low; leafless trees cast long shadows across sidewalks and cars float slowly through the streets below. Again I wonder how it is that memories can seem so distant yet still feel like yesterday. I've returned to San Francisco many times over the years and in this moment am surprised that I've never made the short drive over the bay to revisit Orinda before now.

The Senate Watergate committee was in full swing and President Nixon on the ropes the week we started at the new school in August 1973, and everything in our lives seemed to change. The year before, we'd been running around calling the girls names, and they us, pretending we didn't like each other when really we did, but at junior high we were suddenly going to parties with each other like bantam adults, invited in pairs,

and at one I saw a couple disappearing into a bedroom, which shook me a little. The transformation had been so abrupt: how had we known to do this and who had decided that we would? In a new "health education" class, a studiously hip young teacher who let us sit on the desks as if we were at a be-in warned about VD and drugs, telling us that if you injected heroin three times you'd be an addict, and that at the huge California Jam festival, which Deep Purple headlines down the coast at the Ontario Speedway, "pushers" were sticking people with junk-filled needles at random in order to get them hooked. As with most things, I had no idea whether to believe her or not at the time, but later wasn't surprised when both claims turned out to be untrue.

Watergate had hung over the country like a cloud of noxious gas and left a haze of heightened cynicism in its wake, which combined with the oil crisis and rising unemployment to make the world feel much less stable than it had. Awful though the Vietnam War was, it had provided a focus for dissent and its corollary, hope, in comparison with which the new problems seemed so formless and hard to grasp, so *macro*. The California sun still shone and we still had fun, but the stakes of our lives had been raised in ways that we couldn't yet appreciate and that were already being reflected in the gritty realism favored by a new wave of American film directors like Scorsese and Bogdanovich; in the pre-1963 nostalgia of George Lucas's *American Graffiti* and Samaritans comforting people outside *The Exorcist* as the spiritual revolution turned in on itself. More seriously for me, my hero Evel Knievel became a laughingstock when he attempted to "jump" Snake River Canyon in a rocket, a stunt which made him look like a cheap circus daredevil and reeked of desperation. I'd thought the arcs he traced through the air on his bike were about flight, but this was just showbiz. He'd lost his way, too.

The hills are softer and rounder and more closely huddled than I remember, beautiful in a way that I couldn't see as a child, and just in case anyone still doubts that the real victors of the Cold War were estate agents, the place is now called "Orinda Village." Amazingly, my old playmate David from the day of the first landing is still here, newly divorced but little changed and

living in the same street, and so is the old clapboard house where those ghosts of ghosts drifted across the screen that day. When the Golden Age was done, we had to move because Dad had left his job and couldn't find another to satisfy him. We spent the summer building a retaining wall to stop the garden slipping into the creek that ran through the back, in which I spent hours catching frogs and newts while savings dwindled and Mum grew increasingly fraught, and when the work was done, we left for England in the summer of 1974, where a blistering heatwave was followed by three months of solid slate skies and rain. The foundations of the retaining wall are still there because Dad had designed it well—in the way of his generation, who've always seemed to me more rounded than my own. Two years older than Armstrong, he could build anything, but what he dreamt of being was a writer: all my life he was working on a book that, like Apollo, was never finished, and I wonder as I stand waiting for the dusk to come whether it's coincidence that finishing this one has felt so strange? I mention this because there was a point toward the end of my travels when almost everything, not least the lunar program itself, began to look like part of the peculiar dynamic between fathers and sons—from JFK and his tyrannical, supercompetitive father onward. In the end it has to be about more than that—and if I had to capture the spirit of the spooky adventure in a word ... for astronauts, dreamers, doubters, conspiracy theorists ... the word would be *desire*—but it's part of the story all the same. It'll take me months to realize this, but when I set out on my return journey to Apollo I was within weeks of the age that my father was when *Apollo I* set down in the lunar dust.

I spent a while at the old house, as the woman who lives there now explained that her kids never played in the creek because she thought it might be dangerous. These days it's hidden behind a fence and as I look around I seem to see fences everywhere: I thought my visit would feel like a homecoming, but in the event it feels more like a catharsis.

The question I started out with remains. Why had I wanted to come back to the time and place of Apollo? Why had Pete Conrad's death and Charlie Duke's "only nine" affected me the way

they did, impelling me to go and find them, fueled by anxiety that these people whom I'd barely thought about in the intervening years would soon be gone? For eighteen months this has vexed me, but suddenly the answer seems obvious: that the astronauts represent a time when the world seemed to reflect my own innocence. Bad things happened, all the time, in spades, but for a brief period people tried to convince themselves that these horrors stood against the natural order and run of humanity, as opposed to constituting its most perfect expression–that progress in the broadest sense could win the day, was liberating and inevitable. For me, the custodians of this radical and optimistic notion were the lunar astronauts and the flower children, both of whom promised bright futures that were later discredited and abandoned; that disappointed, yet retained a latent, almost involuntary, hold on the imagination. Little wonder that we as a culture return to them constantly, can't leave them alone. Like the curious decade that spawned them, they carry the fascination of the unresolved.

Little wonder that at about the astronauts' Moon age, the age they were when they flew, I'd wanted to find out what they and their era were worth, what they'd left us with–if anything. And in Apollo's case, it's clear that the answer had nothing to do with engineering or technology, that what it did, via Neil Armstrong's upstretched thumb, was afford us the enormous privilege of seeing ourselves for the first time as *small*. It's no coincidence that when I review my travels among the astronauts, my mind's eye goes first to the Houston shopping mall where Alan Bean sat for hours after returning from space, just eating ice cream and watching the people swirl around him, enraptured by the simple yet miraculous fact that they were there and alive in that moment, and so was he. Then, no matter what else I might be feeling, I also feel lucky, because in a cosmos of infinite scattered moments, each one I can lay claim to and use well seems precious. For me, this is the surprise collective lesson of the Moon men. No one was changed, but everyone was galvanized. Whatever they took with them, they brought back tenfold, like coals crushed to diamond. Through Apollo, the Moon did what it has always done: it shone fresh light on what was already there.

AND STILL ONE surprise remains.

Against form and expectation, Armstrong got in touch, saying that he would be willing to try to answer my questions, making me laugh by adding that he would be more inclined to address matters of "fact" than "questions of opinion"–a much clearer distinction for him than it is for me, I suspect. In the months that followed, he proved unfailingly courteous if typically cautious in his responses, yet the truth is that the technical details of Apollo have been so extensively cataloged that few original "facts" remain for even him to disclose.

There was one particular exchange that I cherish, though. It followed my observation that in 1999 the reprinted edition of a book called *Chariots for Apollo* by Charles R. Pellegrino and Joshua Stoff had revealed how close Armstrong's *Eagle* may have come to an unhappy end in the moments after landing, when a slug of frozen fuel became trapped in a pipe, causing a buildup of temperature and pressure that threatened to set the ship off like a hand grenade. Their story has engineers at Grumman headquarters scrambling for blueprints and ideas, guessing that they had five minutes, maybe ten if they were lucky, to sort the problem out. Someone suggested they "burp" the engine, but that carried a risk of tipping the module over, and studying the options, the engineering manager said, simply, *"Get them out of there."* Yet just as concern was turning to panic on the ground, telemetry indicated that the fuel plug was shifting on its own. By this account, very few people have known how close *Eagle* came to recasting Tranquillity as a graveyard even before the One Small Step could be taken. How different America and the Sixties might look to us now if it had.

I'd mentioned to Armstrong that I've never seen this story anywhere else and had asked whether it was true as reported. He replied that although he considered the book in question "a case study in creative writing" (heinous crime!), the blockage was real and "we did have some discussion with Mission Control . . . [but] we were not unduly concerned about it." This doesn't necessarily mean that the authors were exaggerating,

because Houston may have kept the seriousness of the situation from the crew, and in any case we have Michael Collins's word that "Neil never admits surprise."

Of more interest to me, though, was the First Man's response to a supplementary question about "the strange, electronic-sounding music" that Collins reported him taking to Luna, to which he offered a piece of trivial information that gives me as much pleasure as anything I discovered in the course of my research. He told me that he took Dvořák's *New World* Symphony, but that the electronic sound I referred to was the theremin music of Dr. Samuel Hoffman, specifically an album called *Music Out of the Moon*, which he'd committed to tape from his own collection. The theremin was an early form of synthesizer, played by moving one's hands through two invisible radiostatic fields to produce a kind of unearthly quaver, *eerie,* like the pleadings of an alien choir. Now mostly associated with Fifties sci-fi movies such as *The Day the Earth Stood Still* and the Beach Boys' "Good Vibrations," along with a few moody modern groups like Portishead, Armstrong's decision to make it part of his own sound track struck me as at once deeply, deeply eccentric and absolutely *perfect,* and ever since, when I've thought of Apollo, I've thought not of the first step or the raging Saturn, but of him and his little band drifting out there toward the secret Moon, spinning slowly to distribute the heat and spilling spooky theremin music out at the stars, who think it's just as weird as I do—and it occurs to me that in the final analysis this might be as good a way as any to remember Apollo, as a kind of collective dream, a tale from a comic book come to life. I'll drive away from Orinda thinking that it might be a while before we see anything like it again, but finding a rare peace in this knowledge. It's time to go home.

SELECT BIBLIOGRAPHY

Ackmann, Martha. *The Mercury 13*. New York: Random House, 2003.

Aldrin, Buzz, Jr., & Wayne Warga. *Return to Earth*. New York: Random House, 1973.

Aldrin, Buzz, & Malcolm McConnell. *Men from Earth*. New York: Bantam, 1989.

Aldrin, Buzz, & John Barnes. *Encounter with Tiber*. London: Hodder and Stoughton, 1996.

——. *The Return*. New York: Tom Doherty Associates, 2000.

Ambrose, Stephen E. *Nixon: The Triumph of a Politician 1962–1972*. London: Simon & Schuster, 1989.

——. *Eisenhower: Soldier and President*. London: Simon & Schuster, 1991.

——. *Rise to Globalism: American Foreign Policy Since 1938*. London: Penguin, 1997.

Asimov, Isaac. *The Tragedy of the Moon*. London: Coronet Books, 1975.

Ballard, J. G. *Memories of the Space Age*. Sauk City, Wisconsin: Arham House Publishers Inc., 1988.

Barnes, Julian. *A History of the World in 10½ Chapters*. London: Picador, 1990.

Baxter, John. *Stanley Kubrick: A Biography*. London: HarperCollins, 1998.

Bean, Alan (with Andrew Chaikin). *Apollo: An Eyewitness Account by Astronaut/Explorer Artist/Moonwalker Alan Bean*. Shelton, Connecticut: The Greenwich Workshop Inc., 1998.

Benjamin, Marina. *Rocket Dreams: How the Space Age Shaped Our Vision of a World Beyond.* London: Chatto & Windus, 2003.

Bennett, Mary, & David S. Percy. *Dark Moon: Apollo and the Whistle Blowers.* London: Aulis Publishers, 1999.

Bernstein, Irving. *Guns or Butter: The Presidency of Lyndon Johnson.* Oxford: Oxford University Press, 1996.

Bizony, Piers. *2001: Filming the Future.* London: Aurum Press, 1994.

Bockris, Victor. *Warhol.* London: Penguin, 1990.

Booker, Christopher. *The Seventies.* New York: Penguin Books, 1980.

Brokaw, Tom. *The Greatest Generation.* New York: Random House, 1998.

Caro, Robert A. *The Years of Lyndon Johnson: Vol. 3, Master of the Senate.* London: Jonathan Cape, 2002.

Carpenter, Scott. *The Steel Albatross.* London: Headline Book Publishing, 1992.

Carpenter, Scott, & Kris Stoever. *For Spacious Skies: The Uncommon Journey of a Mercury Astronaut.* Orlando: Harcourt, 2002.

Cernan, Eugene, & Don Davis. *The Last Man on the Moon: Astronaut Eugene Cernan and America's Race in Space.* New York: St. Martin's Press, 1999.

Chaikin, Andrew. *A Man on the Moon.* Richmond, Virginia: Time Life Inc., 1999.

Clarke, Arthur C. *2001: A Space Odyssey.* London: Arrow, 1968.

Collins, Michael. *Carrying the Fire: An Astronaut's Journey.* New York: Cooper Square Press, 2001.

Cooper, Gordon, & Bruce Henderson. *Leap of Faith: An Astronaut's Journey into the Unknown.* New York: HarperCollins, 2000.

Dallek, Robert A. *Flawed Giant: Lyndon Johnson and His Times 1961–1973.* Oxford: Oxford University Press, 1998.

——. *John F. Kennedy: An Unfinished Life 1917–63.* London: Allen Lane, 2003.

Doran, Jamie, & Piers Bizony. *Starman: Yuri Gagarin, the Truth Behind the Legend.* London: Bloomsbury, 1998.

Duke, Charlie, & Dotty Duke. *Moonwalker.* Nashville: Thomas Nelson Inc., 1990.

George, Nelson. *Where Did Our Love Go? The Rise and Fall of the Motown Sound.* New York: St. Martin's Press, 1985.

Godwin, Robert (ed.). *The NASA Mission Reports: Apollo 11 (Vols 1–3).* Burlington, Ontario: Apogee Books, 1999.

——. *The NASA Mission Reports: Apollo 12.* Burlington, Ontario: Apogee Books, 1999.

——. *The NASA Mission Reports: Apollo 14.* Burlington, Ontario: Apogee Books, 2000.

——. *The NASA Mission Reports: Apollo 15* (Vol. 1). Burlington, Ontario: Apogee Books, 2001.

——. *The NASA Mission Reports: Apollo 16* (Vol. 1). Burlington, Ontario: Apogee Books, 2002.

——. *The NASA Mission Reports: Apollo 17* (Vol. 1). Burlington, Ontario: Apogee Books, 2002.

——. *The NASA Mission Reports: Freedom 7: The First U.S. Manned Space Flight.* Burlington, Ontario: Apogee Books, 2001.

Hartmann, William K. (ed.) et al. *In the Stream of Stars: The Soviet/American Space Art Book.* New York: Workman Publishing, 1990.

Heinlein, Robert A. *The Moon Is a Harsh Mistress.* New York: Orb, 1997.

Hobsbawm, Eric. *Age of Extremes: The Short History of the Twentieth Century 1914–1991.* London: Abacus, 1995.

Hoskyns, Barney. *Beneath the Diamond Sky: Haight-Ashbury 1965–1970.* London: Bloomsbury, 1997.

Hughes, Ted. *Moon-Whales and Other Poems.* New York: Viking Press, 1976.

Kauffman, James L. *Selling Outer Space: Kennedy, the Media, and Funding for Project Apollo, 1961–1963.* Tuscaloosa: University of Alabama Press, 1994.

Kelly, Thomas J. *Moon Lander: How We Developed the Apollo Lunar Module.* Washington: Smithsonian Institution Press, 2001.

Kozloski, Lillian D. *U.S. Space Gear.* Washington: Smithsonian Institution Press, 1994.

Kraft, Chris. *Flight: My Life in Mission Control.* New York: Dutton, 2001.

Kramer, Barbara. *Neil Armstrong: The First Man on the Moon.* Berkeley Heights: Enslow Publishers Inc., 1997.

Kranz, Gene. *Failure Is Not an Option.* New York: Berkley, 2001.

Kurlansky, Mark. *1968: The Year That Rocked the World.* New York: Ballantine, 2004.

Latzeff, Paul. *Moon Madness.* London: Robert Hale, 1990.

Lee, Stan, John Buscema & Jack Kirby. *Essential Silver Surfer.* New York: Marvel Comics, 2001.

Light, Michael. *Full Moon.* London: Jonathan Cape, 1999.

Lindsay, Hamish. *Tracking Apollo to the Moon.* London: Springer-Verlag, 2001.

Lovell, Jim, & Jeffrey Kluger. *Apollo 13.* New York: Houghton Mifflin Co., 1994.

MacInnes, Colin. *Absolute Beginners.* London: Penguin, 1964.

McCurdy, Howard E. *Space and the American Imagination.* Washington: Smithsonian Institution Press, 1997.

McDougall, Walter A. *The Heavens and the Earth: A Political History of the Space Age.* New York: Basic Books, 1985.

Mailer, Norman. *Of a Fire on the Moon.* Boston: Little, Brown & Co., 1970.

Mitchell, Dr. Edgar, & Dwight Williams. *The Way of the Explorer: An Apollo Astronaut's Journey Through the Material and Mystical Worlds.* Buenos Aires: Richter Artes Graficas, 2001.

Murray, Charles, & Catherine Bly Cox. *Apollo: The Race to the Moon.* London: Simon & Schuster, 1990.

Murray, Charles Shaar. *Crosstown Traffic: Jimi Hendrix and Post-War Pop.* London: Faber & Faber, 1989.

Naifeh, Steven, & Gregory White Smith. *Jackson Pollock: An American Saga.* London: Pimlico, 1992.

Nixon, Richard. *The Memoirs.* London: Sidgwick & Jackson, 1978.

Pellegrino, Charles R., & Joshua Stoff. *Chariots for Apollo: The Untold Story Behind the Race to the Moon.* New York: Avon Books Inc., 1999.

Penley, Constance. *Nasa/Trek: Popular Science and Sex in America.* New York: Verso, 1997.

Piszkiewicz, Dennis. *Wernher von Braun: The Man Who Sold the Moon.* Westport: Praeger Publishers, 1998.

Reeves, Richard. *President Kennedy: Profile of Power.* New York: Touchstone, 1994.

——. *President Nixon: Alone in the White House.* New York: Touchstone, 2002.

Reid, Lori. *Moon Magic: How to Use the Moon's Phases to Inspire and Influence Your Relationships, Home Life and Business.* London: Carlton Books, 1998.

Remnick, David. *King of the World: Muhammad Ali and the Rise of an American Hero.* London: Picador, 2000.

Reynolds, David West. *Apollo: The Epic Journey to the Moon.* London: Harcourt Brace International, 2002.

Runyon, Damon. *Broadway Stories.* London: Penguin, 1993.

Savage, Jon. *England's Dreaming: Sex Pistols and Punk Rock.* London: Faber & Faber, 1991.

Schefter, James. *The Race: The Definitive Story of America's Battle to Beat Russia to the Moon.* London: Arrow Books, 2000.

Schirra, Wally, & Richard N. Billings. *Schirra's Space.* Annapolis: Naval Institute Press, 1995.

Schlesinger, Arthur M. *A Thousand Days: John F. Kennedy in the White House.* Boston: Houghton Mifflin, 1965.

Scott, David, & Alexei Leonov. *Two Sides of the Moon: Our Story of the Cold War Space Race.* London: Simon & Schuster, 2004.

Shayler, David J. *Disasters and Accidents in Manned Spaceflight.* Bodmin, England: Praxis Publishing, 2000.

Shelton, Robert. *No Direction Home: The Life and Music of Bob Dylan.* London: Penguin, 1987.

Sidey, Hugh. *John F. Kennedy: Portrait of a President.* London: Penguin, 1965.

Sigma, Rho. *Ether-Technology: A Rational Approach to Gravity Control.* Kempton, Illinois: Adventures Unlimited Press, 1996.

Slayton, Donald K., & Michael Cassutt. *Deke!* New York: Forge, 1994.

Solloway, Frank J. *Born to Rebel: Birth Order, Family Dynamics, and Creative Lives.* London: Abacus, 1998.

Stafford, Tom, & Michael Cassutt. *We Have Capture: Thomas Stafford and the Space Race.* Washington: Smithsonian Institution Press, 2002.

Steinbeck, John. *Travels with Charley.* London: Penguin, 1980.

Stevens, Jay. *Storming Heaven: LSD and the American Dream.* London: Paladin, 1989.

Terkel, Studs. *My American Century.* London: Phoenix Giant, 1998.

SELECT BIBLIOGRAPHY

Turnill, Reginald. *The Moonlandings: An Eyewitness Account.* Cambridge: Cambridge University Press, 2002.

Updike, John. *Rabbit Redux.* London: Penguin, 1995.

Verne, Jules. *From the Earth to the Moon.* Stroud, England: Alan Sutton Publishing Limited, 1995.

Vidal, Gore. *The Last Empire: Essays 1992–2001.* London: Abacus, 2002.

Wendt, Guenter, & Russell Still. *The Unbroken Chain.* Burlington: Apogee Books, 2001.

White, Frank. *The Overview Effect: Space Exploration and Human Evolution.* Boston: Houghton Mifflin Co., 1987.

Wolfe, Tom. *The Right Stuff.* London: Picador, 1990.

Worden, Alfred M. *Hello Earth: Greetings from Endeavour.* Los Angeles: Nash Publishing Corp., 1974.

Young, Hugo, Bryan Silcock & Peter Dunn. *Journey to Tranquillity: The History of Man's Assault on the Moon.* London: Jonathan Cape, 1969.

Zappa, Frank, & Peter Occhiogrosso. *The Real Frank Zappa Book.* London: Picador, 1990.

ACKNOWLEDGMENTS

ENORMOUS THANKS TO all at Bloomsbury in London for their enthusiasm and encouragement, and at Fourth Estate in New York, especially my wonderful editor Courtney Hodell, whose constant coaxing and questioning made all the difference in the world. Whenever I hear the word "why?" these days (which is not often enough, on the whole), I think of her. Thanks also to Emma Parry and to my great friend and editor at the *Sunday Times,* Adrienne Connors.

Equally, thanks to everyone who gave their time and thoughts in the course of making this book, both those who appear on the page and the many, many who don't but made telling contributions nonetheless. A general debt is also owed to all the writers and journalists who've passed this way before, because few events have been so widely or well documented as the Apollo Moon landings. In particular, I would like to thank Andy Chaikin, Al Reinert and Robert Godwin, who lent their support for no better reason than that they liked the sound of what I was doing. Their spirit of inquisitiveness and generosity made me feel proud to count myself a writer, and continues to do so.